THE FRIEDKIN CONNECTION

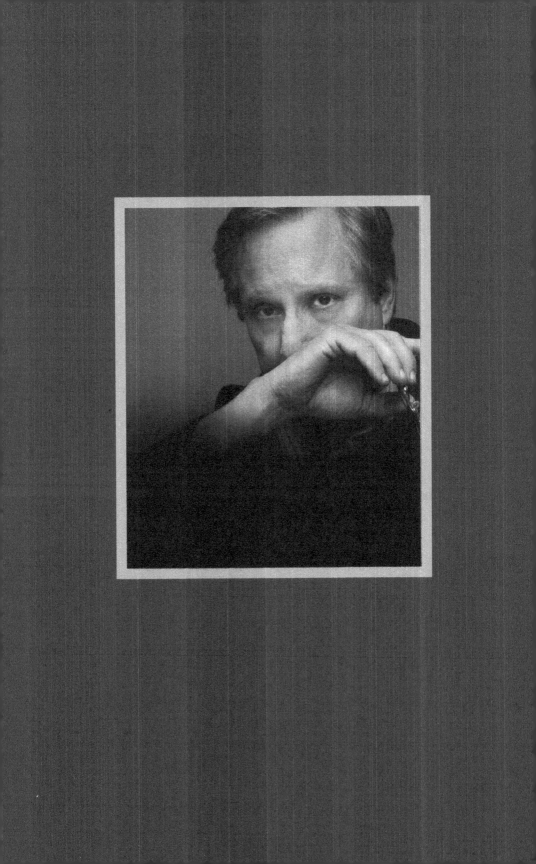

THE FRIEDKIN
CONNECTION

A MEMOIR

WILLIAM FRIEDKIN

HARPER

www.harpercollins.com

HarperCollins books may be purchased for educational, business, or sales promotional use. For information, please e-mail the Special Markets Department at SPsales@harpercollins.com.

Permission for extract from *Bug* © 2006 by Tracy Letts.

Translation of Carl Orff, *Carmina Burana* © 1984, The Decca Record Co., Ltd., London.

Extract from *Kazan on Directing* by Elia Kazan, edited by Robert Cornfield, copyright © 2009 by Frances Kazan. Used by permission of Alfred A. Knopf, a division of Random House, Inc. Any third party use of this material, outside of this publication, is prohibited. Interested parties must apply directly to Random House, Inc. for permission.

FIRST EDITION

Designed by William Ruoto

Library of Congress Cataloging-in-Publication Data has been applied for.

ISBN: 978-0-06-177512-3

HB 12.22.2023

This book is for my sons Jack and Cedric, and for Sherry, whose love has given me the inspiration to write it.

O Fortune,
Like the moon
You are changeable
Ever waxing and waning . . .

. . . Fate—monstrous
And empty,
You whirling wheel,
You are malevolent,
Well-being is in vain
And always fades to nothing.

 —CARL ORFF, *Carmina Burana*

Arrogance, however disguised, is the essence of every artist. What could be more arrogant than saying, "Pay attention to what I've done, it's of great worth and importance." The energy to paint, compose, sculpt, be an architect, comes from a belief that is without qualification at least during the hour of creation. When someone calls you arrogant, don't deny it. Smile and gently say, "Yes, I suppose I am."

 —ELIA KAZAN, *Kazan on Directing*

Camera Logic. The instinctive choice a director makes on where to place the camera to best tell the story. The camera's not jiggling or wandering around or being seduced by something else in the frame. It's exactly where it should be. Hitchcock, John Ford, Sidney Lumet, and others achieved this. Would that Camera Logic applied to Life. Everything would be framed just right. Not only *what's* in the frame but *who*.

—WILLIAM FRIEDKIN

No matter.
Try again.
Fail again.
Fail better.

—SAMUEL BECKETT

CONTENTS

SPOILER

There's nothing salacious in this book, unless you count the descriptions of certain scenes in some of my films. I've left out most of the intimate details of my private life, lest the book be slapped with an NC17 rating.

The conversations all come from my recollection of them, though they are not written to represent word-for-word transcripts, nor can they claim to be objective truths. Rather, I have retold them in a way that evokes the feeling and meaning of what was said. In all instances, the essence of the dialogue is accurate.

—WILLIAM FRIEDKIN, LOS ANGELES, 2013

PROLOGUE: FIREFLIES

An oversize manila envelope lay on my desk when I arrived at the production office of *Cruising*, the film I was directing in New York. I opened the envelope and pulled out acrylic and spray-painted works on paper, collages of faces and bodies with scrawled words and splashes of color in the style of graffiti. I found them amusing but not to my taste. A handwritten note accompanied them telling me how much the young artist Jean-Michel Basquiat admired my films and how pleased he would be if I would accept these early works as a gift. I threw them in the wastebasket and never acknowledged his note. A few years ago a Basquiat painting from that period sold at auction for fourteen million dollars.

At about the same time a demo recording was sent to me that contained rhythmic soul-disco tracks behind a high falsetto voice. The music was original but not something I appreciated. There was a handwritten note from the young recording artist, Prince, wondering if I'd consider doing a "music video" of one of his songs for the fledgling network called MTV. I didn't respond.

I passed up an ownership stake in Mike Tyson when he was first discovered by Cus D'Amato. I declined one third ownership of the Boston Celtics and the opportunity to be one of the producers of *Star Wars*.

There were films I directed that I shouldn't have and others I

passed on that were successful. I've burned bridges and relationships to the point that I consider myself lucky to still be around. I never played by the rules, often to my own detriment. I've been rude, exercised bad judgment, squandered most of the gifts God gave me, and treated the love and friendship of others as I did Basquiat's art and Prince's music. When you are immune to the feelings of others, can you be a good father, a good husband, a good friend? Do I have regrets? You bet.

Not long ago I was interviewed by two foreign journalists at a restaurant near Beverly Hills about my new film *Killer Joe*, which had just been shown at the Venice and Toronto film festivals. We were talking about filmmakers who changed the course of cinema forever: D. W. Griffith with *Birth of a Nation*, Orson Welles with *Citizen Kane*, and Jean-Luc Godard with *Breathless*. Their work had a lasting impact on all filmmaking that followed, including my own. The interviewers asked me how I felt about the films being made today.

At that point, two young women came to our table. It was four o'clock in the afternoon, and they were the only other customers in the restaurant. They apologized for interrupting, but they'd overheard our conversation and just wanted to tell us why *they* go to the movies. They don't want to wallow in depravity or violence; they want to come away feeling joyful and happy. Fair enough. I asked them what films they had recently seen that qualified.

Bridesmaids, they agreed. Also *The Help*. I had seen neither, but I knew they were popular.

"Have you ever heard of Jean-Luc Godard?" I asked. They seemed puzzled.

"What about Federico Fellini?"

Yes, they'd heard of him.

"Can you name a film he made?"

They couldn't.

"What about Orson Welles?"

Of course they'd heard of Orson Welles.

"Can you name a film of *his* that you've seen?"

"Oh, um . . . *Rosebud*," the blonde said proudly.

"What do you remember about it?" I asked.

"A sled."

"Have you ever seen *The Exorcist*?"

Of course, they blurted out.

"Did you enjoy it? Did it leave you with a feeling of joy and happiness?"

"Yes," the brunette said emphatically.

"Why?"

"Because it made me think," the brunette said.

"So a film that makes you think is important too?" I suggested.

"Well, yes," said the blonde.

I was curious: "What did *The Exorcist* make you think *about*?"

"The devil," said the brunette. "It made me think there's a devil," she continued.

Not precisely what I had in mind when I made the film.

The journalists were eating it up. They had it all on tape; it would provide great color for their pieces. More than likely, these women wouldn't see *Killer Joe*, an edgy black comedy with full frontal nudity and violence. Not the kind of movie that has you leaving the theater filled with joy or happiness.

It takes talent, imagination, and a feeling for the zeitgeist to find a subject that touches a nerve. What I still want from a film—or a play, a painting, a novel, a piece of music—is exhilaration. I want to be moved and surprised at some revelation about the human condition.

I think about the love affair I've had with Cinema. Images or

fragments pop into my consciousness like fireflies. When I'm able to capture their brief flash, they illuminate a dark corner of memory.

In forty-five years I've directed only nineteen films, though I've developed or tried to make far more; I've also directed hundreds of television shows live and on film. I've directed a handful of plays and a dozen operas so far. Some of my films are well known; others are forgotten, lost on the roller coaster that is Hollywood, where dizzying heights are followed by gut-wrenching depths.

After I finish a film, deliver the prints to the distributor, and do interviews in several countries, the parade's gone by, and it's back to real life. The spotlights go off, there are no more autograph seekers, and all that's left is exhaustion and the thought of what's next. Or could this be it? The idea of quitting never occurred to me, but there were times when I sensed the man was at the door ready to collect the furniture and the keys to the house.

From their beginning, the movies developed as an entertainment medium, and its objective has remained profit. A director gets to make a film only because a studio executive or a financier thinks it could make money. It's almost impossible to choose a project with no eye to the marketplace. Ingmar Bergman, Fellini, Godard, and Akira Kurosawa had to sell tickets, and when their films stopped working at the box office, they couldn't get them made.

You can have shelves of trophies and citations, appear on countless critics' lists, be honored at film festivals all over the world, but you still have to take a meeting with a young studio executive who's never produced, written, or directed, and sell yourself all over again. I have fewer meetings these days, and often the executive just wants to tell me how much my films have influenced him. I smile, thank him, and leave to get back on the roller coaster.

Let me share the ride with you, and illuminate, with the help of the fireflies, how my films were conceptualized, shot, edited, and marketed, and how I came to direct operas without ever having seen one.

Life is lived forward, but can only be understood backward.

PART I

FIRST IMPRESSIONS

CHICAGO

My DNA suggested no hint of success at anything. My parents and grandparents came from Kiev in the Ukraine during a pogrom in the first years of the twentieth century. In the early 1900s, Russians were starving, and afraid of a world war or a revolution. They were ruled by the incompetent despot Czar Nicholas II. A violent pogrom in 1903 was fueled by racist literature claiming the Jews drank the blood of Christians at the Passover feast. That's the year my parents, grandparents, and all their relatives escaped to America in steerage, in the bowels of freighters. My mother had twelve brothers and sisters, my father eleven. They spoke no English and were tradespeople and shop workers. The men in my family were dark-skinned, with handlebar mustaches. The women were short and heavyset. Their apartments smelled of gefilte fish, cabbage, smoked herring, and stale clothes.

I loved my mother, Rachel. She was kind and gentle and seemed to care only about my well-being. She had been an operating-room nurse for many years and lost an eye when a tray of surgical instruments exploded as she was sanitizing them. She had an artificial eye that was so perfectly implanted you'd never know it wasn't real. She continued nursing until I was born, then stopped work to raise me. All our relatives and neighbors loved "Rae," as she was called. I never heard her say a bad word about anyone, and she had no interest in gossip or pettiness.

My parents were good people, and we were close. They wanted me to have a happy life, but they didn't know what I needed to do to prepare for it. They never encouraged me to study music, play sports, or marry a nice Jewish girl. Grammar school and high school never engaged me. I went only because it was mandatory.

My father, Louis, worked all the time. He would leave early in the morning and come back late in the evening. I would look forward to his return, but he had little time for me, except occasionally on weekends. He seemed to have no sense of purpose except day-to-day survival. He had been a semiprofessional softball player in his youth, then a cigar maker, and he worked in a men's clothing store, owned by his brother-in-law, on South State Street in Chicago. My father owned nothing and made fifty dollars a week. Until he was laid off. Then we lived on welfare, in a one-room apartment with a kitchenette, one toilet, a small closet, and a bed that came out of the wall for them, next to a cot for me, on North Sheridan Road in uptown Chicago; no surprise I was an only child. Our neighbors were Jewish, German, Irish, and Polish, descendants of the Europeans who settled in Chicago in the early part of the twentieth century. We used to sleep in Gunnison Park just off Sheridan with thousands of other families on a summer's night. Few people in our building or neighborhood had air conditioners—not even the kind that fit into a window. It wasn't as though I was deprived of anything. We were poor, but I never knew it. All my friends lived the same way.

Faces, bodies, trees, cars, flew by as my three-wheeler bike raced along North Sheridan Road past the grocery store, the movie theater, legs pumping furiously against the wind, ending at the shore of Lake Michigan, watching the ice floes breaking with the onset of an early spring, like pieces of a gigantic jigsaw puzzle. Streaks of pink and orange form

in the distant sky over the white lake. I'm five years old, and this will be my last year of freedom before starting kindergarten.

When I was six, my mother took me to the Pantheon Theater on Sheridan Road. We were going to see my first movie. I later learned it was called *None but the Lonely Heart*. The Pantheon was an ornate old movie palace, seating thousands. When we got to the theater, I had no idea what to expect. I sat in a large red velvet chair next to my mother. The theater was full, and the lights started to dim. I was excited, but apprehensive. Suddenly the theater was plunged into darkness. I could hear the curtains parting, then an enormous black rectangle came alive with a blinding white light and a loud blast of music. The comforting darkness was shattered by words I couldn't read. My instinctive reaction was to scream at the top of my lungs. I clutched my mother's arm; I couldn't breathe.

Strange faces turned scornfully toward us in the half-light, and my mother rushed me out of the theater into the blinding sunlight. We walked home for miles, until I could calm down. That was my first experience of seeing a film.

Miss Dorothy Nordblad's third-grade public school class at Graeme Stewart School started promptly at 8:00 a.m. We'd line up, about thirty of us, outside the classroom. We had to be early, because Miss Nordblad was never late. She was an attractive brunette, probably in her mid-thirties. She wore tight-fitting pastel suits and sensible heels, and her silken hair fell to her shoulders. Her manner was gentle and direct. She taught Spelling, English, and Math, and she's the only teacher who made me curious to learn. I don't remember any of the other teachers or anything specific about any subject. I learned to spell, add, subtract, and multiply, and that was it.

I was eight years old in 1943, but I wasn't afraid of the war. Miss Nordblad and our parents assured us that American soldiers were fighting in a just cause and would ultimately win. We did our part by bringing in old newspapers and tin foil from gum wrappers to be recycled for the war effort, but we knew from all we had been taught, or heard on the radio, that the enemy would never come to our shores, and that eventually, we would defeat them.

My real enemy wasn't the Germans or the Japanese but Miss Sullivan, the school principal. To an eight-year-old, she was the enemy within. She was tall, matronly, severe, her gray hair pulled back in a bun. She wore dark floor-length dresses, usually gray or black, with lace cuffs and collars, and she looked like Norman Bates's mother in *Psycho*. I remember her charging into classrooms and taking a misbehaving student to hang him by the collar of his shirt in the cloakroom behind the blackboard, where he would stay for the remainder of class. Sometimes two or three of us would hang silently in the closet together. You learned to suppress inappropriate behavior, and there was a price to be paid if you screwed up.

Her name was Nancy Gates, and we were nine years old. Nancy was tall for her age and slim, with blond curls. She had beautiful skin and perfect features, and when I looked at her something warm would come over me, something I didn't understand. She dressed smartly in white blouses and long skirts, or Victorian-style dresses, and she always came to school in a wide-brimmed hat. It was the hat that first caught my attention, the way it framed her face and provided a soft shadow over her bluish-gray eyes. Her voice had a quiet lilting tone, and she was mysterious and seductive.

One day, standing in the hall outside our classroom, I was staring at her hat and the back of her neck when suddenly she turned

around, looked into my eyes, and said, "You're very handsome, Billy." The way she held my gaze, her conspiratorial tone, and the way she lightly brushed my chest and smiled, opened a door within me. It was a quiet moment, but to me explosive. From then on we held hands and even kissed passionately in the auditorium during screenings of Encyclopedia Britannica films that warned of the evils of drunkenness, premature sex, and talking to strangers. The rest of that blissful semester, Nancy and I were in love. Among my buddies it wasn't cool to admit you had a girlfriend or that you had any feelings for the opposite sex. I never talked about Nancy to my parents or anyone else. Sometimes we would meet at Mary Jean Bell's apartment and listen to records. Mary Jean's father was "Ding" Bell, who played with the Spike Jones Orchestra. Mary Jean had all the hot 78 rpms, a lot of Spike Jones of course, but also Stan Kenton's Orchestra, which was considered taboo at our school. Kenton's music was a sinful, corrupting influence, our teachers told us, much like Elvis's for a later generation. I remember listening to Kenton's band on a portable 78 rpm player under the bed at Mary Jean's apartment. The music was dissonant, rhythmic, surrealistic, compulsive.

One morning I arrived at school, and Nancy wasn't there. She must be sick, I thought. Two or three days went by, and she didn't show up. I got up the courage to ask Miss Nordblad if something was wrong with Nancy.

"She left school, William—she transferred."

My heart sank through the floor, I felt helpless and empty. "But . . . where?" I stammered.

Miss Nordblad was wearing a lipstick-red suit; she put her hand on my shoulder. "I don't know, William. Really." For the rest of that day my stomach was in knots. I walked every street near the

school looking for her, even though I didn't know where she lived, then into other neighborhoods, before I came to realize that her loss was permanent. I haven't seen or heard from her since, but I often think of that little girl in her wide-brimmed hat and Victorian dress, forever nine years old. In the space of that year, I found and lost love, and learned to live with disappointment.

I found I could frighten the neighborhood kids by making up scary stories. I would improvise terrifying scenarios out of whole cloth, and the little girls would listen with rapt attention, often moved to tears, but they kept coming back for more until the effort to invent new stuff taxed my imagination. But I discovered that people, especially young people, *liked* to be scared. Many years later, Dr. Louis Jolyon West, then head of the Neuropsychiatric Clinic at UCLA, explained to me why he thought people enjoy suspense and horror films. You're in a dark room with dangerous, life-threatening events happening before your eyes, but as a viewer you're in a safe place, removed from what's happening on screen. "A safe darkness," he called it. A handful of films have terrified me: *Psycho, Diabolique, Alien, Jaws, Seven, The Texas Chainsaw Massacre.* But even as they make me afraid of the unknown, I can leave the theater when they're over, and I continue to seek the experience.

Growing up in the homes of my aunts and uncles and in a one-room apartment with my mother and father, I heard no music, read no books, went to movies only on Saturday afternoons (I had gotten over my fear of them). A bunch of us would go to the Modé Theatre near the El station at Irving Park at noon on a weekend, and we wouldn't get home until six in the evening. The movies were cartoons, short subjects, and serials: Mickey Mouse, Donald Duck, Bugs Bunny, the Green Hornet, Boston Blackie, the Bowery Boys, Don Winslow of the Navy, the Lone Ranger and Tonto,

Hopalong Cassidy. The good guys always won, except in the cartoons, where the rascals often triumphed until they got blown up or fell off endless cliffs. My friends and I used to believe that the action was taking place behind the screen and that Hopalong Cassidy would come out of the back of the theater on his white horse after an afternoon of chasing bad guys. Every Saturday we waited behind the theater until we finally got the message that no one was coming out, and so we sadly drifted off to walk home or ride the bus or the El, where life was less glamorous. No movies from my youth left a serious impression on me.

My parents enrolled me in Hebrew school in addition to public school. The Hebrew school was called Agudas Achim. It was in uptown Chicago near Argyle Street, a few blocks north of our apartment. Argyle was a Jewish neighborhood with kosher butcher shops, delicatessens, and grocery stores. I paid little attention to what was taught in Hebrew school, but I was bar mitzvahed at age thirteen.

There was a boy about a year ahead of me whose name was Joel Fenster. He was a classic bully who preyed on those he perceived to be weak and vulnerable. I was his favorite target. When I was eleven, he would seek me out after school and demand the few coins I had in my pocket. He'd grab my books and hold on to them until I produced the ransom. I began to accept his bullying as a punishment I had to endure each day. Embarrassed by my inability to resist, I never told my mother or father about it. I had learned to suppress, and it haunted me before I went to sleep until it dawned on me one day that this was no way to live.

One morning at the age of twelve, I woke up feeling anxious, but with a newly acquired confidence about that afternoon's confrontation with Fenster. I plotted my strategy and even looked forward to it. As we left school that day, I no longer tried to avoid him;

I sought him out, and he started in immediately. "How are you today, asshole?" he sneered.

"Joel, I've had enough of your shit." The words leaped out of my mouth.

He was amazed at this reaction from his punk. "Oh, yeah?" He grabbed my book.

"Give it back." I stood my ground.

"Make me," he shouted, then threw the book into the street and put me in a headlock as he had so often before. But I had recently watched the wrestling matches on our little television set, *live* from Marigold Gardens. Remembering some of the moves, I kneed Fenster in the groin. In shock, he retreated, and I jumped on him with a headlock and squeezed as hard as I could. He screamed in pain as I wrenched him to the ground and began to pummel him, banging his head on the sidewalk until he bled and making up for the years of oppression he had inflicted on me.

"Give up?" I yelled in his face. "Do you give up, you son of a bitch?" I wanted to kill him. I had the distinct impulse to end his life, and I felt it would make me happy if I did. But he gave up, and that was the last trouble I had from him; *he* had tasted the fear.

At election time the Democratic ward committeeman, in our case the Forty-Eighth Ward, would come around and visit my mother. Drinking coffee in the kitchenette, he would show her a sample ballot and say, "Now, here's who you vote for, Mrs. Friedkin, and these are the propositions you want to put a check mark next to"— all Democratic candidates and initiatives, of course. My mother would smile, offer him more coffee, and agree to whatever he said. When he had gone over the ballot with her several times to make sure she understood, he would say, "Now, what can I do for

you?" When I was twelve and about to start summer vacation from school, she asked him if the Party could possibly find me a job. "How old are you, William?" he asked.

"Twelve, sir."

"Twelve—well, you know, you have to be sixteen to be eligible for Social Security and a decent job." Frowns all around. "Do you like baseball, William?" I did; I was a Cubs fan, though I had never been to a game, but I knew the lineup of the 1947 Chicago Cubs by heart. "Let me see what I can do," he said.

He could do whatever he wanted. The Party ruled Chicago, and though I was an only child, my huge extended family represented a lot of votes. Within a week I had a Social Security card declaring I was sixteen and a summer job selling soda pop at Wrigley Field. I carried thirty bottles of pop in half-moon-shaped cases with a thick strap around my neck. I would make two cents a bottle, sixty cents a load, and during a nine-inning game I could do twelve cases, six or seven bucks. Not chump change. On weeks when there were doubleheaders, I would sometimes bring home sixty dollars, which was more than my dad made as a salesman for the Duke Shirt Company on South State Street.

Goldblatt's Department Store in the uptown neighborhood was where families could fill all their needs, from kitchen appliances to clothing to vacuum cleaners. My mother did a lot of shopping at Goldblatt's, a few blocks from our apartment, and she used to take me with her.

As a teenager, I knew the layout of Goldblatt's pretty well, and I'd go there with two friends and steal stuff. The guys I hung with, like me, had no moral compass. I literally didn't know the difference between right and wrong. We'd go into candy stores or record stores and sneak out with whatever we could. We used

to deface buildings and break car windows. Every night was Halloween.

One afternoon, three of us went into Goldblatt's to boost school supplies, notebooks, pencils, and so on. I was stuffing things into my clothes when a large hand grabbed my shoulder.

Busted. By a burly store detective. First time I'd ever been caught. We were paraded through the store past staring customers and up to a back office on the second floor. He searched us and said, "You guys are goin' to juvie [juvenile hall], you know that? You little punks." He asked for our parents' phone numbers and called them.

My mother soon arrived. She listened to the detective's account and immediately burst into tears. He had followed us as we went on our little tour of the store, and we confessed to having done this before. But for my mother's tears and pleas, I would have gone down for six months or more. But it was her *reaction* that made me quit that behavior on the spot. I didn't want to cause her any more pain.

From an early age my ambitions overwhelmed my abilities. I wanted to be a basketball player, but I didn't make the high school team until my last year. From the age of twelve, I idolized Bob Cousy and the Boston Celtics. I practiced in our apartment and at various indoor and outdoor courts in the neighborhood, trying to improve my skills, but they were never enough to convince the coaches. In the Chicago high schools, there used to be two basketball teams, divided by height: juniors were under five-eight, seniors were over. To play junior ball, which was a faster game, you had to measure in, and I was at least five-nine. The belief among those trying out for junior ball was that you could stay up all night and develop a natural slouch before measuring in. I took the elevated train from our apartment to downtown Chicago and watched the midnight showing of a film called *The Strip* starring Mickey Rooney while

practicing my slouch. I was exhausted but overjoyed the next day when I stepped under the bar and Coach Eugene Fricker, a tall, thin, bald man, pronounced me eligible at five-eight.

The tryouts came a day or two later, and I felt sure I'd make the team. After handing out twelve jerseys, Coach Fricker looked around at the twenty or so other hopefuls sitting cross-legged on the floor, shrugged, and said, "That's all I have." I remained seated, in shock, next to Tommy Bailey, a good player who also didn't get a jersey. I felt the air escaping from my lungs like a punctured basketball.

"You should have made it," Tommy said sadly.

The gym was oppressive. I had to get out of there. I ran all the way home in tears. I was fourteen years old, and the harder and faster I ran, the more I cried. I see this young man in my mind's eye, a shy, sensitive boy with little self-confidence. A vast realignment of expectations takes place when you fail at something you really want to do. It wouldn't be the last time that would happen.

My formal education ended in 1953, when I graduated from Senn High School on the North Side. I never read a book in school, wasn't even curious. My grades were adequate, and my only distinction was as the high school's bad boy. I found a black executioner's mask I put on while running in and out of classrooms and throwing chalk and erasers around. I would do this at special events that were held in the schoolyard on Memorial Day and other ceremonial gatherings. I became "the masked marauder."

I didn't have a promising future, nor any idea what I wanted to do, except not spend one more minute in a classroom. I didn't go to college, not because we were poor, but because I had no motivation to do so. It's a miracle I didn't wind up in jail or on the streets, as did many of my friends, but Chicago gave me a value system and a work ethic. The people I met, the friends I made, were basically blue collar and without pretense. Marcel Proust dipped a little sweet cake

into a cup of tea, and the scent as it approached his nostrils brought a rush of memories of his childhood in a French provincial town. All I need to achieve that experience is a slice of deep-dish pizza from Pizzeria Uno on Rush Street, or a bratwurst on rye from the Grill at Berghof's Restaurant on Adams near the Art Institute, or a French dip sandwich from a dive called Mr. Beef on North State Street. It was on the South Side that I later heard Muddy Waters in a club called the Checkerboard Lounge, and the Miles Davis Sextet with John Coltrane, Bill Evans, Cannonball Adderley, Philly Joe Jones, and Paul Chambers playing on top of the bar at the Sutherland Hotel on Forty-Seventh Street and South Parkway.

Radio had a strong influence on me. Dramatic radio in the 1940s, a form now long dead in America, with shows like *The Shadow, Inner Sanctum, Suspense, Lux Radio Theater*, and *I Love a Mystery*, ushered me into other worlds created only by the human voice, music, and sound effects. They conjured worlds that became real because they took place in my imagination, and they were terrifying in ways I seldom experienced in the movies.

One Saturday afternoon, after high school graduation, my parents and I browsed through the want ads in the *Chicago Sun Times*. An ad caught my attention:

Opportunities for young men to start in the mail room
and acquire a career in television.
High school education required.

It was literally a "male" room then. No women could apply. This would have been 1953, when *live* television was something

of a miracle. When I was twelve, we got our first television set, a twelve-inch Philco with rabbit-ear antennae. There was little programming and only three networks. *The Milton Berle Hour* was on NBC, Jackie Gleason on the old DuMont Network. The black-and-white images were so distorted you could barely see the show, no matter how you adjusted the rabbit ears, but the image itself was a miracle. We were like the first cavemen who saw fire or stared in wonderment at the moon and stars. I remember getting up early just to see the profile of an American Indian, like the one on a buffalo nickel, set in the middle of a focus chart. For a long time, people would stare at this image because it was *there*, magically in your own home. One week after I saw the ad, I took the El from Lawrence Avenue uptown to Lake Street downtown and walked several blocks northeast to Michigan Avenue above the Chicago River. 441 North Michigan was the home of the *Chicago Tribune* newspaper, a gray Gothic tower that also housed its radio and television stations, WGN—"World's Greatest Newspaper"—and WGN-TV.

I went to the fifth floor, where the mail room was located, and there was only one person there: Ray Damalski, a shambling hulk of a man, balding, with thick glasses and baggy clothes. He had a jovial manner and a large, round red face. I told him I was applying for a job and hoped I wasn't too late. He told me to sit down and tell him about myself. I had no résumé, but I guess he liked me because he gave me the job. Thirty-three bucks a week, six eight-hour days, no overtime. I was thrilled—my first steady job.

Before I left, my new boss said, "By the way, kid, are you stupid?" I asked what he meant. He said, "Do you have a copy of the ad that brought you here?" I did. He looked at it and laughed before pointing at it. "What address *is* this?" The address was *448* North Michigan, the distinctive white wedding cake that is the

Wrigley Building. Ray said, "You're at 441—the Wrigley Building is across the street. And do you see the call letters of their station?" It was WBBM-TV. "That's in the Wrigley Building. This is Tribune Tower, and our station is WGN. This isn't our ad; you came to the wrong place."

I was mortified.

"That's all right," Ray said with a smile. "You look like a nice kid. Nice, but dumb. Come in Monday at eight o'clock, and I'll show you what to do." I had taken the first small step of what was to become a marathon.

I loved working in the mailroom. I was meeting people from a fascinating world, broadcast radio and the new world of live television. I was seeing at first hand how television shows were made. At the end of a day in the mailroom, some ten hours, I could stand in the back of the control rooms and watch how they functioned. A typical program had two or three cameras, and the director would view their output on monitors and talk to the cameramen over headphones. He would ask for various lenses and call out to the technical director which shots to put on the air. The technical director sat at a console and could switch to Camera One or Two or Three at the push of a button, or, by pushing or pulling a lever, dissolve from one camera to another. Typically, on an interview show for example, the director might say, "Camera One, give me a wide shot of the set; Two, give me a close-up of the host; Three give me the guest—a little wider—okay, take one, ready Two, and . . . take two" and these shots would appear seamlessly on a master monitor that showed what the viewer would be seeing at home. The director would also call for various sound cues from the audio engineer and cue the projectionist to prepare and roll film clips that contained commercials. The director's voice was constant in the control room, and he determined what was seen and heard.

The other technicians did their work silently at the director's command. I wrote in a pocket notebook what happened when a command was given. Some of the shows were more complex—live dramas, musicals, news programs. I learned how to do them by rote, preparing myself for what I hoped would eventually become my job. I had found a calling. You had to first become a floor manager. The floor manager would position actors or announcers or props on the set and cue various performers to speak or move at the director's command. He too wore headphones with the director's voice in his ear. Some floor managers were so good at what they did, they wouldn't get promoted—they were too valuable "on the floor."

I used to take the El to work and back every day, a distance of about twenty miles from our apartment on the North Side. Neither of my parents knew what sort of work I was doing, though I tried to explain it. But I had a steady job and was giving half my salary to them. I would leave at seven in the morning and not get home until nine at night or later, depending on how long I stayed at the station, watching and learning. I would work six days a week, often seven. After a year, I began to think I wasn't going to get promoted. Two other young guys, one who started after me, moved up. I became depressed but kept it to myself. Occasionally I'd tell my mother how disappointed I was, and how I felt I was going nowhere. She was encouraging as always. I tried to make myself useful and likable at work. I repressed all thoughts of bad behavior and the bursts of anger that would often well up within me. It looked as though I'd spend my life in the mailroom or move on to some other entry-level job. But because I'd ignored my education, I had no idea what to move on to.

My father, who had never been sick a day in his life, began to deteriorate and was taken to the Cook County Hospital, where he

was given a cot in one of the halls. We didn't know what his illness was, probably cancer. His care was barely adequate, and he died within two weeks. I went to visit him every day with my mother, and she was shattered; Dad was the only man in her life. I used to dream I was hovering over his cot in the hallway of the county hospital.

In the WGN mailroom my education began. Francis Coughlin (Fran) was a wise man in his late forties when I met him in my early twenties. He wore dark suits, usually with a bow tie, over a heavy frame. Despite the suits, he always appeared a bit shabby, but he was filled with energy and intelligence and he moved with the light-footed grace of a man half his size and age. He wore thick glasses, and his thinning brown hair left a residue of dandruff on his jacket. Fran was the person who most changed my life. An elegant wordsmith with the gift of the Irish gab and a great sense of humor, he had been a reporter and columnist for the *Chicago Tribune* and wrote speeches for its eccentric owner, Colonel Robert R. McCormick, who would deliver them each week over WGN radio and the Mutual Broadcasting Network, which he owned. When WGN-TV went on the air in the early 1950s, Fran became its go-to program writer. He was also the resident intellectual on a popular quiz show called *Down You Go*, broadcast over the DuMont Network.

Fran was a bon vivant. He knew and loved good food and wine, but mostly he valued good conversation, wherever he found it. He would often stop by the mailroom, which was down the hall from his office, to talk to Ray Damalski, whose fresh-brewed coffee and Polish humor he enjoyed. The two other young guys in the mailroom had no interest in engaging with Fran, so I was the sole recipient of his keen intelligence and vast store of knowledge. He was a fascinating storyteller, versed in all things current and historical.

He was like no teacher I ever had in grammar or high school. His only son, Dennis, was away at Harvard, and Fran gradually became a surrogate father to me. Fran's passion was the Civil War and all its famous battles, on which he could hold forth for hours. He continued to encourage me, and because he had clout at the station, when he boasted of my potential to the executives, they started to pay attention. Fran knew my ambitions and saw in me hidden reserves of talent I had no idea I possessed. He continued to give me books and discuss them with me. He and his wife, Maggie, invited me to their apartment on the Near North Side, where I met their friends: writers, artists, teachers, and politicians. He took me to the Art Institute and introduced me to the Impressionists and the seventeenth-century Dutch painters. On Saturday afternoons we'd have lunch at Riccardo's Restaurant on North Rush Street below Michigan Avenue. As well as being a good Italian restaurant, Riccardo's was a hangout for artists and writers, newspapermen and advertising executives. Fran knew them all, and they'd stop by our table and share stories that added to my understanding of the world.

It's painful to recall how little knowledge or experience I had at that time. My world was insular; family, friends, uptown Chicago—no travel anywhere, no exposure to other cultures. Chicago was segregated then, not just racially but ethnically: Poles hung out with Polish people; Germans, Jews, and Irish the same. I had few opinions of my own, and they were based solely on prejudices formed in my youth. To put it bluntly, I didn't know a damn thing about anything. But I was born with ambition.

One day, after a year and a half in the mailroom, Damalski said: "They've got an opening for a floor manager in a couple of weeks. I recommended you." I was elated. I felt I was ready and I thanked Ray effusively. "I'm gonna miss you here," he said, "you're

one of the best I ever had." I told Ray how much I'd appreciated and learned from him. "I probably should o' moved you up sooner, kid," he said, "but you were too valuable here."

Though I had prepared myself, observing the work of the floor managers and becoming friendly with the directors, my first weeks on the new job were a disaster. I would throw cues in front of the camera while the show was on, instead of from the side, and often I'd screw up the set preparations I was supposed to organize. The best and most senior director at the station was Barry McKinley. He directed every kind of show, and he drew the best assignments, including the Chicago Symphony Orchestra telecasts. I was assigned to Barry in the hope that I'd learn faster. He was about forty years old, short, stocky, and bald, with a wicked sense of humor, and he didn't suffer fools gladly. We were doing commercials for the William A. Lewis Clothing Company, "where the models buy their clothes," three-minute live spots within the body of a syndicated hour-long film show. Barry would tell me from the control room over the headphones how to position the models: "Move that cunt to her left." I would address the woman by name and ask her politely to move. Then, "Move that other bitch forward three steps." I'd do the same. Invariably, they would relocate too slowly for Barry, so his words to me became even more blunt: "These scumbags are stupid, Friedkin. You've got to crack the fuckin' whip." I continued to make my requests politely until Barry opened his key to the studio and shouted over the speakers so everyone could hear: "You've got to be a prick, kid! Everyone thinks you are anyway!" I didn't know if this was true, but I soon learned that a more forceful approach was more effective. Time was a factor, and the director had to get *what* he wanted *when* he wanted it.

Once, Barry asked me to set up three cans of hair spray for a live commercial. The cans were to be placed on a display rack covered

by blue velour. I set the three identical cans side by side. "What's wrong with you, kid?" Barry shouted over the headphones. I turned and looked helplessly up to the control room. "Make a *picture* out of it!" he screamed. I fiddled around with the cans, lining them up farther apart and then together, to no avail, until Barry exploded, jumped out of his chair in the control room, and came down to the studio floor. This was a no-no for a floor manager. He stormed over to the display. "I told you to make a picture out of it!" he shouted again. Then he moved one can to the *foreground*, the other two slightly behind. That was the first and only lesson I've had in pictorial composition. After a few months, I got the hang of it and became one of the best and most eager floor managers. I was doing eight shows a day—kid shows, talk shows, variety programs; I became floor manager for the station's most important show, *They Stand Accused*, a live courtroom drama in which the lawyers were real, the judge was real, and the witnesses were all actors. All the participants were given a scenario earlier in the day, then we had an hour to rehearse before the show went out across the country, just before *The Jackie Gleason Show*.

I had worked on a few hundred shows when a slot opened and I became a "live" director after less than a year "on the floor." I was earning two hundred dollars a week, a small fortune at the time, and thought I'd be happy doing "live" TV for the rest of my life.

In 1960 I bought my first car, a brand-new red Chrysler Valiant, about two grand. I used to drive Fran up to the North Shore of Lake Michigan to the Ravinia Hotel every Sunday morning for breakfast. On my bookshelves I still see the books he gave me fifty years ago, all of which I read and we discussed: the bound works of Dickens, Ruskin, *The Autobiography of Lincoln Steffens*, Sandburg's *Lincoln*, Churchill's *History of the English Speaking Peoples* and *History of the Second World War*, the collected essays of Rebecca West,

the writings of H. L. Mencken, and Shirer's *Rise and Fall of the Third Reich*. Fran and Maggie were the first to see creative potential in me and encourage it.

One day Fran told me about a film that was playing at the Surf Theatre, a small revival house on the Near North Side. "It's damn good," he said, "one of the best ever. Came out in 1941 but still plays. You should see it." On a Saturday afternoon, I went alone to see *Citizen Kane*. I went to the noon show and was mesmerized from the opening credits to the final shots of the burning sled and the smoke rising from Xanadu Castle and the sign on the gate that read: NO TRESPASSING. I left the theater just after 10:00 p.m., having watched the film five times. I became aware of the techniques of storytelling possible only in motion pictures. Composition, lighting, sound, editing, music, acting, writing, all put to use in a way that was completely harmonious and original. The story was fascinating, and its secret was revealed not to the other characters in the film but only to the audience in the theater, and they could make of it what they chose. No film I've seen before or since meant so much to me. I thought, "Whatever that is, that's what I want to do. I don't know how, but I have to find out." I read everything I could about *Kane* and its young creator, Orson Welles. And on that Saturday, just three years younger than Welles when he created *Kane*, I resolved to become a filmmaker.

I discovered the foreign films that came to the Surf, and to other revival houses around Chicago: Federico Fellini's *La Dolce Vita*, Michelangelo Antonioni's *L'Avventura, La Notte*, and *L'Eclisse*, the films of Jean-Luc Godard, François Truffaut, and the French New Wave; Akira Kurosawa's *Rashomon*. From these and from the early works of Stanley Kubrick and Elia Kazan and Alfred Hitchcock, I acquired the inspiration, the techniques, and the burgeoning desire to make films. The literature Fran had given me provoked

thoughts and ideas. The histories and biographies opened vistas to which I had previously been blind or indifferent. The paintings at the Art Institute took on context, and I understood the progression of art, from the cave painters to the Abstract Expressionists. The years of paying no attention at school were behind me, and gradually I was becoming "aware," slowly acquiring the tools I would need.

In 1961, I was going home on the Outer Drive in Chicago near the lakefront, heading north to Foster and Sheridan. It was just after 1:00 a.m., and I had directed the sign-off routine for WGN-TV. I turned on the radio, searching for WJJD, the jazz station where Daddy-O-Daylie did his all-night program. By accident I stumbled on a piece of music that seemed as though it came from another planet. I had never heard anything like it. Quiet, then thunderous, then quiet again. Powerfully rhythmic, complex and orgiastic. Long, sinuous lines of haunting melody giving way to urgent intensity. I pulled to the side of the Outer Drive and parked. Moonlight shone off Lake Michigan as I turned up the volume and let the music engulf me, frightening and exhilarating. Then suddenly it was over. A long pause, then a deep voice announced, "*The Rite of Spring—Le Sacre du Printemps*—composed in 1913 by Igor Stravinsky, conducted by Pierre Monteux." This was the first piece of classical music that had ever taken hold of me. Through sound alone, it opened the door to images and ideas that lay dormant within me.

Years later, at Orchestra Hall in Chicago, I watched as an old man moved slowly with the help of a walker to the podium in front of the Chicago Symphony Orchestra. It looked as though he'd never make it. The walker was removed, and he stood facing the audience, to thunderous applause. He was swaying slightly. Then he turned to the orchestra, and there was dead silence. He raised his right arm

slowly, and the first quiet notes of his greatest composition were brought to life. No music stand, no score in front of him. The music flowed *from* him. Its details, the tempi he coaxed out of the orchestra, were unlike any other version I had heard. Decades passed since I first heard that recording, but not until I watched this majestic work conducted live by Stravinsky himself did I realize the transformative effect it had on my life. Like *Citizen Kane, The Rite of Spring* gave me the inspiration to create.

Apart from Ray Damalski and Fran Coughlin, the most important of my chance encounters, the one that determined the course of my career, took place in 1960 at a cocktail party in an elegantly appointed mansion on the Near North Side of Chicago, known as the Gold Coast. The hostess, Lois Solomon, invited me because she thought I was "interesting." All her other guests *were* interesting. They were doctors, lawyers, judges, actors, teachers, playwrights, scientists; Nobel and Pulitzer Prize winners; *and* Lenny Bruce at the height of his notoriety as a nightclub comic. I was then a twenty-five-year-old television director at WTTW, the public broadcasting station in Chicago, having just been fired in a cost-cutting measure by WGN-TV.

I met Lois at WTTW, where she produced several local arts shows. She was the sister-in-law of Irv Kupcinet, known nationally as "Kup," the syndicated columnist of the *Chicago Sun Times* and talk show host on the local CBS channel. Lois's husband, Leonard, was the owner of a well-known Gold Coast pharmacy called Solomon Drugs. Lois, one of Chicago's celebrated hostesses, was a vivacious, highly intelligent, inquisitive woman, who would later be appointed Chicago's cultural commissioner.

Even though I was completely out of my league, my curiosity compelled me to the Solomon home, and this gathering of about

a hundred of Lois's friends, family, and recent acquaintances. The party spread into several rooms. Squeezed into a corner, trying to become invisible, I found myself standing next to a dark, good-looking young man in priest's clothing, holding a martini. He introduced himself as Father Robert Serfling. "Where's your church, Father?" I asked, just to make conversation. He took a sip of his drink before answering with a smile, "I don't have a church—I'm the Protestant chaplain at the Cook County Jail, on Death Row." My antennae went up. All the others in the room, their conversations, their existence, dissolved into soft relief as I focused on the priest, who resembled a young Clark Kent. How could I know he would open the gates to my life's work? That this chance meeting would be the first step in my career as a filmmaker? I had no idea what else to say to him, but he seemed friendly enough, so I asked if he had ever met anyone on Death Row who he thought was innocent.

"As a matter of fact," he answered evenly, "there's a guy awaiting execution now. He's thirty-two years old. His name's Paul Crump, and he's one of five guys on Death Row. They all say they're innocent, but this guy might be. The U.S. Supreme Court denied his writ of certiorari for the second time, and he's scheduled to die in the electric chair in six months."

At that point, Lois drifted to our corner and asked if I was having fun, and if I wanted to meet Lenny Bruce or Oscar Brown Jr., another famous Chicago-bred entertainer. I did, but not before getting Father Serfling's phone number at the county jail.

For the rest of that weekend I thought only about that brief conversation. I knew nothing about Paul Crump or the nature of his crime. But this chance meeting with Father Serfling, and his assertion that an innocent man was about to be executed, triggered a sense of purpose in me.

The following Monday morning, I called him just after 9:00 a.m. He remembered me, and I asked him if there was any way I could meet Mr. Crump.

"Why?" he asked.

"I told you I was a television director. Maybe there's a way I can help him—"

"How?"

I had no idea. Just a hunch. "Possibly by making his story public," I said.

"Paul's been on Death Row for seven years. I wouldn't want to get his hopes up—"

"Neither would I."

"Let me talk to the warden," Father Serfling offered. "He likes Paul and doesn't want to execute him. It's not easy to visit a man on Death Row, but let me ask him."

The Cook County Jail takes up a full square block on Twenty-Sixth Street and California on Chicago's southwest side. A level five maximum security prison, it's an ominous low-lying building that holds a few thousand inmates pending resolution of their trials, after which they are either freed or sentenced to state prison. All except the inmates in the basement.

They were held in a separate section, just steps from the yellow brick room that housed the electric chair.

Warden Jack Johnson was heavyset, about six-three, with a military crew cut. He resembled a marine drill sergeant or the center for the Chicago Bears, but he was smart, well read, and thoughtful. He wore short-sleeved white shirts with a slim black tie and black trousers. A .38 Special was holstered to his belt. He could be gruff, but he was usually soft-spoken and pleasant. He had about him the air of a man who was sympathetic to human foibles. He had presided over the execution of three men, and he didn't want to

execute a fourth. He stood behind his large desk and came around to shake my hand as Father Serfling introduced us.

"What can I do for you, young man?" he asked.

"Warden, Father Serfling told me about Paul Crump, and I was wondering if you could talk to me about him, and maybe let me meet him?"

The warden walked slowly to a barred window and stared down at me. His appearance made you wary, but his manner put you at ease. He listened thoughtfully, after I explained that I might be able to get Paul's story on television, then he sadly shook his head. "There's no more that can be done."

"Father Serfling thinks he's innocent," I interrupted.

The father smiled and held up his hands defensively.

"What do *you* think?" I asked the warden.

"It doesn't matter; I have to execute him if that's what the court orders."

The only sound in the room was the air conditioner in one of the windows. The warden moved back behind his desk, lit a cigarette, and spoke quietly. "Paul's been here for nine years. When he came in, he was angry and bitter. I had to isolate him and deprive him of a lot of privileges. I've never seen an inmate change so much—"

"How so?"

"He lost all the bitterness. He's now the most cooperative inmate I've got. He's the barn boss on death row, which means he keeps everyone else in line. He's a completely different man today from the one who came in here when he was twenty-three. In terms of rehabilitation, I would say Paul is the best example I've seen."

"What about the possibility that he's innocent?"

A flash of anger. "Mr. Friedkin, I'm trying to tell you that

doesn't matter anymore. He's been found guilty all the way up to the Supreme Court. Guilt or innocence is no longer an argument."

"Is there any argument to be made?"

"The only one would be rehabilitation, but that would be determined by the Governor, and it's never been done."

I realized I had taken up too much of the warden's time, but he suddenly asked if I'd like to meet Paul.

A young black man, thirty-two years old, was led into the warden's office, an armed guard at each side. Paul Crump wore khaki trousers and a white T-shirt, not standard prison garb. He had an athlete's muscular physique from doing pushups in his eight-by-eight-foot cell. His piercing dark eyes looked straight into mine as the warden introduced us.

"Bill Friedkin, this is Paul Crump."

He took my hand in both of his. The warden offered him a cigarette, then invited him to sit. Father Serfling stayed, but the armed guards were excused. So easy was their rapport, I had a feeling that Paul had been a guest in this office many times before. He was writing a novel called *Burn, Killer, Burn*, which was later published in 1962, about a condemned man who commits suicide in his cell rather than face the death penalty. His character, Guy Morgan, is a man filled with hatred when he arrives on death row. He had been beaten by the Chicago cops, and confessed to a murder he didn't commit. But in the course of his imprisonment, he learns to take responsibility for his actions.

You don't often meet someone who's been convicted of murder and facing the death penalty. Maybe it was because the warden and the priest were in the room, with two guards outside, but I had no fear of Paul. I didn't feel I was sitting with a violent man. For the next two hours, he told me about his case.

The robbery of the Libby, McNeill & Libby meatpacking plant

in the Chicago stockyards took place on Friday morning, March 20, 1953. The local press called it "the most daring daylight robbery in Chicago's history." Four men wearing dark coats and black hoods broke into the Credit Union office and robbed the cashiers of $17,000 in payroll money. The captain of the Libby guards, Ted Zukowski, was killed. Another guard was pistol-whipped, and later testified against Crump, identifying him by his voice only, as having shouted four words through a mask, "Give me your gun!"

When a black man committed a crime in Chicago, a general roundup took place in the black community, and "suspects" were quickly arrested, charged, and convicted. Four men were arrested for the robbery, and a ringleader, Hudson Tillman, was identified. After police persuasion, he and three others confessed, but they all implicated a fifth, Paul Crump, who along with the others worked at Libby. Only four suspects were observed at the crime scene, and Crump proclaimed his innocence. His alibi was that he spent the entire day of the robbery with a prostitute. Crump was married at the time, and this alibi did not sit well with the predominately female jury, even though the prostitute testified on his behalf.

A legendary police lieutenant, Frank Pape, known as "Killer Pape," led the investigation. Paul claimed that Pape and his officers beat a confession out of him, but his court-appointed attorney, Bill Gerber, had him plead not guilty at trial, while Tillman and the others pleaded guilty and received short prison sentences. They all testified against Crump, who was found guilty and sentenced to die in the electric chair.

Over seven years, Crump's appeals wound through the courts. In the years before I met him, he had eleven appeals, fifteen different execution dates, and forty continuances.

Crump's account when I visited him was dramatic and convinc-

ing. I liked him, and I wanted to believe him. I also met the man in the cell next to him, a short, wiry young guy named Vincent Ciucci, who told me his story as well. He also claimed innocence, had been on Death Row slightly longer than Paul, and was scheduled to die sooner. On one of his cell walls, Ciucci had small photographs of his three young children, who had died in a fire that also claimed the life of his wife in a small house in an Italian neighborhood on the southwest side.

At first, Ciucci was a hero for trying to enter the burning house to rescue his family when he came home from work. Later, an autopsy found that the wife and children each had bullet holes that had claimed their lives before the flames. Ciucci had recently taken out a life insurance policy on them, and he had a girlfriend. He was to die in the chair in three months. I became friendly with Vince, and I remember being in his cell one day when he pointed to the photos of his three dead children. Tears welled up in his eyes. "I could never have killed them," he said. His emotions seemed real to me, which made me question my ability to evaluate Paul's honesty.

After another long visit with Crump, he again took my hand in both of his, looked at me directly, and swore he was innocent. I wanted to believe him.

"Can you help me?" he pleaded.

"I don't know, Paul, but I'll try."

Ed Warren was head of programming at WGN-TV, a youthful man in his late thirties. I told him about my meetings with Warden Johnson, Father Serfling, and Paul Crump.

"Ed, there's a great documentary film in this. We could save an innocent man from the electric chair."

He cut me off. "Billy, save your breath. We don't make films here. We do 'live' television. Live!"

It's easier to surmount barriers when you're young. There's a long road ahead, with many side streets. The Crump case had taken hold of me. That I knew nothing about how to make a film, though I had directed hundreds of live television shows, wasn't going to deter me.

I had the idea that if I could pull this off, it would be a powerful story, a kind of American *J'Accuse*.

Wilmer "Bill" Butler was a live television cameraman at WGN. In those days, TV cameras were large and weighty, mounted on wheeled pedestals that allowed the operator to raise or lower the camera, push it forward or pull it backward, with one hand. There was a turret for changing lenses, from wide to medium to close. Butler had the smoothest touch of any camera operator in town.

The first time Bill spoke to me was over an intercom from a control room to a studio when I was still a floor manager at WGN. It was down time, and I was examining one of the cameras, trying to penetrate its mysteries. I didn't know anyone was watching until I heard a stern voice over the speakers: "Will the floor manager please keep away from the camera?"

It was not a question but a command. I was embarrassed, as though I'd been caught stealing. I knew that the technicians' union frowned on nonunion members touching the equipment. I apologized to Bill, and we gradually became good friends. We shared a common love of film, and we each harbored a desire to make them one day.

Red Quinlan, general manager of WBKB-TV, the ABC outlet in Chicago, was one of the founders of Chicago-style television. His programs—comedies and musical variety shows as well as talk shows—were locally oriented, inexpensive, and innovative.

They often pissed people off, but he didn't care. If he liked it, it stayed on the air. A believing Catholic and a Chicagoan forever, Red was a self-contained, fearless, optimistic man—no subterfuge, no bullshit. He loved to rat-fuck his competitors. His bosses at the network often had to contain him, but they never owned him, and they mostly stayed out of his way.

Red's offices were in the ABC Network Building next to the State-Lake Theater and across the street from the Chicago Theater, where you could see first-run movies and live stage shows. I sat opposite Red at his oversize desk. "So, kid, you ready to come to work for me?" he asked.

"I've got something else I want to talk to you about." I told him about the Crump case and my desire to make a film of it.

He sparked immediately to the idea. "Why won't they make it at WGN?" he asked.

"They aren't interested in films."

Red stood and paced the room, his hands in his pockets. "Well, it sounds like a damned good story. You know how to shoot a film?"

"Sure," I said, without hesitation.

"How much will it cost me?"

"I don't know, let me do a budget."

"This is something my network might be interested in." He went to a window overlooking the Chicago Theater and turned to face it. After a few seconds he turned back to me. "Okay. Get me a budget, and I'll give you a quick answer." We shook hands.

Butler was enthusiastic about working with me on a documentary. We had to make the film on our own time, because we both had full-time jobs. I was again doing live shows for WGN-TV, and Butler worked eight-hour days plus overtime five days a week at the station. But like me, he wanted to learn how to make a film by making one.

There was a camera equipment rental shop on lower Grand Avenue below Michigan Avenue, Behrend Cine Rental. It was a family-owned business run by the eldest son, Jack Behrend. Butler and I explained what we wanted to do, and Jack told us what equipment we needed and gave us a low rental rate. He also showed us how to load and operate a 16-millimeter Arriflex handheld camera, and to achieve synchronous sound with the new (to the United States) Nagra tape recorder. The demonstration took about an hour. It was the only technical instruction Butler and I ever had in filmmaking.

We worked on a budget one Saturday at the kitchen table in the apartment I shared with my mother on North Sheridan Road. I presented the budget to Red the following Monday. He had never seen a film budget, but it was simple and brief. We asked him for $5,500 to make a one-hour film, with no fee for ourselves.

Red looked at it for maybe two minutes. "Okay," he said. "I'll put *six* grand in a secret account called 'Project J, for Justice' that only you can draw on. If you can make this film for that, go ahead. And if you make it for less, you can keep whatever's left over."

I thanked him and told him I'd be in his debt for life.

Butler and I rented the equipment and prepared the shooting schedule. I contacted a number of people involved with the case, including Paul's first lawyer, William Gerber; Paul's mother, Lonie; his new attorney, Donald Page Moore; the surviving Libby guard who had been pistol-whipped; and former police officers, among others.

I interviewed Paul and Warden Johnson until I knew the details of the case as well as anyone. In searching for a way into the story, I felt I needed someone, possibly a journalist, to join my effort and interview the people who would appear on camera. About a year before I became involved with the Crump case, I'd taken a journalism course at the Chicago campus of Northwestern University,

one night a week, for eight weeks. I thought briefly about becoming a reporter, as my career in local television was at a standstill. The course was taught by John Justin Smith of the *Chicago Daily News*, who had his own column and could write about whatever he wanted. I enjoyed John's class, and felt he had imparted to me not only the principles of journalism but a taste for it. I also liked him, and he became another of my early role models.

His father was the legendary editor of the *Daily News*, Henry Justin Smith, who in the 1920s and '30s was Ben Hecht's editor. Hecht later immortalized him as "Walter Burns" in his great play *The Front Page*, written with Charles MacArthur.

John was a conservative, old-school beat reporter, and a tough-minded columnist. I didn't know if he was for or against the death penalty, but I convinced him to accompany me to the county jail to meet Crump. My belief that an innocent man might be going to the electric chair, and my dedication in trying to prevent it, was what hooked him. Anyway, here I was, his former student, sitting in his cubicle, telling him about a young black guy whose life was at stake, and about possible police brutality, and I was willing to risk my future and possibly my personal safety to try to save the guy.

"Billy," he said in a quiet midwestern drawl, "don't you know everybody on Death Row claims he's innocent? Everybody! Ninety-nine percent of all the guys in jail will tell you they were railroaded."

"I think this guy's different."

"Why? How do you know?"

"I met him. I think he's for real. His defense was botched from day one. Warden Johnson thinks he could be innocent and doesn't want to execute him."

John came with me to the county jail, and we met with Paul in the warden's office for two hours, after which John agreed to be

my narrator/interviewer. We filmed without a script, but later, Fran Coughlin worked with me to create a narration track.

The first sequence we shot was a re-creation of the robbery. The Chicago Stockyards were still in operation, and we were able to sneak in and make shots of the "robbers" driving through the yards to the credit union office. I had friends in the black community on the South Side, and I recruited them to play the robbers. To play young Paul, I went to Brooks Johnson, whom I met through Lois Solomon. Brooks went on to become a collegiate track star, and later coach of the women's Olympic track team. He had never acted before. To fill various other roles, the Libby plant guards and the Chicago cops, I used the Garvey clan, a family of amateur actors, four brothers I met through Fran Coughlin.

My idea was to re-create the crime, exactly as its details had come to light, and to show the difficulty the surviving guard would have had in identifying Crump's voice under the circumstances. The style of the film would blend dramatic re-creations with interviews of people actually involved in the case. Without ever having seen a documentary, I set out to make one. "Facts" are often complex and in dispute. The film was consciously designed as a polemic to save Crump's life—a court of last resort. The question was, How had the evidence against him been obtained? Was his alibi "believable," and was it supported by other evidence? It's doubtful he would have been convicted under the rules that apply today, let alone sentenced to death.

We interviewed Warden Johnson, who spoke about Paul's rehabilitation in the seven years he'd spent in the county jail. Bill Gerber, Paul's first attorney, confirmed his story of the voice identification by the Libby guard, and told us he had instructed Crump not to make a statement to any representative of the state Attorney's office unless he, Gerber, was present. Shortly after that, he

was informed that confessions had been obtained from Crump and others. "It was not a fair trial," Gerber said angrily. "And the U.S. Supreme Court agreed; they sent it back for retrial." Then he added, "At the time I undertook this case, I believed Paul Crump to be innocent. At the time of his retrial and conviction, I believed him to be innocent, and I still believe he's innocent!"

Crump's alibi was a problem, but I dramatized it, with his voice-over describing what had happened. He claimed he'd spent the previous night and the morning of the robbery with a woman named Fay Hinton. He and Fay went to sleep about 7:30 a.m., and in the early evening he met with a friend in the neighborhood named Eugene Taylor. On the night of the robbery, Taylor told him that a friend of theirs, Hudson Tillman, was the ringleader and was holding the stolen cash. Taylor and Crump planned to go to Tillman's house and rob him. "That's right," Paul admits. "I was going to rob Tillman."

Taylor and Crump went to Tillman's house, where they were arrested and held for three days at Twelfth Street Police Headquarters. The police had staked out Tillman's house on a tip, but after being interrogated around the clock, Crump was released! On May 26, 1953, Tillman confessed, and named Crump the trigger man. The police, led by Lieutenant Pape, went to Paul's mother's house, where they rearrested him. Paul's mother Lonie described the scene to me: "Paul was sick. The police roughed him up and ordered him to get dressed. Then they beat on him and dragged him out." Lonie Crump burst into tears, describing these events.

Shortly after we began filming, Vincent Ciucci's final appeal was denied, and a date was set for his execution. I had come to know Vince well, so he invited me to be one of the thirty witnesses to his execution.

We had to arrive at the entrance to the Cook County Court-

house by 9:00 p.m., on March 23, 1962. We were advised to arrive early to get a parking spot, because the streets would be crowded. People would park around the jail and the courthouse on the night of an execution just to watch the lights dim at midnight, when the execution was to take place. There were security guards waiting at the entrance to take us through the underground tunnel that led from the courthouse to the Cook County Jail. We huddled together in a bitterly cold mist of rain. The other witnesses were local reporters and friends of Vince. At a table just inside the entrance, we had to surrender our watches, belts, wallets, all metallic objects, and, of course, cameras. Our left wrists were stamped in quarter-inch red letters with "SAIN," the name of the Sheriff of Cook County, Frank Sain, the man in charge of executions. Sain was a garrulous red-faced man with thick hands, thick glasses, and the hail-fellow-well-met attitude of a Chicago pol: big voice, big features, thinning hair. He enjoyed his job, and once bragged to me how he had the electric chair designed especially for the county jail. An exact two-foot replica of the chair sat on a corner of his desk, and he was proud of it. We thirty witnesses then walked through a long tunnel with several checkpoints along the way, where security guards examined our wrists to make sure we were all SAIN. We were escorted into a claustrophobic yellow-brick room with five rows of old wooden benches facing a corrugated metal screen, behind which was concealed the electric chair. The room was a few steps from death row. Four security guards faced us. We were anxious and alone with our thoughts, except for a big man in his fifties with a ruddy complexion wearing an old black winter coat and a rumpled fedora. This was Ray Brennan of the *Chicago Sun Times*, a hard-bitten veteran crime reporter; the best known and most knowledgeable of his colleagues. He paced off to the side.

Suddenly two more guards entered the room and grabbed the handles of the large metallic screen. It rattled upward, shattering the silence. As the screen continued its raucous journey, the echo of its movement hung in the air, and behind a thick plate-glass window in a smaller room in front of us was the black enamel electric chair, silhouetted against yellow brick walls.

Another long silence. Apprehension turned to fear. The chair looked like a squatting alien, its stillness belying its destructive power. There were gasps in the room, and Brennan stopped pacing. Behind the plate glass, from a door off to our right, we saw four new guards enter. They were escorting Vincent Ciucci, whose eyes were blindfolded. He was slouched over, and I could hear faint murmurs through the plate glass, which meant, since the room was soundproofed, that he must have been screaming at the top of his lungs. The guards guided him carefully to the chair. A strange ritual was about to take place. It no longer mattered whether Vincent was guilty or innocent; a helpless man was about to be sacrificed in a way that was supposed to be more civilized than the stake or crucifixion.

The loud whimpering behind the plate glass persisted. A guard stepped on a foot pedal at the base of the chair, clamping metal restraints around Vincent's arms. Another foot pedal, and ankle restraints snapped shut. A black metallic mask was placed over his blindfolded face, then an electrified pad placed on top of his head, at which point Warden Johnson appeared. He whispered something to Vincent, and looked at his wristwatch. A long pause. Then the warden abruptly signaled to a control room off to our left and out of view. We couldn't see who was behind it, but I was told that three guards each had their fingers on control buttons, so that no one of them would know whose finger had caused death.

I expected to see bolts of lightning appear. But nothing happened. Nothing you could see. Vincent Ciucci sat perfectly still, as did we on the other side of the plate glass. The murmuring behind the glass had ceased. His body was shot through with forty-five hundred volts of electricity; then, at a second signal from the warden, thirty-five hundred volts; and finally, another forty-five hundred volts. The muscles of Vincent's neck ballooned out slowly and expansively, as though they would explode. His neck looked like Dizzy Gillespie's cheeks when he was blowing trumpet; surely it would burst. Then, Vincent's thighs began to glow red, and smoke arose from them. At this point, Brennan, sitting next to me on one of the benches, rolled off the bench and threw up—Brennan, the veteran reporter who'd covered other executions. He went to a corner of the room and continued to vomit. Two guards rolled down the metallic screen, behind which Vincent's body continued to smoke. Smoke rose from his thighs to the ceiling, covering his upper body and face. I thought of the photos of his children on his now vacant cell wall . . . a cell awaiting the next victim.

Moments later the metallic screen was rolled up once again, revealing a tableau of Ciucci free of restraints, draped across the electric chair in a crucified position. The prison doctor hovered over him, checking vital signs. Next to the doctor stood the warden, and on the other side a Catholic priest. Two guards stood at the rear. I saw the doctor nod to the warden, and the metal curtain came down for the last time, as Ray Brennan struggled to his feet. Warden Johnson appeared in the witness room. He seemed a beaten man. He looked at his wristwatch, then spoke in a quiet, almost catatonic voice: "It's 12:07 a.m.; the orders of the court were carried out at 12:01. Vincent Ciucci, convicted of four counts of first-degree murder, was executed as determined by the court. Those of you on deadline can leave now; the others, please wait until I dismiss you."

The beat reporters, about twenty of the thirty witnesses, filed out. I leaned back on the bench behind me. I couldn't speak—no one spoke. This scene has played back in my mind's eye for fifty years. This was the fate that awaited Paul Crump unless I could find a way to get his story to a sympathetic public, and to the governor. I walked slowly from the Criminal Courts Building to a side street where my car was parked. It was freezing cold. A fog had settled in, but I could see a small woman, shabbily dressed, standing alone in the doorway of the courts building: Vincent Ciucci's mother, waiting to claim his body. I had an image of a young Vincent playing on a sidewalk under his mother's watchful gaze. The streets around the county jail were still crowded with cars and people waiting to see the lights dim. It was almost 1:00 a.m., and they were still waiting, and they might have waited forever; the dimming of the lights was a myth. There were thousands of people out there, seeking the vicarious thrill of a man's execution.

When I got to my apartment, my mother was asleep. I tried to wash SAIN off my wrist, but it wouldn't come off. It faded slowly on its own after several weeks, as Ciucci's life had dissolved from flesh to dust.

While working on the documentary, I wrote articles about the case for Lois Solomon's counterculture four-sheet newspaper, the *Paper*. The articles were reprinted in a prominent liberal magazine, Paul Krassner's *Realist*. Lois was also helpful in convincing a young civil liberties lawyer, Donald Page Moore, to take Crump's case pro bono. Paul had one final appeal left to the U.S. Supreme Court, to grant a stay. Moore gave us a blistering interview that brought chills as I stood next to the camera. He said, "There was an overwhelming probability that Paul was beaten to within an inch of his life. . . . This is what the Chicago police have been doing, the memory of man runneth not to the contrary. The police have a dis-

graceful history of beating and torturing people in police stations."
Moore wrapped up his powerful oration with the argument that "if
the State kills Crump, it will be worse than the killing he is accused
of, because this killing will be in cold blood."

The guard who identified Paul by his voice was supposed to be
knowledgeable about weapons, but was unable to identify the gun
with which he was hit. When asked by William Gerber, Crump's
court-appointed attorney, how he could identify Paul's voice but
not the weapon, the guard answered, "When you're working with a
hundred or so of these niggers every day, you get to know one voice
from another pretty easy."

Warden Johnson gave us access to Death Row, where we filmed
Paul in his cell. Paul described the beating he received from the po-
lice until he broke down and confessed. He said that the beatings
were so severe, he started to pray out loud. He begged God to take
his life, at which point Lieutenant Pape shouted, "What would the
white Mother of God want to do with a black son of a bitch like
you?"

When Paul first described to me what he had endured at the
hands of the police, he was angry. His tears were nonstop; he
was hysterical. But now, in front of a film camera, he was unable
to describe these events with the same emotion. At one point I
stopped the camera, and for the first of three times in my career,
I resorted to a technique I read was used by the French director
H.-G. Clouzot to evoke emotion from an actor. I said, "Paul, do
you love me?"

"You know I love you, Bill," he answered.

"Do you trust me?" I asked him.

"I trust you with my life!"

I took him by the shoulders and repeated, "You love me and you
trust me . . ."

"Yes!" he responded emphatically, at which point I hit him as hard as I could across the face.

"Now tell the story!" I shouted, and Butler started the camera. Paul was stunned and hurt, but he gave in to his emotions instead of lashing out at me. The slap brought back the physical and psychological pain he had experienced at the repeated beatings. His tears lasted for several minutes, but Butler's camera ran out of film after only a few seconds of it. In the documentary, after Paul's breakdown there is a quiet shot of John Justin Smith walking alone along the lakefront. On the sound track we hear Paul's crying, as though in Smith's memory.

On a Monday in March 1962, we were filming on Death Row when Warden Johnson appeared with a telegram. The Warden, in a quiet voice, told Paul that his final appeal for a stay of execution had been denied by the U.S. Supreme Court.

His legal rights had now been exhausted, and in the absence of a commutation from the Governor of Illinois, a date for execution would be set.

A long silence. Paul took the news with no outward sign of emotion. I could only imagine what he felt, though he had been to this place before, many times, and had lived for years with the certain knowledge he was going to die in the electric chair. Finally, he cleared his throat and told the warden that he was more concerned about *him*, and his opposition to capital punishment. We filmed Paul receiving the last rites from Father Serfling, and then, speaking directly into the camera, he said, "I've done things in my life that if I ever got caught for them, I'd be in prison the rest of my life, but not this. Not murder . . . I can't help but think about the electric chair all the time now, and I don't feel like a man anymore, just a statistic, only a statistic. It all seems like a macabre dream, a nightmare, but it's not a nightmare. You wonder if prayer and God

mean anything. I try to sleep, but I can't. I can only get to sleep holding on to the bars. It's like holding on to reality . . ."

There follows a shot of him in his cell, lights out, holding the bars, until his eyes close, and then—the film plunges into the abyss:

A montage of the electric chair, as it appears in Paul's nightmare state, waiting like a prehistoric monster for its next victim. We see ankle cuffs and arm braces snapping shut, the electrode pad moving as though on its own to cover the victim's head. We filmed Paul's nightmare on the day his appeals ran out. We were able to steal these shots of the chair without the warden's knowledge. He did not want it filmed, but Butler and I were able to persuade one of the guards to allow us into the chamber and photograph the chair at various angles for a few minutes. In retrospect, I think the warden knew we were doing it, but couldn't grant official permission.

The final sequence shows John Justin Smith, alone in an inner-city neighborhood, on the South Side, watching a group of black children playing near a construction site. A new tenement is going up—a slum of the future. A loud crash is heard as the construction crane drops a load of earth and debris onto an enormous pile. The children, future Paul Crumps, would be thus deposited on the slag heap at the fringes of an uncaring society. Dissonant music is heard over this shot.

Butler and I were editing the film each night as we got the dailies from the lab. Most of the time we worked at my apartment. My mother would make us lunch and dinner, and we'd work on weekends twelve or fifteen hours a day, with an old pair of rewinds and a 16 mm. viewer and splicer we had "liberated" from the WGN-TV newsroom. Splicing was done with glue, not clear cellophane tape, which came in several years later.

One evening, Ernie Lucas, a veteran TV director, happened to pass by on his way to pick up copy for the ten o'clock news. He was

surprised to see us in a film editing bay in the newsroom, since we were involved exclusively with "live" telecasts. He expressed shock that we were editing our *negative*, and that we were not handling it carefully with white cotton gloves. "What are you guys doing?" he asked. We told him we were working on a short film for our own amusement. "But you're cutting the negative; you're not supposed to even touch it."

"Why not?" We were confused.

Ernie was patient.

"Don't you know that camera negative is never touched until you have a final edited work print?" he asked.

"What's a work print?"

Ernie explained that a work print was made immediately after the negative was developed, and that it was this *work print* that you cut and recut, and only when you were finished was the negative *conformed* to the work print version. Neither did we know that the work print, negative, and 16 mm. sound track had to be edge-numbered simultaneously, so that picture and sound could be synchronized. Consecutive serial numbers were printed on the edges of these elements at intervals of a foot. Since we didn't realize this, parts of our negative were scratched and torn, spliced and respliced, until we could belatedly apply edge-numbering. We had to "match" our synch-sound interviews by lip-reading, which took weeks, and we had no idea how to achieve a final print. While we were correcting these errors, Red Quinlan was becoming impatient. Where was the film we promised him, which was now over budget without his having seen a frame?

Meanwhile, the Crump case was heating up. Paul had a new execution date, and once again through the efforts of Lois Solomon, the noted civil rights attorney Elmer Gertz came on board to help Don Moore draft a clemency appeal to Governor Otto

Kerner. Gertz was the lawyer who had successfully achieved the release of Nathan Leopold, the surviving member of the Loeb-Leopold case.

Butler and I showed the film, now called *The People vs. Paul Crump*, to Red in a screening room at WBKB. He was excited beyond my expectations. He said he wanted us to make another print to send to his bosses at the ABC network in New York. He felt that the network would want to air the show, and that it was powerful enough to gain wide public support that might spare Crump's life. He set up screenings for Warden Johnson, Father Serfling, Elmer Gertz, John Justin Smith, and Don Moore. He also arranged to show the film to members of the Chicago press at screenings he hosted, in which he would explain my involvement with the case.

The film became a cause célèbre in Chicago. A casual encounter with a stranger at a cocktail party I didn't want to attend had led to this. I was being celebrated not only as a talented young filmmaker but a crusader for justice. Columnists wrote glowing reviews of the film and the injustices done to Crump before the film had a release date. John Justin Smith wrote several columns in the *Daily News* about his own participation and how in the course of working on it, he came to believe that Paul should not be executed. I went back to the county jail and told Paul and the warden what was going on, and they allowed themselves new hope. After several weeks of euphoria, I got a call from Red to meet him at his office at 10:00 o'clock the next morning. He was standing behind his desk. He came around and put his hand on my shoulder.

"You made a great picture," he began. "An important picture." He led me to a leather couch across the room, and we sat down. His perpetual smile was gone. "I sent the film to New York, and they told me there's no way it can run on the network," he said.

A sense of dread started in the pit of my stomach.

"They said if we even run it *locally*, it could expose the network to all kinds of lawsuits. They haven't ordered me *not* to run it, they advised me strongly that it's inflammatory, but it's my decision."

A tinge of hope. Red continued, "So I asked Elmer Gertz and Don Moore to see the film. Both had the same reaction. It would do Paul more harm than good."

I was confused and angry.

"Moore says he won't stand by the things he said in the film, and Elmer said the best way is to respect the system and appeal directly to the Governor. Not try to create a firestorm of public opinion, which the film will certainly do; and if the Governor feels pressured, he'll just ignore the petition."

"Does Paul know about this?" I asked.

"He has no choice but to go with the advice of his lawyers. He doesn't want the film to air."

I felt betrayed, and that they were all wrong. Paul had gone through the system and relied on lawyers for years, and now he was about to be executed. "What are you going to do, Red?"

"I told you, it's my decision. But here's the thing; what happens if I run it and we're wrong? If the public or some capital punishment pressure group jumps all over it? And if the Governor decides to let Paul burn? How would you feel if they blame your film?"

"I'm not going to run it, Bill," Red said, sadly. "I can't take that chance, and neither can you. But I'm going to send it to the Governor. I think he should see it. I think it will give him a better picture of who Paul Crump is today, and I want the film to be seen. So I asked my guys to find out when the next important film festival takes place, and they tell me it's in San Francisco in September, and I'm going to enter it in the documentary category

in competition." He was certain the film would be accepted by the festival committee, which it was, and he thought good things would result from that.

Red saw that I was crushed; I had put my energy and passion into making this film, with the intent of saving a man's life. I did it with his help and support, but now we both knew it would never be aired. He offered an alternative as consolation. He floated the idea of me coming over to WBKB with Butler, where we would have our own documentary unit at the station, making films about local issues.

It was a bitter defeat, but Butler and I were soon off to San Francisco. My emotions were mixed: extreme disappointment and accomplishment. I didn't know whether to celebrate or mourn.

I had never been out of Chicago, so San Francisco was a revelation. A new American culture was emerging. The Beat poetry and novels of Allen Ginsberg and Jack Kerouac, the bebop and progressive jazz of Dave Brubeck and Gerry Mulligan. The Beat Generation was slow-dissolving into the Haight-Ashbury era of sex, drugs, and psychedelia. The creative energy everywhere was electrifying.

The 1962 San Francisco Film Festival was held at the Metro Theater on Union Street in the Marina. It was one of the last movie palaces, built in the 1920s and remodeled in the early '40s. It had a neoclassical, deco look, with large, graceful chandeliers in the auditorium.

Butler and I arrived for the closing-night ceremony, expecting absolutely nothing, but happy to be a part of it. The seating was assigned, and there were no seats for us. We stood in the back of the auditorium, me in a trench coat, Butler in a short leather jacket. A long list of awards in various categories was presented to ecstatic recipients. The award for Best Documentary was given, but not to

our film. The evening was about to end, and Butler and I looked at each other and shrugged.

There was a pause in the proceedings; then the master of ceremonies took the microphone. I don't remember him but I'll never forget his words: "Every once in a while, and not every year, a film comes along that is beyond categorization; that is so outstanding we give it the highest award of the festival, the Golden Gate Award. This year, that film is *The People vs. Paul Crump*." A short segment of the film was shown, followed by thunderous applause as I made my way to the stage, bringing Butler with me. I introduced him and spoke about his invaluable contribution to the film. I then thanked Red Quinlan, and the festival jury, and I discovered what it felt like to be honored.

There was a dinner afterward at a fancy hotel that went by in a haze, after which I called my mother, who was crying with joy, and Red Quinlan, who laughed and shouted, "That's great. That's so great! Well, my boy, you're off and running!" After a day of interviews, we were to go back to Chicago. At breakfast, I read a story in the *San Francisco Chronicle* about our winning the grand prize, but what caught my attention was a review of a play being revived at the Actor's Workshop. It was the first American production, but it had created a sensation in England a few years earlier and was described with a phrase I found compelling: "a comedy of menace." The reviewer said it was an evening of theater not to be missed. By a new young British playwright named Harold Pinter, it was called *The Birthday Party*. I went to see it that night—a revelation as pivotal as *Citizen Kane*.

In the fall of 1962 Butler and I moved to WBKB to work for Red Quinlan. We were celebrated locally as prodigal sons, and we started to plan new documentaries. It was Red's idea to do a series about former Chicagoans, to be called *Home Again*. Quinlan

wanted the first one to be about the University of Illinois's and the Chicago Bears' legendary running back, Red Grange. Grange lived in Lake Wales, Florida, with Martha, his second wife of many years. They owned a small grapefruit grove. Their entire crop had been wiped out that year as a result of a series of typhoons, so there was an air of melancholy about him when we met.

We were able to find archival films of Grange in the 1920s, when he used to fill stadiums with a hundred thousand people. Films of his college games showed him regularly scoring four or five touchdowns after running all the way to his left, then cutting back to his right and outrunning the other team's entire defense. The phrase "broken field running" was coined by a sportswriter after watching Grange in action.

In 1923 Grange led Illinois to a national championship and became a three-time All American. Then he turned pro, joining the Chicago Bears. He was earning $100,000 a season in professional football when most players made $100 a game. When I met him, he was about six feet tall, and only ten pounds heavier than his playing weight. He was fifty-nine years old. There were no trophies or memorabilia from his celebrated career visible in the modest ranch house, and it was hard to get him to talk about the past. The one event he described with emotion was a heart attack he had suffered while living in an apartment building on the North Side of Chicago a number of years before. He remembered being carried out on a stretcher and into an ambulance, the proud football hero, fallen and vulnerable.

He agreed to come back to Chicago and let us film his return, along with his recollections of growing up in Wheaton, Illinois. Ranked one of the greatest high school players in the country, he was able to pay his way through college by delivering large blocks of ice he carried on his back. He became known then as "the Whea-

ton Ice Man." He told me he learned broken field running from watching a dog cavort in a neighborhood park.

Home Again: "77 Grange of Illinois" was my second film. No censorship problems this time, but neither did it create much of a stir. Quinlan ran it on WBKB in prime time to a lukewarm reception from critics and audiences. There is no print in existence that I'm aware of, and you'd be hard-pressed to find anyone who remembers it. It was made with more skill than *Crump*, but lacked passion.

In December 1962 a hearing was held before the Illinois Parole and Pardon Board, after which they gave a recommendation to Governor Otto Kerner. A few days later, the Governor granted clemency to Paul Crump and sentenced him to life in prison without possibility of parole. It was the first time rehabilitation had been accepted as a cause for clemency. A day after Governor Kerner announced his decision, I received a personal note from him, under the Seal of the Great State of Illinois. He wrote that he had seen my film and was "deeply moved by it." He said it was a major factor in his decision to spare Paul's life, "despite the fact that [his] Parole and Pardon Board 'recommended two to one to send him to the electric chair.'"

I went to Red Quinlan's office and showed him the note. He was proud that we had played a role in influencing the governor's decision, but felt bad that he couldn't broadcast the film. Nevertheless, it had accomplished its goal for Paul and for me.

For years, even after I moved to California, I stayed in touch with Paul by mail. He eventually became eligible for parole due to the efforts of Elmer Gertz. Each year for three years in the mid-1960s, at Gertz's request, I appeared before the Illinois Parole and Pardon Board, seeking to have Paul released to my custody in California. Each year my request was denied. Is it possible they felt

Hollywood was not an appropriate place for a convicted murderer? But in 1993, after thirty-nine years in prison, Paul was paroled to the custody of his sister Naomi and went back to the neighborhood of his youth. He couldn't make it on the outside in that environment. His anger, long suppressed, again turned to violence, and he picked up several assault and battery charges. He was remanded to a mental health center, where he died in 2002 of tuberculosis and lung cancer.

When I see *The People vs. Paul Crump* today on VHS, the only medium in which it's still available, whatever power it may have had in 1962 has evaporated, like a prizefighter once feared, now frail. The film reeks of its own incompetence. But was Paul in fact innocent? He had to make a full confession to be paroled. Was it that the state wanted its pound of flesh, or was he in fact guilty of murder? I tend to believe now that he was, but in 1962 I had to believe he was not, and there is plenty of reasonable doubt in a situation where innocent people, especially black men, were routinely beaten to confess by the Chicago police. A more troubling question for me is whether I would have made the film if I knew then that he was guilty. I was looking for a subject to film; he was looking for a get-out-of-jail card. I don't dwell on the question because it would mean we both gamed the system. Paul got his freedom, I got my career.

A man with thick bushy hair and a mustache, a prominent nose, and a laid-back sense of humor came into my life. His name: Tony Fantozzi. His job was booking nightclubs in the Midwest for the William Morris Agency out of Chicago. He's convinced he was hired by the Morris office because he was Italian, and in those days "the boys" owned and operated all the nightclubs. Tony was instrumental in changing my life.

He joined the New York office of William Morris in 1958, fresh out of the Air Force. He'd made serious money shooting craps in Korea, then moved to Las Vegas. In Vegas he reconnected with Pearl Bailey, a star performer who remembered him from Korea, where in addition to his duties as a soldier he used to book acts for the officers' clubs. Pearl called Abe Lastfogel, head of the William Morris Agency, saying, "There's a kid here that would make a great agent." The Morris rule was that you had to have graduated from college, and then start in the mailroom before you could become an agent. Tony had been there only six months when he was transferred to the Chicago office. He was making $150 a week, and they gave him a rented car. His territory was everything east of Vegas and west of New York City. Typically a top performer like Jimmy Durante would play New York, then go on the road, and Fantozzi would book him and accompany him across America as far as Vegas. They'd play Chicago, St. Louis, Omaha, and Houston.

Tony had a chic apartment on Michigan Avenue in a courtyard above a restaurant called Le Petit Gourmet. The living room was dominated by a full set of drums, which he used to play to relax. One afternoon, after reading about my Paul Crump documentary in the Chicago press, he called Red Quinlan and asked to see it. Why? He has no idea; but he went to the station, screened the film, and thought it was wonderful. "Who the hell did this?" he asked.

Red gave him my phone number, and he called me. Tony had no idea what to do with me at that time, but on a hunch he asked if I'd meet him for lunch.

He convinced me that I could only go so far in Chicago. If not for him, and the fact that he liked me, I would probably never have made it out of there. He asked me to sign with the Morris office, and I became one of his first clients. A master of hype and hyper-

bole, Tony was moving up at the agency and getting into the movie business, as well as booking nightclub acts.

I liked Fantozzi, though I had no idea what the hell an agent did. We had a few meetings, and he started to talk about me to television producers and other clients of the Morris office who were passing through Chicago. One was David Wolper, who was making documentaries for all the networks. Fantozzi brought up my name and the notoriety around the Paul Crump film, and Wolper said, "Great, I'd like to meet him."

When Tony was transferred back to the New York office, then Los Angeles, we kept in touch. He kept prodding Wolper, who by then had seen the Paul Crump documentary. They agreed that if I wanted to come to Los Angeles, Wolper would make a spot for me in his company. Tony began to sing my praises to the networks in Hollywood. "Here is a great young talent," he'd tell them. "Maybe he could shoot an episode of this or that." There was no blueprint, but a snowball effect started to occur, created by Fantozzi out of whole cloth. There started to be a "Friedkin buzz," people in the film and television business talking about "this kid from Chicago." Tony was getting calls from studios and production companies: "Who the hell is this guy? Where'd you dig him up?" The other agents at the Morris office got on the bandwagon, and because of their hype I became a hot property on very little substance. The agents were sending inter-office memos to each other, saying, "Why don't you get Friedkin a meeting at this place or that place?" and I was getting the meetings, and the interest continued to build.

"So even if you didn't know how to point a camera, you became hot," Fantozzi says. True. I would have stayed in live television in Chicago forever, but in Los Angeles I got into the film world fast and started to learn how to direct. After a while it became easier for Fantozzi to sell me. The thing that surprised him most was how

quickly I caught on. "You understood editing, music, everything, all that stuff," he told me, as though it had been preordained.

I had mixed emotions about leaving Chicago, my mother, and longtime friends. With the death of my father, and my move to Los Angeles, my mother went back to fulltime nursing. I had a final emotional dinner with Quinlan and Butler. We promised to stay in touch and hopefully work together again.

I knew nobody in Los Angeles and had not met Wolper or any of his staff. With only three 16 mm. documentaries to my name, I thought I'd fail quickly and come home. I promised my mother I would bring her to L.A. if by some miracle my ambitions panned out.

MR. DOCUMENTARY

The Wolper Company was making successful documentaries for the networks, as well as smaller-budgeted shows for syndication to local stations. Their crowning achievements were documentaries they produced for CBS, adapted by Theodore H. White from his best-selling *Making of the President* books. The first was about the Kennedy-Nixon election in 1960, and Wolper crews had exclusive access to both candidates, resulting in more personal, humanistic portraits. The book and the TV shows won numerous awards. That was followed by the Johnson-Goldwater campaign from *The Making of the President 1964*, with comparable results. I felt like a freshman trying out for the varsity.

The Sunset Marquis at that time was a modest motel where weekend fathers stayed with their children, and where singles could stay in a no-frills room with a kitchenette and one bath. Two single beds in a corner at right angles to one another doubled as couches. The furniture was cheap and utilitarian. There was one twelve-inch television set on a stand. The three-story pale stucco hotel was a rectangle surrounding a swimming pool. Each apartment had a small balcony that looked out over the pool. There was a garage, but no bar or restaurant, just a soft drinks machine. I lived there for two years because it was a block down the hill from Wolper

Productions at the corner of Sunset and Alta Loma, on the quiet eastern tip of the noisy Sunset Strip.

I checked into the Sunset Marquis on a Friday, and I wasn't due to meet Wolper and his staff until the following Monday. Apart from the Morris office agents in Beverly Hills, I had only one other contact. Before I left Chicago my friend Irv Kupcinet, columnist for the *Chicago Sun Times*, told me to call a man named Sidney Korshak if I needed anything—*anything*—in Los Angeles. I called him.

A call came back, inviting me to meet Mr. Korshak at a restaurant on Canon Drive near Wilshire Boulevard in Beverly Hills, the famous Bistro Garden. I later learned that Korshak was the owner. I didn't realize at the time that he was one of the most shadowy figures in the history of Hollywood and Las Vegas. He was the lawyer for the Teamsters' Union and the Chicago mob, and looked after their West Coast interests. That he controlled the unions and could strike the studios or prevent a strike at any time made him the power behind the throne in Hollywood. Everyone had a "Korshak story," and he was either loved or feared by most of Hollywood. A family man, he was often seen in the company of starlets. It's been reported that he negotiated Jimmy Hoffa's release from prison after donating a million dollars of Teamster money to John Mitchell, former U.S. attorney general and head of the Committee to Re-Elect President Nixon in 1972. Korshak is said to have given Mitchell his word that if Hoffa was released, he would never again seek union office. Shortly after Hoffa broke that promise, he was never seen again.

Mr. Korshak was at a table in the back of his crowded restaurant in the late afternoon, finishing a conversation with a very attractive woman who turned out to be the actress Jill St. John. He was a trim six-foot-three in his late fifties, an immaculate dresser with a shock of white hair. Though I knew little of his reputation, he had an aura of power, yet he was friendly and generous.

"Call me Sidney." He had a slight lisp. A waiter brought a fresh pot of tea and two cups. During our conversation, various familiar faces came over to shake his hand or whisper in his ear. This was met with a casual word or a nod. "Irving [Kupcinet] tells me you're a talented young man," he said.

I shrugged.

"Don't be modest," he said. "What are you doing out here?"

"I'm going to do documentaries for the Wolper Company."

"Dave Wolper?" he asked. I nodded. "You have an agent?"

"The Morris office."

He was slightly impressed. "Born in Chicago?" he asked.

"Yes, sir, this is my first time out here."

"Where'd you go to school?"

"College, you mean?" He nodded. "I never went to college. Graduated from Senn High School."

"North Side?" I nodded. "You have family?"

"Just my mother—my father died about ten years ago."

"You take care of your mother?"

"Yes, sir—she works as a nurse at Northwestern University Hospital, but I plan to bring her out here as soon as I can."

"You go to synagogue?"

"I was bar mitzvahed at Agudas Achim."

His eyes flashed to the ceiling for a split second, "That's near Argyle Street," he said.

"Argyle and Kenmore," I said.

He nodded, sipped the freshly brewed tea, and said, "I grew up on the Westside. Lawndale. I've got a brother who lives in Hyde Park." His brother Marshall was then head of the Illinois Department of Revenue. His next question took me by surprise. "How much are you making at Wolper?"

"Five hundred a week," I answered proudly.

"That enough to send money to your mother?"

"Yes, sir—I never made more than two hundred in Chicago."

"Well, it's a little more expensive to live out here." He smiled, leaned forward, and wrote something on a small card, then said in a soft voice, "If you ever need anything, call me at this number. You're a friend of Irving's, which means you're a friend of mine."

Fantozzi took me to meet Abe Lastfogel, head of the William Morris Agency. Several of his top agents were also in Lastfogel's spacious, antique-filled, paneled office. He had been the boss for over forty years. He was a jovial man, no more than five-six, with curly gray hair. His height belied his power, but his energy and positive attitude reinforced it. His office was elegant and understated. I had signed with Fantozzi in Chicago, where the Morris office was a single room in Tribune Tower. After the notoriety of *The People vs. Paul Crump*, Tony sent the film to agents in the Beverly Hills office, and now I was meeting with the head of the agency and his top guys in their three-story headquarters. I was nervous and had no idea what to expect. Mr. Lastfogel had baby blue eyes and thick-lensed glasses. He spoke softly, almost imperceptibly, so that you had to strain to hear him. He led me to an easy chair by a fireplace and sat on a small couch next to me.

"My people tell me you're a fine young director," he said.

"Thank you, sir."

"I haven't seen your film, but I trust my partners' judgment." He gestured to the other agents, who nodded in agreement. "I want you to know that now that you've signed with us, you're part of our family. We think you'll have an important career, and we're going to help you build it, but you must never take an assignment, whether it be a picture or a television show, that you don't have a passion for. Never take a job just for the money. I don't know if you've managed to save anything while you were in Chicago."

"I have six thousand dollars in the bank," I said proudly.

Lastfogel leaned closer. "If you ever have money problems, as long as you're a client of this office we'll give you a loan, interest-free, up to a hundred thousand dollars."

I didn't know how to respond. The others in the room nodded and smiled. We shook hands.

Later I met Dave Wolper and a few of his staff. I was impressed by the size of the offices on Sunset Boulevard. There were at least two hundred people, all busily involved in editing, sound mixing, story meetings, and screenings. Everyone had a secretary or an assistant, and they were all laid-back, California style. I expected Wolper Productions to be a small company; instead, it was a factory, and some of the giants of documentary film worked there: Mel Stuart, Alan Landsburg, and Jack Haley Jr. Wally Green (who later wrote *The Wild Bunch* for Sam Peckinpah, and *Sorcerer* for me) was a staff writer. Kent MacKenzie, a quiet, studious man who directed *Exiles*, a much-lauded film about American Indians, was a staff director. Jim Brooks, who later created some of television's most popular series, including *The Simpsons*, and went on to direct *Terms of Endearment* and *Broadcast News*, was then a researcher at Wolper.

I was greeted by the head of business affairs, a muscular sun-tanned man with a toupee who ushered me into his office. After the pleasantries, he said, "By the way, your deal is for five hundred a week, but we're going to give you six."

"Why?" I asked.

"It's more expensive to live here than in Chicago. We want you to be happy." Korshak! He went on, "Dave has an exciting new series of hour shows for the ABC network. They're being sponsored by the 3M Company. He's going to talk to you about doing one of them right away."

My homesickness faded. He closed the door. "Here's the thing," he said quietly. "We're getting eighty thousand dollars for each show. What's the most you ever had to produce a documentary?"

"About seven thousand dollars," I said.

"We've *got* to come in on budget," he continued. "You understand that?"

"Absolutely."

"If you come in under, we'll split the difference with you."

I was slow on the uptake.

"Say you make the show for sixty-five thousand dollars, we'll split the extra fifteen grand with you."

I was still a little slow: "I would want to put whatever I have into the show," I said naively.

"Of course," he said, "but think about it."

Later I told Julian Ludwig, who was to be my producer at Wolper, that I was concerned about this man's proposal.

"He's probably getting at least a hundred grand a show," he said, "but he wants to pick up every nickel. If he tells you you've got eighty, you can bet it's a helluva lot more."

The lessons were coming fast. I was shown to a spacious corner office and introduced to a secretary, my first one. Then I met the man himself.

David Wolper had gone to USC to study film and journalism but never graduated; he became a buyer and seller of odd-lot B movies, travel films, old serials, and cartoons to the growing number of television stations that were springing up around the country, mostly stations with no network affiliation. With partners he bought the television rights to *Superman* and made twenty-six episodes, which they sold to syndication. When he sold his company three years later, it had become one of the most successful in televi-

sion syndication. He started his documentary unit with the purchase of government films about the Russian and U.S. space programs and put them together as *The Race for Space*, which he sold to over a hundred stations in 1960. Two years later he was producing shows for all three networks, and a *Time* magazine profile labeled him "Mr. Documentary." When I met Mr. Documentary, he was wearing slippers, wrinkled khakis, and a frayed white shirt and smoking a big hand-made Cuban cigar. At that time he smoked about six a day. His nickname among some of his employees, but never to his face, was "The Olive," because of his greenish yellow complexion. He was chubby, with close-cropped light brown hair and heavy-lidded blue eyes. He shuffled around his office not caring about his appearance, but there was no doubt he was the boss. He had an almost permanent smile, and he was quick to laugh, but I was soon to discover that his easygoing manner concealed deeper emotions.

He told me about the three titles he had sold to the 3M Company and the ABC network: *The Bold Men*; *The Thin Blue Line*; and *Mayhem on a Sunday Afternoon*. I was to direct all three, and they were to be delivered and on the air within twelve months. They would each be narrated by Van Heflin, a movie star from the 1940s and '50s, the golden era of MGM.

What were the shows about? Wolper had only the vaguest notion. He had sold *titles* without detailed concepts. *The Bold Men* would be about men who risk their lives for money, adventure, or science. I'd have to find and identify such people and shoot about forty minutes of film per show, but I had to use stock footage to fill out the required forty-seven minutes of programming. This was a disappointment. I didn't come to Los Angeles to work on stock footage, but it was clear that costs came first at Wolper, and it was cheaper to edit film that had been shot than to go out and shoot it.

The Thin Blue Line was to focus on the police force of a big city. It was up to me to figure out the city and the content.

Mayhem on a Sunday Afternoon was to be about professional football. There had recently been a television documentary about Sam Huff, a famous lineman for the New York Giants, and the producers had concealed a microphone on Huff during a game, which captured the brutal sounds of football up close. Wolper wanted to do something similar, possibly with the Cleveland Browns and their great running back Jim Brown. Dave knew the owner of the Browns, Art Modell, and the NFL commissioner, Pete Rozelle.

What surprised me was Wolper's certainty that I could fill three hours of network prime time, when all he had seen was my Paul Crump documentary. For some reason—inexperience or cluelessness—I was completely confident.

At the end of our first meeting, he said, "Good luck, cookie, you're gonna do great."

Soon after *The Bold Man* was announced in *Variety* and the *Hollywood Reporter*, I started to get calls. One was from a stunt-man named Rod Pack. Rod looked the part: tall, blond, a surfer's body, a calm demeanor. He told me about a stunt he had rehearsed with a colleague, Bob Allen. Rod was a skilled parachutist, and he said he could jump out of a single-engine aircraft *without a parachute* at fifteen thousand feet and rendezvous with Allen, already in midair, who would *pass* him a chute. Allen would be wearing the required two parachutes. Pack would then have about a minute to secure the chute and pull its cord after falling four thousand feet at 120 miles an hour with no safety devices of any kind. Pack had calculated that in order to fall at the required speed, he needed to add two belts, each containing fifteen-pound weights, around his waist to compensate for the weight of the missing chutes. This was

a guess—it had never been attempted. "I'm either going to come down safe, or I'm going to come down dead," Pack told me. The pilot was a lanky middle-aged man named Harry Haynes, one of the best commercial pilots around, who flew everything from helicopters to jets.

After meeting with Pack, Allen, and Haynes, and listening to their wild scenario, I rushed into Wolper's office.

He listened impassively, the ever-present cigar in his mouth. "Sounds great, cookie."

"How much should we offer him?" I asked.

Without hesitation he said, "A thousand dollars."

"You've got to be kidding—he could die doing this!"

Dave leaned forward, "You think he's for real?"

"Absolutely," I said.

"And he came to *you*, right?" I nodded. "Offer him a thousand and give him the still photo rights. Tell him they should be worth a lot more than that."

"I don't have the chutzpah to go back to him with a grand."

"He's going to do it *anyway*! Whether we pay him or not, cookie."

I went back to Rod with the offer of a thousand dollars. He laughed and said he already had ten thousand dollars from a freelance still photographer, Larry Schiller, just for the still photo rights. Schiller was one of the best freelance photographers in the country. He worked for *Life*, *Look*, and other photo journals around the world. He saw the value in Pack's death-defying stunt and immediately wrote a check; he was now calling the shots. He let us film the stunt for *The Bold Men*, but he would control the ancillary rights, which included not only the still photos but all subsequent television news coverage. The stills eventually were worth over half a million dollars, and pictures of the stunt appeared on the covers

of every major photo magazine in the world—*before* the airing of *The Bold Men*. But even though we were scooped, it was the highlight of our show.

I covered it with several cameramen, including Bill Butler, who I brought out from Chicago. We had a camera inside the single-engine Piper Cub and a couple of cameras on the ground to film the preparations, and on long lenses, the exchange of chutes in the air and the aftermath. Larry Schiller set up several remote cameras and a micro-camera built into Rod's helmet. We filmed the stunt over the town of Arvin, California, near the Mojave Desert, on a bright weekday morning. We proceeded as though it was just another day at the office, but the threat of death was in the air.

Two days before, Haynes, the pilot, who had nerves of steel, seemed edgy. He confided to me that Pack and Allen were not necessarily the best of friends. There had recently been a rift in their relationship over Allen's fiancée. Pack had supposedly had an affair with her. If they failed to make contact in midair, it would be seen as merely a fatal error. I was aware of this as we filmed them, carefully packing the chutes in preparation for the stunt.

Everything we were going to do was against some law. I never gave that a second thought; nor did Wolper. Pack and Allen had theoretically "rehearsed" the stunt, but this was to be the first time they had actually performed it. They didn't appear nervous, nor was there apparent tension between them. I set up the shots and tried to keep the mood light, but I knew it could all go sour. If someone was injured or died on this stunt, it could involve manslaughter charges against Wolper, the ABC network, the 3M Company, and me. But I didn't hesitate. I told everyone to mount up and started the cameras rolling.

Bob Allen was the first to jump, holding the spare chute at arm's length. Pack then jumped, and the rest of us held our breaths as he

attempted to maneuver toward Allen. It seemed like forever, but it was only a matter of seconds before they rendezvoused in midair and Pack strapped on the chute and pulled the cord.

The result is still thrilling to watch. Afterward there was an FAA investigation. Haynes, the pilot, lost his license. No charges were brought against the rest of us, but I had crossed a line I would encounter again many times.

Julian Ludwig put me in contact with Jaime Contreras, a well-known production manager in Mexico. I flew to Mexico City to meet with him at the Churubusco Studios. He found two wonderful, unexpected characters for *The Bold Men*. One was Carlos Román, a young man who, for a handful of tourists in Acapulco, performed the most dangerous high-dive in the world from the top of La Quebrada (the Broken Rock), a height of 136 feet. The rock angled out another fifteen feet at its base, and the water was only ten feet deep, so *if* he cleared the face of the rock, Román had to execute an immediate flip when hitting the water, or crash into the jagged rocks just beneath the surface. I filmed him frolicking on a beach with his wife before setting out with the only tool of his trade, a bathing suit. He had to climb the face of the rock barefoot to reach the top, where he first offered a prayer to a statue of the Virgin of Guadalupe before executing his dangerous dive.

After filming his preparation and giving the viewer a sense of the danger, I filmed the dive in slow motion, and added Román's point of view as he plunged toward the water's surface. He performed this death-defying act every day for a few clapping hands and a handful of coins.

In a small village just south of the city of Cuernavaca, Jaime introduced me to Mickey Luquin, a Mexican police captain who for eight years had trained his nineteen-year-old son Mickey Jr. to

become a skilled sharpshooter. Captain Luquin demonstrated his son's prowess. Using a six-shooter, Mickey Jr. shot an apple off his father's head at fifty paces. He then did it again, over his shoulder, using the facet of a diamond ring as a mirror! When I asked Captain Luquin for permission to film them, he brought out *cervezas* for us, a bottle of orange soda for Mickey Jr.

"Do you trust my son?" he asked.

I said I did. Then he said something to Jaime in Spanish, which he translated for me: "He wants you to put one end of a cigarette between your lips; the captain will put the other end between his. At fifty paces, his son will split the cigarette in half, firing his six-shooter."

I thought he was joking—he wasn't. He wanted me to show my faith in his son's ability before giving me permission to film. "Don't do it," Jaime urged. "No matter how good a shot he may be, if he misses, you will be dead."

A voice in my head said, Do it! I had become fearless for the sake of my work. I honestly had no idea what would happen as I stood at one end of the Luquins' yard, a three-inch cigarette poised between my lips and the father's. Mickey Jr. lined up his shot. Suddenly I heard the six-shooter's loud report, and felt the *whoosh* of the bullet as it whipped past my face. I saw half the cigarette in the father's mouth, and I slowly took the other half out of mine. The sequence showing Mickey Luquin Jr.'s skills, using his father as a target, runs only three minutes in the finished film, and ends with Heflin's narration: "The question here is, Who is the bold man—the son, or the father?"

From Mexico City I flew to Madrid to film and interview El Cordobés in his hotel suite before a bullfight, donning the suit of lights. El Cordobés (Manuel Benítez Pérez) was a sullen twenty-eight-year-old with no education, caught up in his own celebrity.

He was the idol of the bullring throughout the Spanish-speaking world. As a teenager, he made his reputation as an *espontáneo*, a kid who jumped out of the grandstand with a crude cape and tempted the bulls until security guards threw him out. He resembled, and was often compared to, James Dean. He spoke no English, and I knew little Spanish, but he agreed to let me film him for American television. Nervous before an upcoming corrida but skilled at concealing it, he arranged for me to film the bullfight with several cameras, all on long lenses, showing how dangerously close he positioned his body to the bull's horns. His passes were beautifully executed, and he dedicated the life of the bull to the people of his hometown, Cordova. In the short time I spent with him, I saw that the bullfight was a contest as much about man against himself as man against bull.

I asked him a question I put to others in the film: "What frightens you?"

"I'm not afraid of death," he answered; "only life scares me."

Chet Jessyk, a lion tamer with a traveling circus in San Diego, let us film him as he worked with a whip, a chair, and twelve African lions, all in a cage at the same time. He invited us to come inside the cage with him while he put the lions through their paces. My usually intrepid cameraman, Vilis Lapenieks, was married and wanted no part of it, so I took the 16 mm. Eclair camera and went into the cage. I was scared, but I had learned to put fear aside. Fear is a motivator; my own overriding fear was failure.

I stepped inside the cage.

"Just stay behind me," Jessyk said as the lions circled, snarling and snapping at us. I concentrated on filming his actions and the lions' reactions. After ten minutes in which he brought the lions within inches of us, he dismissed them and brought in six lion-

esses, more excitable, less predictable, and more dangerous than the males. They moved faster and seemed to sense my fear.

"Stay calm," Chet warned me. "They don't know how weak we really are. That's our only advantage." In the film the sequence ends when Jessyk removes a splinter from a lioness's tooth using a pair of pliers. The lioness appears docile and grateful.

About a year after *The Bold Men* aired, Chet Jessyk's daughter called to tell me that a lion had attacked her father, biting off one of his arms. He was hospitalized, and no longer able to perform.

Every year a handful of men seek to break the land speed record at the Bonneville Salt Flats outside the sleepy little town of Wendover, Utah, on the Utah-Nevada border. Throughout the 1960s the record alternated between two men—Craig Breedlove and Art Arfons. In 1965 I filmed Arfons's attempt to challenge Breedlove's record of 526 miles per hour. Like the other subjects of *The Bold Men*, Art was low-key and soft-spoken. He looked like an American Indian; dark skin, thick black hair, and a broken nose. He was six feet tall and in good shape but for a slight paunch. He was a garage mechanic from Akron, Ohio, and he towed his vehicle, encased in a specially built bus, from Akron to Bonneville. The vehicle in which he hoped to set the record was no more than the engine of an F-105 fighter jet he had bought at a surplus sale. He added three tires, a cockpit, and a steering wheel capable of going in only one direction—straight ahead. He called the result the Green Monster, and pronounced it a racing car. The following morning, he and his three-man crew arrived at the Flats, fourteen square miles of rock-hard salt in a dead straight line, so straight and barren you can see the curvature of the earth.

At the track, officials of the Racing Association prepared the timing devices, electronic beams that measure a vehicle's speed

as it passes. The land speed record is achieved by averaging three runs through a measured mile, within an hour. The average of the two fastest runs determines the record. Though the fourteen-mile course involves only one measured mile, the cars can only be braked by inflating two parachutes in the rear. The driver has twelve miles in which to brake or plunge into a tributary of the Great Salt Lake. Many have had to be rescued, or died.

A wire mesh fence screens off the wreckage of vehicles that blew apart, killing their drivers. I filmed Arfons as he stared at the wreckage of the Infinity, a car driven by his friend Glen Leasher in 1962. The Infinity's right rear tire blew at 350 miles per hour, the car skidded into the lake, and Leasher was killed. I intercut stock footage of this tragic event as Arfons stared at the wreckage.

On the morning of the race the officials took their places in a trailer alongside the track to monitor the timing devices. An ambulance pulled up, and we hear Art's voice on the sound track: "All I need's five hundred and thirty miles an hour, and I got the record. If a man leaves a record in the books, his life isn't wasted." Just after 9:00 a.m., the Green Monster's single engine roared to life in a fiery rage. Its sound was deafening and its velocity a blur; within seconds, the chutes flew open and the speed was recorded: 463 miles an hour, well short of the record. Wind force had shattered the glass of the canopy, and Art and his crew had to replace it. Before the second run, he asked me if I'd like to ride along.

Vilis Lapenieks, the cameraman, said, "You're crazy," but without hesitation I put on a safety helmet, took the camera, and wedged myself into the canopy next to Art. I filmed his face, his hands on the speed stick, and the black chalk line against the solid white salt as it flew by. The timing devices measured 515 miles per hour on this run, eleven miles short of the record, with only twenty minutes remaining. On a third and final run he would have to *ex-*

ceed 550 miles an hour to claim the record. But the tires had only been tested safe to a maximum speed of 550.

Art was calm, determined. When I emerged from the airless cockpit, I was nauseous, my stomach in knots. The tires were replaced, and Art and his crew pushed the Green Monster a third and final time to the starting line. He gave a thumbs-up and blasted off. In seconds, as we filmed, we saw the car lose control; *the right rear tire exploded*, and the chutes failed to open. Chaos. The ambulance rolled out, its siren blaring. Vilis, Nigel Noble the sound man and I, the officials and a handful of spectators raced along the track. About twenty feet from the body of water, where it would have sunk, the Green Monster had come to rest, lopsided, its right rear tire blown to shreds. When Art emerged from the cockpit, the official told him that his speed through the final measured mile was 559 miles an hour. His last two runs had achieved an average 536 miles an hour, a new land speed record. The small crowd lifted him to their shoulders. *The Bold Men* ends on this shot.

I returned to Los Angeles to edit the film with Bud Smith, one of Wolper's best editors. We were excited to be working with this visceral footage. Shaping it into a coherent story in a style that drew from contemporary foreign films—subliminal cuts, jump cuts, unexpected transitions—we worked twelve-hour days for six weeks, six days a week, stopping only for lunch.

We presented our first cut to Wolper and his top executive, Mel Stuart, a fine documentary filmmaker in his own right. Wolper and Mel arrived in the screening room, smiling, one late afternoon. Other Wolper directors and executives had been invited, and the room was packed. "The hour of truth," Mel said sardonically. I was proud of what we were about to show, and it came in at the required forty-seven minutes and thirty seconds.

Wolper told the projectionist to roll it. Afterward, the lights came on to an uncomfortable silence that lasted almost a minute. Dave and Mel were no longer smiling. Suddenly Dave stood up, took off his shoe, and threw it at the screen with full force, leaving a hole at the point of impact. He was furious. "There comes a time when the white-hot light goes on and"—he was sputtering—"and the bullshit falls away . . . like bricks on the ground!" Those were his exact words; I've never forgotten them, nor has Bud.

Then Wolper turned to us, fuming. "This is the worst piece of shit I've ever seen!"

Mel Stuart joined in. "Fucking awful! A simple idea, and you assholes made it incomprehensible!"

"I hate this fucking thing!" Wolper added. He turned to Mel. "What can we do? Is it salvageable?"

Mel was pacing the room. "I don't know, but we're going back into the cutting room, and we're going to look at every fucking frame that's been shot and see if it makes any sense at all."

I was crushed. I looked at Bud and Julian Ludwig. Both seemed calm; they had seen this before. I never had a critique so brutal before or since; I was sure to be fired.

"You fucking idiots!" Wolper shouted, staring at me with hatred in his eyes. He turned to Julian. "It's obvious he"—pointing to me—"knows nothing. Why didn't you straighten him out?"

Julian extended his arms as if to say, What could I do? I kept my anger in check. I had no idea what was wrong. We went back to the cutting room, and in a week of sixteen-hour days, Mel slashed the film to pieces as I watched. The finished film was a slick, impersonal montage of stunts, with little opportunity to know or care about the people performing them. I don't claim that my version was a masterpiece; it didn't work for Wolper or Mel, and it was their company. But the ABC network showing of *The Bold Men*

in prime time turned out to be a critical and commercial success. It was my first shot at the big time: a network documentary. The success was qualified, but a giant step nonetheless. I wasn't fired.

For a long time I felt this trial by fire shaped me as a filmmaker. It broke me down, and was an invaluable lesson: go straight for the story, don't clutter it with gimmicks, "technique," or "director's touches." These documentaries weren't meant as a showcase for my talents, slim as they were, nor were they meant to impress film buffs. They were aimed at the largest possible audience, people of all ages across all boundaries. Wolper and Stuart knew how to cast a wide net. I didn't. They broke me down, only to remake me in their image. Much was gained, but much lost. My Wolper documentaries led to future work, but they stripped me of the ambition to make films that reflected my own sensibilities. The filmmakers I most admire are all "visible" in their work. Their approach to life, their compassion, their sense of humor or irony, show in all their films. Because I was a neophyte at Wolper, my only aim was to please, but a film that's only meant to please, that embodies no deeper personal truths, will not resonate. It's impossible for me to watch most of my films today, especially the early documentaries. What I gained was experience and knowledge. I had been to Spain, Mexico, Houston, Utah, and San Diego all for the first time. Film-making had become an adventure as well as an education, and an invaluable insight into various cultures.

I moved on to research and create *The Thin Blue Line*, which Wolper sold as a documentary about law enforcement. Thinking about this subject and how I would portray it opened a door to my past:

An uncle on my mother's side, Harry Lang, was a notorious Chicago cop in the 1930s. A detective-sergeant, he was given the

assignment by Chicago mayor Anton Cermak to "clean up" the Italian mob before the 1932 Democratic National Convention and the 1933 World's Fair. The leader of the mob, after the imprisonment of Al Capone, was Frank "The Enforcer" Nitti, and an often-whispered rumor in my family was that Uncle Harry had ties to Nitti. Corruption in Chicago was so rampant that Mayor Cermak himself had become a millionaire as a result of his own racketeering connections. The North Side crime boss, Teddy Newberry, in concert with Mayor Cermak, paid Uncle Harry $15,000 to kill Frank Nitti. According to legend, later bolstered by facts, Harry took two patrolmen to Nitti's office on LaSalle Street, where he had easy access, shot Nitti in the back and neck, then shot himself in the arm to make it appear that Nitti had shot him first.

Miraculously, Nitti survived, and he ordered hits on Cermak and Newberry. Newberry was killed, and attempts were made on Cermak's life, but he left Chicago for an extended vacation in Miami. He took Uncle Harry along as a bodyguard, and Harry was with him the night he appeared on the dais at a public event honoring newly elected president Franklin Roosevelt. A lone assassin, Gus Zangara, stood up in the large crowd at Bay Front Park and shot Mayor Cermak, who died three weeks later. Zangara was reported to be a madman. His target was said to be Roosevelt, but it was later revealed that he had been a sharpshooter for the Italian army during World War I and a hired killer from the Sicilian Mafia, and that his target was in fact Cermak.

Uncle Harry was fired from the Chicago Police Department and put on trial for the attempted murder of Frank Nitti. A jury found him guilty, and it was reported that he said, "I will blow the lid off Chicago politics and wreck the Democratic Party if I have to serve one day in jail." He was granted a new trial which was later dismissed. I became aware of him when I was five. He was married

to my mother's beloved sister, Sarah ("Aunt Sunny"). They had a handsomely furnished apartment, about twelve rooms on the West Side, with an enormous free-standing radio that stood four feet high and three feet wide. They also had a large black Cadillac in which they used to take my mother, father, and me for long drives to Chicago's northern suburbs for dinner at an elegant restaurant. Some of the happiest times in my young life were on those drives, when I sat by a window in the back seat and gazed at the unfamiliar neighborhoods floating by, as if in a slide show.

On summer vacations from high school I used to work at Uncle Harry's tavern/liquor store, the Sip and Bottle on Irving Park Road, where I would overhear conversations between him and his cronies from the police force and the underworld. This was my first exposure to the ambiguous nature of a policeman's life. It prepared me for *The Thin Blue Line*, my second documentary for Wolper.

Its first image was a policeman's badge. An officer's voice is heard on the sound track: "This piece of tin is a target. Out on the street, we don't know what we're gonna be up against; any second could be our last."

In the 1960s the city of Rochester, New York, had experienced race riots similar to those in Watts. I contacted the mayor and the chief of police, who allowed me to film a day in the life of a Rochester street cop in a troubled neighborhood. Previously respected in his precinct, he had become "The Fuzz," and I tried to capture his feelings and the challenges these changes produced.

In another sequence, I went out with an undercover Los Angeles narc on a surveillance of a gas station attendant suspected of dealing heroin. The cop, "Paul," makes a "buy" from "Eddie," the dealer. We then see the heroin being tested in the police lab in graphic detail. It tests positive, and "Eddie" is arrested and given a sentence of five years, later reduced. The point of the sequence was

that the war on drugs was being lost. Detectives were risking their lives to take dealers off the streets, only to see them come out of jail after doing very little time

Unlike the documentaries made by committed independent filmmakers today, the Wolper shows aimed only to fill forty-seven minutes of air time and lead the audience by the hand with wall-to-wall narration. Wolper's philosophy, often stated, was, "You've gotta hit 'em over the head, and after you hit 'em over the head, you've gotta hit 'em again and again." And so our films relied heavily on narration, telling the audience what to think and feel, rather than insightful interviews and simple observations of human nature.

Pete Rozelle sat behind his desk leaning on his elbows in a large office on Park Avenue South, headquarters of the National Football League, his fingers covering his mouth and nose, revealing only piercing blue eyes. If he meant to appear intimidating, he did. Until the 1950s, the NFL had been a money-losing venture. When I met Rozelle in 1965, the empire over which he presided was valued at a mere $50 million. But television was emerging as the league's benefactor, paying $14 million for broadcast rights, and there was competition from another pro league, the AFL. The NFL had its superstars—Johnny Unitas, Fran Tarkenton, Jim Brown, Jim Taylor—but a team's average payroll was less than $1 million, several million less than what many of the NFL players earn individually today.

"Why should I help you?" Rozelle asked behind his half-shielded face—cold, noncommittal. I told him our show would be seen on the full ABC network. "I have a contract with CBS," he said, a razor's edge to his voice. "CBS has exclusive rights to our games."

"I understand, but our show will be a *special*, and it will be on film, and it would feature a history of the game."

"That's wonderful," he said sarcastically. "I also have a film division, NFL Films. They have exclusive rights to our games and our own specials."

"I'd want to work with them," I assured him.

He buzzed his secretary to send in Ed Sabol, head of NFL Films. The recently launched division was Sabol's idea. Ed was tall, thick, with prematurely white hair, red cheeks, and a brash, aggressive attitude. He wore a dark blue suit with a bright red tie. He and Rozelle talked about my proposal as though I wasn't in the room.

"Why should we, Ed? What do we gain?" And on and on, in the same vein.

Finally Sabol turned to me. "Look, you'll have to use our cameramen, and we'd want full screen credit."

"Absolutely," I agreed.

"I don't think we have anything to lose," he told Rozelle. "It could be good promotion."

"Your call," Rozelle told him, but I knew it was Rozelle's call.

"You know we're in exhibition season," Sabol informed me. It was mid-July. "When do you need to start shooting?"

"As soon as possible; we have to be on the air in October."

Because Rozelle knew and liked Wolper, he eventually agreed. "There's an exhibition game in San Francisco in three weeks, Forty-Niners versus the Cleveland Browns—would that work for you?"

I arranged to film the Browns and Forty-Niners in training camp. Along with two Wolper cameramen, Vilis Lapenieks and John Alonzo, who later became one of the best cinematographers in Hollywood (*Chinatown*, *Blue Thunder*), I set off for Hiram,

Ohio, the Browns' training facility. I also had Wolper's best sound man again, the young Englishman, Nigel Noble.

When we checked into a small motel in Hiram, we were met with curiosity by the locals. There were a lot of young girls in town. Several were waitresses at the motel. They wondered who these four young guys with long hair were, carrying heavy cases of technical equipment. For two days the girls, smiling and giggling, watched us come and go, trying to figure out what we were doing in their little town, until finally on the third night, a few of them approached us. "Who are you guys?" they asked shyly.

We'd known this was coming, and we tried to stay cool, so we had a prepared answer: "Please don't tell anyone, we're Herman's Hermits"—the English rock band, enjoying a huge hit at the time with "I'm Henry the VIII, I Am." They squealed with pleasure. Nigel had an English accent, and Alonzo and I affected one; we passed Vilis off as our manager. He was older and had a Latvian accent.

Why were we in Hiram? the girls wanted to know.

"We're rehearsing a concert tour that starts next week in Cleveland," was our answer.

Occasionally at dinner, we'd sing quietly, as though rehearsing, and the waitresses would stand at our table, hoping for more. The crowds got bigger. Would we consider singing for them in the restaurant? There was a piano in the lounge, but none of us could play or sing.

"They don't sing for free," Vilis, our "tour manager," said.

We had a great time pretending we were rock stars until we quietly stole out of town.

We had total access to the isolated world of the Browns' training camp, including coaches' meetings and the practice sessions. We miked the coaches and some of the players. We recorded a

voice-over with Jim Brown, then the best running back in the game, who in his ninth year had gained more yards and scored more touchdowns than any other player in NFL history. "I love the game and I'd play even if they didn't pay me," Brown said. "We have a phrase: a guy who doesn't love the game is just up here for a cup o' coffee. We can spot him easy and we just call him 'Cup o' Coffee.' "

Our coverage emphasized the violence and brutality of the game. This was Wolper's mandate: mayhem. A young rookie lineman, Don Thiessen, tells us, "I'll forget my life. My body. It's gonna be a destroy type of deal." We showed linemen slamming into blocking dummies and into each other in tight close-ups with the sound magnified. We also captured the complexity of offensive and defensive patterns and the intelligence necessary to execute them. After five days, "the Hermits" left Hiram, never to return.

Our next stop was St. Mary's College, a Catholic liberal arts school in a peaceful valley in Moraga, California, home of the Sisters of Mercy and the Sisters of St. Joseph. In July it was also the training camp of the San Francisco Forty-Niners. Again we had total access to practice and strategy sessions. The year before, 1964, the 49ers had finished last in their division, while the Browns won the NFL championship, and the finale of our documentary was to be an exhibition game between them at Kezar Stadium in San Francisco. Nothing was at stake, but it was my job to make the game seem of vital importance. I had Vilis and Alonzo film the game in extreme tight close-ups, while Nigel picked up the sounds of plays being called and bodies crashing. I augmented our tight coverage with wider shots from the NFL cameramen. It was the first time the game had been shot in this impressionistic way, with little concern for continuity. Bud Smith edited the football montages as though we were covering a war. We isolated the rival

coaches, Jack Christiansen of the Forty-Niners and Blanton Collier of the Browns, as though they were the generals of two contending armies. "To play football, a man must have the killer instinct," said Van Heflin on the soundtrack. "Teams win or lose—defeat is a personal thing."

The Browns won, 37–21. It was never a contest. The documentary was contrived, full of "facts and information," some of it mildly interesting—"Four miles of hot dogs would be sold that day; forty-five hundred gallons of beer; the crowd would go home fifty-three thousand pounds heavier." I don't know if any of this was accurate. It was an exercise in making chicken salad out of chicken shit.

In his novel *What Makes Sammy Run?*, Budd Schulberg has the newspaperman Al Manheim ask the newly promoted copyboy, Sammy Glick, if he likes his new job. "I like it fine this year," Sammy answers, "but if I have it next year it'll stink." That's how I felt after three documentaries and over a year at Wolper. I quickly assimilated story-telling skills, but to no purpose. The Crump documentary, inept as it was, was an attempt to save a man's life and a screed against capital punishment. The Wolper shows were anecdotal and superficial. The 1960s were about to change the world: films, popular music, hippies, war protesters, they were all part of a cultural revolution, and I was on the sidelines.

I became friendly with some of my contemporaries, in particular Francis Coppola. Francis had taken cinema courses in college and was passionate about film and knowledgeable about all the new equipment. He was laserlike in his drive to express himself on film. He had worked for Roger Corman making B movies, but he had the chutzpah to get a major studio to let him direct a personal film called *You're a Big Boy Now*, which was funny and stylistic and signaled to many critics the arrival of an American

New Wave. Pauline Kael called the movie "this generation's *Citizen Kane*"—heady stuff. Francis loved good food and wine, and we would often meet in restaurants or at various social gatherings and talk movies.

Francis was close to his brother Augie, as well as to his mother and father. He was all about family, which is how he would approach *The Godfather* a few years later. There was an unstated competition between us, but he was an inspiration to me.

Joe Wizan, an agent at the Morris office, sent a print of *The People vs. Paul Crump* to several producers, one of whom, Norman Lloyd, was the producer of *The Alfred Hitchcock Hour*. He had been a distinguished character actor, with many important film and theatrical credits; most notably the title role in Hitchcock's *Saboteur*. The *Hitchcock* show had been on television for ten years. Norman ran the shows, commissioned the scripts, hired the actors and directors, and supervised production. In the final season, Hitchcock made a studio appearance only once a week to deliver his introductions to each show. Occasionally he would direct one of the shows, but he was still deeply involved in feature films and entrusted the series to Norman and other associates, who knew precisely what he wanted, having worked with him for so long.

If you want to study film or actually make films, you don't need to go to film school; you just need to watch Hitchcock's movies. The entire vocabulary of cinema is embodied in his work. To refer to him simply as the "Master of Suspense"—which he is—is to understate his total contribution. He was a master showman. When his actors played a double-entendre romantic scene, as in *North by Northwest* with Cary Grant and Eva Marie Saint on a train, you could feel the heat between them. All of his works have moments of comedy, brilliantly directed. Even in a film like *Psycho*,

which is dark and disturbing, Hitchcock knew audiences needed to relieve the tension, and he provided that relief, in the midst of brutal murder.

The playwright Herb Gardner, author of *A Thousand Clowns*, told me that Hitchcock asked him to come to Hollywood to discuss a screenplay. Gardner was ushered into a conference room, where he was shown an array of storyboards for the film Hitchcock wanted him to write. Hitchcock already had the film conceived, in terms of images; he just wanted Gardner to provide the words. When they met, Gardner thanked him but told him that, while he was honored, he couldn't accept the assignment; he didn't think of himself as a caption writer. But he did have a question about two panels in the storyboards. One showed a man falling from a bridge, and the very next one showed the same man sitting at an outdoor café.

"That's correct," Hitchcock answered.

"How do you have this guy fall off a bridge, and in the next shot he's sitting in a café?" Gardner asked.

"The crew goes there," Hitchcock answered with a straight face.

Gardner laughed. "I understand that, but how do you get the *audience* there?"

Without pause, Hitchcock said, "Mr. Gardner, the audience will go wherever I take them. And they'll be very glad to be there, I assure you."

Hitchcock was forthcoming about his techniques. On the matter of suspense, he understood that forecasting what is going to happen creates a more powerful experience for the audience than letting the events play out without a sense of anticipation. Imagine a scene where two people are sitting at a table having a long conversation; then a bomb goes off, killing them both. The audience is surprised, even shocked, but there's no suspense. If the same conversation takes place, but the audience *knows* there's a bomb under

the table, and the characters don't, that creates suspense. A good example of Hitchcock's application of this concept is the shower scene in *Psycho*, where the shadow of the killer appears in the room and on the shower curtain before Janet Leigh is aware of it. Orson Welles's *Citizen Kane* inspired me to become a filmmaker, but Hitchcock's body of work was my tutorial.

Norman Lloyd told Wizan, "There's more suspense in the first five minutes of the Paul Crump documentary than there was in anything *The Hitchcock Hour* produced last season." He asked to meet me. I had never done anything on a soundstage. Now I was sitting across the desk from Norman Lloyd in his sunny office at Hitchcock's company on the Universal back lot. I had to conceal my nervousness and awe. He asked how I happened to make the documentary and told me how impressed he was with it. He also liked the three documentaries I'd done for Wolper. While I was thrilled to be appreciated by an accomplished filmmaker, I was still learning on the job. I had made six documentaries, but looking back, they were mediocre. There are a few decent moments in each, but I don't think I had a natural feel for cinema, and nothing I directed reflected the films that inspired me.

Norman told me this was to be the final season of *The Hitchcock Hour*, and asked if I'd be interested in directing the last show. Interested? Without a doubt. He handed me a script called *Off Season* from a story by Robert Bloch, who had written *Psycho*, and adapted for television by a talented young writer named James Bridges, who later became a fine screenwriter and director, with *Urban Cowboy* and *The China Syndrome* among his credits. *Off Season* was about a big-city cop who accidentally kills an innocent suspect, and is fired from the police force. He moves with his young wife to a small town to start over as a local deputy sheriff with very few challenges. In the story's finale, he accidentally

kills another innocent man, leaving the audience to wonder if the two killings were in fact accidental. John Gavin, then a romantic movie star best known for his work in *Psycho*, was to play the lead, with supporting roles to be played by Tom Drake, once a star of MGM musicals, and Richard Jaeckel, a terrific character actor who specialized in playing heavies.

Norman told me he'd let me direct this episode if John Gavin agreed. John had director approval. He watched my documentaries, then we met. A charming, intelligent man with matinee-idol good looks, he spent about half an hour sizing me up before deciding he would approve me as director. We've remained good friends to this day, and I never forget that it was due to him that I had this incredible opportunity.

Norman emphasized that it was as important to the studio to come in on schedule as it was to do a brilliant show. He gave me this piece of advice: "Make a shot list the day before. Share it with the crew so they can be prepared when you arrive in the morning, and be sure your first setup is simple, so you can get it in one take. That way, the crew will have confidence that you know what you're doing."

For some perverse reason, I set up the first shot as a complicated camera move that took two actors through three rooms, and was impossible to accomplish in one take. At that time television shows didn't normally do complex setups because of the time factor. The director of photography was Jack Warren, who was nominated for an Academy Award as director of photography on *The Country Girl*, a film that won the Academy Award for Grace Kelly. An experienced and respected DP of many years' standing, Jack had worked his way up from being a film loader. I was a novice, who had never worked on a soundstage. Jack and his crew must have thought I was related to someone at Universal.

When I showed Jack the shot I had in mind, he shook his head. "Jeez, kid, this will take me a couple of hours to light."

"I don't care, Jack, that's what I want."

"Let me show you something else." He took me back to the set and laid out several angles to replace the one I'd chosen.

There's no point in arguing in front of the crew or the cast—just say what you want and move on. But in this case I said, "That's boring, Jack—I don't want to do it that way."

He shrugged and proceeded to set his lights, and we blocked the camera move I asked for. A young DP on a television series today would light a shot like this in less than fifteen minutes. Jack took an hour and a half. When we were lit and blocked, it took seven or eight takes for the actors, John Gavin and Indus Arthur, to make the scene work. Around take six, a phalanx of Black Suits, including a worried-looking Norman Lloyd, appeared in the shadows. Word spread around Black Rock, which is what Universal is called, that a young director had been unable to print a setup by 10:30 a.m., after an 8:00 a.m. call.

I thought I was about to be fired, but I also knew I had to bring something original to my work. "Bill," said Norman, "we've got to make the schedule. There's no give here. Our shows always come in on time and on budget."

I had to make a decision: shoot the whole thing like Orson Welles, or do it in the workmanlike style of a TV director. TV directors worked all the time, and Orson Welles couldn't get a job. In TV, whether a film is brilliant doesn't matter as much as bringing it in on schedule. The guys who work all the time are the guys who can do both.

Next morning, the studio again filled with more Black Suits. I was blocking another scene, and Jack Warren was watching, just behind me. I could hear Norman Lloyd's strident tones as he ap-

proached Jack, then said to him in a soft voice, "Jack, I've just seen the rushes. I know that first shot took forever, but it's brilliant."

Warren turned to him in amazement. "You liked it?"

"Liked it? I love it."

I heard Jack whisper, "It was my idea."

"Well, it's great stuff," Norman answered. Then he came over to me and put an arm around me. "Good stuff, Bill. I wish I had more shows for you."

He was pleased, the Suits evaporated, but in that moment an insight popped into my head like a comic-book lightbulb: even someone as distinguished as an Academy Award–nominated cameraman claimed credit for a shot he had opposed. Success has many fathers; failure is an orphan.

On Thursday, the next-to-last day of production, Alfred Hitchcock came to the stage to film his introduction. Norman and a group of Suits brought him to where I was rehearsing. He was wearing a black suit and blue tie, the "uniform" on the Universal lot. He was taller than I expected, but with a mammoth girth. I reached out to shake his hand, and he extended his like a dead fish. It was as though he expected me to kiss it. I found him cold and remote, and made a silent vow never to treat young hopefuls that way.

"Mr. Friedkin," he said in that iconic British drawl, "usually our directors wear ties."

I was in my own "uniform," T-shirt and khaki pants. I thought he was putting me on, and I tried to make light of it; "Oh, I guess I left it at home," was the best I could muster before he turned and walked away, clearly not amused. The Suits drifted along in his wake. We crossed paths only once again, five years later.

Shortly before *Off Season* was aired, Norman Lloyd called to tell me that Hitchcock had made no editorial changes to my cut.

Usually he would suggest numerous revisions. I was pleased to hear that, until I saw it; then I wished the Master *had* put his stamp on it. I recently saw it, forty years on, and it's terrible, lacking style and reeking of compromise.

An actress named Dodie Heath had a small part in *Off Season*. A kind, lovely woman, she lived on Sunset Plaza Drive with her husband, Jack Cushingham, tennis pro to the stars. Among his friends was director John Frankenheimer. While I believed Orson Welles to be the best living film director, Frankenheimer was without a doubt the most innovative and influential director of "live" television drama in a medium that produced Sidney Lumet, Franklin Schaffner, Robert Mulligan, Fielder Cook, Arthur Penn, and Delbert Mann. As a young television director in Chicago I had seen all of Frankenheimer's memorable shows on *Playhouse 90* and other drama anthologies. No one will ever top his shows because live television drama is over. Not only were the performances he drew from actors exceptional, his use of *live* cameras was unparalleled.

One night at the Cushinghams, I met John and his wife, the actress Evans Evans. I was as awestruck as when I met Hitchcock. John had become a successful film director, with *The Birdman of Alcatraz*, *All Fall Down*, *The Manchurian Candidate*, and other classics. We became friends. He was tall, handsome, a ladies' man, though happily married. His hobby was gourmet cooking, and he and Evans had a second house on the fashionable Ile St. Louis in Paris, where he studied cooking at the Cordon Bleu. He was as good a chef as he was a director, and a bon vivant. I looked forward to being in his company and picking his brain. He had Wolper send him my documentaries to screen, and his appreciation meant more to me than any other reactions.

After *The Hitchcock Hour*, the Morris Agency was getting in-

quiries about me. It was time to move on. Fantozzi and Lastfogel met with Wolper, and he agreed to let me out of my contract with the promise that I would one day, at his call, direct a film for him for seven thousand dollars! We remained friends, but he never exercised that option. I'm sure he believed I wasn't ready for the big time, and he was right.

3

GOOD TIMES

I've worked with many talented people, but only a few geniuses. One of them was Sonny Bono. Though he and Cher had a number of hit recordings in the mid-1960s and early '70s, and later their own television series for four years, it was their strange costumes and comedic personae that drove their popularity. When I met them in 1965, they had the number-one hit in the country, a rock ballad called "I Got You Babe." The sentiment in Sonny's lyrics was real; he wrote what he felt. In that year alone the duo had five songs in the top twenty, but soon the zeitgeist changed and the Rolling Stones, Jefferson Airplane, and The Doors would eclipse them.

Sonny was thirty, though he didn't talk about it. Cher was eighteen. They'd first met two years before at Ben Frank's Coffee Shop on Sunset Boulevard just east of the Strip. Sonny was a gopher for the legendary rock producer and creator of the "wall of sound," Phil Spector. Cher LaPiere, a striking young beauty, was basically homeless. Her mother, Georgia, an attractive blonde, had several boyfriends and was estranged from Cher and her father, John Sarkisian, a dark, troubled Armenian drug addict who would eventually overdose. Neither Georgia nor John paid much attention to Cher, and she would crash wherever she could. After a year of seeing Cher at Ben Frank's, Sonny and his then girlfriend in-

vited her to sleep on the floor of their one-room apartment. Sonny used to take her to Spector's recording sessions at Gold Star Studios on Santa Monica Boulevard in East Los Angeles, and Spector would often ask the two, or anyone else who was in the studio, to sing background. He was then recording the Ronettes, Ike and Tina Turner, and the Righteous Brothers. His "wall of sound" was a product of the inherent limitations of the studio's space: its small size, low ceilings, and echo-chamber acoustics. Sound recording at the time took place mostly in high-ceilinged, soundproofed studios with separate microphones for each section—strings, percussion, and so on—but Gold Star's acoustics allowed for no separation. If a producer wanted to hear more drums or bass, he would record them separately and overdub. In the 1950s and '60s, Gold Star was the recording studio of choice, originally because it was cheaper than the others, but before long its string of hits—among them "Good Vibrations" by the Beach Boys, the Righteous Brothers' "You've Lost That Lovin' Feeling," and Ike and Tina Turner's "River Deep Mountain High"—put it on the map.

Gold Star defined West Coast rock of that era, becoming as legendary as Nashville's Sun Studios. Iron Butterfly recorded at Gold Star, as did Buffalo Springfield, Duane Eddy, Bob Dylan, the Bee Gees, Bobby Darin, Herb Alpert and the Tijuana Brass.

Sonny wanted to be a producer like Spector, and he learned by studying Spector's methods. Before coming to Los Angeles, Sonny worked for a butcher in his hometown, Detroit. His parents were Italian immigrants, and like them, he never finished high school. He was married to a childhood sweetheart with whom he had a daughter in 1958, but they divorced in 1962. He was one of the funniest and warmest people I've ever known. It wasn't long before he and Cher discovered they had a lot in common. "You really want to be a singer, don't you?" he would tease her.

She would protest, "No," and then tease him in turn: "You want to be like Phil." Sonny didn't deny it. "Why don't you make your own record?" she suggested.

"I can't do that; not now."

"Why not?"

"I don't know enough about it, and I don't have money to pay for a session."

"Stan would let you use the studio." Stan was Stan Ross, cofounder and recording engineer at Gold Star.

"Who's going to pay the musicians?"

"I know you want to write songs, and you can write as good as Phil," Cher said. Sonny had in fact written a song that Sam Cooke recorded in the early 1960s. Sonny and Cher's mutual teasing became mutual encouragement, and soon Sonny's former girlfriend was gone, and Cher was living with him. They managed to get a recording contract under the name Caesar and Cleo. With what little cash he had and after pawning his electric typewriter, Sonny wrote "I Got You Babe," which became a number-one hit. In personal appearances, Sonny, pudgy and about five-seven in lifts, wore a pageboy haircut, a fur vest, and fur boots. Cher had long black hair and colorful pantsuits that revealed her slender arms and long, lean body. By 1965 they were major stars.

The Morris agents used to have regular lunches at the Hillcrest Country Club, a private club started by rich Jews who couldn't get into the Gentile clubs. At one such lunch, Fantozzi said to Abe Lastfogel, "Sonny Bono wants to do a movie—we introduced him to Friedkin, and they hit it off."

Abe said, "What do you need from me?"

Tony said, "Somebody's gotta pay for the film."

Abe said, "I'll get Steve Broidy to do it."

That was that. I was amazed at the speed at which things hap-

pened, and I started to believe it was because of my talent. Think about it. I'm suddenly in a situation where everyone wants me to direct something. Last year I was in Chicago, struggling to keep a job. A year or two before that, I was in an unemployment line, with no prospects.

Broidy made a small fortune as owner of Allied Artists, a B-picture factory, in the 1940s and '50s. He sold the company and made another fortune in real estate and banking, becoming one of the founders of Union Bank of California. He had been out of the movie business for years and had little interest in pop culture, but the appeal of Sonny and Cher at that time was not lost on him. Over lunch at the Hillcrest he made a deal with his friend Abe Lastfogel for the rights to a Sonny and Cher film. The idea was to make it as quickly and cheaply as possible, before interest in them died down.

Mr. Broidy had shiny white hair, a red complexion, and wore dark suits. His manner was gruff. He had a thick Bronx accent, and rarely looked you in the eye. He had a short attention span, and I'm guessing he was about seventy years old at that time. I was just another wannabe director to him, a necessary inconvenience. My résumé was hardly terrific, which meant I could be had cheap.

At the same time I had another offer from my idol, John Frankenheimer. John was preparing his magnum opus on Formula One racing, *Grand Prix*, and he invited me to be the second-unit director, in charge of shooting the actual races in France. When the offer to direct the Sonny and Cher film came along, I was less than enthused. There was no script, this wasn't my kind of music, and I wanted to work for Frankenheimer.

The Morris agents—Fantozzi, Mr. Lastfogel, and Joe Wizan— summoned me to a meeting. Their advice: "Do the Sonny and Cher picture." Why? "Because if you do second unit on the Fran-

kenheimer movie and it works, you'll be a second-unit director for-
ever. If it doesn't work, you'll have a hard time getting a film to
direct. Do Sonny and Cher, and whether it's good or bad, you are
a film director. They're the hottest act in the business. Steve Broidy
is a great producer, knows when to spend a buck and when not to.
Most important—he knows how to make money."

Sonny and Cher lived in the San Fernando Valley on a hill in
a new tract house among a dozen similar homes, none occupied
except theirs. I pulled up in my 1963 black Ford Fairlane, driven
out from Chicago, known affectionately as the Batmobile. A slim
young man with long hair and an angry look answered the door.
This was Gino, a martial arts expert and bodyguard to Sonny and
Cher. In the living room were Harvey Kresky, their agent from the
Morris office, and Joe DiCarlo, formerly an employee of the gang-
ster Mickey Cohen, then in charge of Sonny and Cher's "security."

When the introductions were finished, Sonny and Cher burst
into the room like a force of nature. Sonny had a bright smile and
was immediately warm and cordial. Cher was beautiful but distant,
saying, "Hi, Friedkin," and soon disappearing upstairs to paint her
toenails. At only eighteen, she had a Garboesque air of detachment.
Sonny handled the business and was clearly the boss. The others
deferred to him, and Cher didn't want to be bothered; but we all
liked each other, and by the end of that meeting I agreed to do the
picture, whatever the hell it might be.

I started going to their house every day, just hanging out, mostly
with Sonny. He was a paternal figure to Cher, who had never re-
ally had a father, just a series of her mother's boyfriends. Cher was
madly in love with Sonny and would do whatever he asked without
question. Behind her remote facade, I sensed a deep wound and a
mistrust of men, but with Sonny she was always affectionate and
deferential.

Sonny and I started reading scripts, but nothing seemed right. One day he showed me an unsolicited letter he had pulled from a stack of fan mail. They were getting thousands of letters and postcards each week. This one was from a would-be screenwriter named Nicholas Hyams who lived in New York, a rambling but intelligent letter suggesting that their movie should be about them making a movie. Hyams seemed to "get" Sonny and Cher, as well as understanding their audience appeal. He made shrewd observations as to what a film audience would want from them: "Just be yourselves, don't try to be actors. The audience loves Sonny and Cher and wants to see you as you are." Sonny suggested we call Mr. Hyams, whose phone number was listed at the bottom of his letter.

Broidy was wary of adding another nonprofessional to our club. Thinking we needed an old pro, Steve brought on board one of his cronies, a veteran producer of B pictures, Lindsley Parsons. Okay, but Sonny and I didn't want an old pro writer. It was the first of many battles Steve was to lose. He wanted to make a cheap picture, pick up a quick buck, and get out; we wanted to make our reputations, me as a filmmaker, Sonny as a movie star. We treated Broidy and Parsons like the medieval war horses we thought they were, but Sonny was always respectful, leaving it to me to voice our objections when disagreements came up.

Nick Hyams was in his twenties, slim, smart, and angry. He tried to conceal his anger, but you could sense it in a crowd. He wore either a perpetual smirk or a scowl on his face, and his manner was unlike the tone of his letter. He was condescending to Sonny and disdainful of me. What he really wanted was to direct the film himself, and he wondered how I had come up with this plum assignment. The three of us met every day for two weeks, with Cher making an occasional disinterested appearance. She'd

listen to a few minutes of our conversation, then ask Sonny when he was going to be done. He would say, "Soon," with a smile or a hug, and we'd go on talking for another four or five hours.

Nick's idea to call the film *The Sonny and Cher Movie* and do it as a kind of documentary with music was good, as far as it went, but he hadn't worked out the details. The truth was, you couldn't really bring cameras into their house and show their actual relationship.

Cher was obviously a gorgeous flower that had not yet bloomed. She was completely and voluntarily under Sonny's domination, but this wasn't an image you'd want to portray. Nick's idea was "new wave" and hip, but there was no meat on its bones. After two weeks of batting it around, I had a private meeting with him. He clearly didn't want to have this one-on-one, and his attitude was sullen and morose. I told him our meetings were going nowhere, and Broidy wanted to start the picture as soon as possible. Nick's response was that I didn't understand his vision.

The next day Sonny got a long letter from Nick, warning him about me: "Friedkin's never directed a movie. Have you seen any of his documentaries? They're not great."

"Well," I said, "that tears it."

Sonny could see I was stung by Nick's comments. "Billy, I trust you a hundred percent, you and I are joined at the hip, we're going to do this movie together," he said. I thanked Sonny for his support but told him that Broidy and Parsons were getting restless. "I know," he agreed: "Here's what I think we ought to do. Before we cut Nick loose, let me ask him for a treatment—his best shot."

In due course a three-page treatment arrived at the house. It was all sizzle; nothing specific, just a restatement of Nick's philosophy about movies in general, Sonny and Cher in particular.

Sonny shrugged. "He's gotta go." A confrontation with Hyams would be a waste of time, so Sonny called and thanked him.

Without a screenplay, we couldn't prepare a budget, but Steve said he wanted to make the film for no more than $500,000, including Sonny and Cher's $100,000 fee.

We told Steve we'd write the script ourselves, at no extra cost to him. Despite the fact that neither of us had written a screenplay, Steve said go ahead. He had no idea what to make of us, but he was committed to making the movie.

We worked around the clock and on weekends. Takeout dinner always came from the Villa Capri, a popular Italian restaurant in East Hollywood. We ate clam zuppa by the dozens and whoever ate the least had to pay for the whole dinner. Occasionally Cher would appear and listen to what we'd written. Her comments were restricted to one word—"Okay" or "Really?" or "Why?" or "Ugh"—usually accompanied by a frown; then she'd take off. She'd have no part of our clam zuppa marathons, warning Sonny not to eat too much garlic bread.

We tried to flesh out Nick Hyams's idea of the movie being about Sonny and Cher making a movie. The film would be a Faustian tale about compromise. How much would Sonny and Cher sell out to make a stupid movie? Sonny came up with the structure, the gags, and all the good stuff, and we wrote everything on yellow pads. The film would show our heroes being courted by a Mephistophelian film producer called Mordicus who only wanted to cash in on their celebrity. Cher in the script, like Cher in real life, was against the whole process, but Sonny was gung ho, and their arguments eventually caused a breakup, followed by reconciliation and a happy ending, of course. The script portrayed their fantasies of the kind of films they'd like to make, and these fantasies were satires of the private eye genre, a Tarzan movie, and a Western. Each "film within the film" would be a short comedic sequence and include a new song. As in real

life, Sonny and Cher were up against a deadline to start shoot-
ing. Steve wanted to call the movie *I Got You Babe*, but Sonny
came up with a title from a new song he was working on, "Good
Times."

We finished the script on a Friday night. The following Monday
we were supposed to start preproduction, which involved set de-
sign, casting, hiring a crew, and location scouting. On Saturday
morning Sonny and I read the pages to his entourage, who were
suitably impressed. Even Cher smiled a few times. Sonny asked if
anyone could type, and since there were no volunteers, he found a
script-typing service in the Yellow Pages. About three hours later
a pleasant young woman arrived with a portable typewriter, awe-
struck to be meeting Sonny. He set her up at a kitchen table, and
we went into the den to watch a football game and hang out. We
had another clam-zuppa contest.

Late afternoon became early evening . . . we had forgotten
about the typist. At about seven forty-five, Sonny looked at his
watch. "How many pages did we give her?" he asked.

"I think about eighty," I said. "No less than eighty."

"How long should it take to type eighty pages?" Sonny looked
around the room.

Harvey spoke up. "What? Three hours?"

Sonny again, "What time did she get here?"

"Around noon," I answered. Blank stares all around.

"I wonder if she's hungry," Sonny said, and went to the kitchen
with a container of clam zuppa. About five minutes later he came
back to the den with a two-inch stack of paper and a wistful smile
on his face. Behind him I noticed the typist going out the front
door, her portable in tow. She seemed upset. "You're not gonna
believe this," Sonny said, smiling, and handed me the pages.

I started to read, shaking my head in astonishment.

"What's wrong?" Harvey asked.

I skimmed the pages, then set them down slowly. "She typed herself into this script."

"What?"

"She took what we gave her and created her own screenplay, focusing on the story of a typist who comes to work for Sonny and Cher and stays on to become their manager."

"No shit!" Joe said. We heard the screech of brakes as the typist's car pulled out of the driveway.

"What did you say when you saw this?" I asked Sonny.

"I thanked her, and told her we wouldn't need her anymore," he said, as though this sort of thing happened every day. "And I gave her the clam zuppa."

When the budget came in at $800,000, Sonny and I had to listen to Broidy scream for an hour: "This picture should be made for five hundred grand! We made pictures at Allied Artists for two or three hundred. We'd shoot them in a week with great directors and big-name actors . . ." Steve was right, of course, but I wished I had accepted Frankenheimer's offer. It was Sonny's optimism, his belief in what he created, and of course Abe Lastfogel's skills in the art of persuasion that calmed matters down. We went ahead with an $800,000 budget. Broidy presold the rights to Columbia Pictures for $1.2 million before we even made the film. This shrewd old bastard knew what he was doing.

Lin Parsons brought potential crew members to the Paramount lot, where we rented a soundstage. The meetings were with "old pros" like Bob Wyckoff, who had worked with Parsons before and became our director of photography. Mel Shapiro, who I had worked with at Wolper, was hired as editor; and to his credit, Lin brought in David Salven to be my assistant director. Dave had a

great sense of humor and worked on at least fifty films. He knew the game and played it better than anyone I've ever met. His father was Cecil B. DeMille's assistant director, and Dave's education was on DeMille's sets. He and I became close friends, and he was like the older brother I never had.

A legendary character actor, George Sanders, agreed to play the evil producer Mordicus. I was shocked when he accepted but looked forward to working with him—with trepidation. He had given so many fine performances, and won an Academy Award in one of my favorite films, *All About Eve*. Why would he take this role in a low budget, under-the-radar movie, starring two nonactors and with an inexperienced director? I soon learned that many well-known actors, no matter how distinguished, had personal demons and financial problems.

Mr. Sanders did what I asked of him, accepted corrections, was suitably malevolent, and left without a word at the end of the day.

We also shot scenes on locations around Los Angeles. If you drive due north of Paramount Pictures for less than two miles you pass a modest residential area before you come to Bronson Canyon, a large undeveloped tract that looks like the Old West, where hundreds of B westerns were shot. We went there to make one shot of Sonny riding across a hilltop on a beat-up old sway-backed horse for our western parody. I told Bob Wyckoff I wanted a silhouette, and we should shoot at the end of the day, not before 6:00 p.m. This was literally one shot with a single camera. To my surprise the crew was called to the location at noon, making it impossible to do any other studio work that day. When I arrived at the location, I saw a bank of twelve enormous theatrical lights called "brutes" pointed at the hilltop. There was a crew of at least sixty people gathered around the catering truck. I went to Wyckoff, who, with

his electricians, was carefully adjusting every light as though he was lighting the Parthenon.

I said, "Bob, what the hell are all these lights? I told you I wanted a silhouette."

"Yeah, I know," he answered grumpily, staring at his shoes. "I got to use these guys, Bill. I'll give you a silhouette, I'll expose for it, but I have to use all this equipment."

Salven explained that it was a case of "back scratching." The cameraman who employed the most crew members got the best crews. Bob was feathering his nest at great expense to management. This shot was one of our most expensive days—massive trucks, gigantic lights, an enormous crew—and lasted less than ten seconds on screen.

Bob was a competent DP; I would describe how I wanted each shot to look, and he would invariably overlight it. He was a by-the-book guy, with no imagination. I was the youngest guy on the set, and the least experienced. I had gotten to this place too soon, but I learned that before you could accomplish anything creatively, you had to be able to manage a crew, win their respect, get everyone on the same page, and most important, vet the crew thoroughly before hiring them.

When it came to the end of our twenty-day shoot at Paramount, we had forty-five minutes of usable film and a lot left to shoot, including three more songs. Steve Broidy was apoplectic. Sonny was philosophic; he and I were like brothers, and could laugh at our problems.

Out of adversity I came up with a backup plan. I would bring Bill Butler, my cameraman from Chicago, to Los Angeles, pick up a small nonunion crew, and go to various locations without permits to complete the shoot for very little added expense—less than $100,000. When I presented my plan to Steve, he was almost

incoherent; what the hell was I thinking? But he thought the film we shot had promise. He decided to take a chance and let me finish the film "under the radar."

Butler came to Los Angeles, and we put him up at the Sunset Marquis. I screened the footage we had for him and introduced him to Sonny and Cher. Then Sonny, Dave Salven, Butler, and I worked out a plan to shoot roughly half the film guerrilla-style. We drove around the city from Malibu to downtown L.A., shooting what were essentially music videos, way before their time. It was good to work with Bill again, and we accomplished more in a day than in three with a full union crew.

One Saturday morning, we all piled into a station wagon. Our small crew and equipment followed in another wagon. I drove the lead car, and we pulled up to the Paramount Pictures main gate. There was one guard on duty. I rolled down my window and said, "Sonny and Cher . . . ," pointing to them, and the guard of course recognized them. He knew we had offices on the lot and had filmed there, but he didn't realize that we'd shut down the week before. He never questioned why we were driving onto the lot unannounced and with another vehicle behind us. "We're just gonna make some publicity shots," I explained. He smiled, nodded, and waved us through. Just beyond the main gate was a permanent Western street used regularly for the hit television series *Bonanza*.

Sonny got into his cowboy costume, and we filmed him on the *Bonanza* street in a parody of Gary Cooper in *High Noon*. We filmed for about an hour, then shot additional footage around the lot with both Sonny and Cher. Everything was done with a hand-held Aeroflex camera operated by Butler. When we finished, we drove to the main gate, thanked the guard, and laughed all the way to the next location.

We filmed Sonny on his motorcycle on the San Diego Freeway at night, also without a permit. We filmed around the new Music Center still under construction in downtown Los Angeles, in the Malibu hills, and on Sunset Strip. The city was ours, and the plan was to shoot quickly, get in and out before passersby or police officers knew what was happening. In less than two weeks we had an additional forty-five minutes. I felt good about the film. I began to think it might work.

In the course of his career as a songwriter, singer, and producer, Sonny (with Cher) sold over eighty million records and had many top-ten singles. Though he could neither read nor write a note of music, when he heard a melody in his head he would call his arranger, Harold Battiste Jr., to come over. Sonny would *hum* the parts to him—melodies, counterpoint, rhythm. Harold would transcribe Sonny's humming into notes on paper, laying out lead lines for the various sections. Sonny would say, "I need eight strings, two percussion, a piano, two trumpets, bass . . ." Harold would book the musicians, known as the "the Wrecking Crew," which often included Carole Kaye, David Bromberg, Dr. John (Mac Rebennack), Glen Campbell, and others who later became successful solo artists. Sonny would arrive at Gold Star Studios, and if there were any changes, he would hum them to Battiste, who would revise the music sheets. Then Sonny and Harold would go into the control room with recording engineer Stan Ross. When Stan had preset his sound levels, Sonny would address the musicians over a speaker from the control room. There was no conductor. "Okay, guys, you ready?" There were nods and waves, then Sonny would say, "One, two three—hit it!" Initially it was all cacophony, then he would "sculpt" the sound: "Trumpets, play softer; guitars, take a break before the violins come in; drums,

do it like this: 'kachung kachung kachuka-kachung,' okay?" Battiste would quickly rewrite the various sections, and they'd start again. Sonny would tell Stan, "I want to hear more violins, less brass, more echo on everything." Stan would readjust the levels, and Sonny would continue to "sculpt" the background track until he was ready to "lay one down." It would sometimes take three days before he was satisfied.

The background track seldom hinted at the melody or the lyrics. When Sonny was satisfied with the orchestral mix and the musicians left, he would sit at a table in the studio with a brown paper bag that once held someone's lunch, or any odd scrap of paper. He'd borrow a pencil from Stan or Harold and write lyrics that seemed "dictated" to him. This took about an hour. He'd make a few changes, then call Cher at home to tell her he would be sending a car for her. When she arrived, Sonny would show her the lyrics and sing them for her. She'd start to sing, and Sonny would direct her, "add this word, emphasize that." Cher always said that as a singer she was imitating Sonny, and Sonny told me he used to imitate Frankie Laine. When Cher felt comfortable, they'd go into a sound booth and, wearing headphones through which they could hear the music track, sing together into a single microphone. Sonny didn't do more than two or three takes, and they were usually finished in about an hour. I remember hearing all the songs from *Good Times* this way, and later "Bang Bang," "Laugh at Me," "The Beat Goes On," and other hits. The process was amazing—a man trusting his instincts and believing in himself, open to inspiration. Stravinsky described the circumstances under which he wrote *The Rite of Spring*: "I am the vessel through which *The Rite of Spring* passed." Sonny was no Stravinsky, but Stravinsky never sold eighty million records.

In May 1967, a week before the movie opened, there was a

"world premiere" in Austin, Texas. We flew down on a private jet provided by Columbia Pictures, filled with what Alan Greenspan later called "irrational exuberance." There was a parade from our hotel to the governor's mansion, where Governor John Connelly was to award Sonny and Cher "the keys to the state." We rode in open cars to the domed capitol building, Sonny and Cher in the lead car. We quickly got a sense of the fate that awaited our film. Along the entire parade route, about three miles, were no more than a couple hundred people, waving at us with scant enthusiasm. There were a few photographers along the way, and some weren't even sure who the celebrities were.

The theater, a large old movie palace, was less than half filled. There was a Sonny and Cher lookalike contest, sponsored by the film's local distributor, in which about a dozen couples dressed like Sonny and Cher were paraded on and off stage to the boos or cheers of the audience. The prize for the winning couple was a weekend at Sonny and Cher's house with the dynamic duo themselves. At the screening, the audience was restless. There were no laughs, and the response when it was over was listless. On the plane ride home, we told ourselves it went pretty well, and what do a bunch of hicks from Austin know anyway?

In Chicago, I took my dear mother, who was in good health and high spirits, still working as a nurse, to the premiere at the Chicago Theater. Of course she loved it and was proud of me, and I promised to bring her to Los Angeles as soon as I could rent a house. I introduced her to Sonny and Cher, one of the highlights of her life, and proof that her faith in me was justified.

The film tanked. Ironically, the very thing it was about—selling out—is what we did, while convincing ourselves we were doing it on our terms. Only Cher seemed to get what was happening. She continued to do everything asked of her, while never fully commit-

ting to the fiasco that was our film. She wanted to make a movie, but not this one.

I've made better films than *Good Times*, but I've never had so much fun. As Sonny and Cher dropped in popularity, my star remarkably continued to rise. The film got good reviews from leading critics, and I was getting more offers. I continued to see Sonny and Cher, DiCarlo and Kresky.

Every Saturday night we had a poker game at Sonny's house. One night we were sitting around the kitchen table, playing cards. The doorbell rang at about two in the morning. Joe got up and motioned everyone to be quiet. He pulled a .45 automatic from a holster concealed by his jacket, and cautiously went to the front door. He was away for two minutes when we heard him yell, "Get the fuck out o' here!" followed by the front door slamming and the sound of a car pulling away. Joe returned to the kitchen, holstering his gun, red-faced and angry.

"What the hell was that?" Sonny asked.

"Two assholes came up here in a taxi, said they won some fuckin' lookalike contest at the premiere in Austin."

Everyone laughed, and we continued our poker game. It was the final nail in the coffin of *Good Times*.

In September 1966 Fantozzi said Blake Edwards wanted to meet me. Blake was one of the hottest writer-producer-directors, and one of the most talented men in Hollywood. He had made *Days of Wine and Roses, The Pink Panther, A Shot in the Dark, Breakfast at Tiffany's, The Great Race,* and other important films. He had a television series on the air about a private detective entitled *Peter Gunn,* starring Craig Stevens and featuring a great thumping bass score by Henry Mancini that became a foundation of rock and roll. Stevens's character, the epitome of cool, was modeled on

Cary Grant. He always dressed impeccably and never got his hair mussed. His girlfriend Edie, a nightclub singer played by Lola Albright, was a beautiful West Coast blonde.

I met Blake for breakfast in his spacious bungalow on the Paramount lot. Blake had a permanent entourage that included his uncle Owen Crump, his associate producer, as well as his set designer and decorator and a corps of assistants. Blake was a karate black belt, wiry, sandy-haired, muscular, wearing tinted glasses that shielded his eyes. He seemed troubled, and I wondered what personal demons afflicted a man who was so successful, but I admired his work and would have been intimidated had he not put me immediately at ease. He was flattering about *Good Times* and wondered if I had ever seen *Peter Gunn*. I told him it was my favorite series, which was true. I asked if he was planning to bring it back, and he said, "Maybe, but I want to do it first as a feature film, and I was thinking, because I have a lot on my plate, you might be the guy to direct it, with me producing."

I was exhilarated and humbled. I didn't know what to say, except "it would be an honor to work with you."

"I want to get going on it, but I have two problems—you have a little time?"

"Sure," I said.

"You know the character Edie?"

"Of course, Lola Albright."

"Well—that's one problem. I want to use Lola, but Bluhdorn thinks she's too old." Bluhdorn was Charlie Bluhdorn, an Austrian billionaire who, with a little capital and a shrewd business sense, cobbled together a bunch of small companies to form one of the biggest of the 1960s conglomerates, the Gulf and Western Corporation. He had recently acquired Paramount Pictures. Charlie loved movies and made it clear he would be a hands-on owner.

He told Blake he wanted to show him a screen test that he, Bluh-
dorn, had commisioned of an unknown actress to play Edie in
the movie version of *Peter Gunn*. The test was directed by Otto
Preminger, a fellow Austrian, as a favor to Bluhdorn. Blake asked
me to see the test with him. Delighted. We walked to the editorial
building to Screening Room 8, an antiquated chamber with no air,
furnished with forty old red velvet seats. A slate appeared on the
screen identifying the test and its director, then an attractive blond
woman appeared, wearing a tight blouse, tight pants—and with a
thick German accent. The test was embarrassing; at one point Blake
shouted, "Oh, my God!"

He asked me to accompany him to the office of the outgoing
head of the studio, Howard Koch, a warm, likable man who was
respected everywhere in Hollywood. President of the Motion Pic-
ture Academy at that time, he had produced films before and af-
ter he became a studio head. Howard was sympathetic to Blake's
concerns: "This woman can't act. She has a German accent. Edie
has to be an all-American girl. I can't understand a word she's
saying!"

"Bluhdorn won't green-light the film unless she's in it," Howard
reported sadly.

"You gotta be kidding." Blake was pissed off now. "He must be
fucking her."

Howard smiled. "Welcome to Hollywood, baby."

Back in Blake's office, I joined him in lamenting what we had
just seen. He was now storming around the room in front of his
staff. "Fuck Bluhdorn! I'll take the picture to Warner Bros.! I own
Peter Gunn, and I'm not gonna let a Nazi play Edie."

Stories about the casting couch are legendary in Hollywood,
and early in my career I discovered that sex between producers
and actors was common, but I knew of no one who got a *leading*

role in a studio movie because of sexual favors. Stories about Marilyn Monroe early in her career have been widely reported, but she earned her way to stardom after a long apprenticeship.

At my next breakfast with Blake, I reminded him that he told me he had *two* problems. What was the other one? I asked.

"The script," he said. "I'd like to get your input."

This was the first time anyone had actually given me a script that was going to be produced. Blake had evidently won his battle with Bluhdorn, because the Austrian woman was not going to play Edie. I brought the script back to my kitchenette at the Sunset Marquis and began to read *Gunn*, by Blake Edwards. With each page my depression increased. The story was thin and predictable, the characters wooden. It had "bomb" written all over it, and after *Good Times* I didn't think I could survive two in a row.

Monday morning I went to see Blake, and my breakfast tray was set up across from his.

"So what do you think?" he asked.

I chose my words carefully, but I had to say what I felt and accept the consequences. "Blake, I think the script is a piece of shit."

He looked up in shock, his English muffin poised in midair. "What?" He set the muffin down and looked at me directly, not so much mad as confused. "What did you just say?" A bitter smile crossed his lips.

"I don't like it at all. It's like you took two old TV scripts and put them together. There's nothing new here, this is *Peter Gunn* light. Your worst enemy wouldn't write you a script this bad."

His uncle Owen, who was standing in the back of the room near the door, and who I had come to like, coughed slightly. There was another person sitting in a dark corner of the office. He didn't say anything, nor did Blake introduce us.

Blake stood. "Why don't you tell us what you really think?"

"I'm sorry, Blake," I said. "I want to work with you, but not on this. I'd need to start from scratch——"

"From scratch?" he bellowed. "What the hell do you know? You're a punk kid with no credits, and you're telling me 'from scratch'?"

We shook hands, and I left. There's honesty and there's self-destruction, but I couldn't continue making films I didn't want to see, even though my agents at the Morris office were now cautioning me, "You're only a film director if you're making films." But I recalled Lastfogel's advice when we first met: "Never make a picture you don't believe in." I left Blake's office with mixed feelings and disappointment as I walked toward the Paramount parking lot. The lot was actually in an enormous tank, and the cars were cleared out whenever they needed to fill the tank with water and put a ship's model on it, or have people swimming in it. It's where DeMille filmed the parting of the Red Sea.

Before I reached the lot, I heard someone call my name. I turned and saw a tall, dark-skinned, dark-haired man coming toward me: "I'm Bill Blatty." We shook hands. "We haven't met, but I was in Blake's office just now." The man in the corner who said nothing. "I wrote the script."

"Really? I didn't see your name on it."

He laughed. "Blake does that sometimes."

I was embarrassed. "Look, I'm sorry if——"

"It's okay." He smiled. "I know the script doesn't work. We all do . . . everybody in Blake's company." I was confused. "He's got a lot of things going on right now. *Peter Gunn* is old news to him; he just wants to get it made." It wasn't the image I had of Blake Edwards, but Blatty went on, "You're the only one who's told him the truth, and I admire that, because I know it cost you the job."

I thanked him, and we went our separate ways.

* * *

During the time I worked at Wolper, and for several years afterward, Dave used to invite me to screenings of new films at his house. One night I met Bud Yorkin, who, with his partner Norman Lear, produced and directed some of television's most successful variety programs: *The Colgate Comedy Hour* with Dean Martin and Jerry Lewis, *The George Gobel Show*, specials with Fred Astaire and Perry Como. Later they conquered the sitcom world with *All in the Family, Maude, The Jeffersons, Sanford and Son*, and others. They started to produce and direct films together, the first one being Neil Simon's *Come Blow Your Horn* with Frank Sinatra; then *Never Too Late*; followed by *Divorce American Style* with Dick Van Dyke. Bud was one of the best comedy-variety directors in TV, and he became one of my biggest supporters. We liked each other instantly, and we've been close friends for forty-five years.

In 1967, at the newly formed United Artists, David Picker, the studio head, made a two-picture deal with Bud and Norman. The first was to be a zany comedy called *Start the Revolution Without Me*, starring Gene Wilder and Donald Sutherland; the second was *The Night They Raided Minsky's*. Bud wanted to go to France to direct *Start the Revolution*, and he proposed that I direct *Minsky's* in New York, with Norman producing. It was an extraordinary opportunity for me—a major studio musical comedy about the last days of burlesque. Bud and Norman were two of the hottest guys around, and United Artists was the distributor of the James Bond films, the Beatles' movies, *Tom Jones, In the Heat of the Night*, and Billy Wilder's *The Apartment*. They were regularly winning Academy Awards for best picture. Forget for the moment that I knew nothing about burlesque in the 1920s, or how

to direct a musical comedy. Forget that I had only the commercial failure of *Good Times*. Bud believed in me and convinced David Picker that with Norman producing, I'd bring something original and contemporary to an older subject. I was offered $100,000, which was huge.

Had I paid attention to Lastfogel's original advice, I would have passed on *Minsky's* despite my friendship with Bud. I don't know whether it was his belief in me or my own hubris and desire to become a studio director that made me accept. Certainly the hundred grand played a part, but it wasn't a good enough reason. The truth is I hadn't yet learned how to control the machine. If it had been a subject close to my heart, a smaller, more personal film, it might have been possible. But I had chutzpah, the goodwill of others, and the recklessness of youth.

Norman didn't write the script for *Minsky's*—it was written first by Sidney Michaels, then Arnold Schulman. When I read the script, I thought it was thin, superficial, not funny, but because it was Bud's project, I didn't want to dismiss it with extreme prejudice as I had *Gunn*. Instead, I told Norman the things that bothered me, and he listened patiently and tried to address them. Bud left for France, and Norman made a few cosmetic changes to the *Minsky's* script, but the voices in my conscious mind told me not to do this picture. We started casting before I could even think about switching gears.

Tony Curtis, the first actor we went to, agreed to do it. He was at the peak of his popularity and good looks, and I met with him to discuss the script at his home on Carolwood Drive, a beautiful mansion that had once been the Keck estate, one of the most impressive homes in the Holmby Hills area. Tony was bright, alert, self-taught; a street-smart kid from the Bronx. He had the largest collection of Joseph Cornell boxes, and he used to make his

own boxed collages, which seemed to my untrained eye every bit as good as Cornell's. Tony was fun to be around.

He told me he wanted to do *Minsky's*, but he felt the script was underwritten. "You gotta tell Norman to put some meat on the bones," he said.

Three weeks before Norman and I were to leave for New York to prepare the film, Tony dropped out. He had an offer to play the Boston Strangler, which he felt would bring him more respect than another light comedy. He was right.

Norman contacted the talent agencies, and in a short period we had interest from two of the brightest stars on Broadway, Alan Alda, who was appearing in *The Apple Tree*, directed by Mike Nichols; and Joel Grey, who was giving his unforgettable performance as the emcee in *Cabaret*. Alda and Grey agreed to do the film and were being fitted for costumes by our designer, Anna Hill-Johnstone. It was a real coup to land these guys. They were steeped in theatrical tradition, skilled at musical comedy. I looked forward to working with them; this euphoria lasted less than two weeks, when we got word that neither Alda nor Grey could get out of their plays. They had long-term contracts, and it looked like both shows were going to run for years. When we cast them, we were assured by their agents that they could give a month's notice to their producers, but this was bullshit.

Jason Robards had worked with Bud and Norman in *Divorce American Style*, and he became our lead, the burlesque straight man Raymond Paine. The young dancer whose story is at the center of the film, an Amish girl, was to be played by an up-and-coming Swedish starlet named Britt Ekland, recently married to Peter Sellers. For the third lead, Chick, the comic, we cast Norman Wisdom, a British star of television, small films, and the music hall, who was little known outside of England and was ending

a run as the lead in a musical comedy on Broadway called *Walking Happy*.

A character called Professor Spats, an old burlesque comic, was to act as a kind of tour guide to burlesque and to the Lower East Side in the 1920s, much as Maurice Chevalier did in *Gigi*. For this role, God blessed us with the great Bert Lahr. One of the rare pleasures of *Minsky's* was working with Bert. He had wonderful stories that spanned his more than fifty years in every medium of show business. He had been in the first American production of Samuel Beckett's *Waiting for Godot*, and played the entire run without knowing what he was saying or "what the hell the play was about." The rest of the cast, all assembled by Lear, was excellent: Forrest Tucker, Joseph Wiseman, Harry Andrews, Denholm Elliott, and Elliott Gould in his second movie, as Billy Minsky, heir to Minsky's Burlesque. Charles Strouse and Lee Adams, who had written *Bye Bye Birdie* and later *It's a Bird . . . It's a Plane . . . It's Superman*, wrote original musical numbers for the film.

Seeing it again recently, I found it charming, innocent, and touching in many ways, but Robards and Ekland are mismatched and have no chemistry as lovers. Wisdom and the other actors are convincing, but Bert Lahr hardly registers. Before we finished even a third of the work he was to do, he fell ill, had to leave the production, and died within the week. His absence left a hole in the film's emotional center.

The zeitgeist was changing, and a nostalgic piece of fluff about a bygone era was out of step with the rise of independent cinema.

Painful to remember, *Minsky's* was a disaster that set me back in every possible way. There were many problems with it, but the biggest was my own ineptitude. I had researched the period but I didn't know how to convey the right tone. I was in over my head. The crew sensed this and knew I was in over my head; from first

assistant director Burtt Harris, to choreographer Danny Daniels, to director of photography Andy Laszlo. A film crew can be like the sailors on the USS *Caine*, on the verge of mutiny. If they sense weakness in the captain, plenty of junior officers are ready to step in and take over. Part of it is self-preservation. Key crew are in demand because of previous success, not failure. If a film goes down, it can take all hands with it.

The burlesque sketches had to play broadly, each joke punched up to the max. I tried to make them "real," more contemporary. Huge mistake. How do you make this exchange sound real: "Who is that lady I saw you with last night?" "That was no lady, that was my wife!" Each time I set up a shot or talked to an actor about a scene, I was filled with uncertainty.

Norman Lear was aware of the situation and one day asked me if I would let Danny Daniels stage the burlesque routines.

I was relieved: "Fine. But if I were you, I'd fire me."

"Is that what *you* want?" he asked.

"We're not on the same page, and it's your show. . . . I know I'm no help to the actors either—"

"Why not?"

"Because the characters are stereotypes. Every line in the script is a setup or a punch line." Clearly Norman knew more about what we were doing than I did, as witness his subsequent career.

Fantozzi and I spoke by phone later that evening.

"I know you got problems," he said, concerned. "David Picker doesn't like the dailies and wants to get rid of you—"

"What about Lear?" I asked.

"Lear hasn't agreed to that." A note of urgency came into Fantozzi's voice. "Don't quit," he insisted. "These studio guys talk to each other every day. If you quit or get fired, it'll be professional suicide. If you pull this picture off, you can wind up with a mul-

tipicture deal at UA." I didn't quit. I brought what I could to the picture, but I was the director in name only.

Years later I was surprised to hear Norman Lear's version of our sole collaboration. To my shock, he has no memory of the vitriol that marked our work together. He doesn't remember my telling him I hated the script. "There were many scenes I thought you got exactly right," Norman said. And though he loves the film to this day, his anger at me kicked in after I turned in the rough cut and left the very next day for London to prepare to direct *The Birthday Party*. While there, I gave an interview to a late-night talk show saying I thought *Minsky's* was a terrible movie and that people needn't bother to see it. My anger at myself caused me to confess my own incompetence in a misguided attempt to expiate my guilt. This little caper was thoughtless and self-destructive.

Two days after that interview, I got a call in London from Fantozzi in Los Angeles: "David Picker called me, and he wants to kill you." There was anger in his voice. "What you said was inflammatory; Yorkin and Lear are furious, and I don't know how to solve it." They thought I was trying to sabotage the film before it came out, and Picker told Tony I'd never work at UA again. Tony worked to build my career from nothing, and now he was telling me he didn't think he could save it. Hearing his words was like receiving a death sentence.

The final cut of *Minsky's* was Norman's, with assistance from our title designer, Pablo Ferro. Much as I'd like to absolve myself of blame for the film, I see my handiwork all over it, especially in the documentary approach to many of the scenes.

As a complete change of pace, I began to prepare Pinter's *The Birthday Party* in London. It was the first film I really wanted to make, understood, and felt passionate about, but I embarked on it with a

heavy heart, my career in shambles. I was thirty-one years old and had burned a lot of bridges in Hollywood. London in the 1960s was a perfect antidote: the Beatles, the Stones, the angry young men of British theater and film, Chelsea, Carnaby Street, a culture more diverse than any I had ever experienced. And from a creative standpoint, the year I spent with Pinter on the screen adaptation of his first play was an awakening and a life-changing lesson in the art of creating serious, suspenseful drama.

4

SILENCES

Tony Fantozzi arranged a meeting with Edgar Scherick, former president of the ABC television network, who had recently gotten financing from the network to start his own film company, Palomar Pictures. Palomar was trying to make low-budget films with young directors who wouldn't cost or spend a lot of money. *The Birthday Party* was alone on my wish list.

The power and impact of Harold Pinter's play and its potential as a film became my obsession. Fantozzi contacted the William Morris office in London, where Pinter lived, to find out if the rights were available. In a matter of days I was on the phone, hearing Pinter's mellifluous baritone. He had no idea who I was or why I'd want to make a film of *The Birthday Party* or if I had the wherewithal to do so, but his interest was piqued. Scherick was willing to gamble on a difficult piece of material. Since he couldn't compete with the major studios for stars or material, he had to sail against the wind. Given Pinter's recent worldwide fame, Scherick thought *The Birthday Party*, filmed in London on one set for a budget of $1 million or less, would bring prestige to his company. Fantozzi put him in touch with Harold's agent, and they worked out a tentative agreement. But Harold would only finalize it after we met and found common ground.

I checked into an inexpensive hotel in Bayswater and took a

short cab ride to Number 7 Hanover Terrace, one in a long crescent of white six-story stucco houses designed by John Nash in the early nineteenth century in Regent's Park.

Harold came to the door. I was warned that he tended to be intimidating, but I found him engaging, accessible, courteous, and modest. He was taller and more muscular than I had expected, with black curly hair and dark, penetrating eyes.

His expression morphed from a wicked smile to a feigned wince of pain to a penetrating stare. While listening, he would cock his head to one side, occasionally smoking a cigarette. He was dressed in black trousers and a black silk shirt. He was five years older than me and had achieved international success. His house was elegantly furnished, filled with good paintings, books, and fresh flowers, so unlike the drab interiors of his plays. Harold's top-floor study was crammed with photographs of famous cricketers. Cricket was his passion. He had created a comfort zone from which he seldom ventured.

His wife, Vivien Merchant, a distinguished stage and film actress, was usually at home when I visited. She and Harold had been married for eleven years. They met while both were struggling young actors and he was working under the stage name David Baron. She always called him "David" around me, and when I asked why, he explained that his own name sounded too Jewish, given the undercurrent of anti-Semitism in the British theater during the 1950s. I personally thought "David Baron" sounded as Jewish as Harold Pinter. They had a son, Daniel, then eight, a quiet, gifted child who frequently sought his father's advice while doing his homework. Vivien would have a pot of tea for us before we started work each day. They seemed a perfect family, though I sensed an underlying tension, which I attributed to my presence as an outsider, vying for Harold's attention. Vivien was Harold's

muse, having appeared in a number of his plays and television shows as well as the film *Accident*. The year we met she had a great success in *Alfie*, for which she received an Academy Award nomination, and she was appearing on stage as Lady Macbeth in an unforgettable performance with Paul Scofield. She was quiet, sultry, mysterious.

I must have seemed as strange to Harold as his plays did to many theatergoers. I was young but with no interesting film credits, no theater experience, no impressive education, and I was American to boot. I had little to recommend me except Fantozzi's assurances to Harold's agent that I was a brilliant director. I had two mediocre films, one of which was yet to be released, and an episode of *The Alfred Hitchcock Hour*. Harold's fame was spreading. He had shifted the paradigm of what was possible in serious drama, blurred the line between truth and falsehood in his characters. "Pinteresque" had entered the language to mean something challenging or difficult to decipher. I had the financial backing to make the film but Harold didn't need money. He had become the most fascinating and celebrated playwright in the English language. *The Birthday Party, The Caretaker,* and *The Homecoming*—all of his plays were being performed around the world, and he had written screenplays for the critically acclaimed films *Accident, The Servant, The Pumpkin Eater,* and *The Quiller Memorandum*.

I was clearly way over my head, but *The Birthday Party* had a profound effect on me from the first time I saw it in San Francisco in 1962.

The play is set in a shabby boardinghouse in a small town near Brighton. Meg, a slovenly middle-aged woman, runs the place with the help of her husband Petey, who has a part-time job setting

up deck chairs on the beachfront. They have only one boarder, Stanley, a broken man who appears to have lost interest in life. A neighbor, Lulu, a would-be sexpot, occasionally comes to visit but can make no connection with Stanley, while Meg treats him with compassion and something like love. She claims that today is his birthday and wants to give him a party, but he denies that it is and doesn't want a celebration. Into this seemingly banal environment two men unexpectedly appear, Goldberg and McCann, looking for a room. They are well dressed and slightly sinister, and we wonder why they would come to such a run-down hovel. The mood shifts abruptly with their arrival, and the tension mounts.

With these six characters Pinter creates an atmosphere of suspense and violence. Goldberg and McCann seem to have come to this out-of-the-way boardinghouse expressly to find Stanley, interrogate and persecute him. But why? What has he done? Or is it a case of mistaken identity? Stanley is afraid. Something in his past has come back to haunt him. The party takes place against his wishes and becomes his worst nightmare. The next morning he's led away by Goldberg and McCann. Petey is powerless to help, and Meg only remembers how much fun she had the night before.

The play can be viewed as a metaphor for the police state, society's need to make the individual conform, the need of the strong to dominate the weak, the futility of resistance, the tyranny of religious persecution, and our inability to empathize with the suffering of others. It's all of this and more, but it's best enjoyed for its surface pleasures, a disturbing comedy-drama about irrational fear and paranoia. It's not that Pinter's characters can't communicate—they communicate only too well, even though they use language to conceal their true feelings.

When *The Birthday Party* was first produced in London in 1957, audiences and critics found it obscure, absurd, and bewil-

dering. The Lord Chamberlain, in effect the censor of plays and movies, dismissed the play as "insane and pointless." Pinter was a struggling actor and only twenty-eight at the time. *The Birthday Party* was his second play, and it was a flop. He was broke, newly married, with a baby to support, and living in a basement slum.

The play closed after eight days, and only six people came to watch the final performance. This would have ended Pinter's career as a playwright, but a miracle occurred. Britain's most influential and respected theater critic, Harold Hobson, saw the play at the end of its run and wrote a review for the Sunday *Times* of London, *after* the play had closed: "I am willing to risk whatever reputation I have as a judge of plays by saying that Mr. Pinter, on the evidence of this work, possesses the most original, disturbing and arresting talent in theatrical London. . . . [He] has gotten hold of a primary fact of existence. We live on the verge of disaster." Hobson's review rescued the play and Pinter's reputation.

Pinter and I met each day for a week at Hanover Terrace to discuss how to proceed. His responses to my ideas were precise and unequivocal. I had no desire to clarify what he had purposely kept ambiguous. I relished the pauses and the silences that conveyed dramatic effect as much as the language.

I asked Harold how he came to write the play, and he told me that when he was working as an actor in the provinces, he once stayed in a boardinghouse run by a flirtatious, unkempt landlady. There was another boarder, an unemployed man who claimed to have played the piano professionally. These characters stayed with him and became Meg and Stanley. He started to write about them when unexpectedly "two strangers knocked at the door." He didn't know who they were or why they came to this place, but he continued writing to find out. He wrote with no particular theme, no outline, and no explanation for the actions of his characters.

Stanley was destined to be a victim, but Harold had no idea why. Everything he knew about the characters was in the play. He was influenced by Hemingway's short story *The Killers*, in which two men come to a small town looking for a man they don't know to kill him "for somebody else," to "oblige a friend."

Though our screenplay would be faithful to the play, Harold wanted three months to adapt it. He was inundated with scripts for radio, television, and movies, along with directing plays of his own and others', and acting in all media.

The cast he wanted was the one we eventually secured. Robert Shaw, who had starred in *The Caretaker* on stage and in the film, would play Stanley. Considered one of England's best actors, Shaw was the villain in the James Bond film *From Russia with Love* and played Henry VIII in *A Man for All Seasons*. Patrick Magee worked with Pinter when they were both actors at the Royal Shakespeare Company. He was considered the ideal actor for Samuel Beckett's plays, and Harold admired and respected him. He would have no one else play McCann. Dandy Nichols was a household name in Britain for the BBC series *Till Death Us Do Part*, which later became the hit American television show *All in the Family*. She played Meg. For Goldberg, Harold wanted Sydney Tafler. Tafler, a competent character actor, little known outside of England, gave one of the best performances ever seen in a Pinter film. We held auditions for the other two roles, casting Moultrie Kelsall as Petey and Helen Fraser as Lulu. Both had appeared only in small parts on British television, but Harold had an unerring sense of casting. Left on my own, I wouldn't have known to cast any of them, but to this day I don't think our cast could have been improved. Scherick decided to bring on two producers he knew and trusted, Max Rosenberg and Milton Subotsky, former New Yorkers

who had produced several low-budget horror films in England. Happy to be associated with *The Birthday Party*, they hired a first-rate British crew. Denys Coop, the director of photography, had been the camera operator on *The Third Man* and is generally credited with that film's signature Dutch (tilted) angles; as a director of photography he lit *This Sporting Life*, *King and Country*, and *Billy Liar*, all classics. The production designer was Ted Marshall, who designed *Tom Jones*, *The Charge of the Light Brigade*, and *The Pumpkin Eater*. The set was to be detailed and realistic, not abstract or symbolic. Ted, Harold, and I went to a seaside town called Worthing near Brighton and chose the exterior of a boardinghouse. We filmed exteriors there, but everything else was done on a set at Shepperton Studios.

I loved the cast and crew and looked forward to working with them each day. It was the opposite of *Minsky's*. We rehearsed for ten days, and Harold would give me notes. I encouraged him to talk to the cast as well, and he advised them to say the lines and not look for allegory. "There are no motivations for the behavior of these people that I'm aware of, and no way to determine whether they're speaking truth or telling lies. Just find the emphasis in the lines and the *rhythm* of the scene," he would suggest. One day after a rehearsal in which the actors seemed to go slightly off script, Harold said, "If you want to do my lines, they have to be word for word. If *one* word is left out of a sentence or added, the rhythm of the scene falls apart." One of the actors asked him how to deal with the pauses. "The pauses must absolutely be *filled*," was his answer. "Though your character may not be speaking, there is always an *unspoken* language going on."

One evening over drinks, Magee, who according to Harold knew more about *The Birthday Party* than *he* did, told me that two lines he remembered from the original production were cut out of

the torrent of intimidating non sequiturs with which Goldberg and McCann confront Stanley. They were:

GOLDBERG: Who hammered the nails?
MCCANN: Who drove in the screws?

These were references to the crucifixion, and in the days when the Lord Chamberlain was the absolute authority over the British stage and screen, there could be no reference to the crown or to religion. Magee remembered these lines from the original production, and that evening I called Harold and asked him about them. His response was preceded by:

SILENCE. THEN,

HAROLD: What lines?
ME: The two lines you cut for the Lord Chamberlain.

PAUSE

HAROLD: I don't remember cutting *any* lines.
ME: Oh.

LONG PAUSE.

HAROLD: I have my original typescript of the play upstairs in my study. If you hang on a minute, I'll go up and have a look.

I held the phone to my ear for a long time while Harold walked up five flights. Finally he picked up the extension in his office.

HAROLD: I have my typed copy from 1957. I've opened it
to the interrogation scene, and I don't see those lines.

PAUSE.

ME: Damn . . .

PAUSE.

HAROLD: You like those lines?
ME: I love them.
HAROLD: Well, go ahead and put them in.
ME: Are you serious?

He was. Pinter, known to be insistent about the precise use of
his language, was telling me to put in two lines he claimed he
hadn't written.

Where did they come from? I have no idea.

Robert Shaw was a brilliant actor, known for heroic roles. His
own nature was as far from Stanley's as possible, but he had a
deep understanding of Pinter's work, and they were close friends.
Offscreen he was something of a jock, and one of the most com-
petitive men I've ever known. He claimed he was a good enough
soccer player to have played for England. On our soundstage at
Shepperton Studios I had a hoop set up, and I used to shoot bas-
kets between camera setups. One day Shaw came over to watch
me and said, "Why are you playing a girl's game?" I tossed him
the ball and said, "Try it." He took shots from various distances
and couldn't hit the backboard or the rim. He angrily kicked the
ball across the soundstage. Every morning I would come to the
set an hour earlier than the crew to prepare the day's work with

Denys Coop. One day I heard the sound of a bouncing basket-ball. Bob Shaw. He'd come in early to practice so he could play me one-on-one. After a couple of weeks we started to play, and I would inevitably beat him, fueling his frustration. He asked if I played Ping-Pong. I was a Boys' Club champ at the age of twelve. The next day a Ping-Pong table arrived on the set. Bob fancied himself an exceptional Ping-Pong player, and we'd play a dozen or more games a day. He won occasionally, but not enough to satisfy his appetite for victory.

Like the rest of the cast, he was always prepared and enthusiastic. We shot the film in sequence from beginning to end, and I planned each setup in advance so the film was made quickly and efficiently. Pinter was often on the set and looked at the dailies. His comments were always encouraging, and he enjoyed the humor and subtleties of his own text.

My staging was designed to keep the actors moving as much as possible and let the camera follow them. If a scene called for them to remain static, I would slowly and imperceptibly move the camera closer or pull away. I tried to keep the camera invisible, but there were times when I couldn't resist and opted for radical angles. During the blind man's buff game in the party scene when the lights go out, I cut to afterimages that occur when a room is suddenly plunged from light to darkness. When the lights were out, I went from color to black-and-white. As the blindfolded characters moved about the room, I had a camera attached to a gyroscopic mount on their backs pointing over their shoulders on a wide-angle lens as they shuffled around in darkness.

The cast and crew became family to me. I was confident the film would cut smoothly; the performances were excellent, and I was thrilled to have directed actors of this caliber in material this good. Harold wanted to show it to Joe Losey, the director with

whom he had made two brilliant films, *Accident* and *The Servant*. The day after Losey saw the film, Harold and I met at Hanover Terrace.

"Joe thought the film was . . . okay," he began. "He had a few quibbles but only one . . . well, rather urgent request." I asked him what that was.

"There's a shot into a mirror when Meg crosses from the kitchen to an easy chair to resume knitting a sweater for Stanley . . ."

I remembered the shot and thought it was efficient camera logic.

"It's the only mirror shot in the film, and Joe feels it sort of . . . 'borrows his style.'"

Losey was known for mirror shots, and used several in each of his films.

"Joe asked me," Harold went on, "if you'd consider cutting it." I thought this was out of line, but I was more disturbed that Harold would ask this of me. I told him I had no cover angles that brought Meg across the room. I also said it was wrong for Losey to suggest I recut my picture for some misperceived "homage" to him. Up until this moment I had treated Harold with deference and respect, but I couldn't satisfy this request. I wasn't about to destroy the film's continuity to mollify Losey's ego. It was the only tense exchange I had with Pinter in a year of working with him.

In the end I made the film I wanted to make. Palomar released it without fanfare in a handful of theaters, and it didn't find an audience. I had hoped the film would bring redemption for *Good Times* and *Minsky's*. That wasn't to be. But *The Birthday Party* is a film of which I'm proud. The cast played it to perfection. With the exception of an occasional over-the-top directorial flourish, I think I captured Pinter's world. The time I spent with him and the many conversations we had were the most valuable and instructive of my career.

Iulcrious and moving. Those who saw it, and there were over a
thousand performances in its first incarnation, would never forget

* * *

My future prospects in Hollywood were uncertain, but I brought
my mother from Chicago to live with me in a rented house that
was owned by Mickey Rooney on a quiet street in Beverly Hills.
The house was small but charming, old brick and wood paneling,
and my mother had never lived this well. She made friends in the
neighborhood and continued nursing part-time, as she still had the
energy and the will. I would drive her to Cedars-Sinai Hospital,
where she worked, or I'd pick her up. She could not have been
prouder of my accomplishments and that I had achieved enough to
take care of her in this way. She was a calming influence, and it was
because of her love and belief in me that I didn't lead a wasted life.
I met regularly with Tony Fantozzi, but I had no offers. Thirty-
two years old and washed up. But Fantozzi and the Morris office
continued to believe in me.

Not many people saw *Minsky's* or *The Birthday Party*, but two
who did were Mart Crowley and Dominick Dunne. They were
about to coproduce the film version of Crowley's provocative play
The Boys in the Band for a new production company, Cinema Cen-
ter Films, owned by CBS Television. Mart and Nick originally
wanted the play's director, Robert Moore, to do the film, but Gor-
don Stulberg, head of Cinema Center, was reluctant to go with
someone who'd never been behind a camera. They invited me to
come to New York and see the play—but not before Mart called
Harold Pinter, who gave me a glowing recommendation. They'd
heard about my problems on *Minsky's*, so I wasn't a clear choice.
But I had done three films, and wouldn't ask for a lot of money;
possibly they thought the play was director-proof.

It's difficult now to imagine the impact the play had in 1967.
It was the first to deal openly with a gay lifestyle, and it was both

hilarious and moving. Those who saw it, and there were over a thousand performances in its first incarnation, would never forget it. The important playwrights at the time, Tennessee Williams and Edward Albee, both gay, never dealt openly with gay subject matter. When Mart finished his play, he took it to Albee's producing partner, Richard Barr. Barr liked it, but Albee didn't. He told Mart the play was terrible and that it would set back gay liberation and bring more hatred and violence to gay people.

Mart was devastated to have his work dismissed by his idol, but Richard Barr produced it in a small off-Broadway theater. Albee thought it a mistake but agreed only on the condition that the play never be moved to a Broadway theater, which it easily could have after its first two weeks. It was an immediate sensation and the hottest ticket in New York, but to this day it has not been produced on Broadway.

Each of the characters portrayed a different aspect of gay life, from the closeted to the campy, from the faithful to the promiscuous, from a male hooker to a schoolteacher, all guests at a birthday party. (Yes, another one.) The one "straight" character is an uninvited and uncomfortable guest at the party. When I read Mart's screenplay, I was excited about its potential as a film. It was written out of passion, anger, and experience. Two weeks went by during which other directors were interviewed; then I got a call from Mart to return to New York. After several drinks, we had a long talk. Mart told me about his life, being sexually abused as a child; growing up in Vicksburg, Mississippi, in a conservative Catholic family with two alcoholic parents; attending Catholic University in Washington, D.C.; working in Hollywood as Natalie Wood's assistant. She gave him the time and the encouragement to write *The Boys in the Band*, his first play.

He told me about his struggle to come to terms with being gay and how he had written the play in a state of depression, basing the

characters on himself and people he knew. He was overwhelmed by the play's success, having known mostly failure in his creative endeavors up to then. Mart insisted we use the play's original cast, to which I agreed. They had come to embody their roles and worked well as an ensemble. We also agreed we'd have to achieve a realistic tone, and it would of course be an entirely new staging. He had ideas for opening up the film with a visual prologue in a handful of New York locations, but it needed the claustrophobia of a one-room set to retain its impact. The trick was to keep the film claustrophobic but cinematic.

We never spoke about my own sexual preferences. But he knew I'd acquired a reputation for being difficult, and it was important to him that we communicate and work closely together. He was not going to be a passive screenwriter.

Nick Dunne suggested we meet with Adam Holender, a young director of photography who had recently come from Poland and studied at the famous film school in Łódź. Within three months after Adam shot a couple of documentaries and a few commercials, John Schlesinger hired him as Director of Photography on one of the best films of the late 1960s, *Midnight Cowboy*. The film was beautifully photographed and became the only X-rated film ever to win an Academy Award. Adam used handheld cameras, long lenses, and natural light to capture the world of a male hustler on Forty-Second Street. Nick set up a call for me with Schlesinger to talk about Holender.

"He can be difficult," John said.

"How so?"

"I think you should meet him and see how *you* feel about him."

We went on a location scout to the terrace of an Upper East Side apartment that belonged to the actress Tammy Grimes. She agreed to let us use it as the exterior of the apartment where Mi-

chael (played by Kenneth Nelson), the host of the party, lived. The interior would be built as a duplex on a soundstage with walls that could be moved for angle changes and lights. Mart, Nick, and I loved the terrace. Adam didn't. Not enough room for lights, he said. I told him we'd only be using it for two brief scenes in broad daylight and could go with natural light. He looked at me as though I was demented.

We went to a garage nearby, where Michael's friend Donald (played by Frederick Coombs) would stop to gas up and check out the handsome garage attendant. The garage was large and brightly lit with fluorescents. Holender thought it was impractical and would be better set on a stage.

We went to Doubleday's bookshop on Fifth Avenue, where we had three setups at most. Holender said there was too much daylight streaming through the windows.

The last location scout was to a hotel room in the Sherry-Netherland, overlooking Central Park. I needed two shots there; a silhouette toward the window of Alan, Michael's college buddy (Peter White), sitting on the edge of the bed tearfully talking on the phone; and a reverse close-up of Alan, to see his tears. Holender shook his head. Wouldn't work. Why not?

"Where am I going to put my lights?"

That was it. We hired Arthur Ornitz, who'd photographed *A Thousand Clowns*, *Requiem for a Heavyweight*, and later *Serpico* and *Death Wish*. Art was fast, and he shot all the locations with no fuss. He made it possible to shoot a wide array of angles and imperceptibly change moods as "day" evolved into "night."

I rehearsed for two weeks and encouraged the cast to rediscover their characters. At first they resisted; they'd done the play for a year. Words they had learned long ago I told them to forget, rethink, and rediscover. They found subtleties in their performances

that weren't possible onstage, and I was able to emphasize relation-
ships with the placement of the camera. *The Birthday Party* had
sharpened my sense of how to capture a scene without allowing the
camera to be intrusive.

Mart wrote a scene that was offstage in the play. Hank, the
schoolteacher (Larry Luckinbill), and Larry, his lover (played by
Keith Prentice), leave the party when it swerves drunkenly out of
control and go up to a guest bedroom, where we see them kiss
passionately. It would undoubtedly have been the first time such a
scene was portrayed in a mainstream film. Luckinbill and Prentice
reluctantly agreed to do it; then, after objections from their agents,
refused. Such a scene would ruin their careers, they were told. Mart
and I talked to them for weeks as their anxieties grew, along with
their resolve *not* to do the scene. As we were about to reach the end
of the schedule, they realized the scene's importance and its value
as a statement about their characters' commitment. They were put-
ting their trust in me to shoot the scene sensitively, and I tried to
approach it as just another shot. Much later in the cutting room,
we felt we *didn't* need it, that it would only sensationalize the mo-
ment. In retrospect, I think we should have kept it.

During preproduction, Mart and I would socialize together. He
took me to the Pines section of Fire Island, a Long Island beach
community that was an all-gay enclave, and I was able to meet the
prototypes of his characters. There, everyone was without inhibi-
tion, and parties went on all weekend, day and night. As a straight
man in a gay world, I got a sense of what it was like to be an out-
sider.

I approached Mart's screenplay as a love story, with humor and
pathos. I saw his characters as people, not types, and I tried to re-
flect their pain at having to hide their true natures from the preju-
dices of family, friends, and colleagues. *The Boys in the Band* is a

compassionate, insightful work, and I tried to understate its deeper social implications.

The film was widely publicized, but the reviews were mixed and the box office disappointing. A great many people loved it, and to this day I hear from people on whom it had a profoundly liberating effect. Today, it's generally regarded as a landmark film. I say this in all modesty because I believe its power lies in Mart's script and the brilliant performances by the entire cast, which went virtually unrecognized at the time.

Three members of the cast—Larry Luckinbill, Peter White, and Reuben Greene—survive. I can still watch the film with pleasure, but at the time it was another box-office failure. Four in a row.

PART II

THE '70S

5

POPEYE AND CLOUDY

In 1913 Cecil B. DeMille was looking for a place to shoot a western, *The Squaw Man*. He was living in New York City, so he boarded a train heading west and got off at Flagstaff, Arizona. Surprisingly, the weather was bad there. He sent a telegram to his partners back east, Jesse Lasky and Sam Goldfish (later Goldwyn): "Flagstaff no good. Want authority to rent barn for $75 a month in place called Hollywood." The yellow barn was at Selma and Vine Streets and was still being used for horses. *The Squaw Man* was released a year later, and is one of the first full-length films made in Hollywood. It was certainly the first most successful. In 1926 the barn was moved to the United Studios on Marathon and Van Ness Streets, which soon became the home of Paramount Pictures.

If the weather in Flagstaff hadn't been bad, if the barn in Hollywood hadn't been for rent, if *The Squaw Man* had not been a hit, there wouldn't have been a Hollywood. In later years the old weather-beaten barn in which *The Squaw Man* was photographed was converted into a gymnasium on the Paramount lot, equipped with weights, mats, rings, chin-up bars, and, most important: the best steam room in Los Angeles. From the time of its reincarnation as the Paramount gym, the man who ran it was a short, bald, good-natured fellow named Orlando Perry, or Perry Orlando—not even he was sure which was correct. I got to know Perry and

his gym when I was directing *Good Times* on the Paramount lot. I remained a regular for sixteen years, until the old barn was designated a landmark, moved off the lot, and relocated opposite the Hollywood Bowl, where it is now the Hollywood Heritage Museum.

Perry's massages were wonderful, and his clients included Clark Gable, Steve McQueen, William Holden, and many other male stars in Hollywood. Until the mid-1970s women weren't allowed. You could lift weights, take a steam, then fall into a deep sleep on Perry's old massage table. Before you knew it, you'd wake up refreshed and invigorated. Perry's friend Johnny Indrisano, a former light-heavyweight boxing contender, used to hang around the gym and tell great boxing stories. Johnny had over sixty professional fights, and when his boxing days were over, he went on to stage the fight scenes for various films. He did the great bar fight in *Shane* and the fight on the ranch between Alan Ladd and Van Heflin. He also staged the fight in the diner that ends *Giant*. Johnny taught me how to use the punching bags, and I would spar with him two or three times a week for years.

I first met Phil D'Antoni in the steam room at Paramount. Phil had recently produced his first feature film, *Bullitt*, after packaging and producing television specials. He had a quick smile and a Bronx accent; he was even-tempered, but he never let you forget he was Sicilian. The Morris office represented us both, and Fantozzi thought we would hit it off. He sent him my documentaries, and Phil had seen my four features. He thought I had promise, and felt we could work together. We had similar interests and sensibilities. We liked and disliked the same movies. I thought *Bullitt* was one of the best films of my generation.

One afternoon Phil told me about a book he optioned by Robin Moore, author of *The Green Berets*. The book was nonfiction, and

told the story of the largest heroin bust in the United States. It was called *The French Connection*, and it focused on the exploits of two colorful New York City detectives: Eddie Egan and Sonny Grosso. I couldn't get through it; it seemed dry and procedural on the page, and it wasn't until I flew to New York with Phil and met Egan and Grosso that I was able to see a movie in their story.

Egan and Grosso were fascinating. They told me about the off-hand manner in which they stumbled onto the case while off duty in a nightclub. They were opposite sides of the same coin. Egan was a big guy with curly red hair under a porkpie hat that he sometimes wore backward. His nickname was "Popeye." Grosso was dark, wiry, and serious, a detail man. He was called "Cloudy." Egan was intentionally funny. Grosso had a sense of humor as well, and they both had total recall about their most famous case. They took full credit for the case, even though there were dozens of New York City detectives and members of the Federal Bureau of Narcotics (now defunct) involved.

When I met them, they were no longer partners. Eddie was in the Eighty-First Precinct in Bedford-Stuyvesant, Sonny in the Twenty-Eighth in Harlem; two of the most dangerous precincts in New York. They were admired by other street cops, but were resented by their supervisors and department heads for the publicity they received. They would remain friends for life, though Eddie's ended in 1995 in Ft. Lauderdale, Florida, where he died of cancer. Eddie was loud and boastful, while Sonny was low-key and totally supportive of his partner. To Sonny, Eddie was "The Man, the best street cop ever to put on a badge," but he often had to hold him in check on the job. Eddie used to play games with a suspect, often asking unanswerable questions to throw the suspect off balance: "Did you ever pick your feet in Poughkeepsie?" While Sonny would confront the suspect with the facts: "We saw you sell that

guy a nickel bag." Together they led the narcotics bureau in collars, but often "the perp" would be back on the street that afternoon or the next day. And the beat went on.

American law enforcement had declared a "war on drugs," but from what I saw in the early 1970s, at the side of two of New York City's finest, the war was already lost. Dealers were flourishing across the country, and generations of young people were stoned. There are many origin stories of the French Connection case. The "official" one was Robin Moore's, largely provided by Egan and Grosso, and is the one on which we based the film. This version has been disputed over the years and revised by Moore himself in a later book called *Mafia Wife*. Of course, the unvarnished truth is far more complex, involving a number of countries and a ten-month time frame. Our film was never intended to be a documentary but an impression of that period. But to this day, Sonny says the film is ninety percent accurate. Here's Egan and Grosso's version:

On a late October night in 1961, after two straight days on duty, they clocked out of the First Precinct in Lower Manhattan, headquarters of the Narcotics Bureau. Eddie ("Popeye") coerced Sonny ("Cloudy") to join him for a nightcap at the Copacabana in midtown, where Eddie was a regular and dated the hat-check girl. The headliner that night was Joe E. Lewis. There, they observed a party of known criminals and "junk connections" in the company of wives and girlfriends at a corner table, where a young guy they couldn't identify was picking up tabs and "spreading cash around like the Russians were in Jersey." On a "hunch," Eddie persuaded Sonny to "give the big spender a tail, just for fun." The big spender and the blonde in the car with him turned out to be Pasquale "Patsy" Fuca and his wife, Barbara. Patsy was a small-time hood with Mafia connections who had been arrested for armed robbery in an attempt to hold up Tiffany's on Fifth Avenue. He was also

suspected of a contract killing, but the investigating officers didn't have enough to indict him. Barbara, nineteen years old, had been arrested for shoplifting and drew a suspended sentence. Patsy's uncle was Angelo Tuminaro, a Mafia don who had murdered his way to the top and was suspected of controlling the heroin traffic from Europe and the Middle East into the United States.

Patsy and Barbara left the Copa at 2:00 a.m., got into a late-model Olds. The two detectives followed at a safe distance in an unmarked maroon Corvair. Patsy made several stops along the way, in and around Little Italy. He was met by various men who appeared briefly out of the shadows. They would talk, Patsy would hand them each a small package, then drive to another location. Same routine until 5:00 a.m. Sunday morning, when the Olds stopped under the Brooklyn-Queens Expressway. Patsy and Barbara got out, locked the car, and walked to a 1947 Dodge parked nearby, then took off again. This time they drove only a few blocks into Brooklyn, where they parked in front of a small candy store/ luncheonette called Barbara's, went inside, turned on the lights, and started to compile sections of the Sunday-morning papers. At 7:00 a.m., the luncheonette opened for business.

What was going on? A goombah, throwing money around like it was paper in an expensive nightclub, who turns out to be the owner of a luncheonette in Brooklyn? After surveilling Patsy for four months on their own time, Egan and Grosso got permission to wiretap his home and store. Known criminal "characters" were turning up, and packages were being delivered by UPS. At first their target was Patsy's uncle, Angie Tuminaro, whose whereabouts were unknown. Ed Carey, chief of the City Narcotics Bureau, informed George Gaffney, his counterpart at the Federal Bureau of Narcotics, about the surveillance, and Gaffney assigned Special Agent Frank Waters to accompany Egan and Grosso. From the

outset there was friction between the feds and the city cops—personal as well as turf. The tail on Patsy and Barbara continued for two more months as the net began to widen.

Late in 1961 a visitor arrived in New York from France on an ocean liner, the USS *United States*. He was Jacques Angelvin, a popular French television star, host of a daily program called *Paris-Club*. In Paris, Angelvin had purchased a 1960 Invicta. He brought the Buick to New York at the request of a friend and benefactor, François Scaglia, a Corsican, aged thirty-four. Scaglia was known in France as "The Executioner," having organized several contract killings. He was also big in the Marseille heroin trade, and when he heard his friend Angelvin was going to New York, he asked him for a favor: take the Buick. Angelvin later denied knowledge of the cargo embedded in the rocker panels of the Buick: 112 pounds of uncut heroin, street value in America, $32 million.

While these plans were under way, Sonny and Eddie heard from informants that there was a heroin drought, but a big shipment was arriving from overseas. The shipment was accompanied to Montreal and eventually New York by Scaglia and his partner, a Frenchman named Jean Jehan, boss of the world's largest heroin network and known as the "Giant." The tail on Patsy Fuca eventually led Egan, Grosso, and Waters to Jehan (Frog One), Scaglia (Frog Two), and Angie Tuminaro. In all, over three hundred state, federal, and international detectives were involved, as well as other criminal conspirators, but, taking Moore's lead, we focused on Egan and Grosso, Jehan and Scaglia, with Waters reduced to a minor role.

The case followed a circuitous path: the impromptu nightcap at the Copa, the unexpected sighting of Patsy Fuca, the hunch that led to his surveillance, the arrests of the minor players, and the escape from justice of all the big shots.

Here was a canvas broader than anything I'd ever been involved with, from Marseille to Brooklyn and all over New York City. The underlying theme was the thin line between the policeman and the criminal: Jehan, the dapper gourmet with a daughter in a convent and a loving young wife; Scaglia, the ice man, who could kill without emotion; Patsy, the low-life dealer, with dreams of a score that would put him in the big time; Sonny, a confirmed bachelor, subservient to his partner, whom he idolized, but lethal in the street; Eddie, the ladies' man, a braggart and a tough guy, obsessive, never without his porkpie hat or a policeman's .38 Special strapped to his ankle. Popeye and Cloudy. Though they were assigned to different precincts when we met, they arranged to work together in their off time, so I could experience their dynamic firsthand.

For weeks, without permission from their chiefs, Eddie and Sonny took me on the job, to the Twenty-Eighth or Eighty-First Precinct. They took me to bars and "shooting galleries" in Harlem and Bedford-Stuyvesant, where they were certain to find users and dealers. One night we broke into an apartment in Harlem, where a family of twelve, from young children to grandmothers, was lying around a living room floor with needles in their arms. "My God," I said to Sonny. "This is ten minutes from where I live." At the time, I was renting an apartment at Eighty-Sixth Street and Park Avenue on the east side of Manhattan. Similar scenes were happening across the city and the country. Every day, we'd go to African American bars, where Popeye would feel along the ledge under the bar, grabbing magnets filled with drugs that he tossed into a cocktail shaker, mixing them with stale beer. Cloudy would grab the perps and "lock" them in a phone booth near the entrance to the bar. I saw them do this at least a dozen times before I re-created it on film. As we entered the bars, Eddie would take out his .38 special and hand it to me. "Cover the back," he'd say under his breath.

I'd be standing there with a lethal weapon, which I'd never fired, hoping the perps wouldn't bolt for the back door. Eddie and Sonny needed to know that if necessary, I had their backs. They'd take control of at least fifty of the baddest dudes I'd ever seen. Everyone had a record; everyone was "wrong," as Eddie would say.

I went on stakeouts and busts until I knew what they said and did in every situation. While on the job or on a lunch break, they'd reveal more details of the French Connection case and the personalities of the other players.

D'Antoni and I had meetings at the major studios. We had no script, but we could talk through details of the story, and we added a chase scene. There was no interest.

National General was a small company, a kind of hobby for its three owners, who were millionaire investors and sportsmen in their day jobs—operating partner Irv Levin, who owned the Boston Celtics, and later the San Diego Clippers basketball teams; Sam Shulman, who owned the Seattle Supersonics; and Eugene Klein, who owned the San Diego Chargers football team. They liked the idea of *The French Connection*, though there was no script and no star attached, and they trusted D'Antoni because of *Bullitt*. I, on the other hand, was a question mark—"Too soft, too artsy-fartsy," opined their head of production, Dan Polier. But D'Antoni believed in me and held out, even when they threatened to pull the plug if I was the director. Phil convinced National General to let us commission a screenplay.

Alex Jacobs had written *Point Blank*, a vengeance film that was becoming a cult favorite. We gave him Robin Moore's book and our take on the story, emphasizing the chemistry between the two detectives. Alex worked for several weeks and produced a script that neither Phil nor I liked. We turned it in to National General and got the bad news from Polier: they were putting the project in

"turnaround." There are pictures that go into turnaround for ten or more years before they get made, or they never get made at all. "Turnaround" meant that if another studio decided to make the picture, they'd have to reimburse National General for the money they had invested in the script.

We schlepped *The French Connection* around for two years without a script we believed in. We took it to every studio, and were rejected by all. We pitched it to the head of MGM, a distinguished, white-haired gentleman named Bob O'Brien. He was cordial, but had no interest in what we were talking about. After the meeting, which we knew would be another pass, Phil and I left the MGM lot and stopped at a soft drink stand across the street. It was a hot summer afternoon, and Phil had to sit down. He had been smoking three packs a day and was short of breath. No studio believed I had the skills to deliver an action picture, especially one without a great script. I looked at Phil and felt his pain. I told him I would walk away and he could find another director who was acceptable to the studios. He insisted we were partners and would continue to be. We had to believe in ourselves and in the material because we had nothing else to believe in.

Phil and I continued to meet, but less frequently. We were each trying to get something else going. He gave me the galleys of a novel he had just read called *Shaft*, about a black private detective, that had a feel for the mean streets of New York. It was a first novel by a foreign news editor on the *New York Times*, Ernest Tidyman, who wanted to write screenplays and quickly accepted our offer to do a draft of *The French Connection* for five thousand dollars. We gave him the previous drafts, along with Robin Moore's book, and met with him to lay out a structure and describe our experiences with Egan and Grosso. He produced a workmanlike script in less than a month. The Morris office sent the new draft to the studios,

and again they all passed. Two years had gone by since I finished *Boys in the Band*, and I hadn't shot a frame of film.

I was asleep one winter morning in New York when the phone rang at about 4:00 a.m. Ed Gross, my business manager. He told me my mother had died that day. She was walking on Walden Drive in Beverly Hills and dropped dead of a heart attack. I asked Ed to arrange to have her buried, no funeral service. I stayed awake crying that morning, remembering all my mother meant to me and how much I loved and valued her. She had sacrificed her life for me. She was in her early sixties when she died. Whatever goodness resides in me comes from her; and whenever I've strayed, I know that somewhere, she disapproves but loves me nonetheless.

That morning, it was snowing in New York. I booked a flight to Los Angeles and got to the airport early. Standing at a fence, watching the planes land and take off, was strangely comforting, but I was filled with anxiety. When I got to the Beverly Hills house, I arranged with Ed to donate my mother's clothes to the poor and packed my own things to put into storage. I walked around the little house for the last time and tried not to lose myself in memories.

One day, after I had signed up for unemployment benefits for the second time in my life, Larry Auerbach called. Larry was D'Antoni's agent at the Morris office and never gave up on *The French Connection* or us, though it seemed a lost cause. Larry said that Dick Zanuck, head of Twentieth Century-Fox, who'd previously passed on the film, wanted to meet with us. Phil and I went to Zanuck's enormous office on the Fox lot, which once belonged to his father, Darryl, one of the storied Hollywood producers and studio heads. "Fellas," Dick said, "I've got a million and a half dol-

lars hidden away in my budget for the rest of the year. I'm on my way out. They're gonna fire me, but I've got a hunch about that *French Connection* script. Can you guys make it for a million and a half dollars?"

Our own budget estimate was double that. Phil silenced me with a kick to the leg. He said, "Sure. I don't see why not."

"How soon can you start?"

Phil jumped in again, "Right away."

"Who do you see in it?" Zanuck asked.

"What about Paul Newman?" Phil said.

Zanuck laughed. "You'll never get Newman. He makes half a million a picture, which is a third of your budget. Who else?"

"I'll tell you who I think would be great," I offered. "Jackie Gleason, he's a black Irishman, like Eddie Egan, a great actor—"

Dick cut me off. "I'll never do another picture with Gleason as long as I'm at this studio." He was angry. "Ever see *Gigot*? It was the worst disaster in the history of Fox . . . a silent movie about a clown. Can you believe it? And I let him make it." He shook his head. "No Jackie Gleason—no way!"

I then suggested a new actor that Phil and I had briefly discussed: Peter Boyle, who'd just appeared as a murderous bigot in a successful independent film, his first, called *Joe*. Silence. Zanuck's expression didn't change, but he slowly nodded. "That's not a bad idea."

We met with Boyle. He was tall, heavy, broad-shouldered, with piercing black eyes and a bald head with a fringe. He had a threatening appearance, though he was actually kind and funny. He was caught up in sudden success, playing an unlikable character, but his performance was powerful, original, and real. We told him our story and gave him the Tidyman script. Two days later he called: "I appreciate your interest in me, but I don't want to do characters

like this anymore. I'd like to do a romantic comedy next." He must have looked in the mirror and seen Cary Grant. Years later Mel Brooks saw Young Frankenstein.

But Zanuck was completely on board; we had a "go" picture after two years of no interest. "Listen," he said, "you don't need a star for this. Stop thinking about stars—you just need a good actor. It's better for the picture if he's unknown and can inhabit the character. You don't need a name! I don't want names—and you can't afford them." No studio head would say something like this today.

"Would you go with a guy who's never acted before, but is totally right for this character?" I asked him.

"Who?"

"Have you ever heard of a newspaper columnist in New York, Jimmy Breslin?"

Zanuck smiled. "You think he can act?"

"I don't know, but he'd understand what we're trying to do, and he's a fascinating guy."

Dick thought it an interesting idea. "Why don't you go back to New York and test him?"

We set up offices at the Fox Building on the West Side of Manhattan. Phil brought Egan and Grosso on as consultants. We started to put together a crew, and one of the first people we hired was a "casting director" recommended by Phil. Bob Weiner was not exactly a casting director. He was a theater and film reviewer for the *Village Voice*, opinionated to the point of abrasiveness but aware of every new actor on the scene. One of the earliest reviewers to praise Whoopi Goldberg, he saved every *Playbill* from every play he'd ever seen. He lived in a dark one-room apartment on West Fifty-Seventh Street that was stocked floor to ceiling with old newspapers and magazines, his research materials. In a short time,

he brought me little-known actors Tony Lo Bianco, Roy Scheider, and Alan Weeks.

Scheider was an underemployed actor, mostly in off-Broadway plays. He had a small role in the film *Klute*, which hadn't come out yet. The second he walked into my office, I knew he was perfect for Grosso; he was dark, lean, good-looking, and smart. "What are you doing now, Roy?" I asked.

"I'm in an off-Broadway play, *The Balcony*, by Jean Genet."

"What do you play?"

"I play a cigar-smoking nun."

"Seriously?" He nodded. "Great," I said. "You're hired."

He thought I was putting him on.

"I said you're hired. You're gonna play Sonny Grosso."

"Don't you want me to read?"

I saw no point in reading actors. If I wasn't already familiar with their work, I went by looks, demeanor, intelligence, and my gut feeling. In the past, I'd read actors and found they could often "read" but couldn't *play* the character, or the other way around. Some actors don't come alive until the cameras start rolling and are terrible at table readings or auditions. I've always felt the audition process puts too much pressure on an actor, and I've learned to trust my instincts.

That's what a director has to do on every aspect of a film—the script, the cast, the crew, the locations; you have to listen to that inner voice that says "go" or "no." We hired Scheider, and I immediately put him together with Grosso to get some street cred.

I met Jimmy Breslin at Gallagher's Steak House on the West Side near the theater district. The large wood-paneled room was smoky and crowded, with a circular bar and drawings of celebrities on the walls. Gallagher's was one of Jimmy's many watering holes. He was a quintessential New York character and a terrific writer.

We had a lot to drink that night, and we were joined by one of Jimmy's closest friends from Queens, Fat Thomas, who was soon to become an important part of the *French Connection* team. Fat had been arrested for bookmaking fifty-two times, with only one conviction. He was also the agent for New York's premier arsonist, who Jimmy used to call "Marvin the Torch" in his column. Jimmy wrote about the exploits of Fat (real name Thomas Rand) and "Marvin" (real name still a secret) in his thrice-weekly column in the old *New York Herald Tribune*. Fat and I became good friends. He was a jovial street guy, 425 pounds, about six-three, prematurely gray, and nearsighted. Nobody knew New York better than Fat, and he had connections in every corner of the city. It took a lot of Jack Daniel's for me to convince Jimmy to test for the lead in the movie. "Whaddaya crazy?" he said. "I ain't no actor, and I don't like cops. You put me in that movie as a cop, they'll kill both of us."

"Jimmy, I think you can do this."

His ego was always near the surface. "I ain't gonna give up my day job," he insisted.

"You won't have to," I said. "You can write your columns from the set and on your days off."

"You're nuts! Can't you find some actor?"

Fat Thomas chimed in, possibly because he sensed something in it for himself. "Go ahead, Bres, whaddaya got to lose?"

Breslin slapped him on the back. "Ya fat fuck, yuz." We laughed. I didn't know if Breslin could pull it off, but he had the look, the personality, and an innate understanding of the cop mentality. He also had the Irish gift of gab. Given that, and our friendship, I thought I could get it out of him even though he had no technique. I worked with him for a week, improvising scenes between him, Scheider, and Alan Weeks. On Monday Jimmy was brilliant, inventing the dialogue of a cop harassing a suspect, some of which

made it into the final film. On Tuesday he was confused and frustrated, forgetting what he had done the day before. On Wednesday he showed up late, having had a few drinks. During a lunch break at a diner in East Harlem, Egan and Grosso stopped by to check out what was to them a disturbing rumor: that we were rehearsing Breslin, the "cop hater," to play Egan. On Thursday Breslin didn't show up and didn't call. I heard many years later that he'd been at a dinner party the night before, seated next to the legendary agent Sue Mengers. Sue wanted the part for one of her clients and condemned Jimmy for taking a job that should have gone to a real actor. When Jimmy arrived on Friday, I knew I had to cut him loose, but he began the conversation, asking me, "Is there a car chase in this film?" I nodded.

"I gotta tell ya," Breslin continued, "I promised my mother on her deathbed I would never drive a car. I don't know how to drive." With relief, I told him he was fired. We called Zanuck to tell him that Breslin was out. He said we'd better find somebody fast; we had to start the picture in three weeks: "It's getting bad out here for me. I'll be gone before you guys finish the picture."

Sue Mengers suggested Gene Hackman. Neither Phil nor I was excited, but she lobbied hard, and Zanuck suggested we meet with him. We were running out of options. I didn't remember anything Gene had done on film except *Bonnie and Clyde*, in which he played Clyde Barrow's brother. More recently he had been in a tearjerker called *I Never Sang for My Father* with Melvyn Douglas. Phil and I met him for lunch in the Oak Room at the Plaza Hotel on a Friday. He seemed humorless. I almost fell asleep at the lunch. When it was mercifully over, I told Phil there was no way this guy could play Popeye. Phil didn't disagree, but he said, "What the hell are we gonna do?" We had to give Zanuck a yes or no by Monday. On the plus side, Hackman was available, and his fee was only $25,000.

On Saturday night Egan and Grosso invited Phil and me to the Policeman's Ball, a fund-raiser at the midtown Sheraton Hotel. There was an underlying tension between us when I told Phil I couldn't see doing the film with Hackman.

He said, "If we don't, we're dead, Billy. There's nobody else." As the speeches wore on, I kept glancing at Phil, the man who defended me when the executives said no way. It was the lady or the tiger: no picture, or go with an actor we didn't believe in.

On impulse I took him to a quiet hallway outside the ballroom, and I hugged him; we were both in tears. "Phil, I love you. I won't let you down. You stood up for me for two years. If you want to go with Hackman, let's go." He hugged me, and his look said, Thanks.

While this was going on, a reunion was taking place at the Polo Lounge in the Beverly Hills Hotel. Robin Moore, author of *The French Connection*, was having a drink with his old friend G. David Schine. Schine asked Moore if he had any books he could option, as he wanted to become a producer. Moore told him that D'Antoni's option on *The French Connection* had just run out and hadn't been renewed. Schine made an agreement on the spot to option it, and they signed a napkin at the Polo Lounge. Now we had a "go picture" at Fox, but Phil no longer owned the rights!

Larry Auerbach gave us the news that Monday. Phil was furious; he called Zanuck and said he would sue Schine, Moore, and everybody involved. Zanuck was calm. "Look, Phil," he said. "If you sue them, you may or may not win the case. In five years! Meanwhile, you won't have a picture."

"What should I do?" Phil asked him.

"Make a deal with Schine," Zanuck said.

G. David Schine seemed a gentleman. He admitted he knew nothing about the film business. He cut a deal with Phil for

$10,000, and 5 percent of the net receipts, plus executive producer credit. He agreed never to come on the set without Phil's permission and never to try and contact me. I met Schine and his wife only once. Ultimately he made about $2 million for his napkin.

We gave Egan and Grosso roles in the film, Egan playing his old boss Ed Carey, chief of the Narcotics Bureau. Grosso played another of the detectives. The police garage mechanic, Irv Abrahams, who took apart and put back the Buick containing the smuggled heroin, was cast as himself, and we shot the scene at the Police Department garage. We cast off-duty cops to play cops *and* bad guys. But we still had to cast "Charnier," the Corsican (Jean Jehan) who masterminded the scheme, and his henchman (François Scaglia), whom we called Nicoli. Weiner and I developed a kind of shorthand. We both had an encyclopedic knowledge of foreign films. I would refer to a recent movie: "Bob, remember the guy in *Z* who kills the Yves Montand character?" Weiner identified him immediately. "His name is Marcel Bozzuffi. He's a French character actor." We cast him without a meeting.

For the role of Charnier, I said, "Bob, let's get that guy who played the gangster in Buñuel's *Belle de Jour*, the dark guy with the five o'clock shadow."

"You mean Pierre Clémenti?" Weiner asked.

"No, he's the weird-looking guy who played his partner. He's great, but not right for this."

A short time later Weiner came back to me: "The guy you want is Fernando Rey."

"See if he's available." He was, and we hired him. I drove to JFK Airport to pick him up and take him to his hotel. When I got to JFK, I didn't see the guy I was looking for. I went to the TWA desk, and there was a man I recognized, but he was not the actor I had in

mind. He introduced himself as Fernando Rey. I was shocked. This wasn't the guy from *Belle de Jour*! He was of medium height, with salt-and-pepper hair and a neatly trimmed goatee. He looked like an aristocrat and spoke in a Spanish accent. We got his bags and went to my car. I tried to think of something to say as he looked out the window at the Queens skyline and we headed into Manhattan. "You worked for Buñuel . . . ," I said.

"Oh, many times. I tell you how he discovered me—he was looking for a certain type, and he saw a film with an actor who was recommended to him. Afterward, his producer asked if he liked the actor, and Buñuel said, 'No, but I like the guy who played the corpse.' That was me. I was in two scenes where I was dead in a coffin, but Buñuel liked how I looked, so he hired me.

"Strange, no?"

Strange, yes.

"By the way," he said, "you know I'm Spanish, not French. You have two or three scenes where I must speak French, so if I'm not completely accurate I can dub them later." I tried to smile as I asked him how he liked making *Belle de Jour*. He turned to me in surprise. "I was not in *Belle de Jour*." Of course not. I tried to concentrate on the highway while seething inside.

"This character Charnier," I said. "He's Corsican, he was a longshoreman, so I think you have to look . . . rougher. I mean, your goatee . . ."

"Oh, I could never shave my goatee." He was adamant as he stroked it gently. "You wouldn't want to see my chin, it's red with sores. When do rehearsals begin?"

I dropped him at the Doral, made sure he got to his room, then went to a pay phone in the lobby. D'Antoni and Weiner came on the line. "Bob, you idiot!" I screamed.

"What's wrong?" he asked.

"He's the wrong guy! This is not the guy from *Belle de Jour*!"

"What?" Bob screamed back. "He's Fernando Rey, isn't he?"

"Yeah, and he's been in a few Buñuel films, but he's not the guy we talked about."

"What do you want me to do?" Bob asked nervously.

"I want you to kill yourself, but first find the guy we want and try to get him."

"What do we do with Fernando?" Phil asked.

"Fire him! He hardly speaks French, he's Spanish, and he has this stupid goatee . . . Weiner, what's the name of our movie?"

"*French Connection*," Weiner answered.

"Right, you shmuck! Not *The Spanish Connection*!"

When I got to the office, they had figured out that the guy we wanted was Francisco Rabal. "Fine," I shouted. "Fire Fernando Rey and get *him*!"

"That's a problem," Weiner groaned. "Francisco Rabal is also Spanish. He doesn't speak a word of English, and he's not available." I stared at Weiner in disbelief—I wanted to strangle him. I was convinced the film would be a disaster. Hackman was all wrong for Popeye, and now, God help us, Fernando-fucking-Rey, who looked like a character out of an El Greco painting. I thought the rest of the cast was fine, but the guys who had to carry the film were Popeye and Frog One. Roy Scheider was going to be terrific, as were Bozzuffi and Tony Lo Bianco as Patsy Fuca, but the two leads were not our first, second, third, or fourth choices.

The most important hire a director makes, aside from the cast, is the Director of Photography.

Dick Mingalone was considered one of the best camera *operators* in New York, but he had never *lit* a film. It was a tough seniority system for operators who wanted to become DPs. You started

as a film loader, then general assistant, focus puller, then operator, and finally, if a director hires you, you can become a Director of Photography, whose responsibility is to light the set, determine lens exposure and film speed, and be responsible for the overall "look" of the film, in collaboration with the director. If you're too good a focus puller or operator, it's hard to move up to DP because everyone wants to keep you in those jobs. I asked Mingalone, who was the operator on *Minsky's* and *Boys in the Band*, if he was ready to light a picture. He jumped at the chance and said, "Let me shoot some tests, Billy, and make sure we're on the same page." I told him I didn't need to see tests. I liked him and thought he was ready.

Kenny Utt, our veteran line producer, smiled: "You better look at those tests."

The following week, Mingalone brought in his "test." He, Phil, Bob Weiner, and I watched it in the Fox screening room on West Fifty-Sixth Street. Weiner left before it was over, muttering under his breath. Mingalone had set up a scene with two friends in which one played a cop, the other a suspect who was being shaken down. He shot it at night under a streetlamp with a handheld camera, lighting it with what was called a "sun gun." The sun gun is a handheld quartz halogen light powered by a battery that lasts about twenty minutes. It illuminates anything close to the camera, but the light is flat and uninteresting when pointed directly at a person or an object. You could see it waving around, and though it produced a decent exposure at night without other artificial lighting, it was mostly used to shoot newsreels. This was not what I wanted for *The French Connection*.

Dick DiBona owned General Camera. He rented equipment to most of the productions filming in New York. Dick had a no-bullshit manner; he took problems in stride and always copped to a mistake if it was his fault. I trusted him and sought his advice. He

had a small kitchen at General Camera and liked to cook pasta for his friends and clients.

"I hear you didn't like Mingalone's stuff," he said.

"Who do you suggest, Dick? You know every cameraman in New York."

"Ever hear of Owen Roizman?" I hadn't. "He's a young guy, his father was a cameraman, and *he's* paid his dues. He's shot lots of commercials, and he just did a little independent feature in Puerto Rico that looks good." I wanted a new guy, but I didn't think he'd come from commercials. "I think you should meet him," Dick persisted. "Let me run his feature for you, and I'll make lunch for us here." The pasta was great as usual. The film was lame, but well photographed.

Roizman was thirty-one years old. He could see I wasn't knocked out by the film he showed me, which I don't think was ever released. But I liked him, his youth and enthusiasm.

"Let me tell you how I see *The French Connection*," I said. "Handheld natural light, push the exposures, no big lights at night, no lights at all on the streets during the day, bounce lights off the ceiling on interiors. We're going to shoot practical locations, no sets—police stations, bars, hotel rooms—and the shots have to look like they were 'stolen.' "

"I love it," he said.

"There's going to be a chase scene. I don't have it worked out yet, but it will be through New York traffic. Ever shot a chase before?"

"No," he answered.

"Neither have I."

With the exception of the chase, I knew instinctively how I wanted to shoot the film. I had a sense of the thin line between the policeman and the criminal and how to dramatize it as "induced

documentary." *Good Times* and *Minsky's* were painful learning experiences. I was emotionally attached to *The Birthday Party* and *The Boys in the Band* and loved making them, but they're thought of as "plays on film." *The French Connection* was going to be a *movie* over which I had control, with a strong producer who had my back. We decided to set the story in the present, 1971, instead of ten years before, when the events took place. This was for budget reasons. We didn't want to change the cars in the street, the signage, the clothing, or the hairstyles to reflect 1961.

Every day, Fat Thomas would drive me around lower Manhattan, Queens, Brooklyn, Bedford-Stuyvesant, and Spanish Harlem. I wanted to create my own New York City. In the editing process I would cut from a shot in Queens, let's say, to another in the same sequence in Brooklyn. We went to Welfare Island near the Hellgate Bridge, where we found an abandoned bakery, part of a nineteenth-century mental institution. The building was in such bad shape the city designated it unsafe for filming, but I thought it would be a great location for our final scene. Eventually we got permission, and assumed legal liability for injury. We chose a junkyard on the most dangerous street in Bedford-Stuyvesant for the foot chase that opens the film. In the very next cut the interrogation of the dealer continues in an empty lot between two old apartment buildings in Spanish Harlem.

Eddie and Sonny took me to Roy's Bar in Brooklyn, where they would regularly shake patrons down for drugs. We also got permission to film in the old First Precinct in lower Manhattan, which was closed but had originally been the Narcotics Bureau headquarters. Fat and I drove around Coney Island, where I found a housing project on Stillwell Avenue that resembled a prison. I chose it for Popeye's apartment building.

I had recently seen the French film *Z*, directed by Costa-Gavras.

Set in Greece, it was about the assassination of a much-loved liberal candidate for the presidency, Grigoris Lambrakis, played by Yves Montand. The story focused on the efforts of a young judge, played by Jean-Louis Trintignant, to bring the killers to justice. On the walls and streets of cities across Greece, Lambrakis's partisans had scrawled "Z," which meant "He lives." Costa-Gavras's style was "induced documentary." The handheld cameras could go anywhere; the "fourth wall" was shattered. It was as though you were watching the story unfold rather than seeing something that happened in the past. I had never seen this style applied so effectively.

Owen hired as camera operator a heavyset Cuban refugee named Enrique (Ricky) Bravo whose fun-loving nature belied his seriousness and extraordinary skills. Ricky's thick Spanish accent was hard to understand, but he had photographed the Cuban Revolution at Castro's side, from the Sierra Maestra to the capture of Havana. He became disillusioned with the Castro government and moved to New York, where he quickly became one of the most sought-after camera operators. The documentary style suited him perfectly. We didn't need to set up dolly tracks to move the camera. The grips would simply push Ricky, holding a handheld camera, in a wheelchair. I would talk to Owen about the lighting of a location—say, the First Precinct offices. I would work out the staging, Owen would set his lights, but I didn't let Ricky watch rehearsals. I told him to shoot the scene as though it was happening in real time. Owen lit the interiors with small units set on bars high in the walls, bouncing light onto the ceiling, which would reflect softly on the actors below. Since there were seldom lights on the floor, the camera could go anywhere. Ricky asked me if I was sure I wanted to work this way rather than set up well-framed compositions. I said, "Ricky, did Castro tell you what he was going to do before he did it?"

"No, señor."

Ricky's instinct led to interesting framing. Sometimes if he missed focus on a shot or blew the composition he was seeking, he'd yell "Cut!", turn off the camera, then explain what went wrong. After several such occasions I took him aside. "Ricky, don't ever say cut! I don't care if a light falls into the shot, or you see a microphone, or you lose focus. I want the actors to go through the whole scene, and what you think is imperfection may be exactly what I'm looking for."

We then shot a long sequence with three actors, and it took us an hour to work out so they could improvise rather than "say lines." We did a take, and it seemed believable. I turned to Ricky: "How was it?"

He flipped up the eye patch he wore over his left eye so he would have no distraction looking through the viewfinder. "Completely block," he shouted triumphantly. "Block! I see nobody. Everybody block lens!"

"Why didn't you tell me?" I shouted.

"You tell me never say cut!" The crew and I burst into laughter. After that, if something really looked bad to Ricky, he would whisper to me, and if I felt we were going to lose something important, I'd restage the scene.

In the early '70s we didn't have what is called a "video assist," a TV camera linked to the film camera that can play back a shot on a monitor. Then, you had to rely on what the operator saw through the lens, and if it looked good to him, and you liked the performances, it was a take.

We started filming in late November 1970, during the coldest winter on record in New York. The first scene we shot was the interrogation of the young pusher played by Alan Weeks. I had seen Eddie and Sonny do this scene for real on dozens of occasions. It

reminded me of the surreal interrogation in *The Birthday Party*. Non sequiturs a suspect was unable to process, coupled with specific incriminating questions to which he knew the answers:

EGAN: Did you ever sit down on the edge of the bed, take off your shoes and socks, and put your fingers between your toes?

SUSPECT: Wha—what?

GROSSO: Who's your connection, Willy?

EGAN: You ever been to Poughkeepsie? I want to hear it. Have you ever been to Poughkeepsie?

SUSPECT: No . . . yes . . . yes . . .

GROSSO: Is it Joe the barber, is he your connection?

SUSPECT: I don't know, man . . .

EGAN: Ever pick your feet in Poughkeepsie?

SUSPECT: Yes . . .

This would go on until the suspect finally gave them the answers they knew he had. I taped those interrogations many times and wrote them down. They always took place in an unmarked police car, the suspect in the front seat, squeezed between Egan and Grosso.

On the first day of shooting we had to do thirty-five takes of this scene, which called for Hackman to slap the suspect in the face. He couldn't do it, nor could he get the words or the attitude right. Alan Weeks and Roy Scheider were convincing on every take; Gene was not. I urged him to be more aggressive and to say the words exactly as I had written them. As in a Pinter scene, I saw the words as a kind of blank verse that couldn't be altered without destroying the rhythm of the scene.

Next day we looked at the rushes, all thirty-five takes, a full

day's work, each one more embarrassing than the last. The actors were in the screening room along with Phil, Kenny, and Bob Weiner. This was the scene that defined who these cops were and how they worked a suspect. We all knew the scene didn't play, and everybody left with long faces, saying nothing. That afternoon, Gene called his agent and told her he wanted to quit the picture. When I got home, I tried to think through what had gone wrong. Was it that Hackman couldn't cut it, or was it my fault? Did my staging inhibit him? Were there other ways I might have staged the scene? I was using Eddie and Sonny's actual dialogue, but I was asking the actors to deliver it word for word instead of letting them be spontaneous. This was *not* a scene from a Pinter play. Spontaneity was what I wanted. By having the actors squeezed into a car and holding them to the exact words, I had stifled their performances. Hackman was the focus of the scene and the movie. I couldn't let him quit; the picture would have been shelved and written off. Fox was in worse financial trouble every day. I met with Gene the next morning. I told him truthfully I thought the failure was mine. I would reshoot it and let the actors do it in their own words, get them out of the car and let them move around.

Gene was hard to talk to. When he let his feelings out, he often exploded, then withdrew. He told me he was going to quit.

"I don't think you have faith in me," he said.

Is that the impression I was giving him? It was indeed what I felt. "Gene, I do have faith in you," I lied. "It's probably my own self-doubt." That part was also true.

"I don't think I can do Egan the way you see him," he said.

"You've been with him for a couple of weeks now, you see how he works."

"Yeah, and I don't like it. I think he's a racist, I think he uses his power over people to intimidate them."

"What would *you* do? You see the kind of people he deals with—"

"He goes too far," Gene continued. We got into a heated conversation that cut into the start of the shooting day. Gene talked about himself, how as a boy growing up in Danville, Illinois, he'd hated his father. This led to a reaction against all authority figures and made it tough for him to get along with directors. "I'm not even sure I like being an actor," he confessed. "I never thought of it as a real job." He told me that after he left the Marine Corps and while he was studying with a respected acting teacher, Sandy Meisner, he worked as a doorman at the Essex House Hotel in New York. One day, his former commanding officer got out of a limo with a beautiful woman and headed to the front door, which Hackman was supposed to open. Instead, embarrassed, he turned away as though he was on the house phone. As the officer passed him, he said quietly, "Hackman, you were always a fuckup, and you're still a fuckup." Gene believed it. He went to acting school because he had nothing better to do. He roomed with Robert Duvall and Dustin Hoffman, who both established themselves earlier.

Over the years, he became one of the best film actors ever, and I've long since come to appreciate what he brought to *The French Connection*, but he had to go deep within himself to reveal "the mouse inside the elephant," and he didn't want to go there. It was hard for him to play a man who so easily used the N-word and held court in the street. Eddie would show him how to frisk a suspect, then Gene would go before the camera and do it perfectly, and Eddie would shout to everyone within earshot, "Look at that! He's more me than me!" This would infuriate Gene. One day we were filming a scene on First Avenue and Fiftieth Street near the United Nations on a frigid winter's day. In the scene the two detec-

tives stand across the street from a fancy restaurant, Le Copain, where the drug dealers, Charnier and Nicoli, are enjoying a gourmet lunch while the detectives eat pizza and drink cold coffee. The crew had to go inside a store on First Avenue to keep warm, and defrost the camera between takes. I still remember the discomfort of the freezing weather. We did a few takes with Gene and Roy out in the street, then I wanted a close-up of Gene's gloved hands as he rubbed them together to keep warm. One take after another wasn't convincing; I finally yelled to Gene: "Jesus, it *is* freezing, can't you show it to me with your hands?" Gene yelled back, "Why don't you come up here and show me exactly what you want? I mean *exactly*!" I stepped in front of the camera and demonstrated. "That's exactly what I want," I shouted. "Okay," he said angrily, then did exactly what I had shown him. "That's fine," I said, and he walked off the set for the rest of the day.

I didn't know whether he'd come back the next day or not, but I had an insight: Gene had to play an angry, obsessive man, and I could provoke that anger in him and let him focus it on *me*. Many of his outbursts, all in character, were aimed directly at me after I issued curt, aggressive directions. There were times Gene got into it and became Popeye, but his anger was directed toward me more than the drug smugglers.

The scene where Popeye and Cloudy burst into Roy's Bar, pull the jukebox plug out of the wall, and start shaking down the customers was a scene I'd seen Sonny and Eddie do many times in real life. You had to see it to believe it, and a lot of people still don't believe it was possible for two white cops to burst into a bar filled with black pushers and dealers. Gene was terrific in this scene, funny and terrifying; he did it as well as Egan ever did. Maybe I judged him too harshly; remember I'm the guy who wanted Jackie Gleason, Peter Boyle, or Jimmy Breslin. Scheider,

and the others, down to the smallest roles, were spot on, every take. Fernando Rey brought elegance and likeability to Charnier. It wasn't what I was originally looking for, but Charnier, as a gentleman, who loved his wife and treated her with affection, contrasted effectively with Gene's depiction of Popeye as a womanizer and a brutal cop. I take no credit for casting them. They were a gift from the movie god. Tony Lo Bianco was trying to make his character Sal Boca a class act, a big shot, and the more he played him that way, the sleazier he appeared. Hackman came to realize, though he had no fondness for Egan, that he had to find Egan within himself. Scheider understood Sonny Grosso, liked him, saw him as a stand-up guy, and enjoyed playing him. Bozzuffi ("Bozu") was a subtle actor who could find his way into any role. He played Nicoli with little effort and invented details and pieces of business that brought him to life, such as eating a piece of baguette belonging to the undercover detective he's just killed.

We followed the outline of the actual case, but the studio lawyers made us fictionalize all the names, including Eddie Egan, who became Jimmy Doyle, and Sonny Grosso, who became Buddy Russo. Harold Gary, who played the New York "bank," Weinstock, who financed the heroin purchase, was based on Angie Tuminaro. We made him Jewish instead of Italian to satisfy the lawyers. They were afraid we'd get sued. By whom? Dope smugglers? After the film was released, Frank Waters, the Federal Bureau of Narcotics agent—called Mulderig in the film and played by Bill Hickman, who was also our stunt coordinator—actually did sue us. I remember Egan saying to me that if he had the opportunity, he'd have "killed that son of a bitch Waters." Egan's offhand remark gave me the ending for the film, wherein Popeye "accidentally" shoots and kills Mulderig, thinking he's Charnier.

Frank Waters was very much alive—I knew him. He was a bartender at the restaurant Elaine's in New York when *The French Connection* opened, and he stood up in a crowded theater and yelled, "Bullshit!" He then sued Twentieth Century-Fox and Phil D'Antoni for $6 million. The studio settled for $10,000, and we were friends again. Frank actually liked the film, though he felt we glorified Egan's role in the case and turned *his* character, Mulderig, into an "incompetent hard-on." Had we interviewed the many other detectives and agents involved in the case, we might have made a different film, but from the time I first met Eddie and Sonny, I wanted to make the film about them. The French Connection case was just background to me, and the film uses poetic license. The "facts" we found cinematic we kept, like the scene where Charnier eludes Popeye in the subway and gives him a wave and a smile. But the big audience scene, the chase, we invented.

Two weeks before we had to start production, D'Antoni and I decided to meet at my apartment on Eighty-Sixth and Park early one morning. After breakfast we started walking south on Park Avenue. We vowed to keep walking if it took us to the Battery and back, until we could "spitball" a chase sequence. It's hard to say who came up with what—we just let the city envelop us from one neighborhood to the next, and we kept tossing out ideas. This is how our conversation went:

"We can't have a car chasing another car."

"Why not?"

"You did that in *Bullitt*."

"We've already got two foot chases—We've got to use a car—"

"Okay, but it doesn't have to chase another car."

The smoke rose from the sewers as we walked past hordes of shoppers, people hurrying to and from work or lunch . . . ten blocks

. . . fifteen blocks . . . we felt the roar and rattle of the subway beneath our feet as we walked.

"What if—"

"A subway train!"

"We're using the subway in the scene where Charnier gives Popeye the wave."

"Right," sadly.

Long pause—twenty blocks.

"The elevated—"

"What?"

"An elevated train, before it goes into the subway, or after it comes out—"

"Are there any elevated lines left?"

"I don't know—there used to be the Third Avenue Line."

"That's gone—"

"There might be one or two in the other boroughs. There's nothing in Manhattan."

"Okay—how do we get our guy on the El?"

"He's running from something, and Popeye's chasing him—"

"Who?"

"Not Charnier, we need him for the end of the picture."

"Nicoli!"

"Okay, Nicoli gets on an elevated train—"

"What if we get Popeye on the same train and they go from car to car and the passengers are—"

"No—that's another foot chase."

Another pause. Twenty-five blocks.

"Nicoli hijacks the train."

Then, together, "Popeye hijacks a car—"

"Below the tracks!"

"So it's a car going at top speed—"

"Through city traffic—"

"With pedestrians everywhere—"

The subway continued to roar and rumble beneath us.

"And the car is chasing the train as we cut back and forth—"

"Why is Popeye chasing him?"

"Say he killed somebody—"

"Who?"

We stopped on a pedestrian island in the middle of the street for a few seconds, surrounded by the yellow blur of taxis, serenaded by a symphony of car horns.

"Nicoli tries to kill Popeye—misses him—"

"Maybe he kills someone else—"

"Popeye chases him, but Nicoli has a head start and runs up to an elevated platform—"

"Popeye follows him but misses the train—"

"So he has to go back down, hijack a car, and—"

"What if the motorman has a heart attack?"

"—he loses control, and the train plows into another train parked at a station—"

"Nicoli and the other passengers are thrown, and that allows Popeye to get to Nicoli—"

We stopped on a corner, shook hands, and hugged. After walking fifty-five blocks in one direction, we had our chase.

We never scripted it, I never storyboarded it. I simply talked the cast, crew, and stunt people through it, shot by shot; it was all in my mind's eye. There were numerous variations and D'Antoni and I met often to refine the details. Aside from the question of whether there were any elevated lines still in New York, there were two other major questions. First, how fast could an El train go at top speed? If it could do a hundred miles an hour, we didn't have a chase, unless we had Hackman commandeer a racecar, which

would have been ludicrous. But the most important question was, Could we get permission to film on an elevated train? I had already decided I would steal the street shots—that is, shoot without permits, with hidden cameras, and put our actors into situations with real pedestrians. There was a film commission in New York, but it didn't have a lot of support from the city under Mayor John Lindsay; a lot of the shots we made, for example a traffic jam on the Brooklyn Bridge, would not have been approved, even by a strong film commission. But to shoot *on* an elevated train, we needed permission.

Fat Thomas had good news: there were two lines left that we could use, both in Brooklyn. One was the Myrtle Avenue Line; the other, the Coney Island Line. I drove below both with Fat, and it was clear that the line running from Coney Island was above the most interesting neighborhood, along Stillwell Avenue. At the second stop, Bay Fiftieth Street, a three-story staircase led up to a long platform just two blocks from the Marlborough housing project, which I chose as the location for Popeye's apartment. It was directly across from the Stillwell tracks. It gave me the idea that Popeye could be coming home from a bad day, and the assassin, Nicoli, could be waiting for him on the roof of Popeye's building to kill him with a long-range rifle. Nicoli would miss, and Popeye would then chase him on foot to the Bay Fiftieth stairwell, up to the platform, lose him, then go back to the street, flag down a car, commandeer it, and resume the chase under the tracks. It all sounded terrific, but could we get permission from the Transit Authority?

Their main offices were in lower Manhattan. We met with the head honcho, a middle-aged African American. With me were D'Antoni and Kenny Utt, our production manager. We had no script of the chase, but I described the concept as D'Antoni and I worked it out on our walk. The TA guy listened with interest,

occasionally nodding, sometimes frowning. When we finished, I asked him how fast an El train could go at top speed.

"About fifty miles an hour," he said.

"Great—that means a car going full speed could theoretically catch up to it."

He nodded. "I suppose so."

Phil jumped in. "Is it possible we could use one of the two lines—either Myrtle Avenue or Coney Island?"

The TA guy smiled. "Your idea is far-fetched. No one's ever jacked a train, and we don't want to give people ideas. What you're asking would be difficult, damn difficult."

I started to think how I might "steal" the sequence. Phil and Kenny told the TA guy it was the most important scene in our film, and we might have to go to Chicago to shoot the whole picture, which would take a lot of New Yorkers off the clock. That was bullshit, of course—we could never move the production out of New York—but we were trying to appeal to the guy any way we could.

He shook his head. "Awfully difficult."

It seemed hopeless. We thanked him and asked if he'd let us shoot the subway cat and mouse between Popeye and Charnier. "That could be arranged," he said. We didn't want to push our luck further, so we got up to leave. As we got to the door, he said, "Just a minute."

We turned back. "I said it would be difficult, not impossible."

"What would it take?" Kenny asked.

Without hesitation the Transit Authority guy said, "If I let you shoot what you just described, I'd be in a world of trouble."

"Right," said Phil.

A long pause. Remember, Phil is a Sicilian from the Bronx. "What would it take?"

"Forty K and a one-way ticket to Jamaica."

"Why one way?" Kenny Utt asked.

"'Cause when your film comes out, I'll be fired."

And that's what it took. We had a total budget of $1.5 million, that was tight, but Dick Zanuck understood. He approved the extra forty grand and Kenny put it in a separate account so it could be paid under the table. When the film opened, the honcho was fired, and I hope he lived happily ever after in Jamaica.

Even though we got a green light, the Transit Authority placed a number of restrictions on how and when we could film. There was no way we'd be allowed to stage a train crash. Owen and I came up with a simple solution: we could park the front car of our train directly behind the rear of another, and pull away quickly, filming in backward motion, eight frames per second instead of twenty-four. This gave the illusion of a subjective view of hurtling into a stationary train. What makes it believable is the sound on impact which we added later; also, the next immediate shot was a handheld angle showing the passengers falling and thrashing around as Nicoli is thrown to the floor of the train and loses his gun.

We were allowed to use a section of the Stillwell Avenue line from Bay Fiftieth to Sixty-Second Street in Brooklyn. For most of the action we used El car number 6609, which is now in the Transit Authority Museum on permanent display. We could only film from ten in the morning until three in the afternoon to avoid rush hours. The chase was filmed over nonconsecutive days from December 1970 to January 1971. Daylight in New York in the winter was gone by 4:00 p.m. Though the entire New York sequence was filmed in thirty-five days, it would have been shorter if we had a more flexible schedule with the train, but we were lucky to get permission to do it at all. Bill Hickman, the stunt driver, drove for Hackman, whenever you couldn't see his face. All of Hackman's reactions were

shot separately with a camera mounted on the hood of the Pontiac, or occasionally we would tow the car from a camera truck with two cameras on different lenses pointing at Gene. These shots were made within a very short distance, usually less than a city block. I would shout instructions to Gene over a two-way radio, which rested on the passenger seat next to him:

"You're pissed off . . . you're looking up at the tracks. . . . You're going to hit something. . . . Turn the wheel! . . . Turn it! . . . Look left . . . a car is going to hit you!"

Gene's reactions were terrific; you actually feared not only for his safety but that he might kill a pedestrian. All the close shots of his face, his hands on the wheel, or his feet on the gas pedal and brakes were made separately, with Gene driving. I planned five specific stunts that reflected the characteristics of the neighborhood. We didn't put stunt people in the street; all the passersby were real, and the other traffic as well, including cars that Gene tries to flag down before he commandeers the Pontiac. The only times we used stunt drivers were for the near-misses that accidentally became collisions.

These were the six "events" I had planned:

1. Popeye confiscates a car while it's in motion. (The Pontiac was prerigged by the stunt and special effects crew.)

2. Popeye's car is going full speed under the tracks. He looks up to check the progress of the train. A car shoots out of the intersection as he goes through a red light. Popeye's car spins away, and cuts across a gas station to get back below the tracks.

3. As Popeye tries to pass a truck, we see a sign on the truck's rear bumper: "Drive Carefully." The truck makes an unexpected sharp left without signaling, just as Pop-

eye tries to pass him on the left, causing a collision and spin-off.

4. As Popeye approaches an intersection while looking up at the tracks, a large moving van crosses in front of him, obscuring his view of a metal fence directly ahead. As the van passes, Popeye hits the fence straight on.

5. Popeye runs a red light. He sees a woman pushing a baby carriage step off a curb and into his path. He's forced to swerve and crash into a pile of garbage cans stacked on a safety island.

6. He turns the wrong way onto a one-way street to get back under the tracks. Over his shoulder we see the train running parallel to him, less than half a block away as he crosses oncoming traffic.

Bill Hickman was driving Popeye's car. We rehearsed several times at slow speeds, but the stunt driver in the other car mistimed his approach and, instead of screeching to a halt just before collision, rammed Popeye broadside. No one was hurt, but the car was bent like an accordion. Sass Bedig, our sole special effects man, went to work and, with his toolkit, put the car back in shape. I kept the crash in the film, as though Popeye's car was only mildly damaged.

To achieve the effect of Popeye's car narrowly missing the woman with the baby carriage I had a camera car mounted with three cameras on different lenses drive slowly toward a stunt-woman. We changed the camera speed to fast motion. As she stepped off the curb, the car swerved away from her before coming close. The focal length of the lenses made her appear closer. Separately, I had a stationary camera do a snap zoom into the woman's face as she arrived at a designated mark on the street,

and screamed on cue. These shots were intercut with close-ups of Hackman reacting behind the wheel, first with shock and fear, then anger.

There were other unplanned accidents involving stunt drivers, but in each case Sass Bedig was able to restore the Pontiac to driving condition.

Filming on the train went smoother. I used an actual conductor to play the conductor who gets shot, and the motorman, named Coke, was the actual motorman on the train. After several takes, he was able to convincingly fake a heart attack.

If you had been a visitor on the set, you wouldn't have expected to see a legendary chase. Shooting any sequence, indeed an entire film, is like knitting—one stitch at a time. To an outsider, it can seem tedious. The director, like the knitter, has to *visualize* the entire film before shooting it.

But even after we shot everything planned, I didn't feel we had a great sequence. The kinetic energy of the train footage was not equaled by the car stuff. Sometimes at the end of a shooting day I'd sit with Bill Hickman over drinks at a nearby bar. One afternoon he asked me how I felt about the stunt footage. I didn't feel good about it, and I told him so. He was a skillful stunt driver, but his ideas were more sizzle than steak. The conversation became heated, and I said, "Bill, I've heard how great you are behind the wheel, but so far, you haven't shown me a damn thing." We were both wired from the drinks and what had been a difficult shoot. "You want me to show you something?" Hickman said, coming close to my face. "Put the car on Stillwell tomorrow morning, then I want you to get in it with me if you've got the balls!"

I had no idea what he had in mind. I couldn't change the next day's schedule, but I went to Phil and Kenny and told them I wanted to take the Pontiac back to Stillwell Avenue as soon as

possible, which turned out to be several days later. I said I thought Hickman was going to do something crazy in response to my gauntlet. We called no actors or extras that morning. We mounted a camera in the passenger seat, a camera over Hickman's shoulder, and one braced to the front bumper of the Pontiac on a wide-angle lens, which would appear to "eat up" the street. We got a police gumball (siren) and placed it on the roof of the car, unseen by the cameras. When Owen and Ricky saw what was about to happen, they begged off operating the over-shoulder camera; they each had families, and knew what we were about to do was dangerous. Two of the cameras were braced and would function automatically, without operators. I would operate the over-shoulder camera, despite objections by Kenny and Phil. The stunt crew padded me with a mattress and pillows. Randy Jurgensen, Sonny Grosso's partner in the Twenty-Eighth Precinct, who has worked on several films with me, was on the floor of the car to make sure I was okay, and show his badge if unsuspecting policemen tried to stop us. Owen set the lens stops, Ricky turned on the remote cameras, and we took off: twenty-six blocks at ninety miles an hour, through busy intersections, through red lights, with no traffic control, no permits, no safeguards of any kind, only Hickman's chutzpah, his skills behind the wheel, and "the grace of God."

I have not, and would not again, risk the lives of others as we did, but the best moments of the chase came from this one long run with three cameras; pedestrians and cars dashed out of the way, warned only by the oncoming siren. No one was hurt, thank God. I was exhausted and terrified. After we drove slowly back to base camp, I thanked Hickman, hugged him, and bought drinks that night. The next day I saw the rushes, and I knew the sequence was going to kill . . .

The chase sequence was important not only as a set piece but

as a metaphor for Doyle's obsession. I shot several scenes that attempted to underline his character, Charnier's, and Nicoli's. In the editing room I discovered that a lot of what I shot was, in fact, scaffolding. The film was a picture about obsession. The characters did not need "underlining." The action defined the characters.

The scene in which the uncut heroin is tested for quality at the home of the "banker" Weinstock (Harold Gary), was shot at a luxurious suite in the Pierre Hotel. The young actor who plays the "chemist" Howard (Pat McDermott) was another discovery of Bob Weiner's, and all the dialogue about the high quality of the raw heroin was improvised by him. I filmed the test in extreme close-up, using a small amount of actual heroin Sonny was able to liberate from the police property clerk's office. "Howard" attaches a moistened needle to an ordinary household thermometer. He dips the needle into the heroin and inserts the thermometer into a small beaker of mineral oil over a Bunsen burner. He lights a flame at the base of the burner; the temperature of the oil will rise rapidly to over 250°F if the heroin is pure. "Howard" comments with increasing appreciation as the temperature rises, "Good Housekeeping Seal of Approval . . . U.S. Government certified . . . lunar trajectory . . . junk of the month club sirloin steak . . . Grade A poison . . ." At 250°F he removes his glasses and proclaims, "Absolute dynamite . . . eighty-nine percent pure . . ."

The sixty kilos at $8,000 a kilo would be diluted before hitting the street, making the street value of the heroin around $32 million. In another field test shown later in the film, "Howard" cuts into one of the bags of heroin, inserts a small amount into a Petri dish, and adds a drop of oily substance known as a marquis reagent. If the powder turns purple, the heroin is pure. Again we used real heroin, so the color purple slowly appears.

Another key sequence for which we also had no permission was

the traffic jam on the Brooklyn Bridge, wherein Doyle, Russo, and Mulderig are tailing Patsy Fuca's car into Manhattan and lose him on the bridge. Doyle stops his car, gets out, and starts running after Fuca. We would never have gotten permission to film a traffic jam on the bridge, but I had Egan, Grosso, and other off-duty detectives running interference for me. One morning I took Sonny to an overlook where we could see down to the Brooklyn Bridge. Traffic was flowing evenly.

I said, "Sonny, you see that bridge?"

"Yeah?" He nodded.

"In about a half hour," I said, "I'm going to be ready to shoot a traffic jam down there. Remember the time when you and Eddie lost Frog One on a tail?"

Sonny remembered, and sent twelve detectives down to the bridge to park their cars. Hundreds of cars built up behind them, horns honking, tempers flaring, a real traffic jam, and I sent the actors into it to play the scene. Traffic had backed up so far that Police Headquarters sent a helicopter over to see what was happening. Eddie and Sonny flashed their badges at the chopper officers. They told them we were shooting a movie, and by then we had the scene in one take.

Another time, when we were shooting Doyle's surveillance of Charnier on the Grand Central shuttle, I arrived early that morning and saw that Paul Ganapoler, Kenny Utt's assistant production manager, had booked only twenty extras for the whole scene. The subway looked empty. I told Lou DiGiaimo, our extras casting director, to go up to Forty-Second Street and bring down as many people off the street as he could, telling them they'd be in a movie. Lou and his assistant managed to corral about two hundred people, which gave the scene its credibility—a cat-and-mouse game played against the background of a large, unsuspect-

ing subway crowd. I don't remember if we ever paid these people or not; certainly our budget didn't allow for it, but you'd be surprised how many people will put aside what they're doing to be in a movie. I briefed the crowd, telling them not to pay attention to what the actors were doing. Ricky picked up the handheld Arriflex, Owen gave him a lens stop, and we were shooting in natural fluorescent light. Often the actors didn't know exactly where the cameras would be.

Orson Welles said that making a movie was like playing with the biggest electric train set a kid ever had. That was literally true on *The French Connection*. Some of the things I did would never have been approved by a studio. I put people's lives at risk. I say this more out of shame than pride; no film is worth it. That said, the danger level on *The French Connection* was Code Red. If someone had been hurt—or killed—I'd be writing this from a prison cell. Why did I do it? Why did I take things so far? You'd have to ask Ahab, Kurtz, or Popeye. If the film works, one reason may be that I shared their obsession.

New York was my Erector set, from the Upper East Side to the Lower West, with sections of Brooklyn and Queens thrown in. We operated more like a small independent company than a big studio. Dick Zanuck, as he'd predicted, was about to walk the plank at Fox, and no successor had been announced. Before we finished shooting, he was done, and the studio was being run by Elmo Williams, Darryl Zanuck's former film editor. The Fox studio was in limbo, awaiting a Wall Street takeover. We were one of only two films in production, and no one was left who gave a damn about our picture. They were more concerned about saving their asses.

The last scene we photographed in New York was an unscheduled retake of the first day of shooting, wherein Doyle and Russo interrogate and rough up the dealer. I took them to an empty lot

in Spanish Harlem and I told them to move freely and improvise. I asked Gene to end the scene with, "I'm gonna nail you for pickin' your feet in Poughkeepsie." I set up two cameras at right angles and had them shoot the scene as if we just happened on it. Fox didn't allow reshoots without permission, and we were already over budget, so without telling the studio, we slipped it into the schedule, and the actors nailed it in one take.

The day we wrapped in New York, D'Antoni asked me how I felt about the picture. I said, "Phil, I think we'll get away with it, if we're lucky, but don't get your Oscar speech ready."

Three days later we took off for a week of scouting and shooting in Marseille for the scenes that would introduce Charnier, Nicoli, and Devereaux (real name Angelvin). We hired a French crew, and they turned out to be excellent, especially the sound man, Jean-Louis Ducarme, who later worked with me on *The Exorcist* in Iraq and *Sorcerer* in many parts of the world.

The opening scene of *The French Connection* is in Marseille. We see a man in a trench coat watching a Lincoln Continental (we couldn't get a Buick Invicta) that's parked at the curb of a busy intersection. We cut quickly to the same man standing across the street from a café called the Fon-Ton (said to be the place where bouillabaisse was created). Two well-dressed businessmen come out of the café in the heart of the Marseille harbor. We follow them as they get into the Continental, and it passes the camera to reveal the man in the trench coat, still watching the car. The driver of the car, we later learn, is Alain Charnier (Jehan). Much later, it will be revealed that the trench-coated man is an undercover French narcotics detective. We follow him as he buys a baguette on one of the back streets of Marseille. He enters a small apartment building. In the lobby of the building we see Nicoli (Scaglia) behind a .45 mm. handgun as he shoots the detective in

the face, then walks calmly away, grabbing a chunk of the dead man's baguette.

To show the detective being shot in the faces we had a leading British makeup artist make a latex piece that, when pulled by an imperceptible wire, would explode a blood bag. We did several takes, none convincing. In frustration I called it a day without printing a single take. That night in Phil's hotel room we talked about alternatives. I had never done a shot like this before, so we relied totally on the makeup artist. The phone rang; it was Stan Hough (pronounced "Huff"), head of physical production at Fox, calling from Los Angeles. Stan was a gruff man with a crew cut and the attitude of a marine drill sergeant. He was married to the beautiful actress Jean Peters, formerly the wife of Howard Hughes. Stan didn't suffer fools gladly. We had three days to film in Marseille, and this was the end of the third day. Phil held the phone away from his ear so we could both listen.

"You guys finished yet?" Stan yelled.

"We've got one more scene, Stan," Phil answered.

"What's that?"

"The makeup didn't work when the French cop gets shot in the face."

"You know, you guys only had three days, Phil!" Stan said calmly.

"Yeah, I know, but we have to shoot the cop—"

I'll never forget Stan's next words. "I don't give a goddamn if you shoot him, poison him, strangle him, or push him off a building. You wrap tomorrow morning! Half a day—that's all, then get the hell back here!"

"I hear you, Stan," Phil answered.

"You hear me?! You're going to wind up a quarter of a million dollars over budget, and you're still not finished!" Phil didn't

respond. Stan didn't know I was listening, but even if he had, he would have said it anyway: "You tell that son of a bitch Friedkin, if he's not done tomorrow morning he's fired! You hear me? I'll pull the plug—"

Phil quietly set the phone back in its cradle, cutting Stan off. In truth, we needed two days of shooting to complete the sequence. We still needed to film the meeting between Charnier, Nicoli, and Devereaux. It was in this scene that the plan to bring the Lincoln to New York City, embedded with thirty-two pounds of heroin, was hatched. We filmed the scene at the former offshore prison, now a deserted landmark, the Chateau d'If, where Alexandre Dumas set *The Count of Monte Cristo.*

I had a sleepless night in the cheap hotel where we stayed. I had no idea how to make the shot work. Missing, in addition to the failed makeup gag, was the surprise and fear on the detective's face.

When we got to the set the next morning, I saw that our special effects man had brought a large rubber syringe filled with makeup blood. I idly picked up the syringe and squirted it against the wall, where it left an enormous stain. An idea came to me: I moved the camera closer to the actor playing the detective. Two feet away from him, I sat on a box just below camera, holding the syringe. I told the actor to go through the motions of opening his mailbox, then turn toward the camera on my cue and look right into the lens. When he did, I squirted him square in the face with the blood syringe. His surprise and the large red stain that covered his face made him throw his head back, and we had the shot. It's in the film with no additional effect. Stan Hough kept calling, but Phil didn't take his calls. On the last night of shooting we treated the cast and crew to dinner at the Fon-Ton. We had bouillabaisse and a house wine—delicious. Hough wired us to get the hell out of there im-

mediately, finished or not. By the time the wire got to the hotel, we were heading home.

We set up our cutting rooms on the Fox lot in a bungalow near the far western edge. The studio was not as sprawling as it is today, with television and movie production, layers of executive office buildings, and few available parking spaces. The only other feature film in production was *The Salzburg Connection*, which was filming in Europe. Zanuck was gone, but some of the lower-level executives survived. The feeling on the lot was like a small European village waiting for the Nazis to invade.

The other major studios—Warner, Paramount, and Universal—were also experiencing hard times. The movie business was going through a transition that the Hollywood establishment feared. *Easy Rider* had come out two years before, and its impact caught them completely off guard: "You mean a bunch of hippies can go out with no script, a few hundred grand, no stars, and shoot a movie that critics and audiences love?" Made under the radar and with no studio supervision, the film caught the mood of the country—disaffected youth wandering aimlessly, no faith in authority or the future. This alienation was happening not only in the streets and in the corridors of power but in literature and art, which caught the same vibe: Jack Kerouac's stream-of-consciousness writing in *On the Road*; the Abstract Expressionist paintings of Franz Kline, Jackson Pollock, and Robert Rauschenberg. Also influential were the films of John Cassavetes, small in scope and ambition but revolutionary in style. They looked inward at their characters, not outward at the landscape. The French New Wave and Italian Neo-Realism came across the pond like a tsunami, catching young American filmmakers in its wake. Style and attitude gradually replaced content. It was becoming clear that the future was not in movies based on Broadway musicals or patriotic war films

or chaste comedies, but change didn't come overnight. In the early seventies, the studios were still making *Fiddler on the Roof, Summer of '42, Nicholas and Alexandra*, and *Mary, Queen of Scots*. Robert Young, in *Father Knows Best*, had earlier promised television audiences that the American family was still intact, and Lucille Ball, Mary Tyler Moore, and *The Partridge Family* also offered comforting scenarios. Columbo and Mannix solved a crime every week; the bloody consequences of brutal murder were only suggested. So while there were aftershocks from *Easy Rider*, Cassavetes, and the new European films, the '70s revolution in American cinema was like a fireworks burst that faded to black. And while countercultural shifts of the 1960s and '70s—the antiwar movement, *The Joy of Sex*, Tim Leary's "tune in, turn on, drop out" psychedelia, the human potential movement, and the new consciousness pioneered by the Esalen Institute in northern California—were happening all around me, I was oblivious to them. I worked for the factory. In 1970 it happened to be Twentieth Century-Fox. The guys who ran it, Elmo Williams and Stan Hough, were old-school. "You guys are irresponsible!" Stan screamed. "You don't give a damn about budget! You know how tight money is today? I'll tell ya, you'd better get in that damned cutting room and not fuck around. This picture is coming out in October, whether it's finished or not."

Gerry Greenberg, assistant to the veteran New York editor Carl Lerner, was the young film editor I brought with me from New York. We had worked together on *The Boys in the Band*, but *The French Connection* was his first film as an editor. It's common for an editor to do what's called an "assembly." He or she determines the preferred takes and puts them together in the order of the script. When shooting is finished, the director and the editor look at the assembly, then make changes—lengthen this shot, shorten that one, move a scene to a different position, even delete sequences.

From my days at Wolper I'd been uncomfortable working this way. I saw it as a colossal waste of time. I prefer to look at all the printed footage with the editor and determine how it should be put together shot by shot, often in ways that differ radically from the script. In this way I can rediscover and "listen" to the film, give notes, view the changes, and move on. The late John Ford would print only one take of each setup, so that the editing process on a Ford film consisted of little more than removing the slates. Gerry Greenberg is a good editor, but his first assembly of *The French Connection* made me want to quit directing. Running about two and a half hours, it was painfully slow and labored and made little sense. It included a take of everything I shot. My next impulse was to destroy the film as Howard Roark in the novel *The Fountainhead* blew up a building he designed because it was compromised by a committee. This wasn't Gerry's fault. I'd shot the film so freeform it could have been assembled any number of ways.

In editing I don't start from the first scene and work through to the end. I might work on a scene in the middle of the film, or even the final sequence. I like to work first on the easiest scenes, the ones with fewer setups. Often the length of a shot is determined only by how long I think it can hold the screen. Sometimes there will be a technical problem, like a microphone entering the frame, or an actor blowing a line in a take that's otherwise good. I try to cut first for performance, then pace.

A film is made three times: first when you *prepare* the script. When you *shoot* it, with contributions from the cast and crew, it becomes something else. Then in the *cutting room*, during editing and sound mixing, it acquires a new life. The film changes and evolves, and only coalesces when these stages are complete.

* * *

The chase was obviously the most challenging to put together. There was a framework that dictated the sequence of events, but the length of shots, the inserts of details, and where and when to use Hackman's reactions were arbitrary. Looked at without sound effects, the sequence would be half as effective. While we worked on a rough cut of the picture, a crew of sound editors was recording audio backgrounds and effects. Chris Newman, the production sound recordist, had recorded distant traffic, crowds, and other backgrounds in their original locations; but all the *individual* effects—the El train, the Lincoln, the Pontiac, the gunshots, and other specific sounds—had to be rerecorded. Guns, of course, don't fire real bullets in a movie . . . they're blanks, and they sound thin, like firecrackers. It was common to use studio library effects for all films. When I told Stan Hough I had to go to New York to record the El train, the Pontiac, and the Lincoln, because there weren't individual tracks of them available in the Fox sound library, he hit the roof.

"God damn it! Who's gonna know the difference?" he shouted.

"An audience will," I said. I told him I would go to New York alone and record everything myself, with no location fees and no paid personnel. He reluctantly agreed. Dick DiBona at General Camera let me use a Nagra. We got the picture cars again, and with the help of Sonny Grosso and Fat Thomas, I recorded all the acceleration sounds, brakes, sudden turns, everything. We went back to the Stillwell Avenue Line in Coney Island, where we recorded an El train starting, stopping, and running at top speed, from inside the train, outside, and under the tracks. The impact of the crash was made by a large hammer hitting an anvil—to which we added reverberation and boosted the volume.

A sound we couldn't find was a powerful gunshot. Magnetic tape produces a clean, crisp sound; optical track has a loud hiss, loud as

the desired effect itself. For some reason, Fox kept its sound library on optical tracks, not magnetic tape. I read that George Stevens, the great American director of *Shane, Giant,* and other classics, used to replace the sound of a six-gun with that of a shotgun to enhance the effect. I asked the sound editors and the rerecording mixers at Fox if anyone owned a rifle or a shotgun. One of them did.

We were editing, mixing sound, predubbing dialogue and movement, while separately assembling sound effects tracks. The release date was looming. We worked seven days a week, sometimes fourteen-hour days, and the overtime for the crew was piling up, causing Hough to vent at me every day. Occasionally he'd come into the rerecording studio and yell at Ted Soderberg, the chief mixer, and his crew to work faster. One early Sunday morning the mixer who owned the shotgun brought it to the Fox lot, which was empty except for our sound crew. Ted Soderberg recorded the shots. These were the last remaining specific sounds we needed. We were about to finish mixing a reel, just before the lunch break, when Hough stormed into the mixing studio. He wasn't in his usual mufti but dressed for a Sunday game of golf.

"What the fuck is going on here?" he bellowed. I'd never seen him this angry. The crew was terrified. His gaze shifted and lasered onto me.

"What's wrong, Stan?" I asked innocently.

"What's wrong? We had a bunch of neighbors complain they heard gunshots. They called the switchboard and they bounced it to me!" I explained to him what we had done and why. This made him angrier. "Where the hell do you get off, bringing a loaded gun to this lot?"

"Stan, we tried to use the library gun shots, but they're covered with hiss and they have no level—we can't make them louder without raising the background noise."

"You're full o' shit!" he shouted, moving closer. I honestly thought he was going to take a swing at me. He pointed a finger that came an inch from my face. "You're telling me the library gunshots are no good?"

"That's what I'm telling you," I said quietly.

"God damn you," Stan shot back. "I recorded those gunshots *myself* for *Butch Cassidy and the Sundance Kid*. They're good enough for Butch Cassidy but not Bill Friedkin!"

Ted Soderberg chimed in, "They're on optical, Stan. The hiss is so loud I can't use them."

"Let me hear them," Stan said menacingly. Ted played the optical gunshots at an acceptable level—the hiss was apparent, even to Stan. He sat down. "Can't you clean 'em up?" he asked Ted.

Ted shook his head—negative.

"Here's what *we* recorded," Ted offered. He played our shotgun shots at full level. There was no hiss.

Stan shot me a dirty look and stormed out.

By the time I finished my rough cut and had a temporary sound mix, Twentieth Century-Fox was controlled by a Wall Street brokerage firm, but the caretaker studio management was led by Darryl Zanuck's longtime film editor, Elmo Williams, and his head of editorial, Sam Beetley. Elmo and Sam were "below-the-line" blue-collar guys, not "suits." Phil and I were anxious to meet Elmo; he had a reputation as a great film editor, having won Academy Awards for, among other films, *High Noon*. He told us that Fred Zinnemann, the director, lost his way on *High Noon*; that he, Elmo, had gone out with a second unit and filmed the empty railroad tracks, the clock as it approached noon, the train speeding to its destination with killers on board; and that he had commissioned Ned Washington to write the title song. These were the most memorable elements of the film. In short, he claimed he not only cut the film

but also shot the scenes that framed and held it together. Elmo was so convincing and his reputation as an editor so huge, we believed him. After lunch we screened our rough cut for Elmo and Beetley, and I was looking forward to their critique of the film, convinced that whatever their comments, they would improve it.

Rough cuts are without color correction, final music, or sound effects, and sometimes with dialogue missing that will be dubbed or added later. *The French Connection* rough cut was rough, but you could get an idea what it might become. By the time I finish a first cut, few surprises are left and insecurity sets in. I wasn't overjoyed with the rough cut; I thought it could be improved, but I didn't know what else to do with it. It was tight at an hour and forty minutes. The characters were well drawn in a kind of impressionistic way. There wasn't a lot of dialogue—just enough, I thought, to tell the story.

Screening rooms are dark, airless places. The Zanuck had big overstuffed red leather chairs, cracked with age; a sound panel was set up a few rows from the back of the theater where you could control the playback level. It was set at what the projectionists agreed was "comfortable"—usually too low for my taste. Before the screening I snuck over to the panel and cranked up the volume. When Elmo and Beetley arrived, Elmo had his assistant crank it back down to "normal." During the entire screening, Elmo, who sat a few seats to my left, gave a continuous stream of quiet dictation to his assistant—from the opening titles until after the lights came up. Can you imagine how disconcerting it is to a filmmaker showing his film for the first time, to hear whispered chatter from a studio boss, whose head is turned away from the screen and toward his assistant? About fifteen minutes into the screening, I turned around to look at Sam Beetley, sitting just behind us. He was not giving

notes to his assistant, which was comforting until I realized he was fast asleep—not snoring, just breathing softly. This was our first audience for *The French Connection.*

When the lights came up, we knew we were in trouble. None of the usual condescending remarks about how the film had potential but needed work, or how it could easily be fixed with a nip here and a tuck there, or "let's preview it and see what an audience thinks." Elmo dove right into his notes, taking the pad from his secretary. In his high-pitched nasal tone, he read, "In the shot where you see the French killer shoot the guy in the hallway, add four frames to the dead guy's face. By the way, who is the guy who gets shot?" (That, by the way, was never completely clear. He's supposed to be an undercover French detective.) "The shot where we see the two cops in Brooklyn beating the pusher, take off six frames. When the cops are sitting in their car watching the couple make up the Sunday papers in the grocery store, add four frames . . ." And on it went, Elmo suggesting frame cuts or additions to almost every shot. Occasionally he would turn to Beetley, who had just awakened and was trying to clear his head and pretend he was alert, "Do you agree, Sam?" in that nasal twang.

Beetley nodded vigorous approval. "Oh, yeah." The secretaries were stone-faced—they knew we were in trouble. Finally, Elmo arose and the others followed. He walked over to Phil and shook his hand, saying, "Well, there's some good things in the picture, but I think it needs a lot of work. I'm off to Salzburg, and I should be back in a week. When I get back, I'd like to see the changes and look at the whole film again. Part of the problem is, I don't understand the story." With that, he and his entourage were gone.

Phil and I were alone in the screening room. Sheepishly he said, "Well, that wasn't too bad, a few shots here and there—"

I started to pace angrily. "Phil, this guy is full of shit. He's never

seen the dailies. He doesn't realize that when a cut is made on a certain frame, it's because the next frame might have a serious problem; a light falling into the shot, or a camera jiggle, or a microphone in the picture, or an acting flub, or a—"

Phil tried to calm me down. "Billy, he's one of the greatest editors who ever lived—"

"Bullshit! Zanuck must have told him exactly what to do. Also, to just chop the film up like this, we'd ruin the pace."

"Can't we just try it?" Phil asked.

"You've trusted me this far, go the extra mile," I pleaded. "This guy doesn't know what he's talking about. He's just trying to assert his power. You're the greatest bullshit artist I've ever known. When he comes back in a week, just tell him we made all his changes and they worked like gangbusters."

"Are you crazy?" Phil cut me off. "He'll know."

"He won't. He's not sitting there, counting frames. Every note he gave us is off the top of his head. If I do any of it, we'll ruin the picture." Phil sat down in one of Darryl's cracked leather chairs. The decision was his, and we both knew if he went the wrong way, the picture would suffer and maybe die. "Let me think about it," he said softly.

We were summoned to the sumptuous offices of Jonas Rosenfeld, president of marketing for Fox. Jonas was a heavyset, wavy-haired man, well dressed, usually smiling. His number two was a yes-man with a perpetual five o'clock shadow named Johnny Friedkin, no relation to me, though he always called me "cuz." If they knew they were presiding over a dying empire, they didn't act like it. To them film was just product. Johnny and Jonas plunged right in, even though they hadn't yet seen a rough cut of the film. They had charts, surveys, and mock-up posters strewn around the room:

JONAS: Fellas, we did some surveys and we feel we have to change the title.

Phil and I stared at each other.

JOHNNY: *The French Connection* means nothing to the average Joe, nothing!
JONAS: In fact, people thought it was (a) a foreign movie; (b) a porno; or (c) a condom. We can't go out with that title. We'll get killed. Johnny, show them what we have.

Johnny dutifully walked behind Jonas's desk, where stacked against the wall were two large cardboard posters. He handed them to Jonas. Jonas took one and set the other facedown on his desk.

JONAS: This is the one we prefer.

It was a bland depiction of Hackman posing in front of a group of uniformed cops, his .38 Special in hand. Under the image in big black letters was the title: *Popeye.*

"You must be kidding. First of all, you know there's a comic-book character by that name." I stared at the poster in disbelief. I looked over at Phil—he was laughing.

At this point, Jonas showed us his other concept. Same image, basically, but a new title in bold letters: *Doyle.* A long silence while Phil and I stared at it.

"It's fucking terrible," I said. "You haven't seen the picture, and you want to change the title to something as bland as this?"

Jonas was angry now, his polite facade gone.

JONAS: Fine. Why don't you guys come up with some-
thing? Come back with your suggestions. But we've got
to get a campaign going. We have to release this picture
in four weeks.

It seemed the picture was cursed. The difficulty of getting it
financed, the casting problems, the studio's reaction, and now the
advertising guys, considered among the best in the business—
could they all be wrong? Phil and I spent a few hours in our little
bungalow, kicking around other possible titles. I don't remember
what they were, but we hated them all. We made an appointment
to see Jonas the next day. The fact that the studio was in play, and
several dissident stockholders were fighting for control, worked to
our advantage. One of the biggest and most restive shareholders
was the Broadway producer David Merrick. I met Merrick a few
times and thought him to be brilliant but mentally unstable. I said,
"Jonas, if you try to change our title, we're going to go to David
Merrick. We're going to tell him the title by the man who wrote
The Green Berets, you now want to change because of some stupid
survey."

Phil was hurting inside, but he agreed with me and let me ram-
ble on. When he thought I'd said enough, he chimed in, ever the
diplomat, "Guys, we appreciate what you're trying to do, but we
believe in the *French Connection* title."

Eventually, Johnny and Jonas backed down. There were times
when Phil and I were so beaten down by the process we were ready
to give in, but this time the other guys blinked first.

Elmo, Beetley, and their assistants returned to the Zanuck
screening room ten days later, eager to see the changes Elmo
suggested. We'd changed nothing—not a frame.

D'Antoni greeted Elmo with a hug as he and his entourage en-

tered the screening room, "Elmo, you nailed it," Phil enthused. "You saved our ass; the changes are great."

Elmo was smiling as he turned to me. "You're happy, William?"

"Oh, yeah." I smiled back as I clapped him on the shoulder.

The picture Elmo saw on that occasion was the same one he saw, before he left the country. This time he gave no notes to his assistant, and as far as I could tell, though he was sitting behind me, Beetley stayed awake. When the lights came up, Elmo got up and turned to us. "Congratulations, fellas, you did a great job."

"Thank you, Elmo," Phil and I chimed in.

"Well, it's a lot better, but I have two important notes," Elmo said quietly. What the hell was this? "I still don't understand the story. I think we need narration," he said evenly. "And I think your sound mix is too loud."

They left happier this time, but I was more concerned than ever, and so was Phil. He now realized Elmo was jerking our chains. "We can't put narration in this," Phil said.

"Of course not," I agreed.

"What do we do?"

We knew the producer of Hackman's new film, Joe Wizan, my former agent, and called him to confirm that Gene wasn't available in case someone from Fox called. We told Joe the whole story, and he agreed with our position, earning my eternal gratitude. We decided not to tell Elmo, but just let the release date get closer. Eventually he called to ask if we had written the narration, and whether Hackman was available to do it. I had to break the news to him that Gene was unavailable, but I told him we were working on the narration. We hadn't written a word, or even thought about it.

"Meanwhile," I said, "we better finish sound mixing if we're

going to make the release date." Elmo agreed. We could add the narration at the last minute, just before printing.

I've always thought of the sound track as separate but equal to the film. This goes back to my love for radio drama of the 1940s, where evocative sound played a big part in telling the story. I've often replaced dialogue recorded on location or even on a sound stage, with what we call "looped" or "postsynchronized" dialogue. Since many of my scenes are shot in the streets, not on a stage, you get background noise that obscures or even drowns out an actor's words. In the calm, quiet atmosphere of the looping room, the actor can reproduce, even alter and improve, his performance.

The sound mixers, especially Ted Soderberg, were extremely helpful and efficient. The mixers are really your first audience. They're the first to hear the sound track matched to the edited picture, and if you want them to be honest, they will. They're able to spot when a scene isn't "playing," what's too long or too short, and I often act on their advice. They created a sound track for *The French Connection* that I think makes the picture. Sometimes total silence is more effective than a loud explosion. When we came to the final shot, where Popeye runs along an empty corridor in the abandoned building on Welfare Island and disappears, the music was quiet and slightly schizophrenic. After I'd seen the rough cut hundreds of times, an inspiration came to me. I turned to Soderberg, who was sitting at the center of the sound console. "Ted, why don't we end this with a bang?"

He smiled. "What do you mean?"

"When Hackman disappears offscreen, let's hold for a beat, then put in an offstage gunshot."

"What does it mean?"

"I have no idea," I admitted. "But people will think about it— did he shoot somebody? Or was he shot?" And that's the answer to

thousands of people who have written to ask me why the film ends this way. Originally I had planned to end with a surreal sequence, which we photographed but cut before the mix, in which Popeye is alone in the abandoned hospital on Welfare Island. He has lost Charnier, and he's killed a federal agent by mistake. I was trying to portray his chaotic mental state, so you see him shooting at a figure running toward him that is himself; another, himself dressed as Santa Claus; another, as Charnier coming at him from everywhere. I shot this sequence and put it together, but before we showed it to Elmo, I decided it might work in a Fellini film, but it wasn't going to work for a commercial thriller. Dave Wolper would have killed me for that.

There used to be a supper club on Melrose called Nucleus Nuance, where I first heard the Don Ellis Orchestra, a big band made up entirely of electronic instruments. They played every Monday night under what was called a "rehearsal contract," which meant they didn't have to get paid union scale. They played for the love of it, and they were taking big-band jazz to a new level. The club held about three hundred people and was always packed. The orchestra played offbeat and constantly shifting time signatures: 14/8, 25/16, 13/4. The arrangements were unique, experimental, and thrilling. Don was in his early thirties when I met him, but seemed even younger. He was soft-spoken, soulful, with a Beatles haircut. After listening to the band at Nucleus Nuance for almost two years, I asked Don if he would be interested in scoring a film. *The French Connection* was his first film score, and it was a perfect fit.

I fought Elmo Williams for final cut. Not out of ego, nor did I think I knew more about editing than he did. The movie was something I lived and breathed. To Elmo it was just another title on the long trail of his career. The editing process is mysterious; you enter it, as in a trance, and with the help of a good editor, if

you "listen" to the film, it can tell you what it is and what it isn't. Fixed ideas don't belong in the cutting room. Just as jazz depends on improvisation and variation, so in the editing room you find that sequences you thought were important, even necessary, can be cut or moved to a different place. Scenes that once seemed vital are revealed to be irrelevant. In this way, a performance you thought was fair, even bad, can be trimmed, polished, and made to work.

I remember working with the great actor Joseph Wiseman on *The Night They Raided Minsky's.* Joe was playing the father of Billy Minsky (Elliott Gould), and I thought he wasn't giving enough in his scenes. With trepidation I told him so. He said, patiently, "Wait till you see it in the cutting room. You'll find that 'less is more.' " He was right.

You watch your film over and over, allowing it to enter your subconscious, and as you open yourself to it, it takes on a new shape. This has happened to me on every film I've ever worked on, which is not to say you can pull success from the jaws of failure. Even so, a film is successful or not for reasons having little to do with how good it is. The zeitgeist plays a major role, and what I choose to call "the grace of God." You can offer any reason for a movie's failure and who's to dispute you. Think of a movie that failed, say, *Dr. Dolittle.* What was wrong with it? "The story," or "the acting," or "the directing," who knows? Whatever.

But try to explain success.

By the first week of October 1971, Fox had a new management. Dennis Stanfill was appointed chairman and CEO, after a proxy fight for control of the company. Dennis had no experience in the film business. He was a Rhodes scholar and former head of the Carlyle Group, one of the world's largest private equity funds. Fox was close to collapse after the uninspired box office performance of *The Bible, Star,* and *Hello, Dolly!* Dennis appointed Gordon Stulberg

to be president of the film division. I knew Gordon as the chairman of Cinema Center Films, where I made *The Boys in the Band*. I liked him, and looked forward to his taking over Fox. Elmo and his cronies were on their way out, but not before one last shot to our bow. We managed to fake Elmo out of the narration track, and out of his plan to re-edit the picture, but now it was about to be released. Jonas and Johnny came up with a print campaign that I hate to this day, showing the small figure of Doyle in the distance, shooting the large foreground figure of Nicoli, the French hit man, in the back. The copy line was lame: "The time is now right for an out and out thriller like this." Phil and I protested to Jonas, but we weren't going to win this one. A culture of depression had spread through the studio like a virus.

Amazingly, *The French Connection* opened on October 9, 1971, to glowing reviews and sold-out audiences. Why? The studio spent little on advertising, and it was a limited release. In some areas, including Forty-Second Street in New York, it opened as half of a double feature. The studio just threw it out there. But the movie god, true to his own purposes, smiled upon us. The picture was an instant hit, and many critics called it a classic, singling out the chase and Hackman's performance. Phil and I were in shock. We thought the film was pretty good—but not this. All I could think about was: the struggle to get it made; the studios who had turned it down twice; the many actors who turned us down; Hackman walking off the set; Stan Hough's many attempts to fire me; Elmo trying to put his stamp on the picture without really understanding it.

But Elmo wasn't finished. Toward the end of the film's first week in theaters, I got a call from Ted Soderberg: "Billy, you're not gonna believe this . . . Elmo wants to remix the picture." I thought he was joking. No, the vampire had risen again.

"He's ordered all the elements brought down to the mixing stage this Thursday, and he plans to supervise a remix himself."

I told Phil, then I called Elmo. The nasal twang came on the line right away, with a noncommittal "Yes?"

"Elmo," I plunged ahead, "are you planning to remix *The French Connection*?"

"Yes."

"Why?"

"It's too loud, it's distorted—I told you fellas that."

"But it's playing in theaters now, and it's doing great."

"Yeah, but the mix is bad, and we—"

I took the gloves off. "Elmo, you're full of shit. I'm going to Gordon [Stulberg] with this."

I told Gordon of our dealings with Elmo, and about the remix. Gordon was low-key. He summoned Elmo to his office and, with me sitting there, said, "Elmo, you don't really want to remix *The French Connection*, do you?"

Elmo explained, "the mix is bad. It's too loud, it's distorted—"

"How many prints do we have out there?" Gordon asked.

"I don't know," Elmo answered. "What's the difference? The important thing is to get it right."

Gordon leaned back. "You want to recall all the prints?"

"Yes."

"What would that cost?"

"That's not the question. Darryl would never question the cost of getting a picture right."

"Well, Elmo, I'm not Darryl. How soon can you get me some numbers?"

"I'll work on it right away." He left.

Later that afternoon, Gordon called and asked me to come back to his office in the main administration building. Soon af-

ter I got there, Elmo arrived with Beetley in tow and with a set of figures. The cost of recalling the prints, remixing the film, reprinting it, and sending out new prints was considerable, about $200,000, according to Elmo, who probably shaved the numbers. Gordon studied the figures carefully, then tossed the sheaf of papers back to Elmo across the desk. "You know, Elmo, the picture's doing so well, I think I'd rather spend the money on more television spots."

Elmo registered the verdict stoically, "Okay," he said, retrieving his papers. Then he turned and went to the door, followed by Beetley. I felt sorry for the old warrior. The rules were changing, and his war was over. In a couple of weeks he was gone, as the new regime cleaned house. Before he left, he sent me the original of a telegram he had received on opening day:

DEAR ELMO, SCREENED THE FRENCH CONNECTION
LAST NIGHT AND FOR ITS TYPE IT IS A PERFECT
MASTERPIECE THAT SHOULD RECEIVE CRITICAL
ACCLAIM AND WILL CERTAINLY HIT AT THE BOX
OFFICE. ALTHOUGH I HAD READ THE SCRIPT AS YOU
KNOW REPEATEDLY, AND WE HAD DISCUSSED IT ON
NUMEROUS OCCASIONS, NEVERTHELESS I GRIPPED
AT EVERY MOMENT AND THE CHASE SEQUENCES ARE
THE GREATEST I HAVE EVER SEEN AND THE ENTIRE
MOVEMENT AND DIRECTION WAS OUTSTANDING. I
AM SURE IT WAS A DIFFICULT PICTURE TO EDIT,
BUT IN ANY EVENT IT WAS DONE MAGNIFICENTLY.
CONGRATULATIONS TO YOU AND TO ALL CONCERNED.
BEST ALWAYS, DARRYL.

This telegram is framed, and it's been on my office wall for forty years. I had no idea Darryl was even aware of the film, enmeshed as he was in his own problems with the board of directors at Fox, but it was moving to get this reaction from one of the best producers who ever lived. I was never aware that he "read the script repeatedly," or that Elmo took credit for editing the film. Darryl's reaction and praise meant a great deal to me, but a disconnect between his reaction and Elmo's suggests that somewhere along the way Elmo went rogue. Then again, he did send me the wire as a keepsake.

The French Connection ran successfully through the fall and winter, made many short lists of the year's ten best films, and was praised around the world. In Italy, and elsewhere in Europe, the criticism was divided along political lines: those on the right, who thought the cops should own the streets and have carte blanche, and those on the left, who felt the cops had gone too far and that the film promoted right-wing militarism, even fascism. I welcomed this ambiguity, though Phil and I had no political agenda in making the film.

Before the film's release, I screened it for Hackman. I waited for him as he came out of the Fox screening room. He had a detached, noncommittal look.

"What do you think?" I asked him.

A long pause, then, "I really don't know how I feel about it. I guess I'm too close to it. I think some of it's terrific; the action, the chase . . ." He let it go at that, and so did I. To this day I don't know what Gene really thinks of the film. When asked, he acknowledges how important it was to his career; more money, awards, starring roles, recognition as one of America's best actors. But when he's called on to list his favorite role, it's always *Scarecrow*, a lovely little film costarring Al Pacino. Pretty much every-

thing Gene has done since is first rate. Watching his performance now, it appears seamless. It's hard to recall the struggle it took him to get there. How impossible it seemed at times. But there's sometimes an alchemy that occurs between a fine actor and a role, a kind of imperceptible transformation I can only attribute to the movie god.

Imagine how life changes for a young filmmaker with a successful film. Suddenly people you don't know invite you to dinner parties; you get scripts from every studio; executives who turned *The French Connection* down are now calling you for lunch. Or dinner. Come meet the wife. Your closest friends, agents, and business associates are overjoyed. The best tables at the best restaurants are yours for the asking. You don't travel by subway anymore, you ride in limos. Why rent an apartment or a house when you can buy or build one? It seemed to me then I was on a merry-go-round that would accelerate forever.

When a film opens to good reviews, it's often mentioned as a contender for one or more major awards, but they don't necessarily materialize. I never thought *The French Connection* was awards material, but slowly it started to pick up support from critics and the various guilds. The Kansas City Film Critics Association named it Best Film and Hackman Best Actor. The National Board of Review, a society of critics from around the country, gave Hackman its Best Actor Award. Gerry Greenberg was nominated as Best Editor by the American Cinema Editors. Ernest Tidyman was given the Writer's Guild Award for Best Screenplay, which he also won from the Mystery Writers of America. Then the New York Film Critics gave Hackman its Best Actor Prize. When I won Best Director from the Director's Guild, I felt a sense of pride and purpose I had never experienced.

The French Connection was the toast of the Golden Globe

Awards presented by the Hollywood Foreign Press in February of 1972. We were awarded five in all, including sound and editing. I received Best Director of a Drama and D'Antoni accepted Best Picture, Drama. Improbably, we were now serious contenders for the Oscar. Phil and I celebrated with a steam at the Paramount gym, where he first told me the story of the French Connection.

I went to see Stan Hough in his office the following Monday. I thanked him for keeping the faith. He was a lot friendlier this time, and I believe sincere: "That's all right, kid, you deserved it. You fought for what you believed."

"I know you were just doing your job," I told him. He stood and offered his hand; as I took it, he actually smiled at me for the first time. "I hope we can do it again," I said, and left. I meant it. He was a good man. If he hadn't been all over me, the picture might have gone well over the $1.8 million it eventually cost.

More important to me than the rave reviews were the calls from other directors, like Don Siegel, who made *Dirty Harry* that same year, and Sam Peckinpah, who said, "Great picture, but why the hell did you have to make it this year?" (Sam had brought out *Straw Dogs* that year.) The Director's Guild Awards were held at the Grand Ballroom of the Beverly Hilton Hotel. I was amazed to think that my name was going on a short list of some of the greatest American filmmakers of the era: Frank Capra, John Ford, Joe Mankiewicz, Elia Kazan, and others whose films taught me the craft. The award was presented to me by John Huston, who said, "Wonderful film—wonderful," when he handed me the large golden plate. When I finished thanking Phil and the cast, I noticed Alfred Hitchcock sitting with his family at a table just below the podium. I walked down the center flight of steps and stopped at his table. I was wearing a rented tux and a snap-on bow tie. Holding the award with one hand, I snapped

my tie at him with the other and said, "How do you like the tie, Hitch?" He gave me a blank look. He didn't remember his comment just four years before: "Mr. Friedkin, usually our directors wear ties." But I did.

About a month before *The French Connection* went into general release, I went on a publicity tour across the United States, winding up in San Francisco. I had eight o'clock dinner plans and finished my interviews around five. I remembered a package I had received before I left for the tour and tossed into one of my luggage bags. The parcel was neatly wrapped and sealed. After a shower, I decided to open it. Inside was a recently published novel I was only vaguely aware of called *The Exorcist*, by William Peter Blatty.

The book had a curious cover photograph of what appeared to be the face of a young girl taken from an odd high angle, top-lit, with dark eyes, staring into the distance. The dedication was "For Beth," followed by a page of quotations: From Luke (8:27–30), referring to Jesus's confrontation with a man possessed by a devil, who said his name was Legion; an excerpt from an FBI wiretap of the Cosa Nostra, referring to the brutal murder of a man; and finally, a vivid quote from Dr. Tom Dooley, about the merciless killings of a priest, a teacher, and seven little boys by the Communists. This was followed by the words DACHAU, AUSCHWITZ, BUCHENWALD.

I looked up from the page of disturbing quotations to the San Francisco skyline, the exquisite Golden Gate Bridge, and out to the bay. It was a crisp late afternoon, ripe with the promise of good food and good company, in the most beautiful city in America. I was in no mood for Dachau, or Auschwitz, but I reluctantly turned the page to: "Prologue: Northern Iraq," and then another page,

which began: "The blaze of sun wrung pops of sweat from the old man's brow, yet he cupped his hands around the glass of hot sweet tea as if to warm them. He could not shake the premonition. It clung to his back like chilled wet leaves."

"He could not shake the premonition . . ." I turned once again to look at the city, and that was the last I saw of it, or anything else for the next three hours. I quickly finished the prologue, in which we are introduced to an unnamed Jesuit priest-archaeologist near the outskirts of Mosul in northern Iraq who, on a dig, uncovers an ancient green stone amulet of the demon Pazuzu. He prowls the ruins of the dig, where he sees a limestone statue with "ragged wings, taloned feet, a bulbous, jutting, stubby penis, and a mouth stretched taut in a feral grin: Pazuzu."

"He knew. It was coming. . . . Quickening shadows. He heard dim yappings of savage dog packs prowling the fringes of the city. The orb of the sun was beginning to fall below the rim of the world. . . . A shivering breeze sprang up. . . . He hastened toward Mosul and his train, his heart encased in the icy conviction that soon he would face an ancient enemy."

The prologue, about four and a half pages, contains no particular action or events. It simply sets the mood for the evil to come. I canceled my dinner plans and changed into the hotel bathrobe. Comfortable in an easy chair with a footrest, in front of a large panoramic window, I read on. The first chapter takes us to the redbrick and ivy suburb of the Georgetown section of Washington, D.C., where most of the novel is set. We are introduced to a movie star named Chris MacNeil, on location with a film shooting on the Georgetown campus, a Jesuit university. Chris is accompanied by her twelve-year-old daughter, Regan.

Most of you are undoubtedly familiar with the rest of the plot. Regan becomes increasingly, unnervingly sick. Her personality

and appearance change to a degree unfathomable by physicians, surgeons, and psychiatrists. A strong woman, Chris unravels, helpless to save her daughter. One of the psychiatrists, in desperation, suggests an exorcism; and though not religious, Chris turns to the priests at Georgetown for guidance. In his meditation on human suffering, sacrifice, and the mystery of faith, Blatty makes you feel as though the strange tale is happening before your eyes. The writing is graceful, the details incisive; Blatty presents the step-by-step demonic possession of an innocent twelve-year-old girl with clarity and intensity. Like most readers, when I finished the book I was profoundly moved and terrified. Parts of the novel are humorous, and so it fulfilled all three of my criteria for a good story: to make you laugh, cry, or be scared. My hotel room was dark now except for the glow of the reading lamp reflected in the large picture window, where seabirds flew past the soft pastels of the townhouses, silhouetted now and trimmed with golden necklaces of light. The bridges were muted by the fog, but moonlight outlined the surf breaking gently on the western shore. This peaceful view contrasted sharply with my emotions, stirred by transcendence and awe.

Blatty, whom I hadn't seen more than a few times since our disastrous first meeting at Blake Edwards's office, had enclosed a brief note, asking me to read the novel as quickly as I could and give him a call. I did. When he picked up the phone, I shouted, "Bill, my God, this is wonderful! What the hell is this?"

I must have stammered because he interrupted, "Billy, I've sold the book to Warner Bros., and I'm going to produce it and write the screenplay, and I'd like to know if you'd be interested in directing it."

Unprepared as I was for his offer, I was immediately confident I could bring it off. I told Blatty I thought it would make a great

film, but why me? *The French Connection* was getting good word of mouth, but my other films frankly suggested nothing on the scale of *The Exorcist*.

"I sent you the book," Bill explained, "because I remember our meeting outside Blake Edwards's office about *Peter Gunn*, and how you had the balls to tell us what a piece of shit it was, even though it cost you a job; and I believe you'd never bullshit me." He went on to explain how complicated the situation was. "I have to tell you there's a Warner Bros. list of directors that includes Stanley Kubrick, Arthur Penn, and Mike Nichols, and you're not on the list, but I have director approval."

As it turned out, Kubrick declined, explaining that he only developed his own ideas, and wanted no one else to produce his films. Penn said, "I've *done* films about violence"—in particular, *Bonnie and Clyde*—and he didn't want to do anything similar. Nichols was concerned that it would be impossible to get a believable performance from a twelve-year-old girl as the incarnation of Satan.

I called Fantozzi and told him about my conversation with Blatty. He called Frank Wells, vice chairman of Warner Bros. Wells said, "There's no chance of this happening. None of us get Friedkin."

The forty-fourth annual Academy Awards were on a Monday night in early April 1972. The awards show was held at the Dorothy Chandler Pavilion in the Music Center in downtown Los Angeles. The nominees had to be in the pavilion by 4:00 p.m. We met at my business manager Ed Gross's house in Beverly Hills at 1:30 p.m.—me; Ed and his wife, Marci; my agent, Tony, and his wife, Patti, all of us in Ed's white Rolls-Royce. We set out for Sunset Boulevard, heading east to pick up the Hollywood Freeway just a

few miles away. Normally it would take half an hour with no traffic, but given that it was Oscar night, we allowed two and a half hours.

I was nervous, but I tried to appear calm. I never expected to win an Oscar, certainly not for *The French Connection*. I was too deeply involved with the film after three years to see anything but its flaws, and there were many, as well as the difficulties we went through to get it made. Also, the subject matter never struck me as being Oscar-worthy. I thought at best, I had made a good B picture. I thought the chase played well, but I never expected it to be revered.

About half a mile from the Hollywood Freeway, the Rolls broke down. We were at a traffic light at Sunset and Highland, and the engine died. It was just after 2:00 p.m. There was a gas station on the corner, so we all jumped out in our tuxedos and evening dress and pushed the car into the station. Passersby and motorists stared at us in disbelief. An attendant in oil-stained coveralls walked slowly toward us, shaking his head, opened the hood, and admired the intricacy of the engine block. He checked the oil, then got behind the wheel and tried to start the car, without success, before announcing in a Hispanic accent, "Muerto, dead. No battery."

"Can you get another one?" Gross asked.

The attendant laughed, shook his head. "No, man, you gotta go to a dealer for this."

Ed is an eternal optimist. "Do you know if there's one nearby?"

Again the attendant shook his head and threw up his hands. "Not this neighborhood."

I couldn't believe it. I was nominated for an Academy Award, and we weren't going to get to the ceremony. The odds are about a hundred to one that you can score a taxicab off the street in Los

Angeles, even on a main drag like Sunset Boulevard. It was almost three o'clock.

There was one other car at the gas station, a beat-up old Ford. The owner was a guy in his thirties. Filled with equal amounts of self-confidence and apprehension, I approached him. "Sir, would you do us a great favor?"

He stared at me as if I was in a weird outfit at a costume ball. "What's that?" he asked, noncommittally.

"Where do you live?" I asked.

"In the Valley," he answered. The San Fernando Valley was in the opposite direction to where we were going.

"Look, if I gave you a hundred bucks, would you take us to the Academy Awards?"

The guy stared at me as if I was putting him on. "Why?" he asked.

"We're nominated."

"Oh, yeah? What picture?"

"*French Connection*," I said hopefully.

The guy looked at me quizzically. "What do you have to do with it?"

"I directed it."

He paused and replaced the gas pump. If the ladies were appalled at the possibility of climbing into an old Ford in their most expensive evening dresses, they didn't show it.

"I'd like to help you guys, but I'm going home to watch the show with my wife. I left work early 'cause I promised her," he said, heading for the kiosk and peeling off some bills to pay for the gas.

"I'll make it two hundred," I pleaded.

He got his change, then turned to me. "You directed *The French Connection*?" he asked again. I nodded. "What's your name?"

"Bill Friedkin. William Friedkin," I corrected, in case he re-

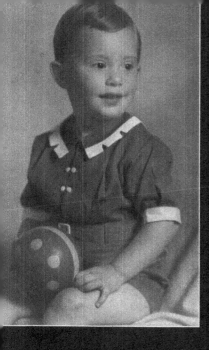

The author

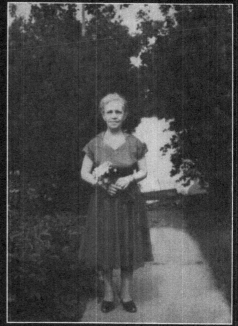

My mother, Rae

With Francis Coughlin — 1960

The People vs. Paul Crump: 1962

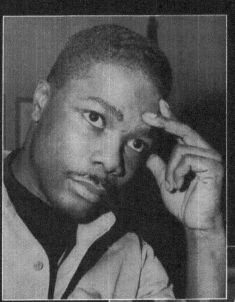

Paul Crump

Warden Jack Johnson

Paul Crump; Donald Page Moore, his lawyer; Friedkin

The Bold Men: 1965

Art Arfons and the Green Monster

(*L to R*) Kenneth Nelson, Reuben Greene, Frederick Combs, Cliff Gorman, Keith Prentice

The boys in the band

Boys in the Band: 1970

(*L to R*) Robert La Tourneaux, Kenneth Nelson, Frederick Combs, Keith Prentice

(*L to R*) Gene Hackman, Roy Scheider, Alan Weeks: "Poughkeepsie"

Gene Hackman: "Popeye"

Fernando Rey: "Frog One"

Phil D'Antoni, Gene Hackman, Jane Fonda, Friedkin—Academy Awards, 1971

The Exorcist: 1973

With William Peter
Blatty

With Jason Miller
and Ellen Burstyn

With Linda Blair

Linda Blair, Ellen Burstyn

Max von Sydow in Mosul, Iraq

Vasiliki Maliaros

Linda Blair, Max von Sydow,
Jason Miller

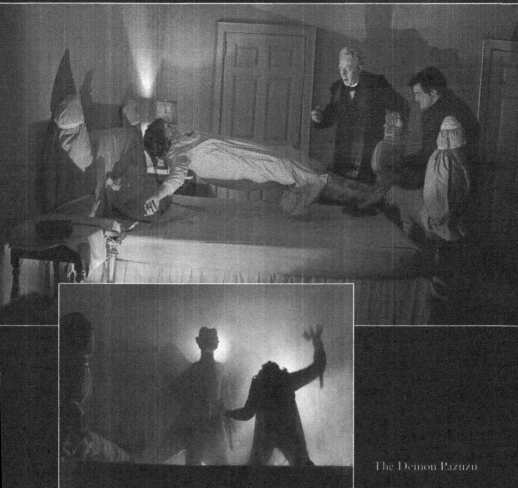

The Demon Pazuzu

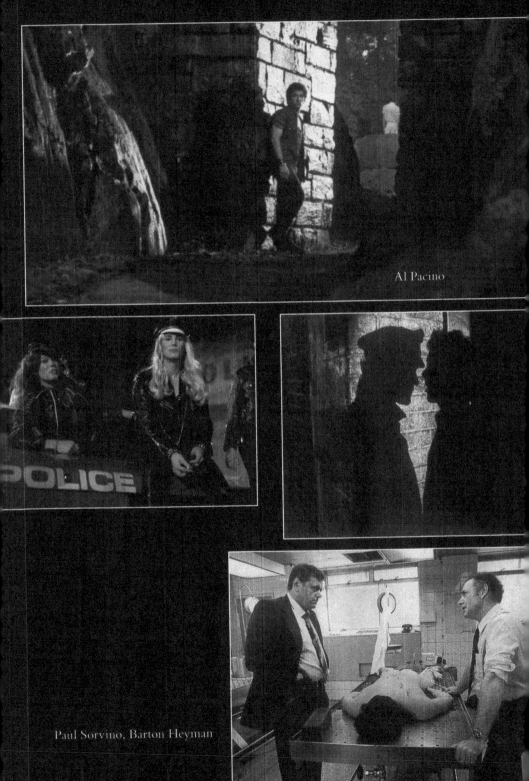

Cruising: 1980

Al Pacino

Paul Sorvino, Barton Heyman

membered the title cards. Then I threw in, "What picture are you rooting for?"

Without hesitation he said, "Yours," smiling.

"Well"—I shrugged—"we're not going to get there without your help." I looked around; still no other cars at the pumps. The Rolls waited forlornly, its passengers now milling around, depressed. Ed looked in vain for a taxi at the busy thoroughfare.

The guy sauntered back to his car. "If you win, you gotta promise me you'll call my wife. She'll never believe why I was late."

There were no cell or car phones in those days. "I swear I will. I'll even call if we don't win," I said. "You got a piece of paper?" He wrote his name and home number in pencil on a greasy old card from the gas station. It was after three o'clock.

The six of us jumped into the Ford. The women had to sit on the men's laps. We couldn't open a window because it would have ruined the women's hair, so the ride was stifling and seemed endless. The traffic was terrible, as expected. The absurdity of the situation somehow eased my anxiety. We were crawling toward the Music Center as our driver eased in and out of lanes. It was 3:50 p.m.

We turned off at Temple Street behind a long line of limos waiting to drop off at the Chandler Pavilion. About 4:10 p.m. we extracted ourselves from the Ford at the reviewing stand where Army Archerd, columnist for the magazine *Variety*, stood on a platform and briefly interviewed the nominees and celebrities as they entered the Chandler. Army had an uncanny talent for recognizing every person he ever met. I knew him fairly well, but when he glanced at the Ford pulling up in the long line of limos, he looked right past us to the next limo in line. This was not a good sign.

Between us we came up with two hundred bucks for our intrepid and gracious driver. He refused to accept it, but he yelled just before he pulled away, "Don't forget to call my wife!"

As we ran toward the main entrance of the Chandler, waving our tickets, I gave him a thumbs-up. "You're gonna win!" he shouted, and merged into the outgoing traffic.

After congratulating my film's nominees—Owen Roizman (camera), Chris Newman (sound), Gerry Greenberg (editor), Roy Scheider, and Gene Hackman—I made it a point to shake hands and wish good luck to my directing colleagues who were there: Franklin Shaffner, Peter Bogdanovich, and Norman Jewison. Kubrick would not leave his home in England, due to his aversion to flying.

When the lights go down and the show starts, if you've got a nominated picture, your anxiety level soars. You can feel the bad will in the hall from those who are rooting for your competition. For me, recognition by my fellow directors and members of the other Academy branches was an honor that will last the rest of my life.

The show was hosted by Sammy Davis Jr., Alan King, Helen Hayes, and Jack Lemmon. It started with a nominated song: Isaac Hayes performing the theme from *Shaft* with a great backup band and hot dancers. It rocked the room, lifting my spirits. We were nominated for eight Academy Awards, but the early returns were not promising. *Fiddler on the Roof* won for sound and cinematography; Ben Johnson won Best Supporting Actor for *The Last Picture Show* over Roy Scheider. Then, all of a sudden, Gerry Greenberg won Best Editor, the first New York–based editor ever to do so. Later, Tidyman won for his adapted screenplay.

Then came the Best Director category. Frank Capra was introduced and received the loud ovation he deserved. With him was Natalie Wood. They read out the nominees, and our faces flashed on the big screen. When Capra called my name, multiple images flashed through my mind's eye: my loving mother, my uncle

Harry, Paul Crump; Hitchcock . . . These and other people and places were with me as I ran up to the podium. This was unbelievable. Yes, I ran from my seat to the stage, as I remembered Frank Sinatra doing when he won the Best Supporting Actor Award for *From Here to Eternity*.

Mr. Capra handed me the statue and whispered quietly, "Terrific, you deserved it."

I thanked Phil D'Antoni, and the cast, but I forgot to thank Ed Gross and Tony Fantozzi. I thank them now. I thanked the members of the Academy for the tremendous honor, which I hoped I would one day be able to live up to. As we walked off together, Capra handed me "the envelope" and the card, which read: "And the winner is—William Friedkin." I did interviews in the press room, clutching my Oscar. Then I waited in the wings to see Hackman win and Phil D'Antoni pick up the Best Picture Oscar. In the end we took home five out of the eight major awards. Not exactly *Gone with the Wind*, but hey, ours was just a little cop picture.

As Phil and I left the theater, I thanked him again. "Phil, we've got the formula."

"No, kid," he said. "You do. I may do a couple more things, but then I'm done."

In high spirits, we all went to the Governor's Ball, where I accepted congratulations from people I didn't know. I was in a daze—elated and empty, a curious combination. We stayed about an hour at the ball, then got a lift from friends to Nicky Blair's restaurant on Sunset Boulevard, just west of the Strip. I promised my friend Nicky I'd come to his restaurant if we won, so I showed up with the Grosses, the Fantozzis, and the gold statue, which I placed in the middle of the table. People came by to touch and admire it. I looked at my watch—it was past 10:30. Nicky brought a phone

to the table, and I dialed a number in the Valley: the guy who gave us a lift to the Academy Awards. He put his wife on the phone, and I thanked them both. They were giddy with laughter at their part in our victory.

I thought back over the evening. The highlight of the show was an honorary award given for the first and only time *after* the Best Picture Oscar. During the commercial break, the winners and presenters stood on risers behind the closed curtain. In front of us, an attractive woman in her sixties, with jet-black hair tied in a bun, walked to center stage, holding the hand of a little man in a dark suit.

In front of the curtain, out of our view, Daniel Taradash, a distinguished screenwriter, then president of the Motion Picture Academy, was speaking to the audience: "Humor heightens our sense of survival and preserves our sanity." He was quoting the man about to be honored: "We think too much and feel too little . . . more than machinery, we need humanity . . . more than cleverness, we need kindness and gentleness." Then Taradash spoke his own words: "He has made motion pictures *the* art form of this century." Just before the curtain opened, the woman who was clutching the little man's hand squeezed it and hurried offstage. She was Oona O'Neill, daughter of Eugene O'Neill, and the man she'd walked to the stage was her husband, Charles Chaplin. A portion of the curtain opened, and he walked onstage in a solo spotlight: a short man, now heavyset, his crop of hair now thinner and all white. The audience leaped to its feet, applauding, screaming, crying, cheering. On the backstage monitors I could see Chaplin's twinkling eyes fill with tears as he acknowledged the ecstatic ovations and bravos. He had been banned from entering the country for twenty years. Now, here he stood, the "Little Tramp," one of the founding fathers of world cinema. Taradash presented him an honorary Oscar, and when the

audience response died down, Jack Lemmon appeared with the signature top hat and cane of the "Little Tramp." Chaplin tried on the hat, but it fell off. He smiled and kneeled to pick it up, but didn't try it on again. When the applause died, he spoke in a small, high-pitched voice: "Words seem so futile . . . so feeble. Thank you for the honor of inviting me here . . . you're wonderful, sweet people." He blew kisses to the crowd, and the curtain was raised to reveal all of us onstage behind him. We sang to him the song that had become his signature, "Smile," from his 1936 film *Modern Times.*

It was a moment of sincere deep emotion; no one who was there will ever forget it.

The first phone call the next morning after a late night was from Mel Stuart, my former mentor at Wolper: "Well, asshole, you fooled them again."

I felt let down, I couldn't get out of bed. Not since the death of my mother could I remember feeling so depressed.

"What the hell's wrong?" Ed Gross asked.

"I don't know, Ed, I can't explain it. I just don't feel I deserve this. Not at this time in my life."

"Billy, I think you better see a psychiatrist," Ed offered. "This should be the happiest day of your life." He got me an appointment to see a well-known shrink at his office in Beverly Hills. The room was dark, and I sat in front of his desk. There was no couch. We shook hands, and he picked up a yellow legal pad. He asked me to talk about myself, anything I wanted to tell him. I didn't know where or how to begin. I'm with this total stranger who never looked up from his pad, writing down everything I said without looking at me for the entire fifty-minute hour. I made up stuff. Total lies. I didn't feel comfortable discussing my deepest feelings with him. When it was over, he asked if I wanted another appointment. I said I'd call him, and got the hell out of there.

I never tried psychiatry again, but I did come away with an insight: the bar had been raised too high, too soon, and I didn't think I was skilled enough to sustain this acclaim with consistency. When I was finished with *The French Connection*, I was like a club fighter who lost thirty straight fights and got the shit kicked out of him before improbably winning a championship. Even though my arm was raised in victory, I was too beat up to bask in its glory.

Things took a turn creatively when I heard about a man named Slavko Vorkapich, dean of the Department of Cinema Arts at USC. In the spring of 1972, Vorkapich began a series of two-hour lectures at the Regent Theater in Westwood, for twelve Saturday mornings. Seventy-eight years old at the time, he was considered a master of film montage, most famously the earthquake scene in *San Francisco*. The term *montage* implies a passage of time through a series of overlapping visuals that suggest a sequence of events. So skilled did Vorkapich become in this technique that montages were often referred to as Vorkapiches. His work could be described as pure cinema.

No more than seventy to a hundred people attended each lecture, but I never saw anyone I knew from the Hollywood community. A small man with a flowing mane of white hair and thick glasses, he had an Eastern European accent, but his talks were inspiring. His theories gave me a new freedom that I continued to put into practice with each new film. The traditional way of shooting, let's say, a conversation between two people involves maintaining the correct screen direction. Vorkapich derided this practice, showing examples from various films. In the documentary *Man of Aran*, directed by Robert Flaherty, one sequence shows a man breaking a large rock with multiple blows of a sledgehammer. The man is seen bringing the hammer down from right to left, but

the close-up of the hammer hitting the rock is left to right; then the hammer comes down left to right, and we see in close-up the rock shattered, right to left. Shots of the man's face are intercut, changing screen direction as well. These shots are cut together rapidly, and seem to draw our attention to the action more intently than if the proper screen direction had been maintained. It was a kind of cinematic cubism. Vorkapich said the most important function of a film director was to immerse the audience so deeply in a sequence that they would not be conscious of screen direction.

When I first began to direct films, I followed the time-tested rules diligently. Do this often enough, and your creative freedom drops into a lockbox. Every generation rewrites the rules as the techniques of the past are absorbed. Contemporary audiences viewing masterpieces such as Jean-Luc Godard's *Breathless*, Alain Resnais's *Hiroshima mon amour*, or Fellini's *8½* would be hard pressed to recognize the innovations these filmmakers originated. The Vorkapich lectures increased my understanding of the possibilities of cinema.

6

THE MYSTERY OF FAITH

"Faith is the substance of things hoped for, the evidence
of things not seen."

—PAUL'S EPISTLE TO THE HEBREWS (11.1)

It was the era of the antihero. The temper of the times was ir-
rational fear and paranoia, both old friends of mine. Filmmakers
and audiences no longer believed in a man on a white horse. We
knew he was flawed because we were flawed. Dirty Harry shot a
suspect in cold blood, and audiences cheered. When Popeye shot
the French hitman in the back, at the end of The French Connec-
tion chase, there was applause in theaters across the country. When
Popeye used the N-word, African American audiences laughed,
because they saw it as an honest portrayal of police attitudes. The
films of the 1970s started to depict the moral ambiguity we recog-
nized in ourselves.

William Peter Blatty was born in the Bronx in 1928. His Leba-
nese parents came to New York City on a cattle boat from Beirut,
with Blatty's two older brothers and a sister. His mother was Mary
(Miriam) Mouakad, a feisty, hardworking woman. His father, Pe-
ter Michael Blatty, was a quiet man. One of Peter's first jobs in

New York was picking up loose paper in the subway with long poles, a sack tied to his shoulder.

The Blattys' religious roots were deep. Outside a monastery in the town of Harissa, in Lebanon, there is a statue of the Blessed Virgin. Blatty's great-uncle, Germano Mouakad, Bishop of Baalbec, founded this monastery in the early twentieth century.

When Mary Blatty applied for U.S. citizenship, a judge asked her, "Mrs. Blatty, why do you want to become an American citizen?" She answered, "For my children." Then he asked her a test question: "In the event of the United States president's death in office, who takes his place?" She answered, "His son." The judge laughed, corrected her, and granted her citizenship. He must have liked the first answer.

When Bill was three, his father left the family. He gave Bill a kiss on the forehead and was gone. Bill remembers him walking slowly from their tiny apartment building to the corner with one suitcase. He never came back.

While a freshman at Brooklyn Prep, Bill was living with his mother in a small, narrow room at the Pierrepont Hotel in Brooklyn, when early one morning the phone rang. His mother answered, listened for a moment, hung up, and said, "You father dead." At school, the headmaster called Bill to his office and said, "Blatty, I heard your father died. You can go home." "I hardly knew my father," Bill answered. "Go home," the headmaster said. At the funeral parlor, Bill saw his father in an open casket, knelt, and convulsed. He ran back to the hotel, his body racked with sobs. At that point, he started to build a defensive shield that few of his friends, relatives, or acquaintances have ever penetrated.

Mary raised the children alone. She made quince jellies and sold them in the street. Her favorite spot was Fifty-Eighth Street and Fifth Avenue in Manhattan, at the fountain in front of the Plaza

Hotel. Bill would watch her from the fountain. He has a photo of her near the Paris Theater, where she used to beg. He has another photo of that same theater, taken long after his mother's death, its marquee advertising "William Peter Blatty's *The Exorcist*."

When Bill was seventeen, his mother invited a woman friend for Thanksgiving dinner. The woman brought a date, a man called Neil Sullivan, who taught theology at Georgetown University. Sullivan had three helpings of Mrs. Blatty's mother's cooking, which pleased her. When the guests left, she said to Bill, "You gonna go to Georgetown." Bill thought it was ridiculous, if not impossible. They were virtually penniless, but no amount of discussion could change her mind. "Momma, how we gonna pay for that?" Bill was then pushing a Good Humor wagon through the streets of Brooklyn. "You gonna win scholarship," his mother assured him.

At that time, Georgetown, a Jesuit school, awarded only one full scholarship a year, based on the best performance on a seven-hour college entrance exam. You could take the exam at the nearest school that administered the college boards. Bill took it at Columbia University. He left the exam convinced he had failed: "If my father had been Rockefeller and endowed Georgetown with a hundred million dollars, they wouldn't have taken me based on my performance on that exam," he told me.

That summer, he was working in the Catskills as a waiter when the call came from Georgetown, telling him he had won the scholarship. In 1949, as a junior majoring in English literature and scholastic philosophy, he heard about a fourteen-year-old boy in neighboring Cottage City, Maryland, who was said to be the victim of demonic possession—only the third case of possession reported by the Catholic Church in twentieth-century America. Blatty heard about the case in a New Testament study class taught by Father Eugene Gallagher, a Jesuit priest. "He came into class all fired up

THE MYSTERY OF FAITH · 223

one day about a Jesuit who was involved in an exorcism. He gave us a number of details, some of which turned out to be incorrect. But there I am, at Georgetown, just in time to hear about this case! My immediate thought was, Wow, talk about validating one's faith! If it proved to be real—religious Nirvana! Gradually I began to think, maybe I could investigate the story myself and write about it, but not as a novel. I thought nonfiction was the only way to do this."

On August 20, 1949, an article appeared on the front page of the *Washington Post* that was the first mainstream account of what had happened. The account is straightforward, obviously from sources in the Catholic diocese of Washington, D.C. It begins: "In what is perhaps one of the most remarkable experiences of its kind in recent religious history, a 14-year-old Mt. Rainier boy has been freed by a Catholic priest of possession by the devil, Catholic sources reported yesterday." Not the sort of thing you'd expect to see on the front page of a major American newspaper. The article went on to describe the manifestations experienced by the boy and his family— mysterious rappings in the walls of their home, radical personality changes, words appearing on his chest, profanity, screaming, blasphemy, shouting Latin phrases, bloody scratches appearing on his arms, projectile vomiting, inhuman feats of strength, objects flying around the house, and other inexplicable events, including levitation.

The boy's family was Evangelical Lutheran, not Catholic. They had exhausted all medical, pharmaceutical, and psychiatric treatments available at the time in an attempt to cure him, to no effect. Luther Schultze, the family's minister, who had observed the manifestations, recommended the family consult the Catholic Church as a last resort, as the Lutherans had no experience with exorcism. According to the *Washington Post*, "The boy was taken to Georgetown University Hospital where his afflictions were exhaustively studied. . . . The doctors were unable to cure him through natural means."

The Catholic Church conducted a lengthy investigation to determine if this was an authentic case of demonic possession. There was scant precedent or documentation to verify this, but Archbishop (later Cardinal) Ritter decided with the approval of the family that an exorcism should take place. A young priest who had no knowledge of demonology, Father Albert Hughes of St. James Catholic Church in Mt. Rainier, was designated as the exorcist. But soon after he started the ritual, the boy ripped a metal spring from his hospital bed and slashed Father Hughes from shoulder to wrist, a wound requiring one hundred stitches. Father Hughes suffered a nervous breakdown and had to withdraw. Archbishop Ritter then had the boy moved to Alexian Brothers Hospital in St. Louis, where he appointed Father William S. Bowdern of St. Louis University as the exorcist, to be assisted by six other priests.

Father Bowdern was fifty-two years old in 1949, and was to figure some ten years later in Blatty's investigation into the case. The *Washington Post* article flatly stated that the boy was cured as a result of the exorcism. And it appears he was. As I write this, he is recently retired from NASA and appears to have no memory of what happened to him at the age of fourteen.

A winding, unpredictable road led Bill from Georgetown to Hollywood. In Los Angeles, he took a job in publicity at USC and auditioned for work as an actor. He was chosen to ghostwrite a best seller called *Dear Teen-ager*, by "Dear Abby." At a party given by the publisher, Bernard Geis, Blatty handed Geis a novel he had been writing called *Which Way to Mecca, Jack?* based on the experiences of his immigrant parents and his own adventures in Hollywood, posing as an Arab prince. Blatty became a comic novelist, receiving offers to write screenplays: *The Man from the Diners' Club* with Danny Kaye, *John Goldfarb, Please Come Home* with Shirley

MacLaine, the Blake Edwards films *What Did You Do in the War, Daddy?*; *A Shot in the Dark*; and *Darling Lili*, with Blake's wife Julie Andrews. And *Gunn*, the script that brought us together, then separated us.

In the fall of 1968, Blatty was ready to pursue the 1949 possession case that had remained in his consciousness for twenty years.

He went to a New Year's Eve party at the home of a friend, the novelist Burton Wohl, in Sherman Oaks, where he met the editor in chief of Bantam Books, Marc Jaffe. Bill had by then published four comic novels, none of them successful. Just to make conversation, Jaffe asked, "What are you doin'?" Blatty'd had a few drinks, so he found the courage to tell Jaffe about his idea for a story about demonic possession. He didn't speak for more than two minutes before Jaffe said, "I'll publish that." Soon Blatty received a contract from Bantam. Now, he *had* to write the book—but as fiction, since the facts of the original case were still unavailable to him.

He read everything he could find on the subject of possession and exorcism. There was little available. The Catholic Church was closemouthed about these cases, to protect the privacy of the victims. He tried to find a priest who had performed an exorcism but was unsuccessful. But through his former theology professor at Georgetown, Father Gallagher, he was able to contact Father Bowdern, who was living at the Immaculata Retreat House in Liberty, Missouri. Bowdern was then seventy-one years old. Though they never met nor spoke on the phone, a seven-year correspondence began between them.

From Father Bowdern's response to Blatty's first letter, October 17, 1968:

> As you stated in your letter, it is very difficult to find any authentic literature on cases of possession; at least I

could not find any when I was involved in such a case. Accordingly, we (a priest with me) kept a minute account each day of the happenings, each preceding day and night. . . . Our diary would be most helpful to anyone placed in a similar position as an exorcist. . . .

My own thoughts were that much good might have come if the case had been reported and people had come to realize that the presence and the activity of the devil is something very real.

And then, this chilling passage near the end of the letter: "I can assure you of one thing: The case in which I was involved was the real thing. I had no doubt about it then, and I have no doubts about it now."

He went on to write that he would be of assistance to Blatty on his novel within the limitations of preserving the victim's identity and under instructions from Cardinal Ritter, who ordered him not to publicize the case.

When he started to write *The Exorcist*, Blatty was divorced from his second wife, Beth. But he and Beth remained on good terms, and she let him use her one-room guesthouse in Encino Hills to work. He wrote from eleven in the evening until dawn, what he calls "dream time," which enabled him to access his unconscious mind. His goal was to produce three polished pages a day. "I thought of myself as a writer of comedies," he told me. "This one venture outside of comedy was going to be *it* for me—this story that had been festering inside me for twenty years—okay, I'm gonna do it. I've got nothing else to do but collect unemployment. No excuses. My hope was that it would be reviewed with respect, that I wouldn't be mocked, that's all I was hoping for."

His original plot was about a young boy who has been accused

of committing a murder; his defense in court is demonic posses-
sion. In that way, he felt he could introduce the history of pos-
session, going back to the New Testament. After Father Bowdern
asked him not to write anything that would reflect on the boy in
the actual case, he changed the character to a twelve-year-old girl.
The plot changed entirely when he started to write. He knew there
was going to be a possession, a priest/psychiatrist undergoing his
own crisis of faith, and a mother, an atheist, who comes to believe
in the idea of possession.

The novel was to be a supernatural detective story. Blatty's in-
stinct was to give readers a tingle by hinting at the existence of
spiritual forces, but he never thought of the story as being terrify-
ing. The details started to come to him, sparked by a statue he had
once seen in Mosul, Iraq, of the demon Pazuzu. In cases of posses-
sion, the invading entity, whether real or fanciful, is identified as a
demon, not Satan himself.

Blatty lived in all the places where the novel is set, and he
based the major characters on people he knew. Father Lankester
Merrin, the archaeologist/priest, is based on Gerald Lankester
Harding, whom Blatty met when he was stationed in Lebanon
for USIA. Harding was formerly curator of antiquities in Jeru-
salem, and was instrumental in the discovery of the Dead Sea
Scrolls. Another spiritual model for Merrin was Pierre Teilhard de
Chardin, the French Catholic priest who was also a scientist, and
whose philosophical writings are an attempt to reconcile religion
and science.

The mother, Chris MacNeil, was based on the actress Shirley
MacLaine, Blatty's friend. Chris is on location with a film on the
campus of Georgetown when her twelve-year-old daughter, Regan,
experiences the symptoms that lead to possession. The director of
the film within the film, Burke Dennings, who dies at the hands of

the possessed Regan, is a pitch-perfect portrayal of J. Lee Thompson, who produced and directed *John Goldfarb, Please Come Home*. Blatty based Father Karras, the psychiatrist/priest, on himself, channeling his own grief over his mother's death, which led to his first and only crisis of faith.

When Blatty turned the finished book in to Bantam, the publishers were enthusiastic. They held an auction for the hardcover rights, which went to Harper & Row, who assigned an editor who wanted two changes: to give Chris MacNeil fewer foul-mouthed outbursts, to which Blatty acceded; and to eliminate the prologue set in Northern Iraq. To Blatty, and later to me, the Iraq sequence was essential in creating an atmosphere of dread and ancient prophecy.

The novel appeared in the spring of 1971 to rave reviews, with few exceptions. Harper & Row spent a lot of money on advertising. Bill went on a twenty-six-city tour, but sales were poor. He describes the initial release as "a disaster." But just as Blatty was about to leave New York and return to Los Angeles, a Harper & Row publicity rep told him that *The Dick Cavett Show* had a guest cancellation and would put him on if he could get over there right away. When he took the stage, Cavett greeted him with, "I'm sorry Mr. Blatty, I haven't read your book," to which Blatty responded, "Then may I tell you about it?" He then spoke for more than forty minutes, interrupted by only one question from the host and a commercial break. Cavett's question was asked with irony: "Mr. Blatty, do you really believe in the existence of Satan?" Blatty's answer was that in every society, in every age, there is mention of an "evil magician" that spoils the work of the Creator.

The Cavett show was seen nationally, and within two weeks *The Exorcist* went from obscurity to number one on the *New York Times* best-seller list. Warner bought the rights before the novel was

published, offering Blatty $75,000 and hoping he would then disappear. They brought in Paul Monash, a successful writer/producer who had written the screenplay for *The Friends of Eddie Coyle*, and was executive producer of *Butch Cassidy and the Sundance Kid*. An accomplished pro, he saw a movie in Blatty's novel.

Blatty later learned, through files he obtained from a friend in Warner's legal department, that Monash had lowballed him: Warner's was prepared to pay $600,000 for the film rights. Monash had also agreed to make significant changes to the script without consulting Blatty, to "make it more commercial." He was planning to set the story in Salem, Massachusetts, scene of the seventeenth-century witchcraft trials, instead of Georgetown.

Blatty met with Frank Wells, then president of Warner Bros. and the architect of the Monash deal. He showed him the Monash memo and the document revealing the sweetheart deal. After denials of wrongdoing, the upshot was that Monash was kicked out and Blatty became the sole writer and producer, *and* recipient of the $600,000 fee plus thirty-seven percent of the net profits.

Frank Wells was a man regarded by many in Hollywood as a gentleman, with a reputation for integrity, but I always thought it extended only to where you were in the food chain. He and I had a cordial, sometimes abrasive relationship, and I found him a prime practitioner of the situational ethics that prevail in the film business.

When Stanley Kubrick, Mike Nichols, and Arthur Penn passed, Wells offered the film to Mark Rydell, a former actor and jazz pianist who had become a very good film director. He had just finished a film for Warner called *The Cowboys*, starring John Wayne, and the studio expected it to be one of their most successful titles. It was then that Blatty first suggested me as director. "Who?" Wells asked, incredulous. "Who's Friedkin? Do you

mean the guy who did *Boys in the Band* and those little art house films? No way!"

"I understand he has a terrific film coming out called *The French Connection*," Blatty said quietly. Wells laughed. "Bill, forget it. We're not giving *The Exorcist* to Bill Friedkin!"

He insisted Blatty screen *The Cowboys*, then in rough cut. Blatty reluctantly agreed and went into a screening room on the Warner Bros. lot. He came out after ten minutes and reappeared in Wells's office. Wells was behind his desk, and jumped as though he'd seen a ghost. "Bill, what are you doing here?"

"I've seen enough, Frank," Blatty said. "I want Friedkin."

By then, I had become obsessed with the novel and wanted desperately to direct the film. I put Blatty in touch with Tony Fantozzi, who knew Wells professionally and socially. Wells told Tony, "There's no chance of this happening." But Blatty pushed back. He called his lawyer, Charlie Silverberg: "Charlie, do I have director approval or not?" Charlie examined the contract. "Bill, you have *consultation*, not approval. If they want to hire Rydell or anyone else, you can raise hell, but they have the right to do it. It's not like they're forcing you to take chopped liver."

At that time, *The Exorcist* was still the number-one best-selling book, and Blatty was in demand on every talk show. He called Wells: "I'm going on the Johnny Carson show again in two nights, and I'm going to tell Carson and his audience that I didn't like *The Cowboys*, and you're forcing me to take the director."

"Bill, I beg you not to do that," Wells pleaded.

"You leave me no choice, Frank."

By then Wells thought Blatty was crazy enough and motivated enough to do anything. There are times in the movie business when it pays to be thought of as a dangerously psychotic person. Blatty tried to cultivate that reputation, and on occasion, so did I,

finding it useful in my dealings with the heads of production and advertising at Fox on *The French Connection*. Blatty would make outlandish threats, and people thought he would carry them out.

The French Connection opened the day Blatty was scheduled to appear on the Carson show. He called Wells, who invited him to come to Warner. When he arrived, Ted Ashley, Warner's chairman, and John Calley, head of production, were in Wells's office. They greeted Blatty cordially. Then Wells said, "Bill, is this about Friedkin?"

"Yes," Blatty answered firmly.

"We've seen *The French Connection*," Ashley responded. "We want him now more than you do."

I had no knowledge of the tenets of the Catholic Church. An agnostic believes the power of God and the soul are unknowable. That defines me. Like many, I feel the disconnect between the barefoot carpenter who preached on hillsides and the papal aristocracy; between the man who ate, slept, and taught in the desert and the man who takes his meals from fine china and silver in the majesty of the Vatican and controls billions of dollars' worth of real estate and banks.

I wonder what it is that draws me so obsessively to dark material. Saint Augustine, in his *Confessions*, written at the end of the fourth century, describes his fascination with "theatrical shows" as a young man: "Why is it that a person should wish to experience suffering by watching grievous and tragic events which he himself would not wish to endure? Nevertheless he wants to suffer the pain given by being a spectator of these sufferings *and the pain itself* is his pleasure. A member of the audience is not excited to offer help, but invited only to grieve. The greater his pain, the greater his approval of the actor in these representations. If the human calamities . . . are so presented that the theatergoer is not caused pain, he

walks out of the theater disgusted and highly critical, but if he feels pain, he stays riveted in his seat, enjoying himself."

Almost everything I've chosen to direct has portrayed "grievous and tragic events," pain and suffering, people with their backs to the wall and few alternatives. But while *The Exorcist* was a unique and original story, I didn't see it as a horror film; quite the opposite. I read it as transcendent, as Blatty had intended.

Fantozzi made my deal with Warner Bros.: $500,000, plus 10 percent of Blatty's 37 percent of the net profits, a princely sum for a director in the 1970s. When my deal was signed, Blatty said, "I've got a surprise for you," and handed me a 172-page script he'd already written! I took it home eagerly, read it, and hated it. He had eliminated the Iraq prologue, and the screenplay was rife with flashbacks and red herrings. Was this going to be *Peter Gunn* again? He said he'd hired me for my candor, so I gave it to him: "Why would you do this, Bill?" I asked him. "Your worst enemy wouldn't hand you a script like this."

"I never thought the book could be filmed as written," he admitted, "and I had no real idea how to do it."

"We need to start from scratch," I said. "A page-one rewrite. And I want to go back to the novel. I want to start with the prologue in Iraq and let the audience *slowly* experience the story as it unfolds."

When he had the impulse to hire me, he had not seen any of the four films I had directed. Much later, he saw *The Night They Raided Minsky's*, which he kind of liked, and *Good Times*, which he hated. Nor had he seen *The French Connection* until *after* he had proposed me to Warner Bros. and been turned down.

We started work on the script in January 1972. We set up offices at Warner Bros., and I immediately hired David Salven as production manager, to start putting together a budget and a crew, though we had no screenplay.

Blatty, Salven, and I went on a location scout to Georgetown, which I saw for the first time. Bill had captured the atmosphere of this beautiful, historic town. From Rosslyn, Virginia, across the Potomac and the Key Bridge looking west, Georgetown University resembles an abandoned castle or sanitorium. Even in bright sunlight, it appears dark and depressing. North of the university is a tall cliff, atop which you can see the backs of Federalist houses that face onto Prospect Avenue. At the northern tip of Prospect is the multi-tiered stairwell called the Hitchcock Steps, named after the designer who built them. Early mornings, the view from Rosslyn includes members of the Georgetown rowing team in sculls gliding swiftly across the Potomac. Just south of the steps is an elegant Federalist house, the one rented by Chris MacNeil in Blatty's novel. A wealthy widow, Florence Mahoney, who in 1972 was said to be the largest contributor to the Democratic Party, owned it. Through the auspices of my dear friend Jack Valenti, then chairman of the Motion Picture Association of America, former aide to Lyndon Johnson, Mrs. Mahoney was persuaded to let us use the exterior of her house for the film. The three-story house is on the corner of Thirty-Sixth and Prospect. It was perfect in all ways but one; it was too far from the Steps. Father Karras's climactic leap from Regan MacNeil's bedroom window down the column of stairs would have been impossible. Our solution was to build a false front that extended the length of the house and contained Regan's bedroom window. The false front continued around the corner and appeared to bring the bedroom window closer to the stairs, making Karras's leap possible.

We sought permission to film at Georgetown University, the pivotal setting of the story. Blatty was one of the university's favorite sons, and since it was a Jesuit school, the faculty and the Jesuit Order were comfortable with a story about the reality of demonic possession. The university was then under the leadership of Father

Robert J. Henle, who had come to Georgetown only a couple of years before. He was a lively, energetic man, a true Jesuit scholar and teacher. There was always a bottle of J&B in the lower left-hand drawer of his old wooden desk. He had been the academic president of another Jesuit school, St. Louis University High, and had written *Henle's Latin Grammar*, five highly respected volumes that are still widely referenced. He was an authority on philosophy and jurisprudence, having translated and summarized Thomas Aquinas's *Treatise on Legal Reasoning*. Immediately upon taking office in 1969, Father Henle made it his mission to raise Georgetown to the top rank of universities in the country, a task he was to achieve.

He and I became friends. He believed in the veracity of the 1949 case and felt that Blatty had written an essentially faithful, though fictional, account of it. He was also a friend of Father Bowdern, the exorcist, and Father Tim Halloran, who had been on the faculty at Georgetown and assisted Father Bowdern in the '49 case. Father Henle agreed to let me film in his office and the conference room next door and anywhere else on the campus. I used to meet him in his office at the end of his workday, and we'd share a glass of Scotch. One early evening he said, "I've got something to show you," and handed me a large, cracked red cardboard folder, tied with string. In it were twenty-nine pages of typed documents. I glanced through them and felt a chill. These were the collated diaries of the priests as well as doctors and nurses and other patients present during the 1949 exorcism.

I felt that Blatty's fiction had the ring of authenticity, and reading the diaries only reinforced my conviction. I discussed their content with Father Henle, who told me that the church took no official position on the case—in fact, it refused to discuss it—but all the accounts are replete with graphic, incredible detail. The dia-

ries were compiled by Father Raymond Bishop, and they begin on March 7, 1949. The exorcism took place in a secure hospital room on the fourth floor of Alexian Brothers Hospital in St. Louis, later at the boy's family home in Maryland, then back at Alexian Brothers. There were

rappings and scratching in the walls of the hospital room . . . furniture moving as though by an unseen force . . . the shaking of the mattress . . . sexual references to the priests and nuns . . . religious relics flying off the walls . . . agonizing shouts and screams that seemed to emanate from deep within the boy . . . curses, swearing and diabolic laughter, as well as gyrations and physical strength beyond his natural powers . . . blood, scabs and welts appearing on his skin . . . violent outbursts and attempts to kill the priests . . . the letters H-E-L-L appearing on his chest and these words spoken from the mouth of the boy by "another voice" and remembered by all the witnesses: "All people that *mangle* with me will die a terrible death."

For the most part, the boy would alternate between stable behavior and inhuman symptoms, between exhaustion and extraordinary stamina. The diaries were verified by more than fifty witnesses. They are still in the Jesuit archives of the Washington, D.C., diocese.

With deep conviction that the diaries were real and not a hoax, and my inherent belief that, as Hamlet says to his friend Horatio, "There are more things in Heaven and Earth, Horatio, than are dreamt of in your philosophy," I set off on a course that would alter my belief system and my life.

As we reworked the script, it became apparent that Blatty

tried to compress about 150 pages of the book into the first 30 pages of his first-draft screenplay. We cut all backstory and red herrings, but we weren't just making cuts; we were finding new possibilities.

I learned about a procedure to diagnose brain damage, called an arteriogram, which I was able to see at the Department of Radiology at NYU Medical Center. I thought it would be a powerful addition to have Regan undergo this procedure to underline the frustration of medical science in determining the cause of her "illness." When I described it to Bill, he immediately put it into his screenplay.

Bill's friend and mentor, Reverend Thomas Bermingham, who taught classical Greek at Fordham and who became an adviser to me as well as appearing in the film, introduced me to Reverend John Nicola, a priest who had studied at the Vatican and written a doctoral thesis on possession. He was then assistant director of the National Shrine of the Immaculate Conception in Washington, D.C. I met with Father Nicola, and he agreed to help me understand the ritual and to clarify its most significant passages. I asked Bill to incorporate Nicola's belief that when a particular phrase seemed to agitate and affect the demon, the exorcist would repeat it. In our film, the phrase is: "The power of Christ compels you!" repeated several times to bring Regan down after the demon has raised her off the bed.

A tall gray-haired man with deep-set eyes, Father Nicola was the acknowledged expert on all reported cases of possession in the United States. He remained a skeptic and never performed an exorcism himself. Without question, he believed in the authenticity of the 1949 case, and he's quoted as having said Blatty's novel was 80 to 85 percent accurate. But after the release of the film, he gave interviews in which he claimed he could justify everything from

a moral standpoint, including the language, but with the exception of the crucifix/masturbation scene. Because of the controversy the film generated, Nicola backed away from all the advice, support, and expertise he had given me. Blatty was asked to comment about Nicola's new public stance toward the film, based on that one scene: "The people who complain [about this scene] are the people who think that stained glass is a religion. The crucifix in the movie is a piece of metal, and that's all. . . . I wasn't going to make the Devil manageable by compromising. The characteristics of the Devil come through in the girl's masturbation with the crucifix. That was the most horrible thing that came to my mind, and that's why it's in the film. We're not condoning the action. There is no sacrilege."

The novel was 340 pages. A 100-page screenplay, more or less, would result in a two-hour film. We worked for several months as David Salven assembled the crew and we started talks with Nessa Hyams, head of casting for Warner Bros. Ted Ashley told me he wanted Audrey Hepburn, Anne Bancroft, or Jane Fonda to play Chris MacNeil. Excellent choices. And with Blatty's and my blessing, the studio offered the role first to Audrey Hepburn, who responded favorably, but said she would only do the film in Rome, as she was living there, married to an Italian doctor. I thought it was a *request* on her part, not a condition. No way did I want to film in Rome; it was impractical from every standpoint. All other actors would have to be imported from the United States, and I didn't want a language barrier with the crew. In fact, I wanted my crew from *The French Connection*, starting with Owen Roizman and Ricky Bravo. We asked Ms. Hepburn to reconsider, but she declined.

Anne Bancroft said she'd love to play Chris, but she was preg-

nant; would we wait a year for her? We wished her *mazel tov*. Jane Fonda sent us a telegram after receiving the script: "Why would *anyone* want to make this piece of capitalist rip-off bullshit?" I never learned how she really felt.

At one point during these maneuverings, I had a phone call from Ellen Burstyn: "Do you know who I am?" she asked.

"Yes, of course," I lied. She was considered a very good actress. She was in *The Last Picture Show*. But I frankly didn't remember which role she'd played, and I tended to confuse her with Cloris Leachman.

"I'd like to talk to you about Chris MacNeil," she said.

A pause, while I considered a response. "Ms. Burstyn, I have to tell you the studio is out to Audrey Hepburn, Anne Bancroft, and Jane Fonda."

"I'm just asking if you'll meet with me," she said. "Do you believe in destiny?"

"Do I believe in destiny? I don't know. . . . Yeah, I guess so."

"I'm destined to play that part," she said. "I know in my heart that role is mine." We arranged to meet at her house on Beechwood Drive. It was on my way home.

Ellen's house was in the hills above the Hollywood Freeway, where you could hear music from the Hollywood Bowl when there was a concert. The house was old, large, and had few items of furniture. Her son, Jeff, met me at the door. He was a pleasant kid, about fifteen years old. He told me he liked rock and roll and wanted to be a musician. Ellen was a single mother, long separated from her husband. After a few minutes she appeared, barefoot in a long brown shift. She was passionate, intense, focused, and highly intelligent. She told me about her Catholic girlhood and how she had left the church and was now studying to become a Sufi. We discussed the novel for a couple of hours, and I thought she had

an acute understanding of it. Yet I didn't think the studio would approve her.

Blatty also suggested his friend Shirley MacLaine, who had recently made a film called *The Possession of Joel Delaney*. As much as I admire and respect Shirley, I thought that *two* films with her, about demonic possession, were one too many. She recognized herself as the model for Chris MacNeil, and her company offered Blatty $75,000 for the rights, plus 5 percent of the net profits but no creative participation in the making of the film. Bill turned it down but still thought Shirley would be right for the role. The studio would have been happy with her, but they began deferring to me on a number of creative decisions.

One of the actors who wanted to be considered was Roy Scheider, Roy was in demand after his Oscar nomination for *The French Connection*. I thought he'd be good as Father Karras, but Blatty felt he was not sympathetic. Nessa Hyams suggested Stacy Keach, who had appeared in some of the seminal films of the late 1960s: *The New Centurions, Fat City,* and *DOC*. Just thirty years old, he was one of the most distinguished stage actors in the country, with leading roles in the plays of Shakespeare and Eugene O'Neill. Blatty and I met with him and liked him, and Warner agreed. They signed him.

I was in New York scouting locations when I read a review of a new play called *That Championship Season* that had recently opened at the Public Theater. It was set during the twentieth reunion of a basketball coach and his starting five, who won a state high school championship in a small town in Pennsylvania. In the course of a drunken evening, it becomes clear that at the urging of the coach, the team had cheated to win the game. Their victory was a fraud. Their lives were a fraud. There was a photo in the *New York Times* of the young playwright, Jason Miller. This was his first produced

play. He had an interesting look, and his biography was even more compelling. He had worked as an actor in off-Broadway plays and road companies, but was barely able to make a living. He had a regular job as a milk deliveryman in Flushing, New York, where he lived with his wife, Linda, and two young sons.

I *had* to see his play, possibly because it was about basketball, but more likely because of Fate. It was riveting—funny, disturbing, beautifully written and acted. The play was about America's obsession with winning at any cost. It held me as it did the audience, the critics, the Tony Award voters, and later the Pulitzer Prize committee. I asked our New York casting director, Juliet Taylor, to set up a meeting for me with Miller. I don't know why. His picture and bio in the *New York Times* intrigued me, as did his play, which portrayed the spiritual conflicts of a group of Irish Catholic men. I felt some *need* to meet with him.

Whatever I was looking for, I didn't find it in our first meeting. I was staying at the Sherry-Netherland and fighting a cold. I had prescription pills everywhere. Jason later told me he thought I was a pill freak. He had no idea why I wanted to meet him; perhaps he thought it was to buy his play for the movies. When he came to my suite at the Sherry, he was distant and reserved. He was also short, about five-seven, and I thought he was stoned. He told me he had studied for the priesthood at Catholic University in Washington, D.C., but dropped out in his third year, having the same crisis of faith as Father Karras, while continuing a love/hate relationship with the church. I told him how much I loved his play, and he thanked me. When I told him I was planning a film of *The Exorcist*, he seemed only mildly interested. He was overwhelmed with all the attention being afforded *That Championship Season*, and had not read the novel.

I continued meeting with Ellen Burstyn. Having started with

the certainty that she would never get this role, I soon became convinced that she was our best choice.

"No way!" Ted Ashley shouted from behind his desk. "I'm not giving the lead in this picture to a woman who's never played a lead in anything!" He was furious. "Ellen Burstyn will play this part *over my dead body*." At which point he walked to the side of his desk and lay down, faceup, on the floor. "Go ahead," he said to me, "try to walk over me."

"Ted . . . ," I started to protest.

"Go ahead," he shouted, "I dare you." I shrugged, then walked to where he was lying, to step over him. He quickly grabbed my leg and held it tightly so I had to lean on his desk for balance. "You see!" he shouted triumphantly. "That's what'll happen if you try to cast Burstyn. I'll come back from the dead to stop you!" But alas, the studio had no other choices, and eventually Burstyn was approved.

I got a call from Jason Miller in New York: "Hey, how ya doin'?" he asked cheerfully, as though we were old buddies.

"Congratulations on your play," I said. It was going to Broadway in the fall.

"Listen," he said, "I read that book you told me about. That *Exorcist*. That guy is me."

"What guy?"

"Father Karras." I would have ended the conversation if I didn't respect him as a playwright. "I appreciate your interest, but we've signed an actor." He went on as though he hadn't heard me: "I'm telling you, I *am* that guy. Will you at least shoot a screen test with me?"

"We've cast the role!" I shouted.

"I don't care—"

"You don't *care*?"

There was *something* in his voice—his insistence, his passion—which was irresistible. "As long as you understand we have a pay-or-play deal with another actor for this part, you can come here on your own nickel, and I'll shoot a test with you."

"Great," he said.

"How soon can you get here?" I asked.

"About a week," was his answer.

"A week! Why don't you fly out tomorrow?"

"I don't fly, man. I'll take a train. Be there in four days."

Blatty and every executive at the studio were now convinced I'd lost it, but I set up a test for Jason on an empty stage at Warner Bros. and recruited Ellen to work with him. I asked my friend the cinematographer Bill Fraker, who'd shot *Bullitt* and *Rosemary's Baby*, to light the scene where Chris tells Father Karras she believes her daughter is possessed. After a few takes, I had Ellen interview him about his life and kept the camera over her shoulder on his face.

Then I shot a close-up of Jason as he said Mass, and I asked him to say it as though for the first time, to discover the meaning of the words, not rattle them off as I heard so many priests do. He seemed relaxed in front of the camera, but I wasn't knocked out. Ellen took me aside: "You're not going to cast *him*, are you?"

I was surprised by her question: "Why not?"

"Oh Billy, come on," she said. "He's too short, and he's not really an actor. When I break down in that scene, I need to fall into Karras's arms. I need a big, strong man . . ."

It happened that Ellen was dating "a big, strong man" at the time, a fellow actor she asked me to audition. I did and was unimpressed. The next morning, I screened Jason's test. The camera loved his dark good looks, haunted eyes, quiet intensity, and low, compassionate voice. He had a quality reminiscent of the late

John Garfield. The fact that he had a Jesuit education and had studied for the priesthood sealed the deal for me. I ran the test for Blatty and the Warner executives. "This is the guy," I told them.

"What's wrong with Stacy Keach?" Blatty asked.

"Nothing, but this guy's the real deal."

Frank Wells spoke up: "We have a contract with Keach."

"Pay him off," I insisted.

Wells was livid: "You just *cast* him."

"I was wrong," I said. "Jason Miller is going to explode in this part."

The other major roles were quickly cast. Blatty showed me a photograph of Gerald Lankester Harding, his inspiration for Father Merrin. Harding was lean and gaunt, with close-cropped white hair. The image of Max von Sydow came immediately to mind. Max had been Ingmar Bergman's leading actor in classic films like *The Virgin Spring* and *The Seventh Seal*. We sent him a script in Sweden, where he lived, and got an immediate response. He would be pleased to play Father Merrin.

The casting of Lieutenant Kinderman was another unexpected gift. Blatty and I went to see a play in the San Fernando Valley. An actor in the play was suggested to us for a key role. We didn't respond to the actor, but there was someone in the audience that night, a few rows ahead of us: Lee J. Cobb, immortalized for his performances as Willy Loman in *Death of a Salesman*, Juror Number Three in *Twelve Angry Men*, and Johnny Friendly in *On the Waterfront*.

With Cobb and von Sydow cast, we had a solid foundation, but the biggest problem would be to cast Regan. For four months in 1972, half a dozen casting directors around the country put hundreds of young girls, ages eleven through thirteen, on videotape.

Over a thousand girls eventually auditioned. I watched the tapes, if only for a minute or two, and personally interviewed at least fifty girls. It seemed hopeless. The question was not only whether a child could portray the character's *innocence* as well as her *possession* without self-consciousness, but how she would react to the experience itself. How would it affect her life? None of the girls I met seemed likely to overcome those obstacles. I thought about Mike Nichols's reason for declining the job—"You'll never find a twelve-year-old girl to carry the picture." We started to audition fourteen-, fifteen-, and sixteen-year-olds who looked younger, with similar results. One afternoon at my office in New York, my secretary buzzed me: "There's a woman out here named Elinore Blair. She doesn't have an appointment, but she brought her daughter and wonders if you'd see her"

She was smart but not precocious. Cute but not beautiful. A normal, happy twelve-year-old girl. Her name was Linda Blair. Her mother was quiet, pleasant, not a "stage mother." Linda was represented by an agency that suggested ten other girls to us. Not her. She had done some modeling, no acting. Her main interest was training and showing horses, for which she won a lot of blue ribbons. She was a straight-A student in Westport, Connecticut. I found her adorable. Irresistible. I asked her if she knew what *The Exorcist* was about. "Well . . . ," she said thoughtfully, "it's about a little girl who gets possessed by the devil and does a whole bunch of bad things. . . ."

I nodded. "What sort of bad things?"

"Well . . . she pushes a man out of her bedroom window and she hits her mother across the face and she masturbates with a crucifix." I looked at her mother. She seemed to realize her daughter was special. Linda was unperturbed.

"Do you know what that means?" I asked her.

"What?"

"To masturbate."

"It's like jerking off, isn't it?" she answered without hesitation, giggling a little. I looked again at her mother. Unflappable. "Have you ever done that?" I asked Linda. "Sure, haven't *you*?" she shot back. I'd found Regan.

I asked her to come back to Los Angeles and shoot a test. Clearly, she was not troubled by the language or the substance of the film, but I had to be sure she could sustain the character, and I needed the approval of Blatty and Warner Bros. I asked Linda to prepare a few of the early scenes, and Ellen and I worked with her, but you could see her "acting." I kept the camera rolling and had Ellen interview her, as she had Jason. Talking about herself and relating to Ellen, Linda was spontaneous, and I realized I had to create an atmosphere on the set where she could *be* spontaneous, not worry about doing scenes word-for-word.

Blatty introduced me to Father Bill O'Malley, who taught English and theology at McQuaid Jesuit High School in Rochester, New York. He was in his early thirties when he first met Blatty and criticized the portrayal of Father Dyer in the novel. He thought Dyer, as written, was a cliché. Blatty was amused by his criticism, but we were both impressed with his sense of humor and good nature. I was spending a lot of time with Jesuits and I thought O'Malley embodied their keen intellect and scholarship. I asked him to *play* Father Dyer.

I began to immerse myself in the New Testament and the Jesuit order. On one occasion I received Holy Communion and later told Blatty what a moving ceremony it was. He thought I had unwittingly committed a sacrilege and phoned the officiating priest to

apologize. The priest told Blatty not to be concerned: "It can't hurt him."

One Sunday morning about a month before filming began, I invited Blatty and Father O'Malley to spend a weekend with me at a beach house I was renting on Long Island. O'Malley said Mass, using a bagel and cranberry juice, as I had no bread or wine in the house. The words of the Mass have continued to move me ever since, and on that occasion, they moved me to tears.

So much has been written about the "freedom" young filmmakers enjoyed in the '70s. In fact, Coppola on *The Godfather*, Spielberg on *Jaws*, myself, and others were often at odds with studio management, usually over budget and schedule. We were constantly on the verge of being fired. Blatty and I created a scenario that would keep the studio at arm's length. At the first production meeting, to decide where and how we would make the film, we met in the offices of Charlie Greenlaw, head of physical production, with his assistant, Ed Morey. David Salven and Blatty joined me. Greenlaw and Morey were tough old-school guys who would usually dictate terms to producers and directors. Blatty and I pretended to be on our best behavior, listening carefully to the cost-cutting measures they wanted to impose. At one point, I said, "You know, I've given this a lot of thought, guys, and I think I have an idea how we can save some money." All eyes turned to me. I looked at Blatty, who knew what was coming; we had rehearsed it. I produced a sheet of paper filled with meaningless numbers and pretended to refer to it. "We have to serve lunch and sometimes dinner to the cast and crew, so I've worked out a plan that I think could save us, at least fifteen grand."

"What's that?" Blatty asked, feigning genuine interest.

ME: I think we should serve just *one* salad dressing, not give everybody a choice of several.

Greenlaw and Morey turned to each other, then back to me. Could I be serious?

ME: By my calculation, the least expensive dressing would be oil and vinegar or vinaigrette.

A long uncomfortable pause, then . . .

BLATTY (calmly): I think it's a great idea, Bill, but I don't think it should be oil and vinegar.

ME: No?

BLATTY: Personally, I prefer Green Goddess.

ME (with mock solemnity): Green Goddess! Bill, you can't serve Green Goddess to the crew. These are meat-and-potato guys. They want oil and vinegar or vinaigrette.

BLATTY (annoyed): Billy, I don't care about the crew!

ME (incredulous): You don't care about the crew? I have to work with them every day.

BLATTY (now angry): Well . . . I'm the producer, and you've got to work with me every day! And I happen to prefer Green Goddess!

I stood up.

ME: Fuck you and your Green Goddess!

There was tension in the room. Production hadn't begun, and

Blatty and I were already screaming at each other. Bill stood and shouted, "Call me when you've come to your senses!" And with that, he turned and left the room. Dead silence. Salven was doing his best to suppress laughter. Then Greenlaw quietly asked, "Does this happen often?"

"Every day," I said, and suggested we move on. This little caper kept the Warner's executives away from us. They thought we were both crazy enough to blow up the production.

With reluctance, Morey offered that there were too many night locations in the script. Night shooting is very expensive and time-consuming, requiring big lights and lots of electricians. He suggested we shoot all these scenes "day for night," which is only possible on an outdoor *studio* set, draped with large black covers to block out all daylight while the scene is lit for night.

I said, "But Ed, we don't have any studio street scenes."

"We can shoot all the Georgetown exteriors right here on the backlot," he responded. I had recently won an Academy Award for direction, but I gave the impression of being dumber than a first-year film student: "Ed, what exactly *is* day for night?" He explained it to me, simplistically and at great length.

"Yeah," I said, not seeming to grasp it. "But we're going to shoot *all* the Georgetown scenes in Georgetown."

"Jesus, that would cost a fortune," he said. "We could paint all the buildings black," I said.

"What?" Greenlaw asked.

"For the night scenes, we obviously can't tent in the Georgetown streets, so why don't we just paint all the buildings black?" I suggested.

"You're not serious." Morey tried to laugh it off.

"Oh, and by the way, we'll be doing all the New York exteriors and interiors in New York," I informed them.

"Why?" Morey and Greenlaw asked in unison.

"The script calls for a New York tenement street and a subway station, also Bellevue Hospital and various doctors' offices which we can do on practical locations. But more important, you know the laws governing child labor in Los Angeles are tougher than they are in New York. In L.A., we'd have Linda for only four hours a day. After that, she'd have to have two hours of rest followed by two hours of tutoring. In New York, we can shoot ten to twelve hours with her, as long as her strength and energy hold up, and she only needs to be tutored between set-ups."

I had always planned to shoot in New York, to get away from the studio and the bosses and the L.A. culture. I didn't want to drive to the Valley every morning, past shopping malls, to re-create Georgetown. "The house interiors will be built on a stage in Manhattan," I continued. "We can do it all with a New York crew, and it would be cheaper to take *them* to Georgetown than an L.A. crew."

"How much is this going to cost?" Greenlaw asked Salven.

"I have no idea," Salven said.

"Haven't you been working on a budget?" Morey asked.

"Yes, but I don't know how we're going to do the special effects or how much *they'll* cost," Dave explained. "This stuff has never been done, it's all experimental."

I was told that the studio hoped to make the film for $5.4 million, but I never saw a budget. All I kept hearing was that we were *over* budget every day.

We set up in New York, and I didn't see any of the bosses for the entire shoot. Greenlaw visited the set twice, stood in a corner, then went up to the production office to meet with Salven and crunch numbers. Word came back through Fantozzi that Wells was freaking out and wanted to fire me. He invited Tony to his home in

Beverly Hills and, over drinks, complained about the various acci-
dents or problems that kept raising costs. Years later, Tony told me,
"I don't think they knew what to do if they fired you. It was such
an off-the-wall project, who would want to step in? I used to say to
Frank, 'You've got this guy till death do you part.' "

I worked with John Robert Lloyd on *The Night They Raided
Minsky's* and *The Boys in the Band*, and he also did the sets for
Midnight Cowboy. We leased a soundstage at F&B Ceco, a large
old facility on West Fifty-Fourth Street and Ninth Avenue where
John was going to re-create the interior of the Mahoney George-
town house: "A red brick Colonial gripped by ivy" near "a fringe
of campus belonging to Georgetown University," next to "a sheer
embankment plummeting steep to busy M Street." Blatty made
it an important character in the story, as he did Georgetown it-
self.

I asked John to design the interior of the house to reflect the
Colonial style, but to make the rooms larger and all the walls
"wild" so we could move the camera freely. Half in jest, I told him
I never wanted to see the colors pink or chartreuse anywhere on the
set, never thinking he would actually use them. We had to build
Regan's bedroom as a separate, free-standing set, on top of a large
ball bearing so it could be pitched and rolled during the exorcism
sequence.

Shortly after the interior of the "MacNeil House" started con-
struction, what I saw shocked me. There were curved archways, not
common in a Colonial interior; the ceilings were too low to allow
overhead lighting; the rooms were too small to allow for depth or
complex staging; and worse, there were paint samples on the walls:
pink and chartreuse!

John Lloyd was nowhere to be found. He had been going
around New York for several days, being photographed with Linda

Blair as "Regan's father," for family pictures to be placed around her bedroom set. I hadn't asked him to do this, nor did I see him as the ideal person to "portray" the absent father. Literally hundreds of photos were taken with John and Linda, none of which were usable. When I confronted him, he had no response, no excuse. It was a nightmare, but I had to fire him.

Salven suggested a young designer named Bill Malley. Malley had no feature credits, only a handful of television shows, but Dave had problems finding an experienced feature designer to take over. The top people in the creative areas of filmmaking are reluctant to replace a colleague, especially a respected one. But Malley had nothing to lose. He seemed pleasant enough, and as we were about to start shooting, without having seen any of his work, I hired him.

Production was to begin August 14, 1972. Three months before that, Salven and I had selected a team of five special effects men and sent them to New York to begin experimenting. The team was led by Marcel Vercoutere, who moved with his wife and young child to the basement of the soundstage on West Fifty-Fourth Street. Marcel and his crew worked twelve- to fifteen-hour days to achieve the levitation, bed movement, head spinning, and all the effects the script required. Everything had to be done mechanically. Marcel would call me in to see their efforts, and it became a process of trial and error, but he and his crew were tireless. They'd show me an effect, I'd criticize it, they'd make corrections. Without this lengthy advance preparation, none of the effects would have been achievable.

Along with the special effects team, I hired Dick Smith to begin preparing makeup for the various stages of Regan's possession. Dick created special makeup for *Little Big Man* and *The Godfather*. He first made an impression of Linda Blair's face, which he took

to his studio in upstate New York, where he began to sculpt various horrific masks. The most highly respected makeup artist of his time, he trained some of the best at work today, including Rick Baker, who was his assistant on *The Exorcist.* Dick could be temperamental in defending his work, and on a number of occasions he was ready to quit. He showed me various attempts to turn the face of an innocent, angelic child into that of a violent, raging demon. I rejected his early efforts, not because they weren't good, but because they didn't seem to be *organic.* They concealed too much of Linda's own features, which I felt were essential to convince an audience this was happening to *her.*

There's a brief scene in the novel and screenplay where a metal crucifix is discovered under Regan's pillow in her bedroom. She later uses the crucifix to slash her vagina. Could we not assume she used it to disfigure her facial features as well? Then, as the film progresses, the demonic makeup could evolve out of these gangrenous self-inflicted wounds. I presented this idea to Dick Smith, and he embraced it. He brought me a medical textbook that showed the effects of gangrenous wounds on burn victims. From these he created the demonic makeup that would worsen throughout the "possession" scenes. After weeks of experimentation, Linda's makeup required three hours to apply each day and an hour to remove.

Blatty and I knew that criticism would come from the Church if the film was perceived to conflict with doctrine, but I also consulted with prominent doctors—Norman Chase, professor of radiology at NYU Medical Center, as well as two prominent physicians, Drs. Herbert Walker and Arthur Snyder, so that the details of internal medicine and psychiatry would be accurate. I asked each of the specialists if the early symptoms experienced by Regan were possible and if they would have been diagnosed

and treated as depicted, with psychiatry, hypnotherapy, radiology, even confinement in a mental institution. These doctors had all witnessed similar behavior, and it seemed to resemble hallucinations derived from paranoid schizophrenia. Yes, that was how they would have treated it within their known disciplines, up to the point of the manifestations that led to the possibility of possession. As the clinic director in the film reluctantly suggests after a thorough examination of Regan: "There is one outside chance of a cure. . . . I think of it as shock treatment . . . it's purely force of suggestion . . . the victim's belief in possession is what helped cause it, so in that same way, the belief in the power of exorcism can make it disappear."

Before we started production, I rehearsed every scene, with the exception of the Iraq sequence, in a storage room on the top floor of Al & Dick's restaurant on West Fifty-Fourth Street. This was my hangout, where D'Antoni and I first met Eddie Egan and Sonny Grosso. We were able to approximate our various sets. The rehearsals were a way for the cast to get to know each other and discover their characters. But by the time we started to film, their performances became "frozen."

The best films I've made are the ones where you can't *see* the acting, where the actors embody their characters, and their performances are allowed to breathe. By rehearsing to an obsessive degree, I'd squeezed the life out of the performances. I could see this happening in the first few days of shooting. What was most important to me was spontaneity, not perfection, so I told the actors to forget everything we'd rehearsed, which is like a judge telling a jury to disregard the testimony they've just heard. I told them they could change the words, as long as the ideas and plot points were maintained. I would never do this with a classic text, but it's often done with contemporary dialogue. Acting is *reacting*,

listening to what the other characters are saying, hearing them as though for the first time, and responding without preconceived line readings.

Principal photography began at the Goldwater Memorial Hospital on New York's Welfare Island. We decided to film the New York locations first in order to give Malley time to redesign and build the interior sets for the Georgetown house. The scene at the hospital involved Father Karras and his uncle John visiting Karras's mother in a hospital ward of mentally ill female patients. Most of the women in the scene were actual patients I filmed with hidden cameras, to enhance the atmosphere of poverty, illness, and depression that marked the end of Mrs. Karras's life.

Karras's mother was played by Vasiliki Maliaros, a woman my extras casting director, Lou DiGiaimo, discovered in a Greek restaurant. Karras's guilt over his failure to provide for his ailing mother brings on his crisis of faith. I felt that Karras, not Regan, was the real target of the demon; the goal, to cause the priest to perceive the human condition at its worst and thus surrender his beliefs. For the hospital scenes, I had Karras's grief-stricken dying mother confined to her bed in arm restraints. At the appearance of Karras, she cries and thrashes around, like Regan during the possession scenes. I looked for other ways to link the mother to the possessed girl as a way of focusing Karras's sorrow and guilt. At one point, while in the bedroom with Regan alone, he sees his dead mother staring at him from her bed. This happens just before he hears his mother's plaintive cry from Regan's mouth: "Why you do this to me, Dimmy?" And later, during the exorcism, the demon taunts Karras: "You killed your mother! You left her alone to die!" In a small apartment on East Twenty-Third Street, we filmed the scene between Karras and his mother before she's hospitalized.

With a few brief strokes, I could show their loving but troubled relationship.

One of the early scenes in *The Exorcist* was set in the New York City subway, where Karras is asked for money by a drunken beggar who says, "Can you help an old altah boy, Fadda, I'm a Cat'lic?" Lou DiGiaimo searched the bars of Manhattan looking for a real alcoholic. He found Vinny Russell, who was in his forties but looked twenty years older; his address was the White Rose Bar on Fourteenth Street. Lou kept Vinny supplied with drinks at the White Rose for several weeks until we were ready to shoot, then brought him to the subway station in Grand Central where the scene was to be shot. He wore his own filthy clothes. I told him how I wanted him to say the line, which had to be coordinated with a subway train passing behind him. Vinny was drunk the entire night and kept asking when he could go "home" to the bar. It took five hours of filming to get him to say the line convincingly. It was recorded with a lot of background noise, so about seven or eight months later, after filming was completed and edited, Lou brought Vinny, drunk as ever, to the recording studio to postsync the line he had said months before. He had no memory of having filmed the scene. When he saw his face on the screen, appearing again and again in a loop, he thought he was in an alternate universe. I told him he had to repeat the line in sync with the way he had said it originally. He had no idea what I was talking about. We recorded this one line for two hours until finally I said, "Great, we're done," at which point Vinny, who never acted before or since, stood up from behind the microphone and announced, "I ain't gonna work for *that* director no more!"

Bill Malley was able to quickly reconstruct the interior of the Georgetown (Mahoney) house and the separate bedroom for spe-

cial effects. Together with the set decorator, Jerry Wunderlich, he made the house interior look as good as the original. Wunderlich was able to rent master paintings, fine rugs, and period furniture. Ellen and Linda developed a rapport that allowed their scenes together to become effortless. The scene where Chris is putting Regan to bed and Regan suggests she thinks her mother is having an affair with the director Burke Dennings is one of my favorites in the film. I shot it with two cameras—one a close two-shot, the other over Chris's shoulder to Regan. Owen used long lenses so we could keep the cameras far enough away to be unobtrusive. It was done in one take. Another favorite scene is between Kinderman (Lee J. Cobb) and Chris, where he shares with her his confusion over the death of Burke Dennings, who seems to have fallen or "been pushed" from her daughter's bedroom window. Kinderman's low-key, respectful manner unnerves Chris more than if he had come right out and accused her daughter of murder. What he *doesn't* say and how she processes it, while trying to conceal her emotions, contributes to two of the subtlest performances I've ever captured. I told the actors to keep their feelings hidden as they begin to comprehend what is unspoken. We shot this scene only twice, once from his point of view, then from hers, with the camera imperceptibly slow-zooming toward each.

Halfway through shooting, we were way over schedule. "I think your problem is Roizman," Greenlaw said. "He's too slow." The real problem was my obsessive desire for perfection.

"What do you suggest, Charlie?" I asked.

"Let me find you another cameraman."

I don't know to what extent he tried to find a replacement for Owen, but it didn't happen. I had approval of his replacement, which I would never have given. It was an excercise.

Our plan was to complete the interior sets on the New York stage, move to other New York locations, then finish photography in Georgetown. One morning, predawn, my phone rang. I was still in the rented apartment on Park Avenue between Eighty-Sixth and Eighty-Seventh. We weren't scheduled to start shooting before 9:00 a.m., and I was half asleep. Salven was on the phone. "Don't bother to come to work today," he said sadly.

"Why? Am I fired?"

"No. The set burned down."

I sat up in bed, now totally awake. "Are you pulling my leg?"

"The whole set's in flames. Completely destroyed."

"What happened?"

"We don't know," Dave said. "The firemen are here now."

By the time I arrived, the stage was filled with smoke. Firemen everywhere. The set was in ruins, along with all the expensive artwork, furniture, and rugs. The question of how the fire started was never adequately explained. There was a lengthy investigation by the insurance company, which paid off on the theory that because the stage was old and there were pigeons flying around in the rafters, a pigeon may have flown into a lightbox, causing a short circuit. There was one night watchman at a desk just outside the stage door. He saw smoke seeping from the crack below the door: "When I opened the door," he said, "the flames were everywhere, about thirty feet high." I was frightened and confused, for the first time since we started production.

Malley estimated it would take at least six weeks, with a lot of overtime, to rebuild the set and furnish it again. The extension to the exterior of the Georgetown house hadn't been built yet, so we would have to shoot other locations in New York: the two scenes in a physician's office; the interior of the Jesuit residence in Georgetown, which we were able to relocate to Fordham University, a

Jesuit college in the Bronx; and the arteriogram and pneumoencephalogram that were to be performed on Regan, to be filmed at NYU Medical Center with a real neurosurgeon and his assistant. In total, it was little more than a week's work. This meant shutting down production for at least a month, with everyone on payroll! The Warner executives were supportive but, like me, completely mystified. Much has been written about "the *Exorcist* curse," and if I believed it at the time, I could not have continued. I had to keep up my spirits and everyone else's; fear was now circulating among the cast and crew. As we prepared the scene between Karras and Dyer, in the Jesuit residence at Fordham, another strange and disturbing event occurred. On a cold morning in November, Jason Miller's wife, Linda, took their young son Jordan to play on Rockaway Beach. A young man about half a mile away was practicing wheelies on his motorbike when the unthinkable happened. The bike started tearing along at high speed toward little Jordan. It hit him straight on. Jordan was taken to a hospital emergency room, and filming was suspended while Jason and Linda stayed with their son. Jordan was in serious condition for a week and given a fifty-fifty chance to survive. Jason came back to the Jesuit residence, where he and the priests stayed up several nights to pray for his son's recovery. Jason decided he wanted to go ahead and film the scene in which Karras and Dyer get drunk and bemoan the death of Karras's mother and his guilt over his neglect of her. Jason's genuine grief pervades the scene; his emotions were real. Thankfully, Jordan recovered.

After Dyer puts Karras to bed, there's a dream sequence over which is heard Karras's labored breathing as he sleeps. The sequence has its roots in Blatty's novel. Here's how the passage reads: "He had dreamed of his mother. . . . He had seen her emerging from a subway kiosk across the street. He waved. She didn't see

him. She wandered the street. She was growing frightened. She returned to the subway and began to descend. Karras grew frantic, ran to the street, and began to weep as he called her name . . . as he pictured her helpless and bewildered in the maze of tunnels beneath the ground." I shot it pretty much as Blatty wrote it, but months later in the editing room the idea occurred to me to combine Karras's dream with images associated with Merrin in Iraq. Many of the images would be subliminal, no more than two or three frames. In Karras's dream, his mother is crying out to him, but I inserted quick shots of the wild dogs in Iraq, the Saint Joseph medal discovered by Merrin at the archaeological dig, the clock pendulum that stops in the Iraqi curator's office, and a quick image of the demon's face.

Karras's dream intermingles with images from Merrin's life in a kind of symbiosis. Merrin and Karras would soon collaborate in a transcendent experience. The dream sequence would encompass *their* past, present, and future. I've never been able to create a scene like this since, but I was so attuned to the story's possibilities, I was inspired to discover what I believe was a new way of storytelling.

Many people, including Blatty, have said that the most disturbing scene in the film is not the demonic manifestations or the supernatural but the arteriogram, the process by which brain damage is determined. A fluid injected into the carotid artery outlines the tiny arteries that surround the brain. It shows if any have been damaged or do not appear "normal." Regan's strange behavior was diagnosed by "Dr. Klein" as having been caused by a lesion in the temporal lobe of her brain. The arteriogram is able to determine precisely where that lesion is located. Marcel Vercoutere rigged the hypodermic injection and the blood spurt, and the procedure was

done by the neurosurgeon and an X-ray technician who performed the *actual* procedure several times a day at NYU Medical Center. This portrayal of medical science at its most invasive was particularly shocking because the patient was an innocent young girl, whimpering as the syringe went into her skin.

7

EMPIRE OF LIGHT

The image that most inspired me and the one that became iconic comes from a painting I had seen at the Museum of Modern Art: René Magritte's *Empire of Light II*. Magritte made several variations of this painting over eight years, but the one that most compelled me is the one he painted in 1954 that's in the Beaux-Arts Museum in Brussels, Belgium.

The painting is that of a dark house on a quiet street at *nightfall*. The bedroom windows on the second floor are warmly lit from within; other windows are visible but shuttered, and there's no front door. Overhead is a *daylight* blue sky with floating clouds. On the street in front of the house is a single lamppost, but the 1954 version shows rainy reflections of the house and lamppost. There are no figures in the painting. I began to recompose this image in my mind's eye. I saw a powerful light shining from Regan's bedroom window down to a silhouetted figure standing near the streetlamp. The man would be Father Merrin arriving at the Georgetown house. Magritte's painting is an example of how he juxtaposed realistic but unrelated objects. In the film it became a real house, on a real street, an upstairs bedroom in which a *young girl is possessed by a demon*.

To achieve the effect of the light from the bedroom window, we

had to construct a platform behind the extension built onto Mrs. Mahoney's house. On the platform was an arc light aimed directly at Merrin as he emerged from a taxicab. Prospect Avenue was wetted down, and we used fog machines to enhance the mood. We put our own streetlamp in front of the house. I had a taxi come down Thirty-Fifth Street, make a U-turn on Prospect, and pull up in front of the house. This meant Owen had to light two streets *and* produce the surreal effect from the bedroom window. We set aside a full day and night to light this one shot and photographed it the next night in one take.

On the morning of the pre-light, Max von Sydow arrived from Sweden. Our wardrobe supervisor had his measurements, so his priest's clothing, black overcoat, and hat had been fitted. Dick Smith had previously made a mold of Max's face, and he and Rick Baker spent the day applying his makeup. Dick applied several layers of latex to Max's face, and dye to whiten his hair, while Rick painted liver spots on his hands. Max was in his forties, playing a man in his seventies. He was about six-eight, lean and with perfect posture, so he had to develop a slouch and arthritic movement for his character. I've never worked with an actor more dedicated. His makeup took four hours a day to apply and an hour to remove, and had to be reapplied each day. In addition to Linda's makeup, this meant that Smith and Baker would be working ten straight hours on just these two characters, and the makeup not only had to be constantly refreshed but perfectly matched from one day to the next.

I had sent Max books by Teilhard de Chardin, and we discussed Father Merrin's profound faith. Max was to remain with us for rehearsals and research with the Jesuit community before we returned to New York to film the exorcism. Just before we were to shoot his introduction he received a telegram. His brother died.

The following morning he had to return to Stockholm for the funeral.

In the fall of 1972, the old red-brick streets of Georgetown, the foliage in bloom, the cold gray skies, occasionally relieved by warm sunlight, were ravishing to the camera, providing a stark contrast to the events we were filming.

During the filming I kept getting further confirmation that the story I was telling was true. Father Henle put me in contact with the aunt of the young boy who was the victim of the 1949 possession. She was unaware of the novel or the film, but I assured her we would not reveal the identity of her nephew. Because our meeting was arranged by Henle, she agreed to talk to me and accepted my word that the characters and events we were portraying were fictionalized. We've never claimed that *The Exorcist* was based on this one case, but the aunt had been witness to many of the manifestations that had occurred, and her account was terrifying and confirmed everything that was reported in the diaries and more.

In the middle of production, Pope Paul VI said, "Evil is . . . a living spiritual being, perverted or perverting. A terrible reality. Mysterious and frightening. It is contrary to the teaching of the Bible and the church to refuse to recognize the existence of such a reality. . . . It is not a question of one Devil, but of many, as indicated by various passages in the gospel. . . . But the principal one is Satan. . . . We know that this dark and disturbing spirit really exists and that he still acts with treacherous cunning . . . [and] finds his way into us by way of the senses, the imagination, lust. . . . The Devil can easily penetrate and work upon the human mind."

Until the Pope made this statement, the idea of a personified devil had been opposed by academic theology. As Blatty has a psy-

chiatrist say in the book and the film, "It's something the Catholics keep in the closet." Paul's successor, John Paul II, also believed in literal possession, and assigned exorcists to many of the dioceses around the world.

Our final scene of night shooting in Georgetown was the exterior of Father Karras's jump, in which he plunges from Regan's bedroom window down the long flight of steps. David Salven found the perfect stuntman in Chuck Waters, who was in his mid-thirties and bore a striking physical resemblance to Jason Miller. Chuck determined he needed to do the fall in several sections. First, he would dive from the false bedroom window extension, past the camera, and onto a cushion of pads and boxes about twenty-five feet below. He would then continue the fall from one landing to another, then to the last landing at the bottom of M Street, where in his final position he would be replaced by Jason, facedown in a pool of blood. Marcel and his crew concealed black rubber padding on the edge of each step. Chuck had to execute four different falls, each linked to the one preceding. We added a point of view shot by suspending a lightweight camera, an Eyemo, from a bungee cord at the top of the steps. Each of the falls was dangerous, if not life-threatening, but Chuck carefully prepared for weeks until he felt comfortable, and we filmed it in four shots, one take each.

When Karras's final position at the foot of the steps was established, Father Dyer (Bill O'Malley) was to appear and administer the last rites to his friend and brother in Christ. Karras, unable to speak, squeezes his hand in confession and receives absolution. By the time we got to this scene, it was three o'clock on a freezing cold morning after a long day and night, and our final day in Georgetown was scheduled for the next morning. O'Malley, not a

professional actor, had problems getting to the emotion. It's a diffi-
cult scene for an experienced actor, with spectators, a full crew, and
lights everywhere adding to the unreality in which films are made.
We must have done twenty takes, and I was beginning to think
we wouldn't get it, not that night. I called a halt, whispered to the
crew what I was about to do, and told them to be ready to roll on a
second's notice. I then took O'Malley aside and grasped him by the
shoulders. I said, "Bill, I want you to listen to me carefully. Look
at me." He was shaking from the cold and his increasing anxiety.
"I don't know if I can do this," he said, already on the verge of the
emotion.

"Bill, you *can* do this," I said with conviction, though I wasn't
sure. I held his shoulders tighter: "Do you love me?"

"Yes." He was trembling, not knowing where I was heading.

"Say it!" I said firmly, pulling him to me in an embrace.

"Yes, I love you, Billy, you know it."

"I love you," I said, at which point I slapped him across the face
as hard as I could and pushed him to his knees, next to the prone
body of Jason Miller. I signaled Ricky Bravo to roll the camera and
shouted, "Action!" O'Malley burst into tears and performed the scene.
The crew was in stunned silence when I yelled "Cut," and went to
O'Malley, helping him to his feet, once again embracing him.

"Thank you," he said, "thank you for that. Oh God, thank
you!" He has told this story fondly many times since. This is not
a solution I recommend to aspiring directors, but there are times
when you have to have *the* solution to whatever problems arise.
Occasionally and rarely, the solution is as drastic as the one I've
described, which I have used on only three occasions in a career
spanning more than forty years.

The next day we shot the finale, in which Chris and Regan are
leaving the Georgetown house to be driven to the airport by the

servant, Karl. Dyer comes to the house to see them off, and Chris introduces him to Regan, once again a normal twelve-year-old girl. Regan notices Dyer's white collar and impulsively reaches up to kiss his cheek, perhaps in memory of Father Karras. Chris gives Dyer the Saint Joseph medal, first discovered in Iraq by Merrin, later worn by Karras, and torn off in his struggle with the demon. Just before the car departs, Dyer returns the medal to Chris. He walks to the top of the steps leading down to M Street and looks to the place where Karras plunged to his death. Over his shoulder we see Regan's bedroom window, now boarded. On the sound track, months later, I took out *all* sound over these shots, even traffic ambience. This sequence and the one following in which Dyer and Kinderman meet in front of the house, the last scene in the film, were all intended to keep the memory of Karras alive in the minds of the survivors and the audience. It was Blatty's sense that the film needed a "happy" ending to suggest Karras had made the ultimate sacrifice, so the child could survive.

We returned to New York to film the exorcism sequence. I knew the film was suspended on a slim thread of the supernatural scenes being believable. And though we had gone through trial and error for months to perfect the effects, much depended on integrating them with the actors' performances. As fine a cast as I had assembled, there was no precedent for what we were trying to accomplish, but I was determined to push myself and everyone else to the limit of our imaginations and abilities.

Events in the country drew people's interest to *The Exorcist* before it was released. People felt they weren't safe in their homes because of the Manson murders in 1969; and the Supreme Court's ruling in *Roe vs. Wade* in January of 1973, that a woman was entitled to control of her own body, had been controversial. In *The*

Exorcist, the child's body is not simply violated; it is *invaded* by a demon. These events were part of the public debate while we were trying to complete the film in an old studio on the West Side of Manhattan.

So that the actors' breath would be visible, the bedroom set was built within a refrigerated cocoon on top of which were four large air-conditioning units. Each night, we'd turn them on until the following morning, when the temperature dropped to thirty degrees below zero. After our lights were on for an hour, the temperature would rise to levels above freezing. We'd then have to shut off the lights and build up the cold again. None of this was originally budgeted, but there was no other way to do it. From the 1930s through the '60s, large bricks of ice were manufactured in the Glendale Ice House, in which scenes requiring cold air, snow, and visible breath were photographed. *Lost Horizon*, *The Magnificent Ambersons*, and many other films were shot there, but it had long since been closed. Our crew wore insulated nylon ski suits. The cast had to rely on long underwear. We all contracted colds and flu—all but Linda Blair, who had the least amount of protection against the cold. We were lucky to complete three or four setups a day, working more than twelve hours.

Walls and ceilings were movable, so we could put the camera and sound equipment anywhere. Behind the bed wall were forklifts, made of steel poles the special effects crew used to lift the bed and shake it. Regan's levitation was accomplished by strong but very thin piano wires suspended from above the false ceiling. Owen had the wires spray-painted alternately black and white, which served to further conceal them. Ceiling cracks also helped to hide the wires. Projectile vomit was accomplished with a long, thin plastic tube that Vercoutere and Dick Smith concealed in Linda's nightdress, up through the thick makeup on her neck and

jaws, then into a mouth harness, where the nozzle was turned to project *out* of her mouth. At the base of the tube was a large vat of "vomit" made from oatmeal with thin pea soup for coloring. This mixture was pumped through the tube. For the reverse shot, where the vomit splashes onto Father Karras, we used a portable pump to shoot it at him.

Regan's head spinning was accomplished with a life-size dummy made and operated by Dick Smith, turning a long stick attached to the dummy's head from below its waist. Another tube ran up into the dummy's mouth, through which Marcel blew cigarette smoke that appeared to be cold breath.

Bill Malley finished sculpting the twelve-foot-high statue of Pazuzu to be sent to Iraq for the opening prologue. I asked him to bring it up to the bedroom set and put it next to the bed. An inspiration came to me: having the statue appear briefly during the exorcism as Regan reaches toward it in supplication. We made the room darker, concealing the demon's presence until on cue, Owen lit it from below, then faded it out. When I saw the shot in dailies, I thought it was over the top, but Blatty loved it and persuaded me to keep it in the finished film.

When we screened the first dailies from the cold room, no breath was visible! Like rain, we learned, breath doesn't photograph unless it's backlit or sidelit. We had to redo the entire day, with Owen setting small lights on the floor around the room, focused on the actors' breath.

The frustration of the Warner executives grew as the problems multiplied, but the pressure I felt was only indirect. They would call Salven and scream at him, but what could they do? John Calley always came to my defense. Having been a producer, he knew how to watch and interpret dailies, and he could sense the film's potential.

We came to the scene where Merrin, exhausted and with a weak heart, has to summon up a final burst of strength and shout at the demon: "I cast you out, unclean spirit, in the name of the Father and of the Son and of the Holy Spirit!" at which point the ceiling above him was to crack. We had six artificial ceilings made, and I thought we'd get a take quickly, given von Sydow's consistency. On the first take, I felt he was too calm, not enough brio. We did another. Same problem. We went through six repeats and didn't get a take. Since the scene had to be shot in sequence, I couldn't move on to something else. We finished early without printing a single take, having run out of false ceilings. I ordered six more to be built. The construction crew worked overtime the rest of that day and night to produce them, and we returned the next morning to the same scene. To my bewilderment, Max was no better. Six more takes. No prints. No more ceilings. I saw the dailies, and they were as bad as I thought.

Six *more* ceilings were built. Blatty was living in Georgetown. There was a writers' strike, so he couldn't come to the set. I called and told him what was happening, or *not* happening, and he heard the urgency in my voice; he flew to New York. I showed him the dailies. Maybe *I* was crazy. Maybe Max was fine, and *I* had a block and couldn't see it. Bill came out of the screening room: "You're right," he said, "it's terrible."

When we first met, Max said, "The most powerful way to deliver a line is quietly." Blatty believed Max no longer had the vocal ability to deliver the line the way I wanted. Whenever he had to take command and raise the volume, something shrill would come out, a high tenor, with no authority behind it.

We went to Max's dressing room. Unlike those of most star actors, his room was sparse—no photographs, no drawings, no memorabilia of any kind. It wasn't so much a comfort zone as a

monk's retreat. "Max," I said, "we've reached the point where I don't know how to finish this scene. I'm willing to ask Ingmar Bergman to come in and direct it." Max shook his head. "No, no," he said. "It's not a matter of Bergman. This has nothing to do with Bergman."

"Well, what is it?" I pressed.

A long silence, then, "I think it's that I don't believe the words," he said. "I don't believe in God."

I never thought an actor had to *believe* the words of his character, only *act* them. An actor playing Dracula doesn't need to become a vampire. Bill was as nonplussed as I was. I said, "But Max, you played Jesus in *The Greatest Story Ever Told*."

"Yes," he said, "but I played him as a man, not a god."

Even more confused, I said, "Why don't you play Merrin as a man? Don't think of him as a priest with supernatural powers."

This was one of the lamest directions I'd ever given. Max turned toward his dressing room mirror. "Give me an hour," he said gravely. Blatty and I left the room. We stood silently in the hall. Because we both shared the same dark sense of humor, we started to laugh.

"Bill," I said quietly. "What if we have Merrin die at this point in the script instead of later, and let Karras finish the exorcism?"

"Well, you know it's not that way in the novel, Billy," he said, "but if that's what it takes to complete the scene, I'll do it." He could see my anguish and frustration.

He quickly wrote a draft of the scene that killed Merrin early. "I actually like it," he said. "I like it better! It'll work!"

I said, "All right, Mr. Producer. You're going to have to tell Max he's going back to his family tomorrow morning." We returned to the set, and before I told the cast how we planned to revise the scene, I asked Max to do one more take as originally written. He

delivered the line with great strength on the first take, and the crisis was over. To this day, and after decades of reflection, I have no idea what really caused this brilliant actor to block, at the most crucial stage of his performance.

Father Karras's final confrontation with the demon was the last thing we shot. It was the one section of the book I wasn't sure how to stage, and after a number of conversations with Blatty, I became even less certain. It is meant to be an act of self-sacrifice in which Karras offers his own life to the demon in return for Regan's. As Blatty portrays it in the novel, only the *aftermath* of Karras's death leap is seen, and only by Chris. Bill wanted to make it clear in the film that it was Karras's choice to leap out the window, that he *was no longer possessed when he sacrificed himself,* and in a subsequent shot we see Regan on the floor, crying, but as her normal self. I confess now that my staging wasn't clear, and I doubt that it was clarified for audiences. Later in the novel, but not in the film, Blatty has the detective speculate that Karras's deliberate death has to do with a mental breakdown.

In a letter to Blatty shortly after the publication of the novel, Father Bowdern argued that suicide as a motivation was misleading in a theological sense. "No matter what good intentions Karras might have had in your story, suicide could never be used as a means to achieve that end," he wrote, underlining that suicide remains a mortal sin in the eyes of the Church.

In a 1998 interview, Blatty said that the film *did not* make it clear that Karras "took the *demon* out the window, not the other way around." Even though we added a moment wherein Karras actually shouts to the demon, "Take me, come into me!" according to Blatty, "*audiences still got it wrong.* . . . It's not that it wasn't delivered in a clear way . . . it's that the audience is so numb with shock that they're not *noticing* the choreography. . . . So that the problem

we created, through no fault of our own, is that many people to this day interpret *The Exorcist* as a downer."

Blatty and I still disagree on this point. My feeling is that people take from the film what they bring to it. If you think the world is a dark and evil place where Satan rules, you can get that from *The Exorcist*. If on the other hand you believe, as I do, that a constant struggle takes place within all of us and that sometimes goodness wins out, that's there as well.

THE DEVIL IN THE DETAILS

I was determined to film the prologue in Iraq. The United States had no diplomatic relations with Iraq, not even a desk in a foreign embassy. I called Jack Valenti again. "Billy, this is probably a long shot," Jack said, "but why don't you contact the Iraqi Mission to the United Nations? They've got an office in New York."

I met with the Iraqi UN representative. He was a gracious man in his late forties, skeptical, but not discouraging. Iraq had been ruled for many years by a one-party government, the Ba'athist Party. "I'll take your request to the highest level of our government," the representative said. "As you know, there are few Americans in my country, so we will see." We shook hands, parted, and I waited months for his response: "You can film where you choose in northern Iraq. However, you must limit the number of American personnel. You will have to make a formal request for exactly how many people you feel are absolutely necessary. We ask also that you hire Iraqis and train them to fill out your crew."

"Is there a film industry in Iraq?" I asked.

"Not at this time"—he shook his head sadly—"which is why we want your personnel to help train our people." I instantly agreed. "Two more requests," he said. "We want your makeup person to teach Iraqis how to manufacture movie blood." I didn't ask why, nor do I know to this day.

"What else?" I asked.

"We want you to donate a print of your film *The French Connection* to the Iraqi government." He smiled. I agreed to everything. I needed to bring only one actor, Max von Sydow. As far as American crew, I needed the makeup artist, Dick Smith, and his assistant Rick Baker; production designer Bill Malley and a veteran production coordinator, Bill Kaplan; and the first assistant director, Terry Donnelly. The rest of the crew would come from England, a country that maintained diplomatic relations with Iraq. My director of photography would be Billy Williams, who photographed *Women in Love* and other distinguished British films.

In June 1973 we were granted permission to film in Iraq. I believed it would be one of the great adventures of my life. Ted Ashley in his usual fashion began by screaming at me: "Are you crazy? We can't send you to Iraq."

"Where else should I shoot this scene, Ted?" I asked.

"I don't care," he shot back. "You're not going to Iraq. They'll kill you."

Wells chimed in: "Aren't we at war with them?" We weren't.

Historically and biblically, there is no more important country on earth than what was once called Mesopotamia. It's known as the cradle of civilization. The Garden of Eden was there, as were Abraham and Isaac. Noah built the ark there. The Walls of Nineveh stood there, and I lived in a tent next to their remnants. Daniel entered the lion's den in Iraq: Nebuchadnezzar, once king of Babylon, is buried there, and I visited his tomb. It's shown without attribution in the film. Two ancient rivers, the Tigris and the Euphrates, cross in southern Iraq, and I used to enjoy picnics there on the beach with my Iraqi friends.

The week I left for Iraq, two hundred Jewish people were rounded up in the streets of Baghdad and tortured. They were

confined for life or slaughtered. I was horrified, yet I knew that the mood, the atmosphere, the desert ruins, the Iraqi people, could not be reproduced on a soundstage or in the American desert. I wanted the film to have authenticity, and that started with the prologue. We couldn't re-create Georgetown, so how could we duplicate northern Iraq?

Bill Kaplan went ahead and sent back excellent location photos. He wrote that our hosts from the Ba'athist Party seemed cooperative and were anticipating our arrival. Iraq at that time had hostile relations with Iran, Kuwait, Syria, Turkey, and of course Israel and the United States. Their relations with the Kurds in the north of the country near Mosul, which was our eventual destination, were also bad.

But Baghdad was a thriving, energetic city in 1973. The Bab al-Sharji souk was ablaze with color and rich with the scent of spice and incense. Rug merchants and tea houses kept family traditions for thousands of years. Western dress was as common as Arabic, and traffic in the main arteries was as claustrophobic as that of most big cities. Kids played soccer in the streets, and many wore T-shirts with pictures of American sports figures and movie stars.

Just to the south of Baghdad were the ruins of ancient Babylon and the Tower of Babel. Little remained of them, and what restorations had been done were shoddy. There seemed to be many more ancient sites left to be uncovered, but the Iraqi authorities weren't concerned with preserving their historic legacy. Many of these sites were looted or moved to museums in other countries. In the center of Baghdad, overlooking the city's main square, was a statue of Hammurabi, known for writing one of the first codes of law. He was also the first king of the Babylonian Empire, seventeen centuries before Christ. His code, carved in stone on twelve tablets, is now in the Louvre. Its draconian punishment calls for chopping

limbs off, disfiguration, and death. But there in the town square his stone image rests peacefully in kingly garb and headgear. On top of a barracks building directly across the street was an array of Ba'athist soldiers, alert behind automatic weapons.

Mosul, 250 miles to the northwest, was our base of operations. The city is divided by a gap along the banks of the Tigris, with five bridges linking both sides. About a million and a half people lived there when I arrived. They were friendly and curious about us. I never felt closer to a people, anywhere, than I did to the men and women of Mosul during the months I spent in Iraq. There was a sense of joie de vivre about them. Women worked in all the professions; they were doctors, lawyers, and teachers. They didn't have to wear burqas or other religious dress unless they chose to. The ruling Ba'athists had no opposition. They were led at that time by President Hassan al-Bakr, who bore a remarkable resemblance to Groucho Marx. On Sundays thousands of families would picnic and swim on the beaches of the Tigris. They would roast large blowfish called *masgouf*, split down the middle and suspended on sticks over small open fires. When the fish was browned on the outside and the white meat tender, you'd eat it with your hands; delicious.

After dark in Mosul, whole families would sit on folding chairs or on the ground in the town center, watching an old twelve-inch black-and-white television set that was powered by a long cord running into one of the shops. I remember seeing hundreds of people watching the American television series *The Fugitive*, starring David Janssen. In English.

I was assigned a guide who spoke perfect English and was as subversive at heart as I was. He loved to tweak the officials who hired him, and he was secretly unimpressed by his Ba'athist rulers. He was under strict orders not to take me into Kurdish territory, near the

Turkish border. To drive through this area, you were stopped every mile or so to show passports to the Arab authorities, and a mile later you'd go through another passport check by the Kurds. My guide's name was Tarik Zubaidy, and his favorite English expression was "peace and pizza," usually whispered under his breath as a kind of slur upon all authority. We lived in tents next to the railroad station, where the Orient Express would come in once a week. Next to the station were the remnants of the Walls of Nineveh, a small pile of ancient mud and stone about a foot off the desert sand, comprising a circle that housed a Bedouin encampment with goats and camels. The only public telephone was in a police station two miles from our tents. It required four days to book a call to the United States, which was fine with me because I quickly developed a Kurtz complex and wanted no contact with the outside world. It took a month to find and clear the locations I needed, including the *chaikhana* (tea house) near the center of town, overlooking the tomb of Nebuchadnezzar; an old metallic forge; the museum curator's offices; and the ancient winding streets.

Our main location was the archaeological site that opens the film. We found it in Hatra, the city of the Sun God Shamash, less than an hour's drive southwest of Mosul. It was built in the desert in the third century BC and contained some of the most beautiful limestone temples and monuments in the Arab world. It had been partially restored, and there was ongoing excavation by a German expedition that had been uncovering ancient Hatra for years. Though heavily fortified, the town was sacked by the Sassanians in 240 AD. A hundred thousand people were decapitated, and their heads, as well as those of statuary, were being discovered by the German expedition. This location, bathed in a magical pink desert light, was bright enough to film from early morning to ten in the evening. It contained many references to the ancient world

and its mythology. The only thing missing was the giant statue of the demon Pazuzu, which we re-created at Warner Bros. in Burbank and had shipped to Iraq. Bill Malley had designed it, referring to photographs in the British Museum. Fourteen feet high and eight feet wide, it was made of fiberglass, with extended talons and a large protruding penis. We had it shipped from Los Angeles to Baghdad by the famous Flying Tigers air transport company, former World War II Air Force aces. They guaranteed the shipment would reach its destination safely within two weeks, but somehow it was lost and untraceable! Lost and untraceable? Impossible to conceive that a crate at least fifteen feet long by ten feet wide, clearly addressed to Baghdad, insured and guaranteed by the Flying Tigers, could be *lost* for as long as three minutes. When it was finally located somewhere in Australia (!) and shipped to the correct address, we installed it on a mound in Hatra, just outside the excavated monuments.

The statue was aged to resemble the limestone and gypsum Assyrian structures surrounding it. We weren't told why the shipment was delayed, but we later learned that the content spooked most of the customs agents along its route.

A week before shooting, Bill Kaplan, the production manager, took slabs of raw meat up to the statue in the hope of attracting vultures while we were shooting. We also tried to lure packs of wild dogs, to snarl and fight as though "possessed." The growls would later be mixed with the sound of the demon voice. The vultures never appeared, and the dogs wouldn't perform. They had been starved for two days, and when cut loose, they ran to the meat, sniffed it, and slumped meekly away. Their handlers told us they had never eaten meat, and obviously had no taste for it. Their diet was a soft flat bread, which we spread around the statue; the dogs fought over and devoured it.

Rumors went out locally that American devil worshipers had erected a statue of Pazuzu in Hatra and were offering sacrifices to it. This came to the attention of the sheikh of the local Yazidi, an ancient tribe of Kurdish descent in northern Iraq. They are known throughout the Muslim world as devil (Shaitan) worshipers, and suffered severe punishment for their beliefs in past centuries. Thinking I shared their beliefs, representatives of the Yazidi sent word to my Ba'athist handlers, asking if I'd like to meet the sheikh and tour their settlement. The Ba'athists were against my making this visit. They warned me that I would have to pass through Kurdish territory to a dangerous place they couldn't control.

The Yazidi were said to practice human and animal sacrifice. Custom dictates that you never walk ahead of a Yazidi, because if Shaitan tells him he must kill you, he will do so without hesitation. The Yazidi don't eat lettuce because they believe the spirit of Shaitan lives in lettuce. Their customs were frowned on by the Arab world as well as by fellow Kurds. Their origins and esoteric practices are unknown to most of the Western world. I was warned that flies circled their encampment; I was to gently avoid them but never kill one, because the spirit of Shaitan lives in flies and serpents.

For some reason, a Yazidi leaves one pant leg on when he makes love to his woman. I pressed for an explanation of this and was told by Tarik that it was probably so that the Yazidi could be ready to act on the devil's instructions at any time. The *sh* sound must never be uttered near a Yazidi, as it would take the name of Shaitan in vain. Since Arabic has many words that require the use of *sh*—for instance, the common greeting "Chosh kaka" means "Hello, my friend"—the Yazidi have their own language, Kurmanji.

I found it ironic that the sheikh of the devil worshipers wanted to meet me, thinking I shared his beliefs. Tarik offered to cross the

territorial boundaries and bring me to their camp, knowing that if he got caught disregarding Ba'athist instructions, he would be in deep shit. If anything happened to me, if I were captured or killed, Tarik would share my fate.

The Yazidi holy site is in a lush valley called Lalish, less than an hour's drive northeast of Mosul. Here, homes and places of worship are built of rock in a conical shape, like a witch's hat. Embedded into each wooden doorway is a metallic serpent. Dogs, oxen, chickens, and bulls roam the grounds freely. There are no roads, only pathways. Yazidi men wear long white robes tied at the waist, and dark kaffiyeh (caps). The women wear black burqas, but mostly stay out of sight. Tarik and I were led to where the sheikh sat crosslegged on the ground outside his house. He looked like the Ayatollah Khomeini—sloe-eyed, with a scraggly white beard and a harsh demeanor. Flies were everywhere—in the air, on the people, on the stone houses; the sheikh was covered with flies on his face and body, in his eyelids, his beard, his hair. He beckoned Tarik and me to sit opposite him and offered us chai. I had to tolerate the flies, waving them off when they became unbearable. The Yazidi paid no attention to them. Try to imagine what it's like to have a conversation in a foreign country in another language, covered by swarms of buzzing flies. I wore Arabic head and body cover, but I could see the bites appearing on my hands, and when I touched my neck, my hands were covered in blood. I wondered how the Yazidi lived with this each day of their lives. Though I had been given ample warning about the danger of being among them, I felt no fear, only discomfort and fascination.

The sheikh was curious about my beliefs, and I disappointed him when I explained that the statue of Pazuzu and the daily "sacrifice" was for a movie! He had never seen a movie nor had any contact with Americans, but I found him to be modest and curi-

ous. He explained his beliefs, which seemed to come down to the idea that there is an all-powerful God who is forgiving, but the devil makes the rules on earth, so he's the one who must be given respect.

A month after my arrival in Iraq, after extensive preparation, we started filming.

In order to link the events in Hatra with those that later occur in Georgetown, I added a sequence showing Merrin's discovery at the dig in Nineveh of a Saint Joseph medal that was not from the Assyrian period. This medal is not in the novel. It was my intention to use it as a kind of inexplicable object, like the obelisk in Kubrick's *2001*. The medal is first unearthed in Iraq, then worn by Karras during the exorcism, and finally given to Chris at the film's end by Father Dyer. It also turns up in Karras's dream. Other Iraq sequences portray Merrin's foreboding of a future encounter with the demon.

The temperature was 130 degrees Fahrenheit by eleven each morning, so we had to start shooting before seven and stop by eleven! Then it was back to our tents until 7:00 p.m., when we could start again, film until ten, when darkness set in. In addition to the oppressive heat, severe desert winds blew sand into our camera and sound equipment, which had to be cleaned two or three times a day. Illness—dysentery and flu-like symptoms—affected each member of the crew, and we were unable to project our dailies, so I had no idea how the footage looked until I got back to New York several weeks later. Once each week, Billy Williams was able to call his contact at Technicolor in London, who told him the footage looked beautiful. On a normal shoot, you see your rushes the next day, but not in so remote a part of the world.

Von Sydow would go into the makeup tent at three o'clock each

morning, and Dick Smith and Rick Baker would work on him un-
til it was time to start filming. He would keep the makeup on dur-
ing our daily hiatus of about seven hours; then Baker and Smith
would freshen him up for the evening shoot. At the end of the day,
they would peel the makeup off, and torrents of sweat would pour
from his face. This took an hour, so he would get three hours sleep
each night, and a nap during the afternoon. We were lucky to get
eight shots a day, but the Iraqi crew was hardworking and enthu-
siastic. One morning, Jean-Louis Ducarme, our sound recordist,
was allowed into a mosque to record the sound of the morning "call
to prayer" that opens the film. It was a beautifully recorded track,
and the song of the muezzin proclaims the underlying theme of the
film: "God is good. . . . God is great. . . ."

After two weeks of filming, our Ba'athist hosts came to me and
politely reported that we couldn't film the next morning; we would
be confined to our tents. "What's wrong?" I asked. They said there
were problems not involving us that would soon be worked out. I
suspected the worst, and I was afraid we had committed some faux
pas or that my extracurricular activities with Tarik had come to
light. The crew became frightened and concerned. We were being
held hostage. This went on for four days, with assurances from
the Ba'athists that it had nothing to do with us and would soon
be remedied. Our nervousness turned to panic when, on the fifth
day of what was essentially a friendly captivity, we were told what
happened.

President al-Bakr was on a state visit to Poland, and his return
flight had been delayed for several hours. Waiting for him and his
party at Baghdad Airport was a forty-man assassination squad
led by al-Bakr's friend, the chief of secret police, Nazim Kazzar.
Because of the plane's delay, over four hours, the hit squad gave
themselves up in groups, fearing they were entrapped—but Kazzar

escaped and was hiding out near where we were filming in Mosul! When he was apprehended and confessed, a trial lasting one day took place in Baghdad. Twenty men were hanged by the neck in Baghdad's main square the next day, and nineteen more the day after. They died facing the statue of Hammurabi, the lawgiver. Kazzar, mastermind of the plot, was spared; President al-Bakr was unable to order the execution of his trusted friend. (A few years later, al-Bakr was overthrown by his cousin, Saddam Hussein.) With order restored, we were allowed to continue filming, with apologies from our hosts.

Always eager to expose me to the more exotic heart of Iraq, Tarik took me to a small apartment in one of the poorest sections of Mosul. You could hear the beating of drums from a first-floor apartment a block away. The small room was packed with about fifty men, some in robes, others in white trousers without shirts. The night was humid, the strong scent of bitter hashish was in the air. Older men pounded drums while teenage boys, shirt-less, danced in circles, chanting. This was the rite of passage of the Rafa'iyyah, a dervish sect. To prove their devotion to Allah, the boys each held a long, thin blade and danced wildly, building up the courage to stab themselves through the midsection from front to rear without damaging an organ or killing themselves. I could see the boys running themselves through, with just a trickle of blood at the point of the blade's entry and exit. Some of the older men showed me their stomachs, with scars from numerous self-inflicted stab wounds. They were taught where to stab, and there was no margin for error. I was told that many had failed and died in their attempts. Several of the boys worked themselves into a frenzy but, unable to complete the ritual, would leave the room in tears. Our camera operator, a sturdy Brit, threw up watching the ritual and had to leave. But I was mesmerized and filmed the

ceremony. I hoped to integrate it into the film, but I couldn't figure out how. Somewhere in the vaults at Warner Bros. are several thousand feet of film of the Rafa'iyyah ritual.

The days and nights I spent in Iraq are etched in memory. The physical conditions were more difficult than any I've ever experienced, but the people were wonderful. I was sorry to leave, but before long the Iraq shoot was over, and I went back to New York to begin editing the film—at 666 Fifth Avenue!

Editing is the most enjoyable aspect of filmmaking. Everything that's shot is basically raw material for the cutting room. A film can be made or destroyed there. A performance that may have seemed unfocused in dailies can be fashioned into something memorable in the editing process.

In late summer of 1973, I finished the almost year-long shooting schedule, but I wouldn't have the luxury of a long editing process, "finding" the film. Warner's had a release date of December 26, and in addition to going through hundreds of thousands of feet, over forty hours of film, I had less than six months to edit, build the sound effects, record the demon voice, record a music score, mix the sound elements, color-time the print, and approve release prints. Delaying the release would cost Warner millions in guarantees, taxes, and revenue. They didn't care how I accomplished it; the picture had to be in theaters on December 26.

There was the question of the rating. *The Exorcist* could easily get an X from the Motion Picture Association of America (MPAA), which would have made mass marketing of the picture impossible. In the years since the code was devised, *Midnight Cowboy* got an X, did well at the box office, and won the Best Picture Academy Award, but it was the only movie ever to do so. *Last Tango in Paris*, also X-rated, was a critical and box office success, but these were

exceptions. An X rating was basically the kiss of death for a major studio release, implying excessive brutality or pornography. The sooner the ratings board could see the film, the better. If they gave it an X, Warner Bros. would have forced me to make cuts to obtain a more lenient but still restrictive R—no children under eighteen admitted without a parent.

I hired four editors—Jordan Leondopolous, Evan Lottman, Norman Gay, and my old pal from Wolper, Bud Smith, to whom I assigned the Iraq sequence—plus two assistants for each, in rooms side by side. Each editor was given different scenes, and I would go from room to room making changes for at least twelve hours a day, six days a week. Once an editor finished one scene, he'd take on another. This was an unprecedented, potentially chaotic way to edit a film. The performances were consistently good, so that what to use became a matter of choice, not necessity, as was often the case with *The French Connection* and some of my earlier films. The editing style of *The French Connection* was something I thought would serve *The Exorcist* as well: cutting too soon, or too late, going against an audience's expectations of where the cut would occur.

On the set, directing is a collaboration with the cast and crew. In the editing room, I tend to become a dictator. I have a feel for what I want, which often differs from how an editor might see the film. I've collaborated with editors who contributed excellent ideas, but the memory of earlier bad experiences on *Good Times*, *The Birthday Party*, and especially *The Night They Raided Minsky's* made me gun-shy of entrusting the film to an editor.

Initially, I had no idea how to achieve the voice of the demon. Linda Blair recorded everything, but her voice had to be transformed, in the same way we altered her appearance.

Blatty describes the demon voice as "coarse and powerful," "an

oddly guttural tone," "a deep . . . deafening voice . . . thick with menace and power."

How do you achieve that with the voice of a twelve-year-old girl? All I knew was that the voice had to be dubbed. But how, and by whom? Before I left for Iraq, it came to me. My old friend from Chicago, Ken Nordine—whose audio experiments and free-association recordings, which he called "word jazz," were the hippest things in sound. He did remarkable sound tracks for radio and TV commercials. Anything that could be done to alter the human voice, he was able to accomplish. Ken's own voice was deep, mellifluous and versatile. We hadn't been in contact for years, but I called him, told him about the project, and sent him a script. I also sent him a sample of Linda's voice. Ken was interested and said he'd like to try a few experiments.

When I returned from Iraq, Ken sent some recordings. Using his own voice, he attempted a demonic sound. However distorted, it was still the voice of a man coming from a young girl's mouth. It made me realize that a *male* voice, no matter how "coarse, guttural, or deafening," could not emanate from Regan's mouth.

What was the alternative? I started to think about the 1940s radio dramas that had a lasting effect on my imagination: *Inner Sanctum, CBS Mystery Theatre, Suspense.* There were great voices in radio—Orson Welles, Jack Webb, William Conrad, Peter Lorre, and one particular woman. Mercedes McCambridge. She later became a distinguished stage and film actress who won a Best Supporting Actress award for her first film, *All the King's Men*. She was also the leader of the murderous gang in Orson Welles's *Touch of Evil* and Rock Hudson's sister in *Giant*, which brought her another Academy Award nomination. But the thing I remembered most about her was her voice! I'd describe it as "neutral" rather than male or female. Bette Davis, Lauren Bacall, Ida Lupino, Lizabeth

Scott—many of the female stars of the 1940s had deep voices—but Mercedes McCambridge! Orson Welles called her "the greatest radio actress ever." I didn't know if she was still alive. I asked David Salven to check.

She was appearing in a road company of *Who's Afraid of Virginia Woolf?* in Dallas. I called her, and there was that distinctive voice over the phone. She heard about *The Exorcist*, but hadn't read the novel. "When would you need me?" she asked. "As soon as possible," I said, and sent her the script.

We met in Los Angeles, and I ran a rough cut for her. She didn't speak for a while. Then she asked, "What do you know about me?" Biographically, I knew nothing. "Why did you come to me?" I told her of the unsuccessful experiments I had conducted that led me to realize I needed a woman's voice, and that she had one of the most distinctive I'd ever heard. "Let me tell you about myself," she began. "I'm Catholic. I was also in AA, and I smoked for thirty years. I have two friends who are priests. If I do this, I'll need their advice and counsel *at all times.* To get the sound you want, I'll have to drink bourbon, smoke, and do other things I haven't done to my body for years."

"I certainly wouldn't want—"

She cut me off. "You shouldn't worry about it. Just get the performance you need, but we'll have to trust each other, and I have no idea how long it will take. It's not just the sound—you want me to find my inner demon. I'll have to unleash things in myself I've kept hidden for years."

For three weeks we worked in the main dubbing stage at Warner Bros. The stage was constructed before the increase in auto and air traffic around Burbank, so you could hear extraneous noises while trying to record a "clean" track. Hal Landaker, who designed sound studios, worked with me to "tune" McCambridge's voice

with various wooden panels he placed around her, moving them so her voice had more reverberation or less.

At her request, she sat with her hands and feet bound to a chair. She wanted the bonds tightened when it appeared that Regan was suffering or being punished. She would sip Jack Daniel's throughout the day, while swallowing raw eggs and smoking cigarettes. This combination gave her voice a guttural, menacing tone. Sometimes she would just breathe into the mike at close range, and you could hear three or four wheezing sounds coming from her throat. We dubbed these sequences a line at a time, sometimes one word at a time. We would do as many as twenty or thirty takes of one word. McCambridge would produce noises or laughter or cries I would later mix into the track or overdub. I also slightly offset two or three of her line readings, so it sounded as if the demon spoke in several voices at once. She would record for an hour or two, then take a break and go to a couch at the back of the stage, where the priests would comfort her and sometimes read scripture with her. Often she burst into tears. We would record ten hours a day, not stopping until Mercedes said she'd had enough.

When we finished, she took me aside. "This was tough," she said.

"I know, but you were wonderful," I told her.

"You think it's all right?" she asked.

"Beyond my wildest hopes."

"I have a favor to ask you," she said.

"Whatever," I answered.

"If the film works, as I expect it will, I don't want people to think about who did the voice. This girl gives a marvelous performance. *I don't want screen credit.* I'm not asking for it contractually, and I won't accept it if it's offered."

"Mercy, you deserve it," I said. "I want you to have it."

"Please do as I ask," she responded. "It's better for the film if I take no credit."

The next problem was the music score, but I looked forward to it; my first and only choice was the great Hollywood composer of the late 1930s through the '80s, Bernard Herrmann. Herrmann had written scores for *Psycho*, *Vertigo*, *Citizen Kane*, *The Magnificent Ambersons*, *The Devil and Daniel Webster*, and many more classic movies, for Hitchcock and others. I took the print to London to screen it for Herrmann, who left America. He had become disillusioned with Hollywood after being fired by Hitchcock for his score for *Marnie*. He was still writing for films, but only from self-exile in London. I thought then, and still do, that he was the best of all film composers.

I met him at the William Morris office in London, after he screened the rough cut, and he came right to the point: "I can probably help you with this dreck, but you gotta get rid o' that first scene."

I had been warned about his bluntness. "You mean the prologue in Iraq?"

"Yeah—what do you need that for?" he asked. "What does it do for the picture?" He went on: "You probably want to keep it 'cause it was hard to shoot and cost you a bundle."

"No. I think it sets the mood for everything else," I insisted.

He waved me off. "It don't mean shit." He went on to say that if I wanted him to do the score, he would only work in London, recording all his music in an old church called St. Giles Cripplegate that had great acoustics and the most beautiful organ he'd ever heard. His candor provoked me to return it in kind: "You want to use a church organ in *The Exorcist*?"

"Why not?" he asked.

I was talking to the best film composer ever, and his participation would lend prestige to the film, but I was as straightforward as he was: "Why not? 'Cause I think it's a cliché. I don't want a church organ in *The Exorcist.*"

"Look"—he was becoming impatient—"you want me to write somethin' for this, leave the print here, and when I'm done, I'll mail you a score."

"You don't want my input, not even where I think we need music and where we don't—?"

"Kid, I've done hundreds of scores. How many films have you made?"

I stood up and shook his hand. "Thank you for letting me meet an interesting person," I said, and left.

On the plane ride home, I played our conversation back in memory. Second thoughts set in. What could I possibly tell *him* about music for film? But this was *my* film, and I wanted first to please myself.

During the 1960s in Chicago, I used to go to jazz clubs—the Blue Note, Theresa's Lounge, and the Sutherland Hotel. One evening I met a young Argentinian pianist and arranger, Lalo Schifrin, who was touring with the Dizzy Gillespie Orchestra. He had written and recorded a brilliant modern jazz suite for Dizzy called *Gillespiana.* We became friends and would correspond regularly as he continued to tour the world. Lalo told me his ambition was to write music for films, and I confessed it was my dream to one day direct them. By the time we next met in Hollywood, Lalo had gone on to write many film and television scores, including the theme for *Mission Impossible* and his great score for *Bullitt.*

We felt sure we could collaborate, as friends who had similar musical references. I ran *The Exorcist* work print for Lalo, and he was enthusiastic. I told him I had been listening to a lot of

contemporary classical music, by composers like Hans Werner Henze, George Crumb, Anton Webern, Yannis Xenakis, and Krzystof Penderecki. I felt that the *Exorcist* score should be atonal and minimalist, like a cold hand on the back of your neck. I wanted abstract chamber music because I felt a big orchestra would overwhelm the film's intimacy. I brought some LPs to Lalo and played him the tracks I felt could be a template for our score. I also thought we needed a brief, sixteen-bar musical motif, occasionally superimposed over the soundscapes, something innocent like Brahms's "Lullaby." I told Lalo I wanted very little music, not a wall-to-wall presence.

About three weeks later, Lalo played the piano score for me. The music was abstract enough, but how would it sound expanded to other instruments? I reminded him that I wanted a small group, not a large orchestra. We were scheduled to record the following Monday at the legendary facility where the great Max Steiner scores were recorded for the Warner Bros. films of the 1930s, '40s, and '50s.

I arrived to the disturbing sight of seventy or eighty musicians assembling. There were five percussionists and a full complement of brass and strings. The opening titles, followed by the first scenes of the film, appeared on a large screen behind the musicians. Lalo gave the downbeat, and what followed was wall-to-wall noise, using every component of this big band, including electric brass. This was not Webern—it was more Stan Kenton or the Dizzy Gillespie Big Band. I was in shock. It's not that the music was badly written or played; but it was the opposite of what I wanted.

I took him aside: "Lalo, I think it's wrong." He moved away, incredulous. Everyone in the studio knew I didn't like what I was hearing.

John Calley was summoned to the session. He asked Lalo if he was willing to make changes. Lalo reminded him that we had the full orchestra booked for two more days, followed by a day of cues with a smaller group. He had no time to rewrite or rearrange the music, if he *wanted* to.

As a filmmaker, you need the stamina and the moxie to trust your instincts and defend your choices. I was concerned about rejecting Lalo's music after rebuffing the great Bernard Herrmann, especially given the approaching delivery date. I've never studied music, but I'd developed a taste for what I liked and disliked—"I know it when I hear it," to paraphrase former Supreme Court justice Potter Stewart on pornography.

Calley had been supportive of me throughout the process, through all the inexplicable disasters and rising costs. He turned to me: "What do you want to do?"

"John, I can't put this stuff in the picture." I told him we should cancel the other sessions and start again with somebody else.

"I'll cancel them, Billy," he said, "but we're committed to pay the musicians for the next three days." I was mortified, but I felt Lalo's music would have overwhelmed the film.

I made so many seemingly irrational decisions throughout the process, but this one capped them off. With less than two months before the release of the film, we had no music score or final sound mix.

There are certain sound tracks that define a film. Try to imagine *A Man and a Woman* without the music; or *Chariots of Fire*, *Psycho*, *Rocky*—just a few bars of these scores on the radio or TV, and you're reminded of images from the films. I didn't want songs or melodies for *The Exorcist*, only mood and atmosphere. I told Lalo I was sorry and tried to shake hands. He returned my gesture with a look of contempt and walked away.

A ten-year friendship was over. Whenever our paths cross, we avert our eyes. We haven't spoken to each other for forty years. I understand his anguish, but I don't know a polite way to reject someone's work. I still listen to some of his scores and to *Gillespiana*, which sounds as fresh and original as when he wrote it over forty years ago. My disappointment in him has long since passed, but if confronted with the same situation today, I would do the same thing. Hopefully I'd find a more diplomatic way, but I'm not sure that would make it easier.

Inevitably, a number of disputes arose between Blatty and me. From my point of view, I was doing what a director does, but in so doing, I was making decisions that usurped Blatty's role as writer and producer, and most important, as *creator* of *The Exorcist*. Though film is the most collaborative of media, it *is* a director's medium. You can't make bottom-line decisions by committee or in concert with anyone—not the producer, the writer, nor the cameraman, the actors, or even the studio. At a certain point, you have to believe in the film you're making and what will be its final form. At any stage of production, one or more of the aforementioned will happily take over and do their own thing. Open that door a crack, and you've lost the film.

In fact, as the creator of *The Exorcist*, Blatty was more qualified than I to make *all* the final decisions. What pushed against that was the process of filmmaking itself. At no time did I feel I was making a film that went *against* Blatty's intentions. He was my ideal and most important audience, and I was sure I'd delivered the film he fought for me to direct, even though we often differed on key details. Our worldviews were similar, not identical. Though we began on the same course and Bill was theoretically captain of the ship, I knew that in the final stages I would have to guide the boat alone.

I lived with the possibility it could all turn to disaster. It had in the past. But with total confidence, even arrogance, I went, as they say in poker, "All in."

After canceling the Schifrin sessions, I met with Larry Marks, Warner's music director. I told him I'd made a temp score from excerpts of the same contemporary classical music I played for Lalo: five pieces by the Polish composer Krzystof Penderecki; one by the renowned German composer Hans Werner Henze; and fragments composed by George Crumb and Anton Webern. I filled in with short works that were sent to me by two young American composers: David Borden and Harry Beer. I segued from one to another, creating my own score.

"The Musicians Union won't allow us to use preexisting recordings," Larry said, so he had to get permission from the publishers, then go to London and hire an arranger, a conductor, and a small orchestra to rerecord them.

Calley was sure of one thing: this film existed in my head and nowhere else. We didn't have time to commission a new composer and risk throwing out another score. He gave Larry the go-ahead, while the other executives at Warner's were convinced I had flipped. The film had already experienced costly overruns, which would inevitably affect the profit margin. If it failed at the box office, the executives would appear incompetent.

Before Larry left for London, I asked if he had any ideas for a motif—something like Brahms' "Lullaby," that could serve as a kind of child's theme. "I have no idea what you're talking about," he admitted, but he pointed to a large room and a table covered with audition discs. "There's a turntable in there; see if you hear anything you like."

Auditioning music this way was called "needle dropping." I began to play through the stacks, listening for no more than several

seconds before changing discs. I did this several hours a day, and on the fourth day I was ready to give up. Wearily, I selected a disc labeled *Tubular Bells*, written and performed by Mike Oldfield. It began with a simple motif played softly on a bell, followed by a lengthy narration by the composer. The disc was a teaching tool more than a piece of popular music. But that opening motif, short but just long enough, was haunting. I played it for Larry Marks.

"This is what you're looking for?" he asked in astonishment. *Tubular Bells* was recorded by a new company in London called Virgin Records. It had come in unsolicited. As Virgin founder Richard Branson would say in his autobiography, its use in *The Exorcist* was his company's first million-selling record, and actually launched Virgin Music. Like much else, it was a gift from the movie god.

I contacted Jack Nitzsche, a music producer who had done albums for Mick Jagger, Boz Scaggs, and Buffy Sainte-Marie, among others. Jack had a great feel for soundscapes as well as music, and he had a simple approach to producing them. The opening sounds over the titles are a series of quiet abstract tonal chords that Jack created simply by rubbing the edge of a wineglass. During a recording session, his girlfriend was sleeping facedown on a couch. He placed a microphone on the floor next to her, then ran across the studio and jumped on her back, landing with both knees. Her shocked reaction is the sound we used when Regan throws up on Father Karras.

We rerecorded the movements of the actors, a process called "Foley" after its creator, wherein "sound actors" walk and move, pick up objects, and open and close doors, in sync with the action on the screen. The Foley track replaces or enhances what the actors are doing onscreen, so that dialogue and sound effects are heard clearly, without extraneous noise. This technique is also used for

foreign versions of a film, so that when it's dubbed into another language, only the English dialogue track needs to be replaced.

Before starting the mix, I had seen two films by a Polish-Mexican director, Alejandro Jodorowsky, which were outrageous masterpieces. One was called *El Topo* (The Mole), the other *The Holy Mountain*, and the sound tracks were extraordinary. They were created by Gonzalo Gavira, who lived in Mexico, spoke no English but had a cousin in Los Angeles who was able to contact him for us. One day Señor Gavira, a short, middle-aged man in an old white cotton shirt and shiny dark pants, wearing no shoes, came to the mixing studio with his cousin. We ran the film for him while his cousin whispered a running translation of the dialogue. When the lights came up, he said in Spanish: "I'm ready."

It usually required months for a sound effects crew to assemble a sound track. I asked Señor Gavira what equipment he needed. His only request was an old, cracked leather wallet that contained credit cards. Placing the wallet close to a microphone, he bent and twisted it, and that became the sound of the bones cracking in the demon's neck as it turned completely around. Gavira was in the studio for about four hours, created several key effects using only his body, then went home to his little town on the outskirts of Mexico City.

In all, the mix went on for three months, six days a week. The demon voice recorded by Mercedes McCambridge was mixed with animal noises and with an audiocassette I received from Father Bermingham that contained an actual exorcism recorded in Latin in the Vatican. McCambridge's screams and moans were enhanced with the terrifying shrieks of the child on the Vatican tape.

I arranged for Blatty to see my cut at the Warner screening room in New York. Though he had seen dailies and made suggestions

for retakes, all of which I did, this was the first time he would see the film put together, with the demon voice and my choices for the music. You are never more vulnerable as a director than when showing a first cut to someone you respect.

The next morning, we met at the St. Regis Hotel for breakfast. As I walked down the short flight of steps to the King Cole Room, I saw him sitting alone. He gave me an enthusiastic thumbs-up and a big smile, then a hug. "It's wonderful," he said. "I have no notes. Don't change a thing." I was elated. As he confirmed in many interviews since, he "sprinkled holy water" on my first cut. He called Leo Greenfield, head of distribution at Warner Bros., and told him the film should play in as many theaters as possible, "This will be bigger than *The Godfather*," Blatty assured him.

Then John Calley saw the cut. While enthusiastic, he *did* have notes: "Take out the second doctor consultation scene; take out the scene between Karras and Merrin, where Merrin 'explains' the 'meaning' of Regan's possession; reverse the order of two scenes, and cut the final scene between Dyer and Kinderman that ends the film on a hopeful note." Calley's notes were unsettling. My initial response was, "Who the hell is he to tell me how to make a film?"

But his notes gnawed at me until gradually my anger dissipated and his ideas resonated. I went to the cutting room and reluctantly began to implement his suggestions one by one. And maybe it was because I hadn't seen the complete film for several weeks, but his ideas seemed fresh. The pace seemed to improve, and I didn't miss the apostolic underlining. Blatty thought Calley's changes would hurt the film, but over his objections, I took out a total of twelve minutes, bringing the running time to just over two hours.

After months of editing, I felt the film should end on a more ambiguous note. I wanted viewers to remain unsettled and without resolution. I cut the Dyer/Kinderman scene and brought the film to an abrupt end as Dyer turns away from the now empty flight of steps. This omission gave many the impression that the film ends on a note of pessimism. Regan tenderly kissing Dyer on the cheek and the Saint Joseph medal were meant to offset this, as a kind of subtle "resurrection" of Karras. This omission became a source of conflict between Blatty and myself for decades. As Blatty said in an interview in 1998, "The film that Billy delivered in 1973 was highly effective, but it lacked a spiritual center. You proceeded from shock to shock without a clear purpose. It was a roller-coaster ride whose success made me comfortably well off, but also troubled me. And ironically, I always believed that removing the moral center of the film actually *limited* its audience appeal. . . . *With* these scenes, you understood *why* you were being subjected to all this horror, why the girl was suffering so."

I still emphatically disagree. I believed that while the film's "message" was unstated, the obvious conclusion was that good had triumphed over evil . . . not always, not forever perhaps, but certainly in this case. In hindsight, I think that if the film has relevance, it's due to the tension between Blatty's tightly structured script and absolute faith and my improvisational, agnostic approach to it. Blatty's stated goal in the novel and the film was apostolic. I simply wanted to tell a good story. Its conclusion to me was inherent: the girl was *possessed*, and the exorcism was *successful*. Blatty wanted that underscored; I did my best to eliminate underscoring.

Few people know the identities of the MPAA Ratings Board members. We were told they're mostly educators and representatives

from the Parent-Teacher Association, plus retired film executives, but their names are purposely withheld. When Jack Valenti formed the MPAA in 1968, he approached Aaron Stern, a psychiatrist in New York, to devise the ratings system. Stern, as head of the Ratings Board, would not normally participate in a film's rating. He would only see it if there was a controversy within his board.

A half hour after the board screening was over, I received a call from Dr. Stern. We had never met nor spoken until that phone conversation. "Billy, this is Aaron Stern. Can I call you Billy?"

"Sure."

"Listen, I've just seen *The Exorcist*. It's a great film. We're going to give it an R, and I'm sure we'll catch heat for that and so will you, but this is a movie that should be seen as you made it, so we're not asking for any cuts. I'm about to call Ted Ashley and tell him." This was electrifying. If Stern had been standing in front of me, I'd have kissed him on the lips. All that remained was to conform the negative and start making prints.

You begin by screening the work print with a "color timer," telling him what shots you want to make darker, brighter, with more contrast, more blue, less red, and so on. You review the print shot for shot, and *The Exorcist*, like most films, had several thousand shots.

Warner Bros. owned the Technicolor lab, so we timed the prints there. As we saw various reels come off the printer, I thought they looked awful. There are reasons why a 35 mm. print can be inconsistent from shot to shot or from one reel to another. The composition of the water in the developer is constantly changing, and the electrical current to the printer fluctuates. This can cause one shot to appear bluish and the next greenish, and consistency is difficult to achieve.

There were a few great "timers" who knew how to achieve con-

sistent results, but the reels coming out of Technicolor were either "milky," too dark, or too bright. Completing the film was going to be an obstacle course to the very end. I went to Calley and Wells and told them that the lab was not producing a satisfactory print. The lab, of course, was another source of revenue for the studio. The cost of printing was billed to the overall cost of the film, so when Warner printed their films at Technicolor, the money went from one pocket into another. If you directed a film at Warner, you *had* to use Technicolor.

I was assured by Roger Mayer, chief executive of what was left of MGM, that the MGM lab was still the best in the business. Roger was a longtime studio boss, reliable and decent, who was active on the board of the Motion Picture Academy. I knew him only slightly, but he had a good reputation.

I told the executives at Warner's I wanted to pull the film out of Technicolor and see what the MGM lab could do. You can imagine how that went over, as the difficulties of finishing continued to pile up. Calley ran interference for me. We took the negative out of Technicolor—scandalous at the time—and moved it to MGM, which had only one picture, ours. The timer was Bob McMillian, a soft-spoken man in his early fifties who spent all his working life in the lab, where he had timed hundreds of films.

McMillian looked at the elements with me, then went to work. We had less than a month, but because of Warner's concern over the possible negative impact of the film, we only had to make twenty-six prints, not several thousand, which potential hit films have been generating for the last few decades. Bud Smith and his assistant editors, Jere Huggins, Ned Humphreys, and Ross Levy, joined me in approving or discarding reels. The reels we rejected were destroyed so they would not "turn up" in subsequent prints. *The Exorcist* was printed on twelve reels. We looked at several hun-

dred reels to get the twenty-six prints I ultimately approved. It was as though McMillian "painted" each frame. Without his skill and dedication, the film would not have been as effective as it proved to be. There is no award for color timing, but the best timers, like McMillian, are artists whose contributions to film are immeasurable and unsung.

We delivered the prints on time, and I went with two technicians from Warner Bros. to the twenty-six theaters around the country where the film was booked for six months. We set the sound level and screen brightness for each theater. Most theater owners lower the light level on projectors to save energy costs. This results in a darker picture than was intended. Often audiences aren't aware of it, but when they complain they're generally ignored. I had the names and phone numbers of each projectionist at the twenty-six theaters and either because I was a perfectionist or a pain in the ass, I called them all, each day, for the six-month run. I would ask where the light and sound levels were set. Often, one would tell me the manager had instructed him to cut the light level, or he'd say, "I had to turn the sound down 'cause we're getting complaints." I would throw a fit over the phone and tell them that unless the levels were returned to where I had originally set them, I was going to pull the picture out of their theater. I had no authority to do this, but the theater owners and managers believed I did.

The number of theaters had to be increased immediately because of demand. In some theaters, people were literally breaking the doors down to get in. But the studio could only expand within theater chains that had originally booked six-month exclusives. We could have opened on five thousand screens and done sold-out business. Eventually it played in many more than that, and grossed more than $600 million over the years. Its financial success is ongoing as home video continues. The money it *did* gross was mostly

achieved on a ticket average of three dollars. With the twenty-six-screen release, I had control of the film as though it was a play. The projectionists would tell me when a print or a reel was wearing out, and I'd get the studio to send them a new one.

With *The Exorcist*, I was still learning on the job; from production to postproduction, it was a voyage of discovery. I never lost faith that we would overcome the problems and find the answers. It would be years before I would again experience that kind of self-confidence on a film set, a belief in a kind of Divine intervention.

In the weeks leading up to the opening, Dick Lederer, head of Warner's marketing, showed me the print ad he had prepared. It was a line drawing of a little girl's bloody hand clutching a blood-stained crucifix above the phrase "For God's Sake, Help Her." I thought his ad would hurt the film, and I told him so: "You can't use God's name in an ad, and why would you underline the film's most controversial scene?"

"What do you suggest?" Lederer responded coolly.

"The ad should understate the film's content," I said, and suggested they use the silhouette of von Sydow standing in front of the house in Georgetown, the image inspired by Magritte. Reluctantly, the studio agreed, and that's been the iconic image ever since.

The Exorcist opened on December 26, 1973. The prints were delivered on Christmas Day. I approved the final ones on Christmas Eve, but we had one print ready on the twenty-third, and that's when the film had its first preview, in Los Angeles at the National Theatre in Westwood.

There were lines wrapped twice around the block. The studio publicity department had put up a gigantic three-dimensional window on the outside of one wall of the theater. It was meant to represent the window in Regan's bedroom, and the curtains

were blowing out toward the street. It was the idea of a Warner's publicity genius named Marty Wiser, and it put audiences in the mood for the film before they saw it. The theater was filled, but there wasn't a sound throughout the screening. When it was over, the audience sat silently without moving or speaking, then slowly filed out.

As I headed for the parking lot, with Ellen Burstyn, Jason Miller, Blatty, and other friends, Mercedes McCambridge suddenly confronted me. She was crying, shouting, and pulling at my arm: "You screwed me! How could you do that? Why would you do that to me?" she yelled. I took her aside: "What's wrong? What's the matter?" I thought she was upset by the film's content and thought it blasphemous, as others have over the years. "You promised me a credit!" she screamed. "Where's my screen credit? You lied to me!" I was stunned. I reminded her that when she agreed to do the demon voice, one of *her* conditions was that she *not* receive credit—that the audience not be reminded that the voice was dubbed. At the time I thought she just wanted cover in case the film was condemned by the Church. I felt bad for her but furious at the same time. I walked away, her voice trailing after me: "I'm gonna get you for this, Bill Friedkin!"

The next week, she gave a story to the trade press, *Variety* and the *Hollywood Reporter*, saying that I denied her screen credit in order to protect Linda Blair's performance. Her lawyer threatened to sue. At the same time, Eileen Dietz, Linda's stunt double, who appears in twenty-eight seconds of the film, claimed that she *shared* the performance of the demon with Linda. These were out-and-out lies by two women who saw an opportunity to claim part of the limelight. Dietz *did* receive screen credit, and Warner's decided to redo the last reel and insert McCambridge's name. As there were only twenty-six prints at the time, the cost of redoing a reel wasn't

much. She deserved this credit, so I had no problem with it, but when the CBS Network bought the film for television several years later and asked for a few changes to the demon's lines, I dubbed them myself in my best Pazuzu growl. One of the lines I changed for television was, "Your mother sucks cocks in hell" to "Your mother still rots in hell."

The week the film opened, a porno theater in Long Beach obtained a bootleg 16 mm. print. They too had lines around the block. There was a hand-printed sign outside the theater: "Technical difficulties, no refunds." In fact, the sound was out of sync with picture because the print had not only been illegally but amateurishly copied. This didn't seem to bother the patrons. I heard about it from a friend, and I immediately reported it to Frank Wells.

"We'll get our lawyers on it right away," Frank said. Ten days went by, and the bootleg print was still playing. What angered me was not the loss of revenue; the film was earning a fortune. It was that people were not seeing it as I intended. I asked Wells what was happening with the lawyers, and he said they were preparing a complaint.

Dave Salven and I had a friend who was on the wrong side of the law. He asked if I wanted him to "handle the situation," and I told him to go ahead. That Saturday night, Dave waited in the car with the engine running while our friend went into the Long Beach theater, past the crowds, and up to the projection booth. He told the projectionist to take the film off the projector, put it in its container, and hand it over.

"Who the hell do you think you are?" the projectionist responded. My "friend" opened his jacket to reveal a .45 automatic, whereupon the projectionist complied, leaving an angry and confused audience.

The following Monday, Wells called me, panicked, asking if I had anything to do with the theft. "What are you talking about, Frank?" I responded innocently. "Somebody stole the print from Long Beach, and the theater reported it to the police! The LAPD is in my office now!" I couldn't believe it. "They want to talk to *you*," he said, his voice a hushed whisper.

He brought two LAPD guys, a cop from Long Beach, and a nervous, balding, heavyset guy who turned out to be the Long Beach projectionist to my office. The cops sat on my couch, I was behind a desk, Frank and the projectionist stood.

Under the couch was the purloined print.

I told them the theft was news to me. "But why," I asked, "are you investigating this, when the theater was showing a *stolen* print?"

"Because it was taken at gunpoint," the Long Beach cop explained.

"It wasn't their property," I said, hoping they wouldn't ask to search my office.

"Pulling a gun is worse," one of the LAPD said. "It's called armed robbery and could get whoever did it eight years."

The projectionist couldn't ID me, so the case went away. But other reports came to me about bootleg videos turning up at bars around L.A. I went to my "friend" each time, but soon, bootlegs were turning up around the country and the world.

As a result of the actions of McCambridge and Dietz, Linda's performance was put into question, which I believe cost her an Academy Award. The Hollywood old-timers were looking for ways to deny *The Exorcist* too much acclaim. This is not sour grapes. My friend Jack Haley Jr. produced the Oscar show that year. He told me that it was being said among influential members of the community that "if *The Exorcist* wins the Best Picture Award, it will change the industry for the worse, forever." The person leading the backlash was the veteran director George Cukor. It so hap-

pened Cukor was hosting a luncheon at his home in Beverly Hills that weekend for the nominated directors. When I arrived, Cukor greeted me at the door. "Bill," he said enthusiastically, "welcome. It's good to meet you." And putting an arm around me, he congratulated me on the nominations. Before leading me into the living room, where the others were gathered, he took me aside. "You know," he whispered, "these rumors about me knocking your film are bullshit. I think it's a great picture." I thanked him and told him I hadn't heard the rumors. It was curious that he denied it so vehemently without my having mentioned it.

Though nominated for ten Academy Awards, including Best Picture, *The Exorcist* won only for Sound and Adapted Screenplay. Though I had expected nothing for *The French Connection*, I thought *The Exorcist* would be widely honored. Entitlement and hubris had overtaken me.

I had come from a one-room apartment in Chicago to the finest hotel suites in the world, first-class air travel, the finest tables in the best restaurants, beautiful women who sought my company, top of the line all the way. I was able to buy a sixteen-room apartment on Park Avenue and Fifty-Fifth Street that took up an entire floor of a twelve-story Belle Epoque building, and a house on an acre in Bel Air, California. I vaulted to the top of the Hollywood A-list, and thought I'd stay there forever. My successes were born of my failures, and like Monroe Stahr, Scott Fitzgerald's character in *The Last Tycoon*, I thought I had the formula. When people tell you how great you are, you start to believe it.

Warner Bros. asked me to go to various cities in Europe to do promotion. I was happy to make the trip and bask in the reflected glory of the film. I stayed at the elegant Plaza Athénée in Paris and was

treated like royalty. There were lengthy articles in French newspapers and magazines about the *Exorcist* phenomenon, and the critics were ecstatic in their love or hatred of the film. I met Chabrol, Truffaut, and a man whose films I revered, H.-G. Clouzot, director of *Diabolique* and *The Wages of Fear*. One of France's leading actors and a favorite of mine, Lino Ventura, showed up at a dinner for me in the private room above Fouquet's, where Warner's PR rep Joe Hyams took me to a window overlooking the Champs-Elysées. He pointed to a large movie marquee that read "L'Exorciste, Regie de William Friedkin" in red, white, and blue neon letters visible all along the Champs, with lines around the block on both sides.

I felt a sense of achievement beyond anything I had ever experienced. To me, the French filmmakers and the French public were the most knowledgeable and enthusiastic audiences in world cinema. To be accepted by them was what I'd hoped for but never expected. What Billy Wilder told me at the time applied to European cineastes: "You're only as good as your *best* picture." In America, it's "You're only as good as your *last* picture."

Hamburg, Germany. The local Warner's rep asked if I would agree to a late-night interview with a journalist from Axel Springer's *Bild-Zeitung*, one of Europe's largest-circulation newspapers. I wasn't arriving until late in the evening, but the *Bild-Zeitung* was prepared to send a journalist and a photographer to my hotel suite and to hold the next day's front page for an exclusive interview with me! I begged off. I was exhausted, but the Warner's rep said this was not only a major publicity coup, but Springer also promised to give us the cover of his magazine *Der Spiegel*, the *Time* magazine of Europe. I reluctantly consented but said I would give the interviewer only half an hour, as I had a full day of interviews the next day and the following two weeks in other cities around Europe.

The hotel manager escorted me to a spacious, elegant suite. The young journalist from the *Bild* was waiting with a photographer. I was dreading the interview. It was late, and I'd long since realized that most journalists' questions are the same, no matter the country. I folded into an easy chair, prepared to be bored, while the reporter sat opposite me. The photographer buzzed around, snapping pictures. To my surprise, the questions were intelligent and insightful. I became fully engaged. It was more than an interview; it was a philosophical conversation about good and evil.

The next morning, the piece appeared on the front page as promised, under a large photograph of—the hotel bedroom. The article was in German, so I had to ask the Warner's rep to translate it. He arrived at the suite apologetic and chagrined. The caption read, "This is the bed where the devil sleeps!" The gist of the article, which contained little of what I said, was that I had reintroduced the devil to America, and was now attempting to export evil to Germany and the rest of Europe and the world.

I called Frank Wells and my lawyer and told them I wanted to sue the newspaper. They were sympathetic and promised to follow through, but the head of Warner Bros. in Germany explained that a libel suit had no chance of getting to court; the German press had an absolute right to print whatever it wanted without consequence. My anger persisted for weeks, and I canceled the rest of my interviews in Germany. It seemed ironic that a German newspaper would accuse *me* of bringing evil to Germany.

Rome, Italy. The film opened at the Teatro Metropolitan on the Via del Corso adjacent to the Piazza del Popolo, a large square usually filled with hundreds of revelers at outdoor restaurants and coffeehouses. But on the film's first night, a thunderstorm broke out and a bolt of lightning struck an eight-foot-wide, twelve-foot-high metallic cross on top of a nearby sixteenth-century church. The

cross fell to the street in the piazza, smashing into the pavement. Only bad weather kept the area clear of the large crowds normally gathered there. Miraculously, no one was hurt or killed.

For almost thirty years, Blatty and I continued to disagree over my final cut. Over the years, the arguments subsided, and we came to accept the film's continuing hold on new generations. It was our stated goal simply to tell a story about the "mystery of faith," until the film began to win international polls as the "scariest film" or "the best horror film" ever made. We could no longer deny public perception. When Blatty would prod me about having undercut the film's moral center, I would call him a "sore *winner*" who continued to profit from my "amoral version" of his masterpiece.

Postscript. In the fall of 2003, American soldiers of the 101st Airborne Division occupied Mosul, shortly after the invasion of Iraq. Some of the soldiers were watching DVDs of *The Exorcist* and realized that the area they were occupying was Hatra, where I had filmed the Iraq sequence.

I got a fax from Major General David Petraeus, commander of the 101st, who told me his troops had given a grant of five thousand dollars to students at Mosul University in order to launch what became known as the *Exorcist* Experience. The locals were totally supportive of the project, which involved revamping the site, building a hotel, and starting a tour company that charged the equivalent of $2 for the tour and $5 with a kebab lunch. With the help of U.S. soldiers, the mayor of Mosul, and other civic leaders, they also built a car park and a police station nearby. Petraeus and I exchanged faxes, and he asked me to come to Mosul, bring some DVDs, meet the troops and the locals, and lend support to their effort. Soon after, I heard from Colonel Ben Hodges, com-

mander of the First Brigade of the 101st Airborne, and Lieutenant Colonel Kevin Felix, who was responsible for U.S. forces in Hatra. We discussed several dates for my visit, and I looked forward to it with enthusiasm.

A month went by with no word. On February 27, I got a message from Major Tom Osteen, operations officer of the Fifth Battalion, Twentieth Infantry, in Iraq, apologizing for not getting back to me sooner: "At the moment, the security situation in Northern Iraq is very volatile, as you may know from the news, particularly in Mosul. A visit by Mr. Friedkin . . . would be a tremendous boost to the area of Al Hadr (Hatra) and Mosul; however, we must ensure that we can do this without endangering the life of a national treasure." He was referring to me. "I will keep you updated on the progress," he assured me.

Sadly, there was no further correspondence. Hatra had survived invaders since the third century. Today, it's under the control of al-Qaeda in Iraq.

PART III

THE TUNNEL AT THE END OF THE LIGHT

HUBRIS

One of the most decent and talented men I know is Francis Coppola. Our interests and ambitions were similar, and while I was struggling through *The French Connection*, Francis was having similar problems with *The Godfather*.

After the opening of *The Godfather*, when the film earned $50 million at the box office, Charlie Bluhdorn, the owner of Paramount Pictures, gave Francis a blue stretch limousine as a gift. Coppola and Peter Bogdanovich, who had just won major accolades for *The Last Picture Show*, Ellen Burstyn, and I went for a ride in the limo to celebrate our recent successes. We had the driver go along Hollywood Boulevard, and we stood up, the four of us, with the roof of the car opened, and shouted at curious pedestrians. "Academy Award, Best Picture, *The French Connection*!" I yelled. "Every major critical award, *The Last Picture Show*!" screamed Bogdanovich. "Fifty million dollars, *The Godfather*," Coppola reluctantly chimed in. Ellen laughed and we enjoyed the ride and the warm California breeze in our faces. We were pranksters who made it big, making fools of ourselves.

Francis told me that Bluhdorn wanted to meet him, Peter, and me with the idea of starting our own production company, to be underwritten by Paramount. We met on the top floor of the Essex House, where Bluhdorn had the hotel's largest suite. I was first to

arrive. I pushed the buzzer outside the suite, and an energetic man about fifty years old, a thick Austrian accent, and a satanic grin greeted me: Charlie Bluhdorn. I was soon to learn that he was not only one of the richest but one of the world's most eccentric men.

Bluhdorn started his business with a small auto parts company in Michigan and became a millionaire at thirty and one of the first conglomerate builders of the go-go sixties. He was the founder and chairman of the Gulf and Western Corporation.

He began to smell my neck! Yes. Smell my neck. "What's 'at shit you're wearin'?" he asked in a disgusted tone. "I'm sorry?" I asked tentatively, completely off guard, although Francis warned me about him. "That shitty aftershave?" he persisted. "Oh," I said, "Guerlain." "Gehlann, Gehlann," he mocked. "Com'ere, I wanna show you something." He led me through the luxurious suite to a large bathroom, opened the medicine cabinet and took out a giant-size cut-crystal bottle of Guerlain cologne, which he began to pour on his black dress shoes! "Gehlann?" He laughed. "This is what I do with Gehlann—"

He then led me back into the living room, which had a magnificent view of Central Park. "I own this hotel," he said. "I used to be a doorman here, now I own the whole fuckin' thing. My first job, I made fifteen dollars a week! I was sixteen years old. Fweedkin. What kinda name is that?" "My parents were Russian," I told him. "Russians!" he snapped. "All crooks."

It went on this way until Francis and Peter arrived. We sat, while Bluhdorn paced the room: "Art don't mean shit. This business is about money! Who gives a damn about a picture that don't make money? You wanna make *real* money?" As he paced, he would occasionally lean forward and shout in each of our faces. I had never seen a performance like this.

"You know I own clothing companies, zinc, cigars. I own all the sugar in the Dominican Republic, the fields, the refineries, I own

'em all. I'm gonna make you fellas rich. We'll start a new company. You'll make all your pictures for Paramount. You can make any film you want for under three million dollars. If you got a picture over three, you come to me. *Only* me. You'll be completely independent of Paramount. You don't have to talk to Fwank [Frank Yablans, president of Paramount] or Bob [Evans, head of production]." Francis hated Evans at that time because of a clash over bragging rights to the success of *The Godfather*. "You'll have no offices, no employees, no overhead! You just make pictures, and the money will go into a pool that'll pay for your *other* pictures. You'll each get ten percent of the profits of *all* the pictures. But I want *commercial* pictures, like *The Godfather, The French Connection, The Last Picture Show*. I don't wanna dump art films into this company." He was fascinating. Riveting. And more than a little crazy. Like the three of us.

Fantozzi and Gross and representatives of Francis and Peter met with Charlie's lawyers, and we hammered out a deal in a couple of weeks. We were in our thirties, and we were all gonna be big shots. But for one little thing: Charlie didn't bother to inform Frank Yablans until the deal was done. One fateful morning, we all met in Charlie's office on the Paramount lot, and Charlie announced the terms of the deal to Yablans, who listened quietly. "Whadda ya think a that, Fwank?"

"I think it's one of the worst ideas I ever heard, Charlie," Frank said softly. He was forty years old, short, feisty, balding, a bare-knuckles street guy from Brooklyn who came up through film distribution. He wore dark, tailored suits and always had a manicure. He knew how to sell pictures. Good pictures. Bad ones. He could sell anything.

"Just a minute, Frank," I interrupted. Fantozzi and Gross each put a hand on my leg to cut me off, but Charlie jumped in first: "What's wrong with it, Fwank?"

"Here's what's *wrong*," Frank began angrily. "When these guys start making flops—and they will—you're gonna blame me, even though I'll have no say over what they do. And if they make a few hits, you'll say, 'What do I need Paramount Pictures for?' It's lose-lose for me."

"Fwank, you're wrong," Charlie shouted. The Directors Company, as we called it, was *his* idea, and he wanted it to happen. I stood up angrily and walked out.

But the Directors Company was formed, "Fwank's" objection notwithstanding. Francis was preparing a small film about a wire-tapper, *The Conversation*, with Gene Hackman. It was budgeted at under $3 million, and was immediately folded into our new company. Peter had a film ready to go called *Paper Moon*, to star Ryan O'Neal and his daughter Tatum, about a con man traveling through the Midwest during the Depression. I had no idea what I wanted to do next.

The first film from the Directors Company was *Paper Moon*, and it was a financial and critical success. It got us off to a great start, and I was proud to be a part of the company that produced it, though I had nothing to do with its making. Then Francis released *The Conversation* in 1974, the same year he released *Godfather II*. I went up to see a rough cut in his screening room in San Francisco with about twenty of his friends and colleagues. I found it ragged and incoherent. It seemed like a ripoff of Antonioni's *Blow-Up*, using sound instead of photography.

After the screening, Francis went around the room asking each of us how much money we thought the film would make. His lawyer said at least $25 million. Other estimates went from $10 to $50 million, which would have meant an enormous profit. He came to me last. I said, "Francis, I don't think it'll take in five hundred

grand. I think we'll lose money on it." The others ridiculed my comment, which was probably not the subtlest way to put it to a friend, but I felt they were just blowing smoke and telling Francis what he wanted to hear. He reminded me that it was unfinished, a rough cut, but I honestly thought there was no way it could be fixed. And because I loved Francis, I wasn't going to bullshit him. The next time I saw it, it was better, but it never gelled for me, though it went on to win major critics' prizes and Academy Award nominations.

One of the many young people Francis was mentoring at the time was a shy, bespectacled young man with a shock of thick, wavy brown hair that made him look like a 1950s teenager: George Lucas. Francis had produced George's first full-length film, *American Graffiti*. Part of our deal at the Directors Company was the option to produce *other* films, if they cost less than $3 million and if we all agreed. Francis gave Peter and me a script George had just finished writing. "We can make this if you guys like it," Francis enthused. "It's gonna cost more than three million, a lot more, but it's really great, and I think we should do it." The script was set in a galaxy far, far away, and it had wookies, robots, a princess, and other assorted comic book characters. "How much will it cost?" I asked. "George has a budget of around nine million," Francis said.

"Nine million dollars!" Peter was laughing, but Francis believed in George from the day he saw his student films, and it's because of Francis that a major studio, Universal, made *American Graffiti*. I read George's script and told Francis I didn't get it. Peter had the same reaction. "Who's gonna direct this?" I asked. "George," Francis said. Because of his relationship with George, we had first crack at *Star Wars*, but Peter and I passed. "You guys are wrong," Francis told us.

Hubris had overcome me, and Yablans used it to divide us. He encouraged Peter to make his next film for our company, an adaptation of the Henry James novel *Daisy Miller*, about a young American girl in nineteenth-century Europe who meets and falls in love with a fellow American. The film was to star Peter's protégée Cybill Shepherd, a pretty young model who made her film debut in *The Last Picture Show*. Francis remained neutral, but I told Peter he shouldn't make it for our company. We had promised Bluhdorn "commercial" films. Peter and I exchanged ugly words, but Yablans not only convinced Peter he should make it, he financed a record album of Cybill singing the songs of Cole Porter and put up a huge billboard with her picture on the Sunset Strip advertising the album, *Cybill Does It—To Cole Porter, Produced by Peter Bogdanovich*. The album sank without a trace, but Peter started filming *Daisy Miller*. I took a strong adversarial position and played right into Yablans's hands, forcing a breakup of the Directors Company. The company lasted less than a year.

I had tasted fame and money, and they tasted good. Little did I realize how shaky was my foundation. While telling myself I didn't suffer fools gladly, I treated people badly. David Brown, the legendary Hollywood producer, used to say, "Those whom the gods would destroy, they first make successful in show business."

Jules Stein, founder of MCA and owner of Universal Studios, had become a friend. We met while I was preparing *The Boys in the Band*, and saw each other socially in New York and Los Angeles. Jules and his wife, Doris, and I used to go to the Hollywood Park racetrack. One day he called and asked me to meet him in his office at Universal City. He was excited about the success of *The French Connection* and *The Exorcist*, and he said, "I'll give you a million dollars if you come over to Universal." I put Fantozzi in touch with

the head of Universal business affairs, and somehow the "million-dollar signing bonus" became a million dollars to direct a picture.

Universal had just finished construction on a four-story office building on the lot for its producers and directors, and I was given my choice of suites. Dave Salven joined me and we were given our own production company. But I still had no idea what I wanted to do next.

I came across a novel by Gerald Walker, a reporter for the *New York Times*. Good title: *Cruising*. The story was fascinating: a series of murders in the gay bars of New York, and a detective who was assigned to go undercover to find the killer. After *The Boys in the Band*, though, I wasn't anxious to pursue another film about gay life. Phil D'Antoni was interested in the book and optioned it, with a new young director attached: Steven Spielberg. They tried to set it up but found no takers. I've often thought about the path Spielberg's career might have taken had he directed *Cruising*.

While on the Universal lot, I was invited to a private screening of Spielberg's second feature, *Jaws*, weeks before it opened. Sitting alone in a screening room, I wasn't impressed by the film. In the space of a year, flush with success and an overblown opinion of my talents, I failed to appreciate the genius of both Lucas and Spielberg. Soon the American film industry would belong to them.

At that point, I was spending more time with lawyers and accountants than actors or writers. I had fallen into the trap of losing focus on the work and concentrating instead on peripherals. It was to cost me dearly. My behavior during this period was erratic. I was at the edge of a cliff, and my demons were standing by, waiting to push me off.

The question of what to do next continued to elude me. It had been more than two years since I'd directed a film, and I was going back and forth between New York and Los Angeles, buying paint-

ings and antique furniture and enjoying the spoils of success. I was no longer the kid from Chicago who walked or took the subway everywhere and played in pickup basketball games. I was playing tennis instead, and driving a new Mercedes. There was a disconnect between who I was and what I had become.

You would hear me regularly pontificating on the Barry Gray radio show or see me on Dick Cavett, Charlie Rose, Merv Griffin, Mike Douglas, any number of television talk shows. On one of these, I was asked about films that influenced me, and two that came to mind were H.-G. Clouzot's *Wages of Fear* and *Diabolique*, both French films I hadn't seen for twenty years. I started to think about a new version of *The Wages of Fear,* not a remake but based on the same premise: four men, strangers in a foreign country, fugitives, broke and desperate, who sign on to drive two trucks carrying crates of nitroglycerin to extinguish an oil-well fire two hundred miles away, across unforgiving landscapes. The premise seemed to me a metaphor for the countries of the world: find a way to work together or explode. My film would have wholly original characters. I would make it grittier than Clouzot's film, with the "documentary feel" for which I had become known.

I believed I could make an audience care about the unlikeliest of heroes—a swindler, a terrorist, a hit man, and a driver for the Irish mob, with no redeeming characteristics.

10

SORCERER

Fantozzi and I went to Lew Wasserman and Sid Sheinberg to tell them this was the first picture I wanted to make for Universal. They agreed to let me develop the screenplay.

But first we had to acquire the rights, and this proved to be complicated. The Clouzot film is of iconic stature, but Clouzot didn't own the rights. The novelist Georges Arnaud, who wrote the original source material, *Le Salaire de la peur*, controlled them, and he had a long-standing feud with Clouzot. He was happy to sell the rights to us, but I felt I had to meet with Clouzot in Paris and get his blessing first.

He was not in good health, and soon to have open-heart surgery. He was being cared for by his second wife, Inès, and we could only speak through an interpreter. For the past ten years, he was doing documentaries for television of performances by Herbert von Karajan and the Berlin Philharmonic Orchestra, but he hadn't made a feature film for seven years, though he had several in planning stages. It was awkward for me to propose a new version of one of his landmark titles. He neither blessed nor opposed it, but told me what I already knew: he didn't control the rights and couldn't stop me. He wondered why I would want to do it, having received so much acclaim for my own recent work.

What I didn't say was that frankly, of all the possibilities that crossed my mind, this was the only one that stuck. I told him I wanted to give him a share of the profits, if there were any, and he thanked me.

Walon (Wally) Green was a young writer and documentary filmmaker I knew at Wolper, where he wrote and produced several *National Geographic* specials. He made a semidocumentary called *The Hellstrom Chronicle* that won an Academy Award the same year as *The French Connection*. A couple of years before that, he was co-writer of one of the best westerns ever made, Sam Peckinpah's *The Wild Bunch*. Wally spoke fluent French, Spanish, Italian, and German, and had an encyclopedic knowledge of classical music and literature. We talked about a new version of *The Wages of Fear*, and he was enthusiastic. He suggested I read Gabriel García Márquez's novel *One Hundred Years of Solitude*, the definitive work of "magic realism." It was another life-changing work and became a template for our version of *The Wages of Fear*. Wally and I worked on an outline together, creating the four desperate characters who wind up as fugitives in a poor village somewhere in South America.

We devised four prologues to show how each man came to this place: a wheelman for a gang of thieves who rob a church in Elizabeth, New Jersey; an Arab terrorist who blows up a bank in Jerusalem; a hit man who kills a stranger in a hotel in Vera Cruz, Mexico; and a French stockbroker who is caught up in a bank fraud involving his in-laws' company. We purposely set out to make these characters hard to "root for." I thought I could take an audience wherever I wanted them to go, and they'd be glad to be there.

The script took four months to complete, but when we finished, I thought it rocked. Sheinberg, Wasserman, and Ned Tanen, president of production at Universal, read it and were concerned about

its cost. The backstories took place in four locales—Vera Cruz, Jerusalem, Paris, and Elizabeth, New Jersey—and the main story somewhere in South America. Bud Smith would be my editor and coproducer. With Wally, we went to scout Ecuador, which had the most wild and exotic landscapes in all of Latin America.

Cabo de San Francisco is a poor fishing village in Esmeraldas, on Ecuador's southwest coast. We chartered a helicopter from Quito, the capital, and landed in a field just outside the tiny village. Makeshift shacks were built on stilts over the sea. Hundreds of schoolchildren, accompanied by their teachers, ran out to greet us, waving Ecuadorean flags and cheering. They had never seen an American, let alone a helicopter. They stood, beaming, at attention and proudly sang their national anthem to us. Two laborers whispered to one another in Spanish as we passed them to tour the school. Wally tried to conceal his laughter. "What's funny?" I asked him. "One guy just said, 'Who is that?' pointing to you," he answered through his laughter. "The other guy said, 'He must be the president of our country.' 'But he's a gringo,' the first guy said. And the other guy answered, 'Of course he's a gringo, you idiot.' "

The classrooms were small: blackboard, broken chalk, and a few erasers. No books. I asked the headmaster if they needed books. "Yes," he answered sadly. I'll never forget those eager, innocent faces. We must have seemed like Martians to them. For three years afterward I sent them boxes of books. But Esmeraldas wasn't the right location for our film.

We went on to Pachamama, in the Amazon rain forest. The natives, known as the Achuar, had scarred, painted faces and colorful headgear. They lived in straw huts, surrounded by giant koaba trees and two-thousand-foot waterfalls that bounced halfway back up. Every kind of exotic bird flew across the area, which was rich

with oil deposits. It's one of the most beautiful places on earth, and though it would be difficult to film there, it had everything we could ask for, scenically.

Two hours by car south of Quito is Cotopaxi, on top of the Andes mountain range at 20,000 feet. We climbed Mount Cotopaxi, one of the highest active volcanoes in the world. Grassy plains gave way to snow-capped peaks that had once been worshipped by the Incas. Because of its position on the equator, this place had officially been designated "the top of the world," indicated by an engraved marker. Wally Green and I had a footrace there, which he narrowly won.

I told Wasserman I wanted to film in Cotopaxi and Pachamama. He was known for never having a piece of paper or anything else on his desk, which made it easier for him to pound. After he listened to my presentation, he started to slap the wooden desk with the flat of his hand: "No way you're going to Ecuador! You'll get killed! You'll get your cast and crew killed! We could never get insurance to film in a place like that!" When Lew pounded his desk, further discussion was futile. I thought I'd circle back another way—I would put together an irresistible international cast, set a start date, then announce to Lew that the only place the film could be made was Ecuador.

Before I had a script, I went to Steve McQueen, who encouraged me to write it for him. He was fun to be around, and his genius as a film actor was that he was able to convey emotions with few words. With a commitment from Steve, I sent the script to Italy's biggest star, whose films were popular everywhere. Marcello Mastroianni accepted the role of Nilo, the hit man. Next I went to Lino Ventura, one of France's leading actors, to play Victor, the stockbroker/embezzler. Lino was concerned about his English, but like McQueen, he needed few words to be effective onscreen. The

fourth role was written for a young Moroccan actor, Amidou, who lived and worked in Paris. I had seen him in a brilliant Claude Lelouch film called *Love, Life, Death*, in which he played an Algerian sentenced to death for murder—an amazing performance—and I made it a point to meet with him when I went to see Clouzot in France. We wrote the role of Kassem, the terrorist, for him, and he committed without a script. Now I had a dream cast of international movie stars, and a script I loved.

When the script was in good shape, I gave it to McQueen, who had recently left his wife Neile for Ali MacGraw. He called me back within a week. "This is the best script I've ever read," he began. I told him about Ecuador and the incredible locations we'd found. "Can't you do it around here?" he asked. I told him the locations in Ecuador would give the film an exotic background impossible to duplicate anywhere else. "Here's my situation," he went on. "You know about me and Ali. I can't leave her for a long shoot. You'll be shooting this thing for months, and I can't just bring her to Ecuador to hang out. She has her own career." I insisted it had to be Ecuador, even though Wasserman had told me it was out of the question. "Okay," he said. "Write in a part for her!"

"You just told me it was the best script you ever read; how do I put a woman in it?"

"Well, make her an associate producer," he suggested, "so she has a reason to be with me."

Foolishly, I refused. How arrogant I was. I didn't know then what I've come to realize: a close-up of Steve McQueen was worth more than the most beautiful landscape in the world. He reluctantly withdrew. I could have found deserted mountain roads somewhere near the Mexican border or in one of the western states. Or written a role for Ali, or made her an associate producer.

With McQueen out, Lino Ventura was on the fence. I then met

with Mastroianni in Rome. He was still enthusiastic, but he had a personal problem involving his young daughter, Chiara, whose mother was the French actress Catherine Deneuve. They shared custody, and Deneuve would not allow Chiara to accompany him to Ecuador or anywhere outside of Europe for so long and difficult a shoot. He too had to make a choice, and I lost him.

Robert Mitchum was another of my favorite actors. We met at his office at eleven in the morning over a bottle of vodka. I wasn't a drinker, but I needed to show Mitchum I could hold my own. Mitchum was world-weary at that point in his life. Whatever ambition he had as an actor was gone. He worked as little as possible, and only for the money. His performances were always tightly controlled and understated, but he wasn't going to win awards for his work, and he knew it and didn't seem to care. He liked the script, but he said, "Why would I want to go to Ecuador for two or three months to fall out of a truck? I can do that outside my house." It was vintage Mitchum, and I had no answer.

The portents were clear, but I dug in deeper. The studio wasn't enthusiastic about the film, and I couldn't put together the cast I wanted. This was a good time to back away, look for something less ambitious. But I thought I was bulletproof. Nothing was going to stop me.

Sid Sheinberg halfheartedly suggested Roy Scheider for the lead. After *The French Connection*, Roy had been one of the leads in *Jaws*, Universal's biggest hit. Roy and I lost contact after I turned him down for the role of Father Karras in *The Exorcist*. He was still bitter, and I had misgivings about him, but Universal would do the picture with him. Lino Ventura would not take second billing to Scheider. My dream cast evaporated, but I thought an audience would see the film simply because *I* made it. I cast a good French

actor, Bruno Cremer, instead of Ventura. The actor I'd originally wanted for the role of Charnier in *The French Connection* was available, so I cast him—Francisco (Paco) Rabal—in place of Mastroianni. They were fine actors, but unknown in the United States. "My advice," said Wasserman, "is to forget this thing. We're not going to do it unless we get a financial partner, someone to share the risk."

Help came from an unexpected source: Charlie Bluhdorn. Charlie heard I had a script that was set in a small South American town and in a jungle. He had everything I needed in the Dominican Republic, which was then virtually a "wholly-owned subsidiary of Gulf and Western," and he told Wasserman that Paramount would co-finance the film if I agreed to shoot in the Dominican Republic. He said his recently appointed chairman of Paramount, Barry Diller (who replaced Yablans), would call me.

The next day I met with Diller. He had been a hot young executive at the ABC Network, not yet the entrepreneur he's become. He was a vice president of ABC during one of its most successful periods, but the Paramount job was his first in the movie business. Diller read my script and was enthusiastic. He offered to have Paramount take over the production. Wasserman and Sheinberg agreed to pay half the costs and let me shoot in the Dominican Republic.

I hired the renowned British production designer John Box, who had designed two of the best films ever made, both for David Lean: *Lawrence of Arabia* and *Doctor Zhivago*. Box was a tall, laconic, mustachioed Englishman. He warned me that he didn't draw or draft plans. He was a "concept" man; he left the drawings and blueprints to his art director, in this case Roy Walker, an affable Englishman who idolized John, as did many in the British film industry.

I had recently seen the film *Tommy* with music by the Who, directed by Ken Russell, and I was impressed with the cinematography. The DP, Dick Bush, did another film with Russell, an impressionistic biography of Gustav Mahler. He also worked with Lindsay Anderson, a director whose work I admired. We brought him in for a meeting; I liked him and hired him.

John Box, Salven, Dick Bush, Wally Green, and I went to scout the Dominican Republic, where we found a dirt-poor village called Alta Gracia, about two hours' drive from Santo Domingo. This town would become our "town at the end of the world," Las Columnas. The bar, the police station, the decrepit houses, while not as exotic as Ecuador, could all serve as locations. The mountain roads were steep, winding, and dangerous. We found a vast area of mounded vegetation that gave way to a clearing where we could build an oil derrick and set it on fire.

I met with the Dominican president, Joaquin Balaguer, a short bespectacled man, nearly blind and deaf, who pledged the total cooperation of his country. He hoped I would be able to portray the beauty of the Dominican Republic, but I wasn't looking for that—I was looking for a place that suggested hell on earth, where desperate fugitives would come as a last resort. I didn't fall in love with the Dominican Republic as I had with Ecuador, but it was the only place I could get the film made.

Salven put the budget at $20 million. This would normally have been a deal-breaker, given that the film starred Roy Scheider and a bunch of unknown European actors. I agreed I'd *try* to make it for under $15 million, still an enormous figure at that time, and we got a reluctant green light.

The film became an obsession. It was to be my magnum opus, the one on which I'd stake my reputation. I felt that every film I'd ever made was preparation for this one.

When we scouted Ecuador, I noticed that all the long-haul cargo trucks, the kind that would be used to convey cases of dynamite, had unusual decorations painted on them as well as names—the names of wives or girlfriends, religious or mythological names such as Orpheus or Herculio, and one in particular that intrigued me, Lazaro (Lazarus). Our trucks were old M211 army vehicles. I asked John Box to name one of them Lazaro, but it took me a while to come up with the other name.

I was listening to an album by Miles Davis called *Sorcerer*, with driving rhythms and jagged horn solos that characterized Miles's band in the late 1960s. We painted the word *Sorcier* (French for "Sorcerer") on the other truck, and I later decided to call the film *Sorcerer*, an intentional but ill-advised reference to *The Exorcist*. The original title I'd proposed was *Ballbreaker*, to which Wasserman responded, "Are you out of your mind?" Maybe I was. It turned out to be the most difficult, frustrating, and dangerous film I've ever made, and it took a toll on my health as well as my reputation.

We started shooting in Paris with Victor Manzon (Bruno Cremer), who tries to cover up a bank fraud he has committed at his father-in-law's respected brokerage house. Victor's brother-in-law commits suicide over this incident, and Victor is forced to leave his wife and country. In a scene between Victor and his wife (Anne Marie Descott), an editor at a publishing house, she reads him a passage from the memoirs of a retired French army colonel who has to make the decision whether or not to kill an innocent woman during the French-Algerian War. He eventually squeezes the trigger, which causes Victor to comment that he was "just another soldier."

"No one is *just* anything," his wife responds. This line is the theme of the film.

We moved to Jerusalem for the sequence that introduces Kassem (Amidou), a terrorist who blows up an Israeli bank. We had the cooperation of the Israeli Security Forces, who appear as themselves in pursuit of the terrorist. The bank was located directly across from the office of Teddy Kollek, mayor of Jerusalem, and the mock explosion we set off was so powerful it broke a window in his office. While we were filming, an actual terrorist bombing occurred two blocks away, and we rushed there to film its aftermath. We were able to "steal" shots of our cast in the old city and at the Damascus gate without extras, so the sequence has a documentary reality.

The third prologue, set in Elizabeth, New Jersey, has an unusual origin.

"Gerry M." is a guy I knew in New York through Breslin and Fat Thomas. Gerry was "a friend" of Hughie Mulligan, head of the Irish mob in Queens. He had a record that included armed robbery, but I enjoyed his company and his stories. After we got to know each other, Gerry gave me the details of a number of capers he had pulled as "the leadoff man," the first man through the door in a robbery attempt.

Gerry told me about one of his "jobs," the robbery of a Catholic church in Elizabeth, New Jersey, where the collections from other churches in the area were brought to the basement, counted by the priests, and divided among the other parishes equally. I asked Gerry to give us details of the robbery, and we used it as one of the prologues. In fact, we filmed in another church in Elizabeth, where "Jackie Scanlon," the character played by Scheider, is introduced as the wheelman for the gang that robs the church during a wedding. I put Gerry into this scene as the leadoff man, along with two friends of his who were nonactors but part of Gerry's world. One of them had been an IRA member in Dublin during the Troubles.

At the end of the scene, Gerry's character shoots one of the priests, and during the gang's escape, the getaway car crashes, killing all but Scanlon. The wounded priest's brother is a local mob boss who puts out a contract on Scanlon.

The accident that causes the getaway car to overturn seemed impossible to shoot. Several New York stuntmen had a go at it, and we went through seven cars without achieving the effect. This went on for a week, during which my frustration reached the boiling point. Salven suggested we bring in a specialist he had worked with in Los Angeles, Joie Chitwood Jr., a famous thrill-show driver. Joie flew to our location in New Jersey and I explained the shot to him. He was short, stocky, part Indian, self-assured, and fearless. He studied the logistics at the site and had our special effects crew build a slanted ramp, about forty feet long, over which he could drive the car at top speed on two wheels, flip it in midair, and crash into a fire hydrant. After three days of construction and calculation, Joie did the stunt in one take. It's a spectacular shot in the film, but the delay put us behind schedule, the first of many such glitches. The action sequences still to come were as dangerous and life-threatening as this one, and months of shooting remained.

I checked into the Hispaniola, a third-rate hotel but the best Santo Domingo had to offer. We were assigned a local contact who was wired into various branches of the Dominican government, the army, and the police. He was able to arrange permits for us to shoot anywhere and get cooperation from the locals to be in the film and lend their vehicles and horses. He introduced me to a Dominican army colonel who was a power broker in the country. The colonel had recently shot and killed a man in a restaurant and never went to trial; he was not even charged with a crime. His explanation

satisfied the authorities: the man he shot was a Communist and deserved to die.

The colonel and his attractive mistress invited Wally, Dave, and me to his home. There were twelve soldiers armed with AK-47s scattered around the steps outside his house. The colonel spoke no English, so Wally translated as he proudly gave us a tour of his paintings and furniture, which were all truly kitsch. After each description, I would say admiringly, "Wow, what a piece of shit," or "This stuff is dreck," or "Pure Howard Johnson." Wally had to fight back laughter and tell the colonel in Spanish how impressed I was with the house. This went on for about half an hour when it became apparent that the colonel's lady, a sexy brunette, married to someone else, who said very little at dinner, did in fact understand English. If she had given up my little joke, the colonel would no doubt have shot me, with complete immunity. Another Communist who deserved his fate.

I chose the locations with John Box and the stunt coordinator, Bud Ekins. The road that takes the trucks to their destination, a burning oilfield, leads over washboard terrain, steep mountain passes, and an old wooden suspension bridge, at one point ending in front of a giant koaba tree that has fallen across the jungle path. The tree was about forty feet long and ten feet across, lying on its side. One of the actors would carefully siphon a few drops of "liquid dynamite" from one of the cases being transported on beds of sawdust onto the fallen tree, and a rock would be rigged to slowly descend and smash the dynamite, exploding the tree and allowing the trucks to pass. Marcel Vercoutere, the resourceful special effects man on *The Exorcist*, worked on *Sorcerer* as well. All the "gags" he rigged had gone smoothly. He loaded the back of the tree, the side facing away from the camera, with a small amount of *real* explosives. I had three cameras ready to roll at various film

Willem Dafoe

William Petersen, Darlanne Fluegel

William Petersen

Suor Angelica

Rolando Villazón, Gianni Schicchi

Anje Kampe,
Salvatore
Licitra, Mark
Delavan, *Il
Tabarro*

Michael Shannon

Ashley Judd

Lynn Collins, Ashley Judd, Michael Shannon

Michael Shannon, Ashley Judd

Killer Joe: 2012

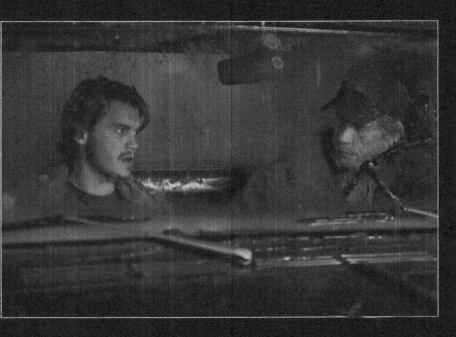

Emile Hirsch and Thomas Haden Church

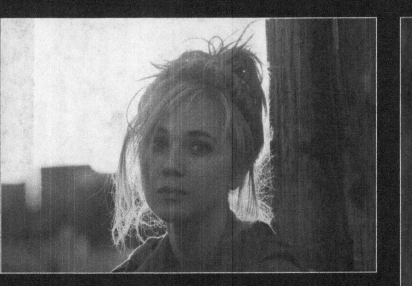

Juno Temple

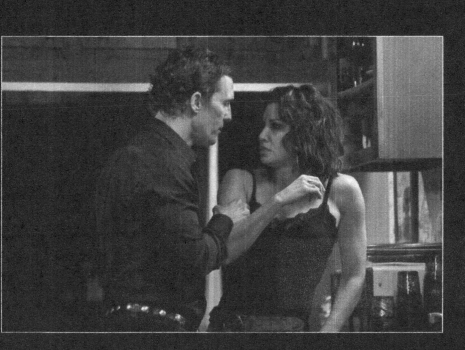

Matthew McConaughey and Gina Gershon

Matthew McConaughey

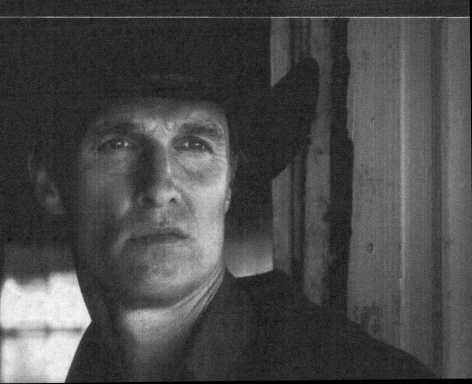

Sherry

Cedric and Jack

speeds when suddenly the sound of a large helicopter filled the air and a giant Sikorsky began to descend in a field near our location, blowing plants, shrubs, and camera equipment every which way. To my amazement, Charlie Bluhdorn stepped out of the helicopter, accompanied by Marty Davis, a short, jovial man in a black business suit and tie who was the public relations head of Gulf and Western (later to become Bludhorn's successor after his death). With them was a beautiful, buxom young blonde in a diaphanous off-white dress and high heels. The area was deep within a jungle, flooded by recent rains, and thick with mud as they struggled toward our explosion site. Members of the crew laid down two-by-fours to facilitate their passage.

"Fweedkin!" I heard ringing out over the sound of the chopper blades shutting down. It was unmistakably Charlie. He embraced me, I shook hands with Marty, and they introduced me to the blonde, a German model and would-be actress. "Fweedkin! What's goin' on here?" I explained what we planned to do while the effects crew continued to prepare the explosion. Charlie had come to the Dominican Republic to check on his many holdings, meet with government officials, and visit our set with his companion before they returned to New York.

"This Fweedkin is ah genius! Ah genius!" he told Marty and the blonde. "Looka this! Only ah genius would think up a scene like this!" I showed them where they could safely stand and provided them with earplugs, checked the framing of the three cameras, then gave the cue for the explosion. There was a loud pop, but nothing happened; then a few scattered twigs flew out of the back of the tree, causing no real damage. I threw down my headset and cursed Marcel and his crew: "What the hell happened?" I yelled.

"I guess we didn't load enough," Marcel explained sheepishly. At that moment, the helicopter could be heard revving up. I turned

to look for Bluhdorn and his guests, but they were ascending without a good-bye.

No longer was I "ah genius."

Marcel didn't have nearly enough explosives to blow the tree. In desperation I called a friend in Queens, New York, known as "Marvin the Torch." Marvin wasn't his real name but a nom de plume bestowed on him by Jimmy Breslin. But he *was* "a torch." He blew up failing businesses for insurance money, "turning grocery stores into parking lots," as he put it. In a room of a thousand men, he would have been among the last three you would suspect of being an arsonist. He was in the beauty supply business in Queens. We used to call his wife "Mrs. Torch."

When I called, she got on the phone. "Hello, Mrs. Torch," I said. She wasn't amused. I asked if I could speak to "Marvin." "He doesn't do that anymore," she screamed at me. "This is for a movie, Mrs. T, it's not for real." When "Marvin" got on the phone, I explained the problem, and he came down to the Dominican Republic three days later. He arrived with two suitcases of flammable "beauty supplies" and the next morning blew the tree to smithereens, then departed with my deepest gratitude, like Willy Loman, carrying his suitcases.

It took a week to see a day's rushes, as we had to fly the exposed film to Los Angeles and have it processed. The prologues were beautifully shot, but the early scenes in the jungle were underexposed. After we'd screened a week's worth of dark footage, I took Dick Bush aside and told him I thought we'd have to reshoot. His response was: "We should have done all this on a stage. We could have duplicated everything we've done here, and I could have balanced the light properly." It was Adam Holender on *Boys in the Band* all over again. "Are you serious?" I asked him. He was. When we first met, I told him I wanted to shoot actual locations. No

sets. He enthusiastically agreed, but now that he'd seen the jungle rushes, there was no argument but that he'd underexposed the film, and lost confidence. I brought in a cameraman I had worked with at Wolper, John Stephens. John was a prolific shooter mostly of commercials as well as a designer of camera mounts for helicopters, bicycles, and skis. He had a thriving commercial business, but he eagerly accepted the challenge. When he saw the rushes, he said we should have used reflectors to balance the deep shadows of the tall trees. We were shooting in natural light, and the locations looked beautiful to the eye, but the exposures and the film speed had to be carefully balanced. John took over and changed lenses and film stock, and the quality of the photography was consistently improved even as the logistics of the production were becoming insurmountable. We fell further behind schedule, until no end seemed in sight. Crew members were getting seriously sick, from food poisoning, gangrene, and malaria. Almost half the crew went into the hospital or had to be sent home.

I was becoming detached from reality. Urgent inquiries came from executives at Paramount and Universal. When would I finish? I ignored them, and Dave Salven bore the brunt of their anger alone. The pressure became too much, and Dave cracked. His wife was threatening to leave him. Raising two young children alone, she gave him an ultimatum: Come home or face a divorce. He quit the picture. We had been close friends for ten years, and this was our third film together. He was the best line producer I've ever worked with, and his loyalty and persistence kept *The Exorcist* together. In a fugue state, I was angry and felt betrayed, and it took years for me to forgive and understand what Dave had gone through and why he had to quit. The studios sent in a new line producer, an experienced and efficient Englishman named Ian Smith. "And so we beat on, boats against the current."

The most important scene in the film and the most difficult I've ever attempted is the bridge-crossing sequence, wherein the two trucks have to separately cross an old wooden suspension bridge that appears completely unstable. The bridge was anchored by crossbeams at each end, and the ropes suspending it were frayed, the wooden planks rotted and in some places absent. The crossing takes place over a rushing river during a blinding rainstorm. John Box designed the bridge so that it was controlled by a concealed hydraulic system with metallic supports. Each truck, as it crossed, was attached invisibly to the bridge so that it would sway but not capsize. That was the theory. Built at a cost of a million dollars, the bridge took three months to complete and was totally realistic, but it was a mad enterprise and definitely life-threatening.

We found the perfect river over which to build it, with a strong current and a depth of twelve feet. The river was more than two hundred feet wide, so that dictated the length of the bridge. Thick forest flanked it at each end.

As the weeks unfolded, there was little rainfall, and the river was diminishing. How could this be? Local experts and army engineers assured us that the river had never gone down. But slowly, agonizingly, it was doing just that. From twelve feet, the water level dropped down to ten, then eight, then five. By the time the bridge was finished, there was a little over a foot of water; and then the river dried up entirely! We had constructed a bridge over nothing. This was becoming a cursed project. With costs escalating and so many on the crew lost to illness and burnout, the sensible thing to do was to come up with a simpler sequence. That was the advice of all the executives, but I had become like Fitzcarraldo, the man who built an opera house in the Brazilian jungle. When I saw the finished bridge, I believed that if I could film the scene as I conceived it, it would be one of the greatest in film history. My obsession was

out of control, and if I hadn't been so successful over the past few years, I would have been *ordered* to stop. The two studios bet on me against their better judgment, because they thought I still had the mojo; maybe I was so in tune with audience tastes that costs wouldn't matter. No one in his right mind would have continued on this course, but no one was in his right mind. I had the confidence, the energy, and the drive of an Olympic downhill skier, and those who stayed with me—the camera crew, the grips, electric, props, John Box, Roy Walker, my assistant director, Newt Arnold, and Bud Smith—all shared my passion. So we dispatched scouts to Mexico, to the Papaloapan River outside the town of Tuxtepec, where we had been told there were rushing waters in similar terrain that had never dropped in level, "the memory of man runneth not to the contrary." John Box went to Mexico and came back with photos that matched our Dominican location perfectly. We dismantled the bridge and left the Dominican Republic with only two scenes left to shoot. We had to shut down while holding on to our four principal actors and key crew.

We flew to Vera Cruz, a shadowy seaport on Mexico's Gulf Coast, which would be our base for three days, while John organized the precise location to rebuild the bridge. I discovered a small hotel in Plaza de las Armas, the main square. The tree-lined square was filled with mariachi bands and old men playing dominoes, smoking cigars, and drinking locally grown coffee. We filmed a prologue for Paco Rabal's character Nilo, who kills a man execution-style in a room at the hotel overlooking the peaceful plaza below.

Our next stop was Tuxtepec in Oaxaca Province, one hundred miles to the south and east of Vera Cruz. From here we pushed farther south into the jungle surrounding the Papaloapan, to what had been an ancient Aztec village, with a small peasant popu-

lation. The weather was humid, and thick, lush vegetation surrounded the fifteen-foot-deep branch of the swiftly rushing river. The bridge was already designed and built, so now it was a matter of reassembling and anchoring it. The shutdown of production lasted a month while we regrouped, at great expense to management. When we arrived at the Aztec village, I noticed what appeared to be a mass exodus of the local population. One of the authorities told me it was because of word of my arrival. They were a deeply religious people, and the man who made *The Exorcist* was coming to their village: bad karma. But a few of the locals and people from surrounding villages stayed and worked with us to put up the bridge.

I know this is hard to believe, but again the river level began to drop, at the rate of six inches or more a day. We had been told it rained often in this area, but we weren't told that rain occurred only in the summer season. It was now the fall. I could see where this was going, but there was no turning back.

I became friendly with the local laborers. I used to share *cervezas* with them after a day's work. One evening a man named Luis, who helped to organize the local crew, knocked on the door of my cabin. We all stayed in small wooden cabins in the jungle, the size of prison cells, with only an army cot, a chair, and a single hanging lightbulb. Luis asked if he might have a word with me. I was exhausted, but he was a good man who worked hard with a pick and shovel all day. I invited him in, and he handed me a beer and had one himself. We sat down and exchanged small talk for a few minutes; then he reached into his shirt pocket and pulled out what looked like an identity card but was on closer examination a badge. His look turned serious and sad. "Si, Señor Bill, I am Federales." He was a federal agent assigned to work undercover on our set. "I have to inform you of an unfortunate situation," he said. "There

are members of your crew who are using drugs. This is a serious problem in my country."

Was this a shakedown? "In a normal situation," he continued, "I would be obliged to arrest them, and they would go to prison. Because I like you, I will *not* arrest them." I was shocked; I wasn't aware of who was using, or what. I thanked him and promised to make sure this activity stopped. "But they have to leave the country. Tomorrow," he added. "Tomorrow?" "Sí."

He gave me a dozen names, handwritten on a scrap of paper. They included members of the grip crew, some of the stuntmen, and the makeup artist. I told him this would seriously damage my ability to finish the film. "I am sorry," he said quietly. "I'm sure you don't want them to go to prison, and it is within my authority to arrest or send you *all* home, even those who are *not* using drugs. This is the best I can do; these people have to leave Mexico tomorrow."

And so they did. It took two weeks to replace key people who had been with the film from the beginning, while the river continued to decline to a height of just under three feet, then became a stagnant pool. I called a meeting of the crew and explained the situation without inquiring who else was using. It was clear that anyone using would be caught and arrested. There were no more "unfortunate situations," and thankfully the actors weren't at risk, or we'd have been forced to shut the picture down.

We were able to divert sections of the river to our location using large pipes and pumping equipment, and I decided to shoot the scene in rain, manmade rain, so we brought in half a dozen large sprinklers that drew water from upriver. The sky was cloudy from morning until noon, then bright sun appeared and we had to shut down and go to our cabins until five o'clock, when the clouds rolled in again and we could resume shooting in matching light. The scene runs twelve minutes, roughly 10 percent of the final cut, but

it took months to complete and cost more than $3 million, most of it not budgeted. The only thing that could save me was a hit picture. I had no doubt it would be. The performances were terrific, and the action scenes were original and believable.

Though the bridge scene was carefully prepared, the trucks would occasionally fall to one side. No one was hurt or injured, and none of the actors took the fall, only the stuntmen, who were heavily padded with flotation gear. I ran three cameras at different angles, but with the split shooting days it seemed as though we'd never be able to complete the scene. By the time it was over, a month later, I was exhausted and stressed but relieved, proud of the film but anxious to get home.

I hired a twin-engine Cessna to take me from Vera Cruz to El Paso, Texas. After clearing customs, I would take off immediately for Los Angeles. One of the stuntmen, Eddie Hice, asked if he could hitch a ride with me instead of going back a day or two later with the crew. No problem. When we landed in El Paso, a customs official came to the plane: "Welcome back to the United States, Mr. Friedkin." I thanked him. We exchanged small talk about how long I'd been away and what we were filming. As we headed for the customs office with the pilot, another official appeared with a German shepherd. The dog ran straight for Hice's bag and started to freak out. The officers took our bags and asked us to wait in the office while they brought the dog onto the plane. After half an hour, the two officials came into the room. Their manner had changed. "Mr. Friedkin," one said, "this aircraft is now the property of the U.S. government." My bags and the pilot's were clean, but Hice's traveling case was found to contain scattered grains of marijuana, totaling more than an ounce. This was punishable by at least a year in jail. El Paso, being a border town, was especially tough. Calls were made to Los Angeles, establishing that neither I nor the pilot

had criminal records, so we were cut loose after hours of questioning. Hice was held for two weeks before the lawyer we got for him was able to spring him as a first offender.

Bud Smith and I started editing *Sorcerer*, and it was coming together well. All the problems of the shoot melted away in the cutting room, and there was enough coverage to pace it any way we chose.

A couple of years before, while on tour for *The Exorcist* in Germany, I'd heard a concert in an abandoned church in the Black Forest by three musicians called Tangerine Dream. They were on the cutting edge of the electronic synthesizer sound that was entering the mainstream. The concert began at midnight and they played long, rhythmic, sensuous chords, somewhere between classical music and the new pop sound. They performed for three hours in darkness, outlined only by the twinkling lights of their electronic instruments, and along with a large audience of stoned young people, I was mesmerized. I met with them afterward and said I'd like to send them the script of my next film. When Wally's script was done, I mailed it to Edgar Froese, their leader, and told him how I saw the film. "Just read the script," I said, "then write your impressions of what I've told you about it." Months later, while I was in the Oaxacan jungle, two hours of audiotapes arrived from Germany. They were an inspiration as we cut the film to the music, selecting passages at random.

The one sequence left to shoot was the last leg of the journey of the surviving truck, the Lazaro, and I wanted it to be different from the other locations. I wanted a surreal, otherworldly landscape, and John Box found it in a place called the Bisti Badlands in northwestern New Mexico, thirty-five miles south of the town called Farmington. The Badlands are spread over several thousand

acres with no vegetation or wildlife, an area that appears to be on another planet. Dirt roads wind past pastel rock formations called hoodoos. Surreal mounds and petrified wooden boulders form mushroom-shaped "cities" of shale, sandstone, and other minerals. This was sacred Navajo land, where the bones of dinosaurs and other prehistoric animals dating back seventy-five million years were still being discovered. It was a place of ancient magic, said to be home to generations of sorcerers and alchemists. It was the landscape we chose for the end of the journey, in which Scanlon embraces madness, abandons his truck, and *carries* the dynamite two miles to the burning oilfield. The entire area was a feast for the senses, and with permission from the Navajo Nation we filmed there for four days. Everywhere we pointed the camera, beautiful images in unique natural light seemed to appear as if by magic, the landscape of dreams.

I had persevered to make a film that I would want to see, a relentless existential voyage that would become my legacy.

I had only a rough-cut work print, neither color-timed nor sound-mixed, but the Universal executives asked if they could see it in the editing room. I explained it would have to be a reel at a time on a twelve-inch editing screen. They said fine, and the next morning Wasserman, Sheinberg, and Ned Tanen, president of production, came into the cutting room and saw twelve reels of rough cut. When it was over, Wasserman thanked me and said it was a terrific film, and Sheinberg was also complimentary. When they left, Tanen took me aside and said: "Whatever happens with this picture, I want you to know I'm proud to be associated with it." It seemed a heartfelt response, and I was grateful for it.

After a few changes, Bud Smith and I got the film ready for a double system (separate sound and picture) screening. We ran it for

Sheinberg and Tanen as well as Barry Diller and his new head of production at Paramount, Michael Eisner, an enthusiastic young man who, like his boss, had formerly been president of the ABC Network. Again, positive feedback. It was the first time I'd seen the film on a screen, and I found most of it watchable, some of it very good. A few scenes were labored, but overall I thought it was a great ride and, with Paramount and Universal behind it, a surefire hit. Diller asked if he and Sheinberg could see me the next day to pass along a few notes from their team. Since *The French Connection* experience I wasn't keen on notes from executives. So I said okay, but I'd want to bring my editors and the writer so they could hear the notes firsthand. Diller and Sheinberg weren't used to meeting with "below-the-title" guys, but they reluctantly agreed, thinking it was in the spirit of cooperation. It was a sham.

I told Wally and Bud and the assistant editors, Jere Huggins and Ned Humphreys, to come unshaven, button their shirts incorrectly, leaving them outside their trousers, wear scruffy, mismatched shoes and socks, and generally look like homeless guys. I told them to wear sullen expressions, project indifference, not smile or nod or do anything that showed understanding, let alone agreement with whatever the executives said—just stare blankly at them while they talked. And don't react to anything I might say or do, I added. Sheinberg and Diller were successful, high-powered executives, but I felt they had little to offer on how to improve a film I worked on for over a year. I thought that an audience's response was worth a thousand times more than any executive's, and that all these guys wanted to do was leave their mark on the film, like a dog pissing on a tree.

The meeting took place over lunch at the posh private dining room at Universal. Sheinberg and Diller were in suits and ties, and my guys were dressed as I had instructed them. Two waiters. Drink

orders. Everyone ordered iced tea or bottled water or Diet Coke except me. I asked for a *bottle* of Smirnoff vodka, no glass. Shocked glances all around, especially from the waiters, who thought I was kidding. I wasn't. When drinks arrived, I opened the vodka bottle and started glugging. Though not a drinker, I can handle booze and have only been drunk twice in my life. Diller and Sheinberg had a handful of meaningless notes, to which we gave neither visual nor verbal response. Lunch was ordered, but when it arrived, I just kept drinking from the bottle. After about fifteen minutes I fell to the floor facedown. No one reacted, so I just lay there until gradually there was silence. Then Diller turned to Wally and the editors and asked, "Does this happen often?"

"Every day," Wally deadpanned.

I leave it to you to evaluate this incident. Some of you may find it appalling, others stupid, still others insulting and self-destructive. It was certainly all of that, but at the time, that was my nature. I was still the class clown, and it was also a dumb-ass way of coping with criticism. I wouldn't want to be treated that way myself.

One good suggestion they offered was that we show how far the trucks traveled, how many miles across the various landscapes. They thought it would help if we used inserts—close-ups—of the mileage on a speedometer. Initially I snapped at them: "I don't shoot inserts. If you want those shots, we'll have to go back to Mexico, the Dominican Republic, or New Mexico." "Why would you have to do that?" Diller asked. "I told you, Barry, I don't shoot inserts."

Then I turned to Bud Smith: "Bud, put together a crew and have Toni (my secretary) book us a flight to—"

"No, no, forget it," Diller cut in.

But he was right. And within the week I arranged to get the interior of the Lazaro (Scheider's truck) on the Universal lot, and

with a cameraman and an assistant made a close-up of Scheider's handwriting in chalk on the dashboard next to the speedometer: "218," the distance in miles to the oil-well fire. Then we photographed the mileage meter, showing various distances, exactly as Diller suggested. And when the Lazaro's motor dies in the badlands location, there's a close-up of the mileage meter, at 216.7, and the camera pans to Roy's initial "218" entry—1.3 miles short. It clarified the difficulty and length of the journey.

When I finished my cut and approved the color timing and the sound mix, I carried the first print in two metal canisters each containing three twenty-minute reels to Sid Sheinberg's office. He came out of a meeting, and I set the cans at his feet and thanked him. We shook hands. I had given him a lot of shit, and the film wound up way over budget, costing $20 million, but he and Wasserman and Diller tolerated my extravagances and actually liked the end result. They had big release plans, with Universal distributing foreign, Paramount domestic.

"How much do you think it'll do?" Sid asked, smiling.

"I don't know," I said. "*The Exorcist* is over a hundred million and still going, and I think this is a better film. So let's say at least ninety million." Was this bluster and bravado? Hardly. I believed it.

Sorcerer opened in several hundred theaters. The reviews came out on the morning of the first day. The *L.A. Times* and the *New York Times* were waiting for me at 7:00 a.m. at the bottom of my long driveway. I walked down in bathrobe and slippers to see what fate awaited me. Charles Champlin had always praised my films, writing glowing articles and interviewing me often for the *L.A. Times* and for his television show.

I opened the paper to his review of *Sorcerer*. It began: "What went wrong?" and went downhill from there. The review was a death knell, as was the *New York Times* review and almost every-

thing else that followed, except Jack Kroll in *Newsweek*, who called the film "the toughest, most relentless American film in a long time." But he was a voice in the wilderness. Most of the reviewers were immune to whatever the film's merits may have been and simply labeled it a remake. I read Champlin's review as I walked slowly up the driveway. The hill seemed steeper. I looked around at the gardens I planted, the house I'd built, where I could read, listen to music, shoot baskets, swim, enjoy a Jacuzzi. I thought it was all coming to an end. In many ways it was. The box office opened soft, which meant lousy. *Sorcerer* had replaced *Star Wars* at the Chinese Theatre on Hollywood Boulevard, but *Star Wars* opened to such enormous business, they brought it back to the Chinese and kicked *Sorcerer* out after only a week. Over the next few days more reviews came in, mostly bad. Bad reviews are like watching your kid being heckled during a soccer match.

I went to Universal the following Monday and told Bud Smith and his assistants and Wally Green that the film was a disaster; it wouldn't recover its cost, and the studios wouldn't support it. I'd gone all in on this film, and alienated the top management of two studios in the process.

That week, Ned Tanen, who'd called me before the film opened to tell me again how proud he was of it, gave an interview to Joyce Haber, the gossip columnist for the *L.A. Times*, in which he said, "Friedkin never showed us the picture. We gave him carte blanche, and he would never show it to us." It was payback time, and I was the piñata. I felt I made a great film, but everything fell the other way. I didn't hear from Sheinberg or Wasserman—they saved their comments for the rumor mill—but I did get a call from Jules Stein. He sounded grave: "Bill, I'm sorry," he said. "I thought the film was wonderful. We all did." I thanked him, but he had more to say: "They want to end your deal at Universal. Effective immediately.

There's nothing I can do." I thanked him again for his support. He said, "I don't know . . . maybe after a little time . . . but they lost a lot of money . . ." A long pause. "I still believe in you. Doris and I want to remain your friends."

I never saw them again.

Fantozzi met with Sheinberg, who delivered the news officially. My deal with Universal, which began with such promise, was over. "Where's my twenty million dollars?" Sheinberg yelled at Tony. "How am I gonna get my twenty million dollars back?"

What was it about this film that so alienated critics and turned off audiences?

A combination of things, surely. *Star Wars*, which was pure fantasy with clearly defined heroes and villains, had changed audiences' tastes. *Sorcerer* was presented as hard-edged reality; the four leads were fugitives from justice. The title was probably misleading, and the copy line, "from the director of *The Exorcist*," didn't help. The ending was not only ambiguous but a downer. The reviews were not just negative but personal attacks, probably deserved, based on my callous, self-involved behavior. My sudden success in Hollywood after years of failure had convinced me that I was the center of the universe. Many were waiting for me to crash, and I obliged them in spades. I had flown too close to the sun and my wings melted.

My films became more obsessive, less audience-friendly, and would turn even darker in the future. They would continue to portray the American character as psychotic, fearful, and dangerous.

Headaches and fever came over me. My doctor was a well-known and respected physician to the stars. She had a great reputation and a lot of patients. She diagnosed my illness as a flu and prescribed antibiotics. But it went on for weeks. I became nauseous and weak,

and prey to a lingering depression. I went to another doctor, who ran blood tests and informed me I had malaria. "Have you been to a foreign country recently?"

"Yes, but I had a series of shots and quinine pills before I left," I told him. He smiled. "The bugs don't *know* you had the shots," he said. "You've got malaria. The good news is, there's a new pill that'll cure you, but you need to rest. I mean, don't do anything for a while. You might think about going into a hospital." The pill, Artemesinin, was a miracle cure. But I had to get out of Los Angeles. I tried to put *Sorcerer* behind me, but failure was now my constant companion.

I flew to Paris. To the Plaza Athénée. I'd recuperate there in a beautiful suite with easy chairs, overstuffed couches, and twenty-four-hour room service. I felt at home in Paris, but like a hospital patient more than a tourist. I immersed myself in French culture and took long walks along unfamiliar but beautiful cobblestone streets. For a long time I had no contact with America and its film industry.

Even so, my reputation wasn't completely destroyed. Producers still wanted to make films with me, though my choices were diminished. A call came from Marty Bregman, a producer–personal manager based in New York. Marty's most important client was Al Pacino, for whom he produced *Serpico* and *Dog Day Afternoon*. At one time he represented not only Pacino but Barbra Streisand, Woody Allen, and Faye Dunaway. He and Pacino were developing a screenplay based on the memoir of the disabled Vietnam War vet Ron Kovic, called *Born on the Fourth of July*. Marty told me that he and Al loved *Sorcerer*, thought it was a great film and wanted me to work with their screenwriter on a first draft of the Kovic book. Films about Vietnam were box office poison at that time, and studios were reluctant to make them, but Al was a big star, and Marty said that

with the two of us, every studio in Hollywood would want to make this picture. I told him I had no plans to come to the States, so he said he would meet me in Paris and bring the writer. They were determined that I direct this film.

The writer was a shade over thirty years old, eager, intelligent; he knew my films better than I did, and he said I was the perfect director for his screenplay. His manner was cordial, respectful; there was little sign of the dark, controversial artist he was later to become. Oliver Stone had directed a few forgotten films himself, but he wanted to be a writer. He would make whatever changes I thought necessary to the script, but he knew his subject well. He was wounded in combat in Vietnam and came home with a Bronze Star and a Purple Heart.

Oliver and Bregman came to Paris for three days of meetings. They got Al on the phone and he told me how enthusiastic he was to play this role with me directing.

The script was camera-ready. I committed to direct it, and Marty and Oliver went back to the States to set it up. "This is a slam dunk," Bregman assured me. Weeks went by. Every studio passed. Was it because of me? Was it Vietnam? It certainly wasn't Pacino. Every studio wanted to do a film with Al, and Kovic's book had strong reviews and good sales. Bregman kept telling me to hang in. He was certain of raising the money privately, but the studios were saying, "Why don't you guys make something else? Make a cop movie."

Dino De Laurentiis called to see if I was interested in taking over a film John Frankenheimer had developed but lost interest in. It was based on a book called *Big Stick-Up at Brinks*, about the famous robbery of the Brinks security company in a Boston garage in 1958. Dino sent the script to Paris; I read it and told him I thought it was weak, and I would have to start over from page one.

He agreed, and when I told him I wanted Wally Green to rewrite it, that was okay too. I insisted we shoot in Boston, hopefully at the actual Brink's garage, and I wanted to retitle the film *The Brink's Job*. The picture was going to be distributed by Universal, the studio that recently broke my deal, but Dino was going to finance it himself. I returned to L.A. to work on the script with Wally.

At the same time, Marty Bregman said he'd raised the money for *Born on the Fourth of July* and was ready to start shooting. But I'd committed to *The Brink's Job*, having heard nothing positive from Marty since our meeting in Paris. I wished him good luck. They hired Daniel Petrie to direct the picture, and started shooting the Long Island sequence in which Ron Kovic comes back from Vietnam a cripple in a wheelchair to his hometown, where he's given a hero's welcome. After a week, Bregman's money dried up and production had to stop. The script reverted to Oliver Stone, who finally got to direct it himself twelve years later, after writing and directing *Platoon* in 1986. Such was the fickle finger of fate. Oliver was *meant* to direct those films, and as much as he wanted me for *Born on the Fourth of July*, he did it better than I ever could.

ARMED ROBBERY
AND MURDER

The Brink's Job had a good cast—Peter Falk, Paul Sorvino, Warren Oates, Peter Boyle, and Gena Rowlands. The owners of the Brinks Corporation had acquired a sense of humor about the twenty-seven-year-old robbery and gave us their cooperation, the use of their name, armored trucks of the period, and access to the actual garage where the robbery took place. Wally and I framed it as a comedy and modeled the story after the classic Italian caper film *Big Deal on Madonna Street*, about a group of inept thieves who try to pull off a heist while their incompetence keeps getting in the way. In *The Brink's Job* a gang of lowlife criminals from the North End of Boston managed to rob the biggest and best-known security company in the world, whose security measures were in fact a myth. The robbers became working-class heroes for what seemed such a bold and outrageous caper, netting them a million dollars in cash in 1950. J. Edgar Hoover called it "the crime of the century," and while the thieves were eventually caught and did time, the money was never recovered. In Boston we met the surviving members of the gang: Jazz Maffie, a North End bookie; Sandy Richardson, a longshoreman; and Vinnie Costa, a small-time thief and cousin to the ringleader of the robbers, Tony Pino, the character

played in the film by Peter Falk. Barry Bedig, my prop man, and I used to play poker every Friday night in my suite at the Copley Plaza with Sandy and Jazz and a guy named Dante, a flashy dresser who ran the bookmaking operation for the North End syndicate. Clever as they may have been as thieves, Sandy, Jazz, and Dante were not good poker players, and over the ten weeks of the shoot I won $90,000 and Barry netted $45,000. Poker was a skill I'd brought with me from Chicago.

Sonny Grosso, who came to Boston to do security for us, warned me to cancel the final game. He had a tip from a friend in the North End that Dante believed Barry and I were "running the game," thinking it impossible that we could keep winning. Sonny emphasized that his information was serious, and the game was going to get "hit." I took his advice and called it off.

Peter Falk was a fine actor, but it was tough to take *Columbo* out of the character he played. I probably pushed him too hard, but his performance as the "mastermind" of the Brink's job is labored, and it's as much my fault as his.

Peter Boyle as Joe McGinniss, the bar owner and fence who forces his way in on the heist, Alan Garfield as Vinnie Costa, and Sorvino as Jazz Maffie are all pitch-perfect, but the standout performance, worth the price of admission, is by Warren Oates as Specs O'Keefe, the slightly deranged member of the gang who eventually cracks under police pressure and rats them all out.

I cast Gerry M. again, in the pivotal role of Sandy Richardson. Gerry had a friend named "Spanish Eddie" Colombani, a safecracker who was finishing a stint in prison. As a favor to Gerry I got Eddie paroled to my custody as technical adviser to Falk, to show him the techniques used by a "peteman" (safecracker). Eddie, accompanied by his parole officer, was on the set every day. He was a dark-skinned, heavyset man, nearsighted, with black wavy hair, and though his

fingers were thick as sausages, he was considered the best peteman in the business. I loved hanging out with Gerry and Eddie in various bars in Brooklyn and Queens, and I thought they'd be invaluable resources for the cast, to give them "a feel" of the underworld.

One day I took Gerry and Eddie with me on a location scout to Charlestown, a Boston suburb, to see an old bubblegum factory. I wanted it for an early robbery scene by Pino and his gang that illustrated their ineptitude, and for which they went to prison. We were ushered into the office of the president of the company, who had an amazing trompe l'oeil painting of an old-fashioned gumball machine on the wall behind his desk. I complimented him on the painting, and he told me it had been on that wall since the factory was first built.

After the visit I went to a production meeting while Gerry and Eddie went off on their own. That night, when I got back to my hotel room, the painting was on my bed! I thought it might be a gift from the president, but there was no note. Then it hit me. I called Gerry and told him to find Eddie and come to my suite immediately. They sheepishly confessed to having stolen the painting. I went ballistic. "How can you guys be so stupid? This guy's letting us film in his factory!"

"But you *liked* the picture," Gerry said apologetically, a delinquent child.

It was late, but I made them go back to the factory, break in again, and put the picture back where it belonged.

One afternoon during the shoot I got word that the cutting room had been robbed by two masked men. The assistant editor, Ned Humphreys, was pistol-whipped, and the editor, Bud Smith, was told to hand over all the exposed reels to the robbers. Later a call came into the production office, demanding a $1 million ransom

for the film, and the Boston police were alerted. Press and television crews were all over the story, and it was national news for three days: the film was stolen for ransom! It turned out that the thieves had taken about a dozen reels of *work* print. The negative was safely stored at a lab in California, and could easily be reprinted. What the robbers took, they didn't realize was worthless.

I didn't confide this to the press because the Boston police entered the case and asked us to wait for the next call from the robbers, and try to arrange a meeting. Within days, I got the call, with the cops on the line. A guy with a New York accent demanded $1 million by a certain date or he'd destroy the film. The Feds asked me to negotiate with him while they traced the call. I kept the guy on the line for about fifteen minutes until I got a thumbs-up from one of the cops. I then told the guy on the phone that his price was too high, hoping he'd get back to us to set a meeting, but the thieves never called again. They probably discovered that what they had was worthless. No one was ever caught, and we simply reprinted the footage. But there was a lingering suspicion, never proved, that Spanish Eddie and possibly even Gerry, my friend Gerry, were behind the caper. On the advice of the local cops, I thanked Eddie and cut him loose.

The Brink's Job has some nice moments, despite thinly drawn characters, but it left no footprint. There's little intensity or suspense, and the humor is an acquired taste. The film doesn't shout, it doesn't sing—it barely whispers. None of this went unnoticed by the critics. Personally, the experience was not a total loss, though. The months I spent in Boston and the contacts I made fulfilled a lifelong dream.

I love basketball, and I still see a lot of games, though I've given up playing. When I was a teenager, there were no televised games, but

I used to see newsreel clips of the Boston Celtics with Bob Cousy and Bill Russell. Cousy is still the most complete player I've ever seen, and I modeled my game after his, though I never came within a fraction of his talent. In 1977, while filming *The Brink's Job*, I was invited to speak at several Boston area colleges. I also agreed to give a talk, followed by a Q&A, at Clark University in Worcester, Massachusetts. I accepted only because I knew that Cousy had a home there. I asked the university president if he'd ever heard of Bob Cousy. He smiled. "He lives right down the street; would you like to meet him?" Cousy came to my talk, was gracious and friendly, and we stayed in contact for years.

He introduced me to Red Auerbach, with whom I instantly bonded. Red came to the set to watch the filming of *The Brink's Job*, and I introduced him to the actors. Soon he was inviting me to all the Celtics home games. I'd go to Red's office at the Old Boston Garden, filled with memorabilia from his then-thirty-year career as the most successful coach and general manager in pro basketball history. His Celtics won sixteen championships, still a league record. Various local politicians and celebrities would gather in his office an hour before the game, and we'd eat deli sandwiches while Red chain-smoked Dutch Masters cigars. I sat next to him at the games and listened to his observations, and afterward we'd go for a late dinner, always to a Chinese restaurant, either in Brookline or in downtown Boston. Red was like a surrogate father to me, and he let me suit up for the practices and scrimmage with the team.

After the practices we used to play racquetball for an hour, and Red, even in his late seventies, was always on the winning side.

The owner of the Celtics since 1975 was Irv Levin, the boss at National General Films when they developed, then passed on, *The French Connection*. National General was defunct, and I used to

rub it in to Irv at every opportunity. In Boston he was known as "Mr. Hollywood," for his multicolored jackets and open shirts revealing a hairy chest festooned with gold chains. He had the reputation of a riverboat gambler but fancied himself a sportsman, and owning the Celtics was a big deal. The Celtics won a championship in Irv's first year as principal owner, but at the end of the 1978–'79 season, they failed to make the play-offs.

The last home game of the season was televised on the CBS Network on a Sunday afternoon, and it marked the retirement of one of the Celtics' greatest players, Johnny "Hondo" Havlicek. At halftime Irv appeared at center court to present Havlicek with the usual retirement gifts. Irv was loudly booed by the disgruntled crowd. The following Monday at lunch he was angry. Getting booed in Boston Garden on national television was painful. He told me he was ready to sell the team. The fans were ungrateful—it was all "what have you done for me lately?" He said, "I know you love this team. I'll sell you a third for what I paid for it, a little over four million dollars, and you can run it. Red likes you. For a million and a half you can call the shots." He was serious, but I had mixed emotions. Much as I loved the Celtics, I didn't see myself running a team, especially Red Auerbach's team. Red wasn't getting along with Levin at the time and was considering an offer to become general manager of the New York Knicks. People in the streets of Boston and in restaurants would approach him and say, "Don't leave, Red, please don't go." Red said that if Levin gave me control of the team, he'd stay, but I knew if I did it, it would be a full-time job. The team needed to rebuild, and I wasn't ready to stop directing.

I took Levin's offer to Ed Gross, who thought it could be interesting and asked to see the financials. I was earning a million dollars a film plus royalties, and I had money saved, but I was by no

means rich. Yet at the time, owning an NBA team was affordable. The sport had not yet become the playground of billionaires and corporations. After going over the financial statements, Ed said to me, "Well, this might be a lot of fun for you, but they *lose* money."

What?

"The Celtics are losing money," Ed repeated.

I've lost money on investments before and since, but never on purpose. The decision was easy. I passed. The next season Larry Bird and Magic Johnson came into the NBA, and its financial structure changed completely. I could never have competed. The Celtics are worth at least a billion dollars today, but Levin never shared in their financial success. When I passed on the deal, he traded the Celtic franchise for the Buffalo Braves to John Y. Brown, the principal owner of Kentucky Fried Chicken, and Harry Mangurian, a wealthy horse breeder. Irv moved Buffalo to San Diego, renamed them the Clippers, and sold them a few years later. They became the Los Angeles Clippers.

The Brink's Job was another disappointment, but I loved Boston and became part of the Celtics family until Red's death in 2006.

Unrelated events came together to plant the seeds for my next picture, *Cruising*. A series of articles—graphic accounts of unexplained deaths and murders in the West Village—appeared in the New York counterculture weekly the *Village Voice*, written by Arthur Bell, who chronicled the gay community for the *Voice*. It was 1979, and there wasn't yet a name for AIDS, but gay men were dying mysteriously in increasingly large numbers. They were also being murdered, as Bell reported, in the S&M clubs in the Meatpacking District on the Lower West Side. Body parts were found floating in plastic bags in the Hudson River. The unexplained deaths and brutal murders aroused my curiosity. The devil was at work.

The clubs had names like the Mineshaft, Ramrod, the Eagle's Nest, and the Anvil, and they were off limits to all but the devotees of hard-core male sex. The consensus among "straights" at that time was that homosexuality was not "normal." *The Boys in the Band* revealed the frustrations of being gay and why gay men led a double life.

I knew about the S&M clubs from Randy Jurgensen, who had retired as a detective first grade since he worked with me on *The French Connection*. Randy was one of the best street cops I'd ever known, and I'd gone on many ride-alongs with him. He had great stories about his work as a detective, and he described how he was sent undercover into the S&M clubs to entrap a killer. He lived in that world for months and described how it "messed up his mind." I didn't ask for clarification.

One morning in the *New York Daily News*, I read about the arrest of Paul Bateson, who was charged with several killings of gay men, including the brutal murder of Addison Verrill, the theater critic for *Variety*. I was stunned to recognize Bateson's picture. He was the radiology nurse at the NYU Medical Center who prepared Linda Blair for the arteriogram in *The Exorcist*. The paper referred to him as "the trash bag killer." I remembered that he wore earrings and a leather-studded bracelet in the medical center, a rarity in the workplace in 1972. His lawyer's name was in the article, so I called and asked him if Paul would see me. Once he agreed, I had to request permission from the Deputy Commission of Corrections, and it took a couple of weeks before I was given a time and a date.

Rikers Island is a complex of ten separate jails on over 400 acres in the East River, between Queens and the Bronx, near LaGuardia Airport. From an aerial view it looks like a giant amoeba. Overhead, the roar of planes landing and taking off is a constant nerve-

jangling nuisance. At any time, the Rock, as it's called, holds more than twelve thousand inmates, accused of crimes or awaiting trial, who can't make bail. It's known as the world's largest penal colony. From the parking lot you can see the Manhattan skyline and, in the distance, the Statue of Liberty.

I was led to a private room with a small metallic table and two straight chairs. Bars on the windows. Paul was brought in by two guards, who then waited outside. He was thirty-eight years old at the time of his arrest, and he was wearing a short-sleeved tan prison jumpsuit over a white T-shirt. He greeted me with a smile and asked, "How's the picture doin'?" *The Exorcist* was still in theaters after six years, and he was clearly pleased with his part in its success.

"Paul, did you kill these people?" I asked. He looked directly at me. "I don't remember. I must have been really high," he explained. "I remember the guy from *Variety*."

"Addison Verrill?"

"Yeah," he said. "I picked him up at the Mineshaft and took him to my apartment. We had sex, got stoned . . . I remember hitting him over the head with a frying pan. Then I guess I chopped him up."

"Why?"

"I don't know."

"How did they get you?" His gaze became distant.

"When I cut him up, I put the pieces into a body bag and threw it in the river. The bag had 'NYU Medical Center' stamped on it in small print, and the police were able to put a tail on me." (The bag was brought to the morgue, and the body parts were labled CUP-PIs, Circumstances Unknown Pending a Police Investigation.)

"There were other bags that came up, Paul—do you remember doing any of those?"

"Not really." He smiled. "I might have."

Neither of us said anything for a long time, then he whispered: "You know the cops offered me a deal?" I leaned closer.

"If I confess to eight or nine more murders, they'll reduce my sentence."

"Why?"

"So they can clear the books. Grab some headlines: 'Trash Bag Murders Solved,' " he said.

"You mean if you confess to *more* killings, you'll do *less* time?"

"Yeah. I might only have to do twenty years."

He was released in 2004.

Now I had Bell's articles, Randy Jurgensen's undercover exploits, and Paul Bateson's story. I called Jerry Weintraub, a concert promoter and manager I met in New York when he was presenting Frank Sinatra at Madison Square Garden. In addition to being Sinatra's promoter, Jerry's clients included Elvis Presley, Neil Diamond, Led Zeppelin, and John Denver. A street-smart Brooklyn guy raised in the Bronx, Jerry wanted to become a film producer. One evening at dinner, years before, he said, "I want you to know I just bought the rights to *Cruising*."

"Why would you do that?" I asked.

" 'Cause I heard you were interested in it, and I want to be in business with you."

"That's flattering, Jerry," I said, "but I have no interest in *Cruising*."

Three years later: "Jerry, you still own *Cruising*?"

"Why?"

"I think I know how to do it."

Jerry is brash and self-confident. A natural salesman, he can charm the butter off the toast, then sell you the butter. He also re-

ally "gets" show business and its natural ally, politics. We formed a partnership. Jerry would produce; I'd write the script and direct. We agreed to take less money in order to co-own the negative with whatever studio would finance it. Within a week, Warner Bros. was interested.

I wrote the script in four weeks. I used the title and premise of Gerald Walker's book, which pre-dated the trash bag murders, and was set in the genteel gay bars of the Upper East Side, not the S&M clubs. I used elements of Randy's story, Bateson's case, and Arthur Bell's accounts.

But I had never seen the clubs myself.

Jerry had a friend who could arrange that. He introduced me to "Uncle Mort," a retired New York City homicide detective who owned a limousine company. The car he drove was a gray bulletproof Cadillac with a gold bull hood ornament and the license plate NYNY1, courtesy of his client Frank Sinatra. He was the most loyal friend you could have, and he knew every corner of the city. It was rumored that Uncle Mort, even as a detective, "did some things" for Matty "The Horse" Iannello, a member of the Genovese crime family who later became its boss and worked with all five of the New York City crime families. Mort knew Matty and introduced me to him.

We drove out several times to visit Matty at his Westbury, Long Island, home. Matty controlled the Mineshaft as well as massage parlors, whorehouses, and peep shows in Times Square and midtown. He also controlled Umberto's Clam House, where Joey Gallo, a prominent Colombo family capo, was gunned down. The Stonewall Inn in Greenwich Village, where the gay liberation movement started, belonged to Matty. In fact, there were few businesses on the West Side of Manhattan that didn't pay him for protection and other services.

Tall and heavyset, with white wavy hair, Matty tended to speak quickly and would often slur words as though English wasn't his first language. To me, he was always friendly, and it behooved me to show him respect. He was called "The Horse" either because he was built like one or could punch one out. He lived in a beautiful house in a peaceful neighborhood and greeted visitors in his kitchen over breakfast, his grandchildren sometimes crawling on the floor, his wife and son occasionally appearing—a loving family man.

One morning, I drove to Westbury and shared with Matty his usual breakfast, soft Italian salami and chunks of sliced provolone cheese. He liked to talk about the film business, and he loved *The French Connection* and had many questions about it, especially how much money it was making. I told him I needed a favor.

"What can I do for you, kid?"

"Matty, I need your permission to film in the Mineshaft." He set down the serrated steak knife he was using to cut the salami and cheese and put a finger to his lips in a gesture of "shhhhh." Then he continued talking about *The French Connection* as though I hadn't changed the subject. After a half hour he said quietly, "Thanks for stoppin' by, kid—come on, I'll walk you to your car."

When we were outside, he put his arm around me and walked me to the middle of the street, *away* from my car. "Don't ever talk about my business in my house. They got the place wired," he whispered.

"Jeez, Matty, I'm sorry . . ."

"Just listen, and don't turn around—there's a brown sedan on the corner behind us. Two plainclothes. They got binoculars on me every time I go out or someone comes in. Now, tell me what you want and talk quietly."

"I want to film in the Mineshaft."

"Why?"

"I want to make a movie about the S&M clubs."

"Why?"

"It's a good story. A detective who goes undercover to trap a killer." We kept walking away from the house.

"This have anything to do with me or my business?"

I shook my head. "It's fiction. A murder mystery."

A long pause, then: "I'm gonna give you a phone number. Don't write it, just remember. Call in two days. Ask for Wally."

Wally Wallace was the manager of the Mineshaft. I made an appointment to meet him at a diner on the Lower West Side. I told him I wanted to check out the scene, which made him smile. He was thin, with short hair starting to gray, and he dressed casually in the hip leathers of the 1970s. He was well spoken, intelligent, and loved films. He knew my work, which is why he agreed to talk to me. "The Mineshaft is a private club," Wally told me. "Don't wear aftershave or sneakers or any designer shit. And don't bring a woman. Or a camera. Come Thursday night after ten. It's jock-strap night, so you'll have to strip down to your jock and check your clothes at the door like everybody else."

At midnight, the West Side waterfront was as deserted as a ski slope in July, except for the meat trucks parked outside the piers, where men had sex all night. Two cops sat in a cruiser nearby. They knew what was happening in the trucks and were paid to dummy up. The piers on the Lower West Side was like another planet for "straights," who tried to avoid it.

The Mineshaft was in the Meatpacking District at the corner of Washington Street and Little West Twelfth Street, across from the piers. A long white arrow painted on a black brick wall pointed to a black door marked in large white letters: 835. In front of the club were two black limousines, one with the license plate FFA5, the other FFA6: the Fist Fuckers of America. Matty thought

it could be dangerous for me to go alone, so he had Uncle Mort accompany me. From the front door, you walked up a long narrow staircase to two gatekeepers, who checked IDs and enforced the dress code. Our names were on a list, and Wally came over to greet us. He escorted us to an area where indeed we had to strip down to our jock straps, shoes, and socks. Uncle Mort had a .38 strapped to his right ankle, concealed in his sock. Everyone was in a jock strap, some with leather boots and vests, executioner masks or leather jackets. Men of all races, colors, and social status mingled as equals.

Black walls. Black and purple light. A jail cell. A dungeon, where men had anal and oral sex. A wall to which men were chained and whipped. A bathtub in which a man sat, being pissed on by groups of men: "the Golden Shower." A sling from which one man was draped while another fist-fucked him. Glory Holes, into which men inserted their penises to be sucked by strangers on the other side. Men giving blow jobs to other men in corners and around the room. A long bar, though the club had no liquor license, at which men took turns licking the bartender's ass. Every conceivable male-on-male sexual fantasy was being fulfilled, and though they involved degradation, they were consensual, not exploitive. Among the men were a few I knew, lawyers or stockbrokers by day. Several were married. Everything was done openly, but outsiders weren't welcome. I think Wally spread the word so no one bothered me or Mort—either that, or we were the ugliest guys in the room. We stayed for a couple of hours and had drinks while trying to appear casual.

When we hit the street, we couldn't speak for a long time. As a homicide detective as well as "a friend" to Matty "The Horse," Mort had seen pretty much everything. Though we were aware of the S&M world, it was frankly shocking to us. I've had every kind

of sexual fantasy myself, but never the curiosity nor the desire to act them out.

The S&M world was out of sync with the gay liberation movement, which made enormous progress in the decade since *The Boys in the Band*. *Cruising* was going to be controversial and possibly offend everyone, but for me it was just an exotic background for a murder mystery.

I returned several times to the Mineshaft and became friendly with the managers and the regulars. I also went to the Anvil, a similar venue a few blocks away, housed in a triangular four-story building with a dance club downstairs and small hotel rooms on the upper floors. I hung out at the Ramrod and the Eagle's Nest, hard-core bars that were only slightly less "private." I wrote my script to reflect what went on in these clubs, avoiding all reference to the Mafia or the ex-cops who were the nominal owners. Weintraub took the script to Warner Bros., where it was eagerly awaited and promptly rejected. The timing was bad for a film about hard-core gay life, but I wanted to tell the story as I saw it, risking censorship and reproach. From my contacts in the police department and the gay community, I became painfully aware of the homophobia, exploitation, and humiliation inflicted on gays, and I wanted the film to reflect this.

The Lorimar Company was about to go into the feature film business. They were best known for the television series *The Waltons*, a phenomenal success that presented a wholesome, idealized image of the American family. One of the ironies of *Cruising* is that Lorimar wanted to finance the film. Jerry and I met with Merv Adelson, Lorimar's chief executive, and told him we planned to pull no punches. Merv said fine, but we *had* to get an R rating. They could

not release an X-rated film; I would have to make whatever cuts the ratings board required to get an R.

Our first choice to play Burns, the police officer who goes undercover, was Richard Gere. A subtle actor, he possessed a toughness as well as an ambiguous quality. I met with him, and he agreed to do the film. Weintraub and I were about to make him an offer when a call came from Stan Kamen, head of the William Morris Motion Picture Department: "Pacino read your script. He loves it and wants to do it." Al and I met several times when we were planning *Born on the Fourth of July*, but I didn't think of him for *Cruising*. He was not only a movie star, he was considered one of America's best stage actors. Lorimar, with the backing of United Artists, made him a firm offer of $3 million, a top salary in those days, and he accepted. Our budget was $7 million, and if we spent less, we could keep what was left in addition to a percentage of the profits. But we were "on completion," meaning that if we went over budget, it would come out of our pockets, Jerry's and mine.

When an announcement of production appeared, Arthur Bell fired a warning shot in the *Village Voice*: "*Cruising* will negate years of positive movement work send gays running back into the closet and precipitate heavy violence." A backlash against the film began *before* filming started. Gay groups petitioned Mayor Koch to deny us a filming permit, but that was rejected. The mayor cited "free speech," but this inflamed activists even more. Every major gay journalist declared war on the film before the first day of shooting. My partners felt this was great free publicity, but I was less sanguine. Bootlegged copies of the script appeared, highlighting the most controversial sections. My recent failures were cited, along with the "exploitive" nature of *The Exorcist* and the retro take on gay life portrayed in *The Boys in the Band*.

Then came death threats, anonymously, by mail and phone; first a trickle, then a barrage.

We had permission to shoot in the Mineshaft and the Anvil, but other bars that originally welcomed us, the Eagle's Nest and Ramrod, were pressured to turn us down. I couldn't blame them. Attempts to prevent the film from being made became a cause célèbre in New York.

Pacino arrived filled with enthusiasm but little knowledge of gay life, let alone S&M, and he didn't want to see the locations before filming. He wanted to experience them fresh as his character would. A week before shooting was scheduled to begin, Al decided to have his hair styled by a gay barber. The "look" then was shorter hair. After his visit to a barber in the West Village, he came storming into the trailer that was our production office. The door flew open and Pacino appeared screaming: "Look what they've done to me!" He was trimmed almost to a crew cut, and he no longer looked like Al Pacino. His hair was his "power"—like Samson's; without it, he appeared a frail little man. This was disaster. This was not the Al Pacino audiences would recognize. He knew it, and came unwound. He wouldn't do the film looking like this, nor would we. "What are we gonna do?" he screamed. I tried to make light of it: "What am I, a barber?" I joked.

Years later, Jerry and I could laugh about it. At that time, we were stunned. Jerry leaped into action. He brought in some of the best hairstylists in New York and Los Angeles. Wigs were tried. Extensions. Nothing looked good, nor satisfied Al. The experts said it would take at least six weeks for his hair to grow back in. So we postponed the start date, with the clock running, and Jerry and I responsible for budget overages. Al was given various potions to make his hair grow faster as his mood grew darker. After a month, and with a few hair extensions and an expensive personal stylist, we

were able to set a start date. I cast Paul Sorvino, the consummate pro who played Jazz Maffie in *The Brink's Job*, to play the chief of detectives. Karen Allen was cast as Al's fiancée. Randy Jurgensen was our technical adviser and played a detective in the film, as did Sonny Grosso. Richard Cox, a New York stage actor, played the young man I modeled after Paul Bateson.

On the first day, we were waiting for Pacino outside the Criminal Courts Building downtown. We were going to film in the office of the chief of detectives, where Pacino is given his undercover assignment. Shooting was to start at 8:00 a.m.

Ten a.m.: still no Al. We panicked and called his apartment. We called his agent. We called every number we could think of, including the teamster assigned to drive him. There were no cell phones then, and we couldn't reach anybody. We worried that something happened to him, or that he'd quit without telling us. Had the gay protests freaked him out, or was it his hair?

At about ten thirty, two and a half hours late, his car and driver pulled up, and Al stepped out, accompanied by his makeup man. He was all smiles, and as though nothing was wrong, he gave me a hug and a high five. I was furious, but he was disarming, so I choked back my anger and introduced him to the crew. "What are we doin' today, Billy?" He had no idea what was scheduled on the first day! Or most days thereafter. As I walked him to the makeup trailer, I said, "Al, what happened, why are you late?" His expression turned dark. "Jeez, I didn't know . . ." He trailed off. He seemed hurt. His makeup man took me aside and whispered, "He always does this. If you want him on the set at eight, give him a six o'clock call or even earlier. It's known as a Pacino call." That's what we had to do for the rest of the shoot. I can't remember one day that he came to the set knowing his lines. He'd look at the pages just before the set was lit and camera-ready. Then he'd require a

number of takes to get the lines right. He called it "spontaneity," which I love, but spontaneity comes from preparation, which gives an actor the freedom to create. The other actors were always ready and had to endure while their best takes were wasted until Al was ready to move on. Often, I thought he'd hit the right note and say, "Great, let's go to the next shot," and he'd invariably hold up an index finger or whisper, "One more," and sometimes it would be five more or ten or twenty more.

We shot scenes in Central Park at night, in an area called the Ramble, where gay sex went on at all hours; we shot in a cheap hotel in midtown, where one of the murders was staged; in West Village apartments; in the clubs and in the morgue, where the renowned coroner Michael Baden let us photograph actual body parts from the CUPPI murders. When word of this leaked out, Mayor Koch fired Baden. It became a public scandal, on the front page of the New York newspapers. Most of the scenes were shot at night while hundreds of protesters shouted insults to the cast and crew. In one scene, Pacino had to walk alone down a dark street in the Village. Across the street, behind police barricades, hundreds of protesters were screaming, "Pacino, you fucking asshole, you little faggot." Piles of garbage were strewn on all our locations. Death threats mounted, and outside the Mineshaft late one night, protesters threw rocks and bottles at us, and we threw them back. It was a full-fledged street fight, and members of our cast who were in the S&M world joined us in fighting the protesters. For weeks we had every mounted police officer in New York protecting the set, and Al had to have a police escort. He had heard only the cheers of the crowd since early in his career, never boos nor curses.

As protests continued, we were denied additional shooting permits. Columbia University in Morningside Heights pulled our per-

mit to film on their campus, so I went there with Pacino, Richard Cox, and a small camera crew and "stole" the shots I needed.

We were allowed to film everything that went on in the Mineshaft, with no restrictions. The club regulars were paid as extras, since no Screen Extras Guild members could be asked, nor would they be able to simulate what took place there.

Despite the "Pacino call," Al continued to arrive late and unprepared. As the "takes" piled up, my uncertainty over his performance affected my attitude. Everyone on a film set has anxiety over his or her work, but when the director does, it can rock the foundations. Weintraub did his best to keep morale up and to keep Al calm, as the reactions of the gay community became more heated. Al was scared. He was not homophobic and couldn't understand why he was being treated the way he was. Sonny Grosso and Randy Jurgensen increased security around him, but it was like filming in a war zone. Al and I grew distant. We pressed on with a sense that it could explode at any time. Weintraub was supportive as always, but I was disappointed with Al's performance. I remember the same feeling about Hackman during the filming of *The French Connection*, and I was hopeful we could make this work in the cutting room.

We shot a scene where Burns (Pacino's character) confronts Gregory (James Remar), the roommate of his next-door neighbor Ted (Don Scardino). Gregory views Burns as a rival for Ted's affections, and the scene becomes heated. A threat of violence hung in the air, and Pacino suddenly exploded to life. For a scene lasting only a few minutes, I could see a flash of his powerful charisma as an actor. It's sprinkled over a few other moments as well, such as the interrogation-room scene at the precinct, where Pacino and a suspect he's entrapped are being roughed up by detectives. At one point, a muscular six-foot-eight-inch black man wearing only

a black cowboy hat, a jock strap, and black boots slaps Pacino in the face, then turns and exits without a word. This was a technique used in police interrogation at the time. Later when the suspect was arraigned, a judge would ask who hit him. He'd say, "This big black guy in a cowboy hat and a jock strap." The judge would laugh it off as a lie or a fantasy.

In the cutting room it occurred to me that as the killer and the victims were all dressed in leather caps, jacket, and Levis, black leather boots, and dark sunglasses, there might be *multiple* killers. All the CUPPI murders had not been solved, though Bateson confessed to many of them. It would be interesting to suggest there was a killer still at large at the end of the picture and that *it might be Burns* (Pacino). In one of the last scenes, set in a hospital, the chief of detectives (Sorvino) offers the suspected killer (Richard Cox) the same deal detectives offered Bateson: "Confess to these other murders, and we'll reduce your sentence." Bateson accepted the deal. The Richard Cox character denies he killed anyone, but his denial is in the voice of his dead father, who he believes urged him to kill gay men. None of this was in my original script.

Weintraub invited Richard Heffner, the new head of the Ratings Board, to have dinner at his home and see *Cruising*. Heffner replaced Aaron Stern, who gave *The Exorcist* an R rating with no cuts.

It was highly unusual for the head of the board to watch a film before it was rated, let alone at a producer's house. But Weintraub was persuasive. He and his wife, Jane, lived on a cliff in Paradise Cove overlooking the Pacific Ocean. The house was painted blue, and there were two large stained-glass windows flanking the front door, each one depicting Jerry and Jane on the phone. "Blue Heaven" was built on seven acres and included a large swimming

pool, tennis court, a separate guesthouse, and a stable for six horses, Tennessee Walkers that Jerry and his guests used to ride on the beach.

Heffner showed up for dinner. It was just him, Jerry, Jane, and me. Small talk. Jokes. Good wine. Heffner was as unlike his predecessor as ice cream and French fries. He was conservative in his dress and opinions.

After dinner we went into the living room, where a screen came down from the ceiling, a projector lit up, and we sat in easy chairs watching the first cut of *Cruising*. Heffner was in front of me. On the screen a disembodied arm appears in the Hudson River. The arm is then examined on an autopsy table, tossed into a drawer in the morgue marked CUPPI that contains other disembodied limbs. A man picks up another man in a leather bar. They taxi to a hotel. A violent murder is shown in graphic detail. And I hear a loud "Ohhh," from Heffner's chair. The victim's body is viewed in the autopsy room by the medical examiner and a detective. We see in detail the pattern of the stab wounds. Then another victim is stabbed and murdered in the Ramble in Central Park. From Heffner's chair, another groan went up. Pacino goes into the Mineshaft and sees men being chained and whipped; a bathtub where a man is up to his chest in the "Golden Shower"; one man is fist-fucking another . . . more groans from Heffner. His jacket comes off, then his tie. I can *feel* his discomfort. I hear a loud, "Oh nooo!"

Finally another brutally beaten and murdered man is discovered in an apartment in the West Village in the building where Burns (Pacino) was staying. Burns comes home to his fiancée. She tries on his leather jacket and cap, admiring herself in a mirror. In the bathroom, Burns is shaving. He looks into the bathroom mirror, directly into the camera. A tugboat cruises the Hudson River

as at the opening of the film. The lights come up. Heffner is sweating! His shirt is soaked, his face a blotchy red color.

"Good Lord!" he shouts. He isn't smiling.

"So what do you think, Dick?" Jerry asks, facetiously.

Heffner is quick to respond: "What do I think?" Then calmly, "Jerry, this is the worst film I've ever seen!"

Jerry forces a smile: "But what's the rating?"

"The rating? There aren't enough X's in the alphabet for this picture!"

Jerry segues from the charm factor to a more serious mode: "Dick, you can't do this to me. I've got money in this picture. I can't get an X." Heffner reaches for his jacket. Jane and I watch, dumbfounded, as Jerry blocks his path and says in a mock pleading voice: "You gotta help us. What do we have to do to get an R?" Heffner tries to move away: "I have no idea. An X usually means *excessive*. Excessive language or nudity or sexuality. This picture is beyond the pale in all three." It went back and forth like this until Heffner offered a suggestion:

"Sometimes, when we have a difficult rating problem, we suggest hiring a consultant, my predecessor. Aaron Stern. He's been able to advise producers, and he often achieves successful results."

This was good news. I called Aaron, and he said he'd be happy to help us. He'd have to see the film, and his fee was a thousand dollars a day. We took the work print to New York and ran it for him. After fifty days of Aaron's negotiations with the ratings board, we got an R rating! We had to superimpose smoke over shots of naked men in the clubs or selectively blur them out. I cut at least half an hour from the club scenes and the murder scenes. I had purposely let these scenes of pornography and violence run long, knowing they'd be cut and I'd be left with the story I wanted to tell. Despite these cuts, the film pushes the boundaries of what

is acceptable in an R-rated film, something the critics were quick to point out.

When I had an approved version, I ran it for Pacino. Bud Smith was with me. I thought the film was powerful, but I knew it would receive as much scorn as praise. When it was over, Al was slow to get out of his seat, and when he turned to Bud and me, his expression was unhappy. "We've got a lot of work to do," he said, gravely.

"What do you mean?" I could see his anger and disappointment.

"I mean I don't get it, Billy. It doesn't work," he said quietly.

"I disagree, Al."

"Well, we'll have to try and fix it," he said.

"Like how?" I started to feel anger myself.

"We have to go into the cutting room and start over," he said.

"Give me *some* idea of what you have in mind, Al."

"I'd take out some of the early scenes. The arm . . . the pickup in the bar . . . the murder in the hotel . . . ," he offered.

"Where would you start the film?"

"When you first see me, when I come into Sorvino's office. But I'd make *other* cuts"

"Like what?"

"The murders should all be off-camera, and you're suggesting that *my* character is one of the killers—"

"That's right," I said firmly.

"Why didn't you tell me?" he shouted.

"I honestly didn't discover it until I got into the cutting room."

He started to pace as his anger built. "I would have played it differently if I'd known . . ." His voice trailed off.

"I didn't *want* you to play it differently," I said, raising my voice. But I could see his point. As a serious actor, he didn't want information kept from him by his director. Had I discovered this twist

during production, I *would* have told him. For me it was a late discovery; for him, a betrayal.

Bud Smith didn't say anything as his face reddened. I stood up. "Al, let me tell you something. I like the film. I have final cut. There's no way I'm going into the cutting room with you. Is that clear?"

I doubt he'd ever been talked to in this way. But the gloves were off.

Weintraub, Merv Adelson, and Al's agents all tried to calm him down, but he wasn't having it. He did no publicity for the film; no interviews—a public silence he's maintained to this day. Word of course got out that he hated the film, and this was used to fire the resentment felt by many others.

The first screening for critics and journalists took place at a theater on the East Side. I walked to the theater alone when I knew the screening would end, to do a Q&A. As I approached, I saw a man walking toward me. Gay Talese. "Boy, are you in for it," he said. I asked him why, and he told me the reaction was incendiary. The audience was booing, shouting at the screen, cursing—he had never seen anything like it. He wished me a tentative "Good luck."

When I entered the theater, the negative vibes were palpable. People were shocked, angry, disgusted. The questions from journalists were hostile, along the lines of, "Why would you make a film like this?"

"Do you think this will increase violence against gay people?"

Arthur Bell, whom I had never met, stood in the audience. He moved from his seat to the aisle and came toward me, brandishing a cane: "You've made a monstrous, evil film," he shouted. Sonny Grosso and Randy Jurgensen moved to restrain him as he continued to shout curses at me. The audience was like the crowd at a bullfight or a boxing match.

"Arthur, I became aware of these places and events from reading your columns," I said.

"Why don't you *pay* me, then? Why did you rip me off?" he shouted.

I took questions for another hour before I left the theater in chaos.

When the film opened, the reviews were excoriating. Bell called it "the most oppressive, ugly, bigoted look at homosexuality ever presented on the screen." The National Gay Task Force likened it to *The Birth of a Nation*, which, though a great film, is still regarded as a screed against African Americans. The review of *Cruising* in *Variety* ended with, "If this is an 'R' the only 'X' left is actual hardcore."

A firestorm of criticism followed. I quickly gained a reputation as a gay basher. I'd been in the eye of the storm for months, and I began to question my own motives.

Had I done *Cruising* simply to stir up controversy? I thought not. I knew it would be controversial, but not to this extent, nor did I believe it would trigger violence against gays. And it didn't.

I made it because it was a fresh take on the detective film against a background that had never been seen by a mainstream audience. And it encompassed the themes that continue to fascinate me: good and evil in everyone; our conflicting desires.

But my timing was off. It was the beginning of the Reagan era, a feel-good period, morning in America. The ambiguous films I revered and the ones I made were passing out of vogue. It happened quickly. *Rocky* and *Star Wars*, followed by *Raiders of the Lost Ark* and *Close Encounters*, formed the new Hollywood template. Audiences wanted reassurance and superheroes, not ambiguity.

Cruising was another defeat, on a par with *Sorcerer*. Flaubert

was asked how he could write a novel from the perspective of a woman. *"Madame Bovary, c'est moi,"* was his famous answer: "Madame Bovary is me." I began to realize that my films came from deep within my psyche. My films are who I am, or at least, they are what fascinates and obsesses me.

Los Angeles, 1980

A problem makes you forget a problem.

<div align="right">

Arab proverb

</div>

Early morning. Fall. I'm living alone in a ranch-style house I designed and built on top of a cul-de-sac in Bel Air, just west of Stone Canyon off Sunset Boulevard. Bacon, eggs, toast, juice, coffee. Into my car, late-model Mercedes-Benz coupe. Push out to my office at Warner Bros. on the San Diego Freeway. Feel great. Classical music on the stereo. Bruckner, *Eighth*, von Karajan.

Sudden sharp pain. Starting in my left arm, spreading quickly to the right. Like a knife, slicing. Can't breathe. Still driving, foot to the pedal. Blur of colors. Cars everywhere. Pull over. Open door, try to walk, can't put—one—foot—in—front—of—the—other. Slide back behind wheel. Can't raise my arms. God, what is this? Pain deeper. Keep arms low on wheel. Drive slowly, ten miles an hour.

Struggle to breathe. Pull into the Warner Bros. lot. Stagger to my office. Sweating. Toni stands quickly as I fall straight down.

Paramedics bending over me. Pumping my chest. Stethoscope. Can't see anymore. Can't open eyes. Words, as though through a tunnel: "I'm not getting anything . . ."

Dying. My God, I'm dying. I've wasted my life. I haven't accomplished anything. Lose consciousness. Try to open eyes. Can't. Dead!

Then, moving, gliding, as though on escalator. Darkness. A dim white light in the distance. And a voice in my head: "It's all right. It doesn't matter. It's all right . . ." Whose voice? Moving toward the light.

Lights blasting in my face. I'm in hell! Can't breathe. Oxygen mask. Pull it off. Relentless pain. Faces all around. Surgical masks. Emergency room, St. Joseph's Catholic Hospital in Burbank. "Keep the mask on, please." I pull it off again, and again. Breath won't come. Mask back on. Fade out.

Darkness.

Three days of observation. Can't sleep. Prayers on a loudspeaker. Transferred to Cedars Sinai, where I had donated the Nurse's Training Center in my mother's name.

Short gray man, wearing glasses, gray suit, slight paunch, enters quietly. Takes my pulse. Sits. Dr. Jeremy Swan, chief of cardiology, co-inventor of the catheter. "Mr. Friedkin."

"Yes, sir."

"How are you feeling?"

"Tired."

"Pain?"

I nod.

"You're in your forties."

I nod.

"You had a heart attack."

Until he told me, I didn't know it. No one I knew had survived one. I didn't need surgery, but I was in the hospital for six weeks. I couldn't move or walk. A nurse came to my room every day to help me raise my arms, one at a time, then each leg. In the final week, I

was able to walk the hospital corridor for two minutes, then three, eventually ten. When I got home, I had to learn to walk again, five minutes a day on the UCLA track. After three months I could walk for an hour.

I was determined not to let a heart attack alter my lifestyle. I'd soon be playing tennis and basketball again. I'd make better films, learning from the mistakes of the past. The coils of depression that imprisoned me slowly unwound, like the caterpillar that encloses the butterfly.

The Twilight Zone

I had no offers and nothing I particularly wanted to do when unexpectedly Phil DeGuere, producer of the new *Twilight Zone* for the CBS network, sent me a script with a handwritten note that read: "You probably would never consider going back to TV, but I think this is a special script you might like and if you do, it's yours." DeGuere had attracted some of the best writers and directors in the horror-fantasy genre, but the script he sent me he adapted himself from a short story by Robert McCammon, a respected writer in the genre. It was called *Nightcrawlers*, and it was indeed "special."

It moved effortlessly from the real to the surreal. Set in a remote diner in Utah, it was about a Vietnam vet who deserted his unit during combat and came home, haunted by his cowardice. Under the influence of mind-altering drugs prescribed by army doctors, he hallucinates that members of his unit, the Nightcrawlers, have come back from the dead to capture and kill him. In the course of this twenty-minute segment, his delusions become real and the "vets" follow him to the diner and shoot the place up, having com-

mitted other murders on the way. The premise was a metaphor for the way Vietnam continues to haunt the American conscience.

We built an accurate replica of a diner on the soundstage and filmed the night exteriors at a remote location on the outskirts of L.A., with rain machines and lightning effects. We cast a young actor named Scott Paulin to play the haunted soldier. Exene Cervenka, a friend from the 1980s rock band X, played the waitress, and I hired several friends from Stunts Unlimited to play the Nightcrawlers. The five-day shoot was exhilarating. Cast and crew believed in the material and inspired me to explore the landscape wherein reality and illusion coexist.

This short segment became one of the most widely praised and watched films of my career. For a brief period it restored my sense of confidence. My juices were flowing again, and I felt I could make another film that might draw on everything I had done before and take it further.

PART IV

AN UPHILL CLIMB TO THE BOTTOM

TO LIVE AND DIE IN L.A.

Gerry Petievich was a Secret Service agent for nineteen years, assigned to jobs as varied as protecting the president of the United States whenever he was in Los Angeles, and pursuing counterfeiters in the 'hood for passing bad twenties or phony credit cards. He fictionalized his experiences in a novel called *To Live and Die in L.A.*, filled with well-drawn characters—Secret Service agent Richard Chance, a bungee-jumping "hot dog" obsessed with entrapping Rick Masters, the counterfeiter who killed his partner. John Vukovich, a younger agent, joins him in a scheme to arrest Masters. Obsession, paranoia, and betrayal, the thin line between the policeman and the criminal—it had the elements of classic film noir. It would have been impossible for me to make this film for a major studio, but along came my old friend Irv Levin, former owner of the Celtics and the Clippers and former CEO of National General Pictures. He felt he had missed out by not financing *The French Connection*, and he wanted to do something with me if I was available.

Irv started a new production company with Sam Schulman, co-owner of the Seattle Supersonics, and Nick Mileti, who owned the Cleveland Cavaliers, both in the NBA. Their first investment was in the hugely successful *Poltergeist* for MGM, with whom they had a distribution deal. I optioned Petievich's book and,

inspired by its finely crafted storytelling, terse dialogue, and the zany antics of the rogue Secret Service agents, wrote a script in three weeks.

I didn't want the film to be a clone of *The French Connection*. I would abandon the gritty macho look of that film for something more in the unisex style of Los Angeles in the 1980s. I went to Lily Kilvert, not only because she was a talented production designer but for a feminine sensibility. I hired other women as key members of the crew, including costume designer Linda Bass and a brilliant set decorator, Cricket Rowland.

I had seen *Paris, Texas* by the German director Wim Wenders, photographed by an Austrian cinematographer, Robbie Muller. His films were beautifully lit and composed, with long uninterrupted takes. This was the style I wanted for *To Live and Die in L.A.*, in which the city would be portrayed as a violent, cynical wasteland under a burning sun.

Petievich became my technical adviser. He arranged the parole of a counterfeiter he busted, who showed me the step-by-step process by which money was printed, from the selection of the correct paper (or "rag") to the method of aging by stuffing the fake bills into a laundry machine along with poker chips.

In England the year before, I'd heard a band called Wang Chung, whose name came from the sound a guitar makes when strummed. Two songs in particular grabbed my attention: "Dance Hall Days" and "Wait," from an album called *Points on the Curve*. Band members Jack Hues and Nick Feldman were at the forefront of what was then called post-punk New Wave. Their sound was created on electronic instruments, a drum kit and keyboard. The lyrics were offbeat, suggestive, and slightly subversive.

In many ways *To Live and Die in L.A.* was influenced by the music of Wang Chung, so before I shot a foot of film, I gave them

the final draft of the script and asked them to record their impressions of what they read—the same way I worked with Tangerine Dream. The only request I made was that they *not* write a song called "To Live and Die in L.A."

I wanted to portray the city with no landmarks, no iconic skylines or neighborhoods. So I chose fringe areas: Nickerson Gardens in Watts; Temple and Eighteenth Streets, home of the Crips and Bloods gangs; Slauson Avenue in South Central; the Vincent Thomas Bridge; the Terminal Island Freeway; a Fijian community in the shadow of vast power plants in Wilmington; and San Luis Obispo Prison.

The warden at Obispo allowed us to stage an attempted "hit" in the prison yard, using inmates, in a scene with one of our actors, John Turturro. The warden also let us use an interrogation room and gave us the services of his prison guards.

My casting director was again Bob Weiner. He saw hundreds of actors at auditions, in plays, and in new films. When Bob brought Willem Dafoe to me for the role of Rick Masters, the counterfeiter, I hired him on sight, as I had done with Roy Scheider some twenty years before.

Petievich introduced me to his younger brother John, who was serving warrants for the LAPD, and through John I met other police officers I hired for smaller roles.

Dean Stockwell was the only veteran in the cast. He had been a child star, making his first film in 1945. He was a skilled character actor, and I was impressed with his performance the year before in *Paris, Texas*. We hired him to play Masters's double-dealing attorney, Bob Grimes.

When most of the roles had been cast except for two of the leads, Weiner called me with excitement in his voice, something that was rare for him. He was in Toronto at the Stratford Ontario

Shakespeare Festival, and he wanted me to come up immediately to see an actor who had the lead in *A Streetcar Named Desire*.

I said, "Bob, I don't want to see *Streetcar*. Brando owns that part, and actors either rip him off or they're totally inferior. If you like this guy, I'll meet him when he's done with the play."

Bob was insistent. He said the actor he wanted me to meet was one of the finest young actors in America.

Stratford, Ontario. A charming town along the river Avon, two hours' drive west of Toronto. As I approached the crowded theater, I noticed something I hadn't expected: dozens of teenage girls waiting to get in, not for an American theatrical classic but to see its young star. Billy Petersen was thirty-one years old, grew up in Boise, Idaho, went to Idaho State on a football scholarship, discovered theater, and moved to Chicago, which was soon to become the most innovative theater town in America. He started his own acting company, The Remains, and toured with a hugely successful one-man show, *In the Belly of the Beast*, based on the prison letters of convicted murderer John Henry Abbott. In *Streetcar*, Petersen made Stanley Kowalski his own. Unlike Brando, he played Stanley not as a brute but as a flawed man, unable to relate to Blanche because of a cultural gap that could never be bridged. Petersen knew what Brando had done—he had seen the Kazan film—yet he reinvented Stanley as a character more complex but just as dangerous and sexy.

Petersen was just under six feet tall, trim, with the grace of an athlete, and it was clear why the audience was made up mostly of women. When I met him backstage, he was warm and personable. We shared a love for Chicago, especially the Cubs and the Bulls. I gave him my script and asked him to come to New York when he finished *Streetcar*.

I thought he could become an action star, and like Hackman, he also had the acting chops. Through Bill I met his friend John Pankow, also from Chicago and a stage actor with little film experience. John was thirty, gentle, with a sweet smile, quick to laugh. I liked him immediately and saw that he and Bill had a rapport that would work for Pankow's character John Vukovich, Chance's younger partner.

To make a popular action film with complete unknowns was a leap into the void, but I was confident I could pull it off. Petievich's novel was delightfully twisted. Two Secret Service agents learn through an informant about a courier carrying $50,000 in cash to buy stolen jewelry. Because the L.A. office of the Secret Service doesn't have enough real money to buy counterfeit money, Chance and Vukovich decide to rip off the courier and make the buy, and entrap the counterfeiter.

The actors spent a lot of time hanging out with Petievich and other Secret Service agents so that when we were ready to shoot, they were in character. Petersen and Dafoe stayed away from each other off the set, and developed a mutual dislike as befit their characters. Dafoe learned the counterfeit process from Petievich's parolee and printed thousands of fake twenties, some on one side only, some on both, and we filmed it in graphic detail.

Before the start of production approaches, I often experience a sense of dread that brings troubled sleep or no sleep at all. A scene that won't play. An actor miscast. A disconnect with a cameraman. Failure of imagination. Conflict with the producers. This dread turns into irrational fear and self-doubt that hovers above me like a storm cloud. It affects my attitude toward family and friends, and I become surly for no apparent reason. Sometimes a hidden reserve of energy emerges from this anxiety and jump-starts my creative juices. This time was different. I never felt more confident or in-

ventive than I did on *To Live and Die in L.A.* I loved the cast, the locations, the script; everything fell into place.

I wanted to do a chase scene as the centerpiece of the film. I thought for many years about what I might do to surpass the chase in *The French Connection.* For *To Live and Die in L.A.* it would be at high speed going the wrong way on a freeway.

"The chase" is the purest form of cinema, something that can't be done in any other medium, not in literature nor on a stage nor on a painter's canvas. A chase must appear spontaneous and out of control, but it must be meticulously choreographed, if only for safety considerations. The audience should not be able to foresee the outcome. It helps to have innocent bystanders who could be "hurt" or "killed." When I see vehicles in a film whipping through deserted streets or country roads, I don't feel a sense of danger. Actual high-speed chases take place in big-city traffic or on crowded freeways. Pace doesn't imply speed; sometimes the action should slow to a crawl, or even a dead stop. Build and stop, build and stop, leading to an explosive climax. It also helps to keep a left-to-right or right-to-left continuum, so the audience understands the geography. I'm not concerned about this when shooting dialogue or other scenes, but with a chase, it must be clear where Person A is in relation to Person B. If A goes left or right, B should follow the same route.

Whether he's on horseback, behind a wheel, or on foot, the chase must be a metaphor for the lead character: reckless, brutal, obsessive or possibly even cautious. If the chase is to be believed, the actors must convincingly portray fear. And the director has to keep reminding them of this; the close-ups "proving" their fear are seldom actually dangerous to perform. The real danger belongs to the stuntmen.

Sound is added after the picture is cut. I like to layer sound, not

only using vehicle noises but mixing in interpretive sounds like a jet engine roar or a shotgun reverb, so some sounds aren't simply heard but felt.

There's a continuing debate among critics and bloggers about the best chase scenes ever filmed. *Bullitt* is way up there. So is John Frankenheimer's *Ronin*, filmed in Paris in 1997. The James Bond films are highly rated. Many critics cite the silent era, especially Buster Keaton's locomotive chase from *The General* in 1927. Keaton directed other outstanding chases: an acrobatic escape, from his early short film called *Cops* (1922); the driverless motorcycle chase from *Sherlock Jr.* (1924); and others. Keaton did his own stunts and directed all his films, and remains to my mind the most innovative of American filmmakers. I was fortunate to have seen all his films *after* I made *The French Connection, To Live and Die in L.A.*, and *Jade*, or I'd have been intimidated or, worse, borrowed from his treasury of ideas.

One of Hollywood's best stuntmen, Buddy Joe Hooker, loved the challenge of *To Live and Die in L.A.*, and if we could pull it off, we believed it could top *The French Connection* chase. The best stuntmen are of course fearless, but more important, they're well trained, cautious, and experienced. They won't attempt anything that might obviously endanger lives, but their work itself is intrinsically dangerous. My habit of shooting off the cuff with little rehearsal doesn't apply to a stunt sequence. Stunt coordinators know that if a serious injury occurs on their watch, they're done. There are overzealous directors who want to push the envelope beyond the safety zone, but the top stuntmen tend to avoid these situations.

Buddy Joe recruited a handpicked crew, and together we planned a sequence. Using toy cars on pieces of white cardboard, Buddy and I worked out options for the scene in which Chance's

car drove straight toward oncoming vehicles on a highway at high speed. For the car itself, he chose a 1985 beige Chevy Impala F41, which he refitted with roll bars, a souped-up engine, new shocks, and brakes. A duplicate car for Petersen required similar safety devices. There may be better chase sequences in films, but few as elaborate. Everything depended on precise timing. We'd come up with an idea, and Buddy Joe would figure out how to execute it so that no one was injured, or worse.

Robbie Muller photographed most of the film, but he told me he didn't feel confident shooting a chase. It was a matter of controlling the light; the cameras had to shoot in all directions at once, and the director of photography has to compensate for the constantly changing daylight with filters and exposures. I replaced him with one of the camera operators, Bob Yeoman, who was too young and inexperienced to be afraid of the challenge. We brought in two more operators, in addition to placing camera mounts on vehicles.

For side-tracking shots of Chance's car, passing traffic going the *other* way, we found that all the "passing cars" could be stationary; the viewer could not tell whether cars were moving or standing still.

We parked cars along a smooth hundred-yard stretch of the Terminal Island Freeway, and Petersen could weave past them while driving. We built a swivel rig on which we mounted the Impala. The swivel was operated remotely, causing the car to twist 180 degrees while being towed on a straight path past traffic moving erratically in the other direction but far enough away for safety. Petersen did a lot of the driving himself, but Buddy Joe or one of his guys drove all the POVs. The oncoming cars, at least seventy-five, were stunt cars that we switched out for different angles. The chase was filmed in an industrial area on the Terminal Island Freeway for six

consecutive weekends, four hours each day. As important as "proving" that Petersen was driving were John Pankow's reactions of abject fear in the backseat. We made these shots from inside the car and from the swivel rig. A new camera called the "Hothead" was mounted on the hood of the Impala so we could see Petersen driving and pan the camera from a remote vehicle to see his point of view in the same shot.

I was excited to get into the cutting room. I could tell from the dailies that this was going to work.

Halfway through production, it occurred to me that Petersen's character, Chance, had to die. This was not in the script or the novel, but I thought it was unexpected and justified, given that he lived constantly on the edge. He wasn't a superhero immune to danger. In the final confrontation between Chance and Masters, it would be Chance who was killed. I didn't have an ending until discovering during production that Vukovich *becomes* Chance in appearance and attitude after Chance's death.

In the editing room, Bud Smith and I superimposed a timeline on every scene: a typed notation on a case report, a longhand entry in a log book, and finally a digital clock counting down the last seconds of Chance's life. This became the framework for the story and made it seem reality-based.

The opening sequence is a montage of random shots I had no idea I would use until I got into the cutting room and their usefulness was revealed. Bud and I cut the film to the music Wang Chung recorded without seeing the footage. When we had a first cut, I invited them to the editing room. Two days later they brought me a title song—the song I had asked them *not* to write. I liked the song so much that I shot a new scene for it, a prologue that introduced Chance and his partner Jim Hart as agents protecting

President Reagan against a terrorist attack. This was my only op-
portunity to portray the most important aspect of Secret Service
work, protecting the president. After that, the film deals only with
counterfeiting.

The counterfeiting scene was filmed in an abandoned warehouse
in the desert outside Bakersfield, California. We shot it in loving
detail. One of the special effects men took home some of the bills, all
twenties, printed on one side only. His teenage son grabbed a hand-
ful off his father's bedroom dresser and with a friend bought some
candy at a local supermarket. Within minutes, Secret Service agents
were on the scene. They arrested the boys and asked where they got
the money. The boy confessed: "From my dad." The boy's father was
interrogated and said the bills were made for a movie, and the guy in
charge of them was the property master, Barry Bedig.

At 4:00 a.m. Barry was awakened by a pounding on the door
of his apartment in Ventura: "U.S. Secret Service." He was grilled
for three hours. They wanted precise details of how and why this
money was printed and how it got into circulation. Barry gave
them my name and called to warn me that I'd be hearing from
them. I called Gerry Petievich and asked him what I should do if
I got the call.

"They're just a bunch of pencilnecks on a fishing expedition,"
he said. "If they want to talk to you, tell 'em to get a warrant from
a federal judge."

The next day I got a call from the U.S. attorney for the Cen-
tral District of California, Robert Bonner. He was pleasant on the
phone: "Mr. Friedkin, I wonder if you'd mind answering a few
questions?"

"About what?" I asked him.

A slight pause, then, "I think it would be better if we spoke in
person," he said calmly.

"Mr. Bonner, I know you talked to my prop man and special effects man, and they told you we printed fake money for a *movie.*"

"Well, you know it's illegal to print money for *any* reason, unless you're with the Government Printing Office."

After more urging by Bonner that I voluntarily come in for questioning, I said: "I'll see you if you get a warrant."

"You're not going to play *that* game, are you?" he asked.

"Get a warrant, Mr. Bonner, and I'll come in, with a lawyer."

I never heard from him again. When the film came out, there were news stories about people trying to make counterfeit money after seeing the step-by-step process in our film. I took some of the twenties, those printed on both sides of course, put them in my wallet, and spent them, in restaurants, shoe-shine parlors, and elsewhere. The money was that good.

Robbie Muller's camera of choice was the Arriflex BL, a compact, flexible piece of equipment with finely ground Zeiss lenses. I used the Arri on other films and appreciated its ease of operation and portability. But Robbie also decided to use Fuji Film, not Kodak stock, which was more commonly used. Robbie liked Fuji because the colors had deeper saturation. When we finished editing the work print, we cut negative and sent it to Technicolor for processing.

The first trial prints were all out of focus. How could this be? We saw the dailies, and they seemed fine. We met with Otto Nemenz, who owned the Arriflex franchise that leased the cameras to us. He ran tests using Kodak stock, and there was no problem. Then he tested Fuji, and again we processed it at Technicolor. Again, it was out of focus. Was it possible that our entire film was out of focus? Larry Rovetti, one of Technicolor's best color timers,

discovered that Fuji negative was thicker than Kodak negative to a microscopic degree. He recalibrated a printer dedicated only to our film. The recalibration was successful, and focus was restored. Were it not for Rovetti's skill, experience, and a hunch we would not have been able to release the film.

I felt good about its prospects. I believed Petersen and Dafoe would become stars, which eventually they did. Bill became the lead in *CSI*, the top-rated television show in the world for nine years. Dafoe went on to Academy Award nominations and international recognition.

MGM released the film in 1985 to mostly favorable and many ecstatic reviews. *Tense, exciting,* and *unpredictable* were the most common adjectives used to describe it. Petersen was compared favorably to Steve McQueen.

The film opened to low grosses, and MGM did nothing to support it. Ted Turner owned MGM then, and *To Live and Die in L.A.* wasn't his cup of tea; he was busy colorizing classic black-and-white films for his television networks, an unpopular idea that ended badly for him when he announced he was planning to colorize *Citizen Kane.*

Get out your handkerchiefs.

I'd long since fallen from the Hollywood A-list and was in the gray area. Word came back that Tony Fantozzi, my dear friend and agent for twenty years, told several people, "Friedkin can't get a job in this town." It was hurtful but true, so I left the Morris office and signed with a series of agents and managers who were no more effective for me. What I had with Fantozzi and William Morris was loyalty and a devotion I haven't experienced since. Most agents who later signed me were hoping I'd create something on my own and they could then ride my coattails. They may have made ef-

forts on my behalf, but without results. Then again, it's rare that an agent will work hard for a client who's at low ebb. Failure is a disease that can spread. The agent will stop calling or return your call a day or two later. Or not at all. Like a Pinter pause, the silence is filled with meaning.

A SAFE DARKNESS

Rampage

It was nearly thirty years since *The People vs. Paul Crump*. What drew me to that story was an inherent belief that the death penalty was immoral, and the possibility that Crump was innocent. Over the years my attitude about the death penalty changed. The murders of John and Robert Kennedy, Martin Luther King, and John Lennon, the Manson family killings, and a series of mass murders across the country led me to the conclusion that such acts were so heinous that no purpose was served in keeping the murderers alive.

In late 1977 a twenty-seven-year-old named Richard Chase killed five people in Sacramento. He became known as the Vampire of Sacramento, and the local sheriff called the murders the most bizarre and senseless killings he'd seen in twenty-eight years. Hysteria spread across the city until Chase was captured and charged with six counts of first-degree murder and pleaded not guilty by reason of insanity. His plea was denied, and he was sentenced to death but OD'd in his prison cell from antidepressants.

Before the murders, Chase's weird behavior caused him to be committed to a mental institution, where he was diagnosed as

paranoid-schizophrenic and put on antipsychotic meds, but he escaped a year later and started his killing spree. After his capture, body parts were found scattered around his house, along with containers of brain tissue and food blenders filled with blood.

William Wood was a deputy district attorney in the Sacramento DA's office who had prosecuted thousands of criminals and tried fifty jury trials before he wrote Chase's story as a novel called *Rampage*. It's the story of a young man (Charles Reece) who kills random victims four days before Christmas. The novel examined not only the morality of the death penalty and the insanity defense, but issues such as justice versus revenge as well as gun control. Reece is seen easily buying a .22 with a waiting period of only fifteen days, a mere formality.

The legal test to determine whether a person accused of a crime is sane or insane is based on English law, specifically the M'Naghten rule, first pleaded in 1843 by Daniel M'Naghten, who tried to kill the British prime minister but mistakenly killed his secretary instead. The question in M'Naghten was whether or not the accused knew what he was doing, and could distinguish right from wrong. Mental health experts testified that M'Naghten was psychotic, and he was found not guilty by reason of insanity. The U.S. Supreme Court later toughened its stance on the law, writing, "The fact that a defendant's conduct can be characterized as bizarre or shocking does not compel a finding of legal insanity, particularly when there is expert testimony supporting an opposite conclusion."

Today the defense is seldom used and rarely successful.

The question raised by Wood's novel that most intrigued me: What factors cause someone to snap and commit mass murder? Often his friends, neighbors, or relatives will later say, "He was a really good boy, quiet, polite. I never saw it coming—would never have believed he could do it."

I optioned the rights to Bill Wood's book and wrote a screenplay in four weeks. I took it to Dino De Laurentiis, who'd produced *The Brink's Job* almost ten years before. Dino was a battle-scarred warrior who made hundreds of films in Italy, the United States, and around the world. He scored a success with David Lynch's strange, disturbing film *Blue Velvet*, and he now had his own distribution company. He thought *Rampage*, if done inexpensively, could tap into the same audience.

Dino started as a spaghetti salesman in Naples and became a film producer in 1940 at the age of twenty-one. For seven decades he worked with people like Federico Fellini, Ingmar Bergman, Roberto Rossellini, Luchino Visconti, and John Huston, making everything from comedies to horror films. Some were acclaimed; many were dogs. He was a diminutive man with a large ego who wanted to compete with the big boys, the major Hollywood studios, but his finances were often questionable, and he was not a hands-on producer. He agreed to make *Rampage* for $5 million, on location in Stockton, California, with no stars. I cast Michael Biehn, who played a leading role in James Cameron's film *The Terminator*, as a liberal young district attorney who is personally against the death penalty but must invoke it in a first-degree murder case under California law. In preparing the case, he covers up inept police work to prevent the killer from getting off on a technicality. Alex McArthur, who had only a handful of television credits but was a fine actor, played the role of Charles Reece. Wood's novel was dispassionate, more of a procedural than a hard-edged drama. It was a polemic against the insanity defense by a former prosecutor. My adaptation followed the novel closely, but I felt that in dealing with so serious a subject, I had to be accurate in portraying the methods then in use to determine psychotic behavior and brain damage. I probably focused more on the psychological aspect than the drama.

I heard about a behavioral science research program at the Isaac
Ray Center of the Rush-Presbyterian St. Luke's Medical Center in
Chicago. The program was truly experimental and controversial.
Its founders were Dr. James Cavanaugh Jr. and Dr. Katie Busch,
forensic psychiatrists who had done studies of multiple personal-
ity disorder. They were treating six men, convicted of multiple
murder and sentenced to death, who were released from prison
and reintegrated into the community. These men became part of
an outpatient program at the Isaac Ray Center, where they were
studied and given drugs and therapy. I contacted Dr. Cavanaugh,
and he allowed me to visit the center and observe the program.
The murderers underwent positron emission tomography (PET)
scans, high-tech imaging that showed that the chemistry of their
brains was different from that of a "normal" brain in example af-
ter example. The patients had to appear at the Center only once a
week for a session with a therapist. The rest of the time they lived
on their own, unsupervised, and held jobs in Chicago, interacting
with people who knew nothing of their personal lives. One of the
men I observed was convicted of killing his mother in cold blood.
When I met him, he held a full-time job as a security guard at the
Field Museum. He began a relationship with a woman at work
and sought Dr. Cavanaugh's advice as to whether he should tell
her about his past. The doctor suggested he wait and see how the
relationship evolved.

I sat in on a Rorschach test Dr. Cavanaugh administered to
this man. I saw only demons and monsters in the Rorschach cards
while this convicted murderer saw butterflies and angels. Clearly
there was something wrong with *me*. Dr. Cavanaugh theorized
that his patients' belief in demons was as real as their repression of
childhood trauma.

The PET scans appeared to show that insanity could be identi-

400 · THE FRIEDKIN CONNECTION

fied. I put what I had observed into the film, which was finished in 1987. There is a courtroom sequence in which I had the prosecuting attorney turn on a stopwatch for two full minutes to help the jury imagine what it was like for one of the victims to die slowly in that period of time. The two minutes of silence seemed endless, with just the sound of the stopwatch ticking over shots of the jury, the relatives of the victims, the judge, both lawyers, and the murderer. The film contains some of the most visceral scenes I've ever filmed, and resembles the straight documentary style I used in my earliest films, but the atmosphere on the set was often depressing because of the subject matter. I didn't portray the murders graphically, but they were powerfully evoked.

The most enjoyable part of making the film was when I took it to Rome and showed it to Ennio Morricone, who agreed to write and conduct the music score. He had written scores for literally hundreds of films. I doubt even he knows how many. He's best known for the spaghetti westerns of Sergio Leone, and I wanted a similar high-energy track for *Rampage*, but Morricone wrote a more pensive score underlining the tragedy left in the wake of the murders. What he wrote is haunting, and I loved working with him. The film had no problem getting an R rating with no cuts.

The problem was with the De Laurentiis Company. They released the film in many parts of Europe, then went bankrupt. They reneged on money they owed me and others involved with the film and were unable to release it in the United States. The negative was tied up by the vendors to whom they owed money, the lab, the sound mixing studio, and others. Dino and his associates stopped answering my calls. There was no point in suing them; they had already declared bankruptcy. But for my long-standing relationship with the debtors, they would have come after *me* for their money, and that's exactly what De Laurentiis proposed—that *I* was legally

responsible for *his* debts. I never had a film implode so badly and go unreleased in the United States.

I tried to get Dino to let me take the film to another distributor, but my appeals and those of my agents went unanswered. There was nothing I could do, and Dino flew the coop. He wasn't around to feel the heat of my anger.

Five years later, in 1992, I met Harvey Weinstein. His company, Miramax, was in the first flush of success. They were acquiring, not producing, international films that slowly achieved prestige if not large grosses. Their big successes did not begin until the early 1990s. I liked and admired Harvey. He seemed like a decent man with a passionate love for films and filmmakers. He knew about *Rampage*, which by then was in limbo for five years. Harvey contacted the bankruptcy trustee, arranged to see the film, then enthusiastically agreed to distribute it. Negotiations took almost a year. He suggested we preview my cut, as the film was now five years old. As a result, I decided to make major changes to the version I finished in 1987. In the original cut, Reece commits suicide in his prison cell after being found sane. For the new version, I recorded a voice-over with Alex McArthur, indicating he was found insane and is alive, writing letters of apology to the families of the victims. An end title card reads that he will be reevaluated in six months and eligible for parole, putting the film firmly on the side of the death penalty. This version is more ironic and unsettling. It was meant to be a serious film about murder and justice, but it played like a polemic. It was *too* serious, nor was it what audiences expected from the director of *The Exorcist* and *The French Connection*. My research was frankly more interesting than the film.

I was fifty-five years old and hit bottom. I thought about what else I might do with my life. There have been successful filmmak-

402 · THE FRIEDKIN CONNECTION

ers of my generation, before and since, who didn't survive disasters like *Rampage*. They never directed another film. It was entirely possible the same fate awaited me.

My personal life was also a shambles. I had been unhappily married and divorced three times; I had two young sons I dearly loved, but professionally, I was the instrument of my own downfall.

Sherry

One morning in mid-March 1991, I was on the San Diego Freeway heading south to Hollywood Park, the racetrack. My car phone rang. Tita Cahn was calling to see if I would take her to an Oscar party. Her husband, Sammy, didn't want to go. I wanted to go to the track, but there was something plaintive in her voice, and for some reason—the mystery of fate—I turned the car around.

Richard Cohen was a wealthy investor with a beautiful home in Bel Air. When Tita and I arrived, standing in front of me was a tall, beautiful brunette with a welcoming smile. Frankly, the most beautiful woman I'd ever seen.

"Sherry, you know Billy Friedkin," Tita said.

"You're much too young and cute to be Billy Friedkin," the brunette said.

Tita continued, "Billy, this is Sherry Lansing." She wore a black Armani dress with one discreet piece of jewelry, an antique silver pin. In high heels she was as tall as me.

"You're much too young and beautiful to be Sherry Lansing," I stammered.

In that moment the course of my life changed. We watched the Oscars, but I don't remember who won. I do remember win-

ning the betting pool. And more than that. At the end of the evening Sherry and I exchanged phone numbers. I called her the next day at her office on the Paramount lot, where she and her producing partner, Stanley Jaffe, had their offices. I was going to Boston for a week to watch a couple of Celtics games and work out with the team. I asked her if we could have lunch or dinner when I returned.

Each night while I was in Boston I called Sherry, and we made plans to have lunch the following Saturday. On Friday I asked her if she had ever been to Muir Woods in northern California. She said it was one of her favorite places. "How about flying to San Francisco for a picnic lunch in the woods?" I asked her.

I picked her up at her small white frame house just off Benedict Canyon. We took a shuttle to San Francisco, rented a car, and drove north to Muir Woods, a five-hundred-acre grove of majestic coast redwoods towering hundreds of feet above fresh water streams and smooth trails. Sunlight streamed through the fog forming long shafts as we walked for miles and talked about our lives.

We both grew up in Chicago, she on the South Side, me on the North. She was nine years younger than me. She moved to Los Angeles in 1966, about when I did. It turns out we crossed paths many times over twenty-five years; we'd been in the same houses in different rooms, gone to the same screenings or sporting events with different people, but never met until that night in 1991. A year earlier I'd met with her partner, Stanley Jaffe, about a film project, and Sherry was in the next office but had no interest in meeting me, although she later told me that she saw *Sorcerer* in 1977, and it was one of her favorite films. I've always taken this with a grain of salt, but she swears it's true.

Her father, David Duhl, died at forty-two of a heart attack when she was nine, and her sister Judy three. Their mother, Margot Hei-

mann, was born in Mainz, Germany, and was evacuated as a teenager
when the Nazis came to power. When Margot left Germany she was
sent to live with her maternal uncle Max, a haberdasher in Chicago.
Her mother and father escaped shortly afterward, and when Margot
married David Duhl, they moved to a small apartment near the University of Chicago. Sherry still remembers sitting on her father's lap
while he listened to opera recordings. He loved *Madame Butterfly*,
and with tears streaming down his cheeks, he would whisper to her,
"Sherry, he's not coming back, Lieutenant Pinkerton's not coming
back," and Sherry would cry as well, not because she understood the
tragic story but because her father was in tears.

Margot was resourceful and self-reliant, and she raised Sherry
and her sister alone while managing her dead husband's real estate
business. The scars of persecution remained with her throughout
her life. She remarried a widower, a furniture manufacturer named
Norton Lansing who had a young son, Richard, and a daughter,
Andrea. As a teenager, Sherry went to the Lab School on the University of Chicago campus as a "gifted child." She met a fellow
student named Michael Brownstein, who was studying medicine,
then she went to Northwestern University, majoring in English
and Math, and she and Michael became engaged. When she was
twenty, they married and moved to Los Angeles, where Sherry
taught at some of the most dangerous schools in the inner city
while also working as a model.

She got small acting parts, but she and Michael saw little of
each other, and their marriage fell apart. After a role in the film
Loving, she worked for its producer, Ray Wagner, reading and analyzing scripts for $5 an hour. She no longer wanted to be an actress,
but she loved the movie business and earned a number of positions
difficult for a woman to achieve at that time: she was vice president
of creative affairs at MGM, then vice president of production at

Columbia Pictures. After moving to Twentieth Century-Fox, she became the first woman president of a major Hollywood studio. "Former Model Becomes Studio Head," read the headline in the *New York Times*.

Marvin Davis, a Denver oil man and investor, bought Fox and asked to meet the head of his studio. When Sherry arrived at his office, he was surprised to see a woman.

"I thought your name was *Jerry*," he explained. After a successful three-year run at Fox, during which she brought *The Verdict* and *Chariots of Fire* to the studio, she left to go into production with Stanley Jaffe, with whom she had worked on *Kramer vs. Kramer*. They produced *Taps*, which introduced Tom Cruise and Sean Penn; *Fatal Attraction*, nominated for six Academy Awards; and *The Accused*, which won an Academy Award for Jodie Foster. When I met her, she and Stanley were working on *School Ties*, a film about anti-Semitism at a New England college. The film introduced several young actors who later became stars: Brendan Fraser, Chris O'Donnell, Ben Affleck, and Matt Damon.

Many of our friends thought our relationship wouldn't work— she was one of the most sought-after women in Los Angeles, beautiful, elegant, and self-sufficient, while the arc of my career was on a downward curve—but after three months we decided to get married. We both wanted a private ceremony, just the two of us.

Weddings could be performed after a week's residence in Barbados, so we rented a house there at the end of Sandy Lane Beach. A minister performed weddings in Barbados in the garden of the Royal Pavilion Hotel, but Sherry wanted a Jewish ceremony. She found a synagogue listed in the phone book, and after she'd called for several days, a woman finally answered. Sherry explained our situation.

"The rabbi's not here," the woman said.

"When does he come back?" Sherry asked.

"In six months."

Sherry was upset. "Where is he?"

"He lives in Argentina," the woman explained. The synagogue dated back to the seventeenth century, but it was now only a landmark, with services performed every six months for the small Jewish congregation living on the island. Sherry was heartbroken. We went to observe a wedding at the Royal Pavilion. The minister was a native "Bajan," clothed in white robes, with a large gold crucifix around his neck.

Sherry asked if he could perform a Jewish wedding. He said yes, but she asked him to take the words "in the name of our Lord Jesus Christ" out of the ceremony.

"Remember," she told the minister. "You have to remove all references to Jesus." He promised he would, and his wife nodded in agreement. Two days later, we were married in our garden at sunset. Our only witnesses were a maid, a cook, and the minister's wife. The minister arrived in full regalia, and Sherry pointed to the crucifix around his neck, gesturing for him to put it away. His wife nodded and made sure he tucked it under his robes. The ceremony began:

"We are gathered here in the name of our Lord Jesus Christ." Sherry shot me a quick look. I shrugged. After the third time he used the phrase, she yelled, "Stop!"

"Honey, what's wrong?" I asked.

"Did you hear that? He used the J-word."

Sherry reminded the minister and his wife that he'd promised not to make reference to Jesus. The wife again nodded vehemently. With the minister's agreement, Sherry took his Bible and crossed out all references to Jesus! The ceremony continued, and we spoke our written vows to one another.

Later, she was in my arms as we watched the afterglow of the sunset and the first glimmer of stars.

"Darling," I whispered. "I have a confession to make."

She turned halfway toward me.

"I have to tell you, I believe in Jesus."

Now she turned full around to face me. "You what?" she snapped.

"I believe in Jesus Christ."

"You think he was a *god*!" she exclaimed.

"Sherry, for more than two thousand years people believe He's the *Son* of God."

"W-w-well," she stammered, "well, he wasn't a god!"

"What was He?" I asked somewhat facetiously.

"He was, he was . . . a nice guy!"

We've now been happily married for twenty-two years, and she's enriched my appreciation of life beyond measure.

Less than two years after our marriage, Stanley Jaffe was elevated to president of Paramount Communications and asked Sherry to become chairman of the Motion Picture Group. The following year the studio released her final film as a producer: *Indecent Proposal*, with Robert Redford. When Sherry told me the story, about a billionaire (Redford) who offers a struggling architect (Woody Harrelson) a million dollars for one night with his wife (Demi Moore), I urged her not to make the movie. I thought it was ridiculous to suggest that Redford would ever pay for sex. Of course it was an instant success, but a year later Sumner Redstone's Viacom Entertainment Group bought Paramount, and Jaffe was replaced by Jonathan Dolgen, formerly a top executive at Sony. Sherry and Jon became close friends, and they had an unprecedented succession of hits—*Forrest Gump*, *Braveheart*, and *Titanic*. All three won Best Picture Oscars. I remember the night Sherry brought home a

script that was in turnaround from every studio for nine years. She was crying as she read it.

"What's it called?" I asked.

"*Forrest Gump.*"

"Lousy title," I said, making my only contribution to this classic film. Sherry had an innate feel for public taste, developed over many years of producing and loving movies. She knew how to interpret a preview audience, a skill that can't be overestimated. I didn't have it, then or now. Even when my own films failed to resonate, I had no idea how to fix them. During Sherry's run at Paramount, 80 percent of its films were profitable. As she was becoming a legendary studio head, I was on a downward slide, but she never allowed my spirits to falter, always offering support, encouragement, and the deepest love I've ever known.

It was an uphill climb to the bottom. I used to collect newspapers and magazine articles and make notes of personal experiences, with the idea of one day developing films from stories that interested me. Eventually stuff piled up in closets, gathering dust. A lot of it is still in my closet, a constant reminder of failed ambitions and broken dreams.

I owned a sixteen-room apartment on Park Avenue, a house on Big Bear Lake, a condo in Snowmass, Colorado, and a home on Mulholland Drive in L.A. With little income, I could no longer afford these extravagances, so Sherry and I moved to a small house in Bel Air. I also owned a Turner watercolor and a Corot oil, which had to go.

Blue Chips

I had no prospects, so many in Hollywood raised their eyebrows when I was offered a film at Paramount: *Blue Chips*, with a script

by Ron Shelton—writer and director of *White Men Can't Jump* and *Bull Durham*, two successful sports films—who would also produce it. *Blue Chips* was about a college basketball coach who, after a losing season, allows a corrupt alumnus to "buy" the best college prospects around—a morality tale, funny, disturbing, and prophetic. As a basketball fan I loved it, and I felt I could make it plausible and exciting. Did Ron and his producing partner Michelle Rappaport bring it to Paramount thinking it had a better chance of getting made because of my relationship with Sherry? Perhaps, but Sherry and Stanley Jaffe, later Jon Dolgen, had an understanding that only Stanley or Jon would determine whether I could direct a film for the studio. The executives at Paramount loved the script, and thought that if Ron wasn't going to direct it, I would be a good second choice. Sherry recused herself.

One of the problems with sports films is that actors are rarely believable as athletes. I decided to cast some of the best recently graduated college players around and let them play actual games. I would stage only the climactic moments of these games.

Nick Nolte was our only choice to play the coach, Pete Bell. Ron based the character on one of the most successful but volatile coaches, Indiana University legend Bobby Knight. Shelton and I took the script to Nick and told him we'd camp on his lawn until he said yes. After a long courtship, he agreed.

Through Red Auerbach I met Bobby Knight, who invited Nolte and me to come to Bloomington, Indiana, and follow him through the 1992 season—during which his team won the Big Ten Championship—including practices and locker room strategy sessions. Bobby had an irrepressible temper. Nick assumed his persona in an almost mystical way. He and I understood Bobby's obsession, shared his inner turmoil, and knew that his anger was directed mainly at himself. Bobby would never do what Coach Bell

does in the film. He occasionally had bad seasons, but he was never tempted to run a dishonest program.

Shelton's script is about the corruption of amateur athletics and the steep price of victory. At the film's end, Nolte's team wins its first game of the season, but the coach is plagued with guilt and resigns after publicly confessing his transgressions.

At Bobby's suggestion we went to Frankfort in north-central Indiana, population about fifteen thousand, home of the Frankfort High School Hot Dogs, winner of four state championships.

Case Arena was only slightly smaller than a college court, seated fifty-five hundred people, and sold out every game. Frankfort was typical of the obsession with high school and college basketball in Indiana, and when we asked the mayor and the school board if we could stage our games there, we got a quick yes. We filled the gym just by bringing in great young players and top coaches and offering lottery prizes. We had fifty-five hundred rabid extras over three days. More than ten thousand tourists came to Frankfort the week we filmed there.

When Nolte came on board, a terrific cast of actors followed: Mary McDonnell, Ed O'Neill, Lou Gossett Jr., J. T. Walsh. The games were filmed in real time with six cameras. I would go from one camera position to another adjusting the setups. Knight and Pete Newell, considered one of the game's best strategists, taught Nolte the finer points of coaching. My friend Bob Cousy played the athletic director, and two recent All-Americans, Anfernee (Penny) Hardaway of Memphis State and Shaquille O'Neal of LSU, played two of the three young "blue chips." Matt Nover, a star at Indiana, was the third. Shaq of course went on to a celebrated pro career, winning four NBA championships. He's a warm, funny, gentle giant. Penny is introspective, shy, and focused. He practiced constantly, and when we brought him to Los

Angeles he had not yet been drafted by the pros, and was dirt poor.

The film was as much improvised as scripted. Nolte wrote a two-hundred-page novel about his character, which he asked me to read before we started shooting. That was his process, and he wanted his directors to share his "inner research." It was filled with details that Shelton would never have considered, but it helped Nick find the character within himself.

Nick was tough to work with. He was going through a difficult divorce–custody case after a ten-year marriage and was on edge most of the time. The year before, he was named *People* magazine's Sexiest Man Alive, and he did everything possible to shed this image, not combing his hair and wearing pajamas in public. I let him actually coach the games against Bobby Knight, and he told me it was the best experience he'd ever had of "living" a role, but he would often shrug off my suggestions, and we had angry confrontations every day. Even so, as I see his performance today, I find it original and powerful.

With some actors you have to be gentle, with others firm; the last thing you want to do is try to "show" an actor *how* to play a scene. Metaphor works best. The great musical conductor Carlos Kleiber, when rehearsing a passage with the Munich Opera Orchestra, told the string section to play a passage as if they were "serenading a beautiful woman." He "described" the woman, and told the string players they should try to court her with their music. When they played the passage again, it was far more emotional and intense.

A fond memory I have of *Blue Chips* is filming scenes with Nolte and Larry Bird in French Lick in southern Indiana, a town of about fifteen hundred people in a four-square-mile area. It was Bird's hometown, and we drove in along Larry Bird Boulevard past

the Larry Bird auto dealership to Larry Bird's home in West Baden, just outside French Lick. Being on a first-name basis with one of the best players in the game and casting him in a film was the wish fulfillment of a lifelong basketball fan.

The film was well received but weak at the box office. It's hard to capture in a sports film the excitement of a real game, with its own unpredictable dramatic structure and suspense. I couldn't overcome that. *Blue Chips* had solid performances but didn't resonate with audiences.

Jade

No one was pounding on my door to direct another film, but the producer Bob Evans, head of Paramount in the 1970s, responsible for the *Godfather* films, *Love Story*, and *Chinatown*, came to me with an interesting idea that Paramount wanted to develop. The script was to be written by Joe Eszterhas, who had *Basic Instinct*, *The Jagged Edge*, and *Flashdance* to his credit. He was then the highest-paid screenwriter in Hollywood, and he as well as Evans and Craig Baumgarten, the coproducers, all wanted me to direct it.

Sex and violence were Eszterhas's specialties, and he had pushed the envelope with *Basic Instinct*. A tall, heavyset man with a large mane of hair and a beard, and the fearsome countenance of a lion—that was Joe Eszterhas.

The film was called *Jade*. Set in San Francisco, it's about a powerful lawyer, his psychologist wife, and a young assistant district attorney who went to college together and remained friends. The DA is still in love with the lawyer's wife. She leads a secret life in the sex trade, and becomes a suspect in the murder of a wealthy San Francisco businessman. The assistant DA is torn as suspicion

falls on the woman he still loves, the wife of his best friend. It was complex, erotic, and suspenseful, a combination at which Eszterhas excelled.

We cast Linda Fiorentino as Jade. She was hot off the surprising success of a low-budget film called *The Last Seduction*, in which she showed the talent and sex appeal of the legendary actresses of the 1940s and '50s—Ann Sheridan, Joan Crawford, Lauren Bacall.

David Caruso was the charismatic lead in the hit television series *NYPD Blue*. Irish and Sicilian, he had bright red hair, youthful good looks, and a deep voice. When he left the series to pursue a career in films, it was viewed as a kind of irredeemable cardinal sin by the entertainment press. *TV Guide* listed it as number six on the ten biggest blunders in television history. We cast him as David Corelli, the district attorney. Chazz Palminteri was our choice to play the criminal lawyer Matt Gavin. Chazz wrote and starred in his own autobiographical play and film, *A Bronx Tale*. The year before *Jade*, he was nominated for an Academy Award for *Bullets over Broadway* and had a key role in a much-praised film, *The Usual Suspects*.

A terrific cast. A wonderful script. Great locations. How could it miss?

The best chase scene I've ever directed and the most difficult to realize is the one in *Jade*. It begins with a black sedan stalking a woman in broad daylight, then running her down on a busy thoroughfare, before it turns into a slow and deliberate chase of inches, two cars crawling through a crowded Chinese New Year's parade, with hundreds of people in harm's way. Finally it breaks into high speed on the O'Doul Bridge and ends with Caruso's car being dumped into the San Francisco Bay.

Some of my films have been dismissed, others overpraised. But *Jade*, a critical and financial disaster, contained some of my best

work. I felt I had let down the actors, the studio, and most of all, Sherry. I went into a deep funk. Was it the *Exorcist* curse, as many have suggested, a poor choice of material, or simply that whatever talent I had was ephemeral? Maybe all of the above.

12 Angry Men

At around this time the O. J. Simpson murder trial was being broadcast live across the country and was a constant topic of gossip, rumor, and disbelief. I knew O. J. and didn't believe he could have committed two murders until I heard the evidence, but after months of trial, a jury verdict acquitted him. Reasonable doubt? He seemed to have motive, opportunity, and no credible alibi. The verdict split the country along racial lines. I remembered the film *12 Angry Men* and watched it again, fascinated how each of the jurors held fast to their own prejudices until a set of contrary facts began to prevail. I hadn't seen the film for many years, and I was struck not only by its timelessness but by the brilliance of Reginald Rose's screenplay. Why was I not making films like this?

I met with executives of the Showtime cable network to see if they'd be interested in a new version for television. Reginald Rose originally wrote *12 Angry Men* as a one-hour "live" drama in 1954 for the Studio One Anthology series. It was expanded and filmed brilliantly in 1957 by Sidney Lumet, with a cast that included Henry Fonda and Lee J. Cobb. It became an immediate classic, though it closed in first-run theaters after a week.

The entire action takes place in a jury deliberation room after the jury is handed a murder case involving a Hispanic teenager accused of killing his father. At the outset eleven of the jurors are convinced of the boy's guilt. Juror number eight is the only hold-

out. He's not certain of guilt or innocence but implores his fellow jurors to carefully examine the evidence before deciding the boy's fate.

Showtime was interested—if I could put togther a cast they'd approve. I called Reginald Rose, and he was enthusiastic. At the time he was seventy-seven years old, retired, and living in Norwalk, Connecticut. One of the best writers of the 1950s, the golden age of live TV, he moved to series long-form, where he created and wrote *The Defenders*. Like his contemporary Paddy Chayefsky, he excelled at writing realistic dramas about important social issues. *Twelve Angry Men* is his masterpiece, and is still performed "live" around the world. The story unfolds in real time, and the deliberations gradually reveal each character's prejudices.

I told Rose I wanted to cast several African American actors, which was not done in the original versions, and I asked him for a few dialogue changes to bring the script up to date. Casting director Mary Jo Slater assembled the finest cast I'd ever worked with— Jack Lemmon, George C. Scott, Ossie Davis, Hume Cronyn, Armin Mueller-Stahl, Tony Danza, Edward James Olmos, Courtney B. Vance, Dorian Harewood, Mykelti Williamson, Billy Petersen (before *CSI*), and James Gandolfini (before *The Sopranos*).

The budget was $1.75 million, low by any standards, especially with that cast. I rehearsed for eight days and filmed for twelve. I had the "jurors" move around the room as much as possible to hold visual interest and my work with the actors was largely a matter of pace and tone. Two cameras were handheld, and I encouraged the cameramen to freelance and find their own shots to give the film a documentary feel. I shot in sequence from the jurors' entrance until they leave the room.

One morning I came in two hours early to work out the blocking of a complicated scene. I heard a lone voice reciting lines:

James Gandolfini. He was to film a scene that day with Lemmon. I watched him for a while and saw that he was trembling.

"What's wrong, Jim?"

He turned to me abruptly.

"I'm nervous," he said.

"Why?"

"You think I'm doin' okay?" he asked.

"You're doing fine."

He walked around staring at the floor, then, "I can't believe I'm in a scene with Jack Lemmon." I put my arm on his shoulder and said, "Jim, one day people will be saying that about you."

"Yeah," he said ironically.

I didn't know if that was true or not. Two years later, *The Sopranos* appeared on HBO, ran for six seasons, and Gandolfini's portrayal of Tony Soprano became one of the most celebrated in the history of television.

Twelve Angry Men was a success, showered with critical praise and awards. I had regained some respect and self-confidence, but the zeitgeist was again changing around me. I had to expand my horizons. That opportunity would come from an unexpected source.

A NEW PATH

For a long time Sherry and I have known the renowned music conductor Zubin Mehta and his wife, Nancy. Whenever Zubin and I are together, we talk about music, but he loves films as well. One night at dinner at the Mehtas' home in Brentwood, Zubin suddenly asked: "Why don't you do an opera with me?" I didn't know how to respond; the idea had never occurred to me.

I said, "Jeez, Zubin, I've never *seen* an opera."

"But we've spoken many times about opera," he said.

"I've listened to recordings, but I've never seen one staged."

Sherry, as always, positive, said, "Oh, go ahead, I think it'll be fun."

Zubin pressed on. "I think you'd be a terrific opera director. What would you do if you had the chance?" What I didn't know about opera would fill the Rose Bowl.

To put him off, I said, "What about either of the two Alban Berg operas?"

Berg wrote *only* two operas, *Wozzeck* and *Lulu*. Both are considered masterpieces of the twentieth century—but the operative word is *twentieth*. The greatest period for opera composition was between the time of Handel in the eighteenth century up to about 1920 and the operas of Richard Strauss, which pointed the way to modernism. *Wozzeck* and *Lulu* break totally with the tradition

of classical opera in that they are atonal, in the twelve-tone system invented by Berg, Anton Webern, and their teacher, Arnold Schoenberg. Their works are still difficult for audiences who prefer Puccini, Verdi, Mozart, and Tchaikovsky.

Zubin left the room and came back moments later with his datebook. It was about four inches thick and had his bookings for the next seven years. He began to leaf through it. Finally he stopped at a page and declared, "Okay, I'll do *Wozzeck* with you in two years at the Maggio Musicale in Florence if you commit to it now." This was in 1996.

Not a lot of American film directors have staged operas. The only one *I* knew personally who worked successfully in both media was the late Herbert Ross. Herb directed a production of Puccini's *La Bohème* for the Los Angeles Opera, which I later saw. It was beautifully staged and is still in their repertoire. Sherry and I visited Herb and his wife Lee Radziwill at their home on Long Island.

"I've been asked to direct an opera," I told him.

"Oh, really, which one?"

"*Wozzeck*," I replied quietly.

"*Wozzeck*!" he bellowed. "Well, that's a tough one."

"Herb, I need your advice. I don't know a thing about opera. I've never seen one. How do you go about it?"

"How do you go about it?" He laughed incredulously. "How do you go about *what*?"

"I mean, how do you rehearse? What do you say to the singers when they come into the room?"

He waved the question off.

"Oh, it'll come to you," he said with condescension.

It was good advice. My questions were those of a dilettante. But his advice, though given frivolously, was good. It *will* "come

to you" if you are willing to study it and immerse yourself in its complexities.

For the first year I did nothing except read the play by Georg Büchner upon which the opera was based. And I listened to a recording conducted by Pierre Boulez.

Almost a year later I got a call from Zubin. "How's our *Wozzeck* coming?"

I had done nothing, but he continued, "Have you chosen a designer yet?"

I hadn't. "We need to have a set plan so the opera company will know how to budget," Zubin insisted.

Only then did I take it seriously. I read everything I could about Alban Berg and the origins of *Wozzeck*, and since the libretto was in German, I took German lessons four days a week from a private tutor at UCLA. Among my readings were articles by the composer and musicologist George Perle. Mr. Perle lived in New York, so I called and asked if I might talk to him about Berg and *Wozzeck*. He agreed, and we had three days of conversations at his New York apartment. I became aware of how influential Berg's discordant and disturbing composition had been for modern music.

Wozzeck was based on an actual murder case in Leipzig in the early 1820s. Johann Christian Woyzeck, a soldier and a barber, was accused of murdering his mistress. It was the first time an insanity defense was offered, but it was rejected by the Royal Court of Saxony, and Woyzeck was executed in 1824. The insanity defense was a daring concept in the early nineteenth century. Some dozen years later a young German doctor of philosophy and would-be dramatist, Karl Georg Büchner, began to set down the events of the Woyzeck case as a play, but he died of typhus in 1837 at the age of twenty-three, leaving the play unfinished. *Wozzeck* was not

420 · THE FRIEDKIN CONNECTION

edited for publication until 1879, forty-two years after Büchner's death. The play wasn't performed until 1913 in Munich, and six months later a young composer who had just been inducted into the Austrian Army, Alban Berg, saw it in Vienna. Berg became obsessed by the play, and during his military service he suffered a physical breakdown that deepened his identification with Büchner's title character.

After World War I, Berg began work on the music. He used Büchner's play as the libretto and finished the opera in 1922. The cost of printing the score was borne by Gustav Mahler's wife, Alma, to whom it is dedicated. The first performance was not until 1925 in Berlin, where it was immediately recognized as a masterpiece.

It's easy for me to say I suggested *Wozzeck* to Zubin "to put him off," but there was something more, something deeper that instinctively drew me to it, not just the challenge of directing an opera.

Wozzeck deals with a hapless soldier who is brutalized, humiliated, and crushed on the wheels of society. He's slightly retarded, both victim and criminal. He seems born to a tragic fate, but he has the ability to love—he loves Marie, the woman he lives with, though he is unable to satisfy her. To supplement his income, he is paid to endure harmful experiments by an army doctor. He is tortured mentally by his captain and physically by the drum major. The final insult is his discovery of Marie's affair with the drum major, which leads to her murder and Wozzeck's suicide. At the end of the drama his little boy is left alone, taunted by his playmates, another Wozzeck in the making. The underlying philosophy of Büchner's play is that there is no free will; our destiny is predetermined, all action is futile, and we are only here to be destroyed. The opera is a descent into the abyss. It was a perfect fit for my own obsessions.

My research gave me the inspiration to devise a staging plan. *Wozzeck* had to be presented simply, devoid of sentimentality but with a deep feeling for its emotional undercurrent. It had to be intimate. *Wozzeck* has none of the grandiose scenes one finds in *Aïda* or *Tosca*; it's a character piece that takes place to some extent in the mind of its central character.

The first problem was how to achieve intimacy. In film you have camera lenses that bring you closer or take you farther away from the action. How do you affect a close-up on a large stage where no angle changes are possible? It's done with lighting and in the way performers are positioned.

I'm often asked the difference between directing for opera and film. The great singers today want the same things good actors seek: a psychological underpinning for their characters and a staging that works. The ideal opera staging allows the singers to move freely and interact with one another, as in a play. Few singers want to come out and just "park and bark."

On a film the director is the final arbiter; it's his or her vision. A screenplay can be changed as the actors make the words their own. Pages are revised or cut from a script, and the story is often altered in the cutting room. Operas that have lived for centuries and continue to fill theaters across the world can be newly conceived but not revised.

The pecking order in opera is first the composer, then the conductor, then the singers, and finally the stage director and the designers. The operas I've directed have been chosen and cast by the theater managers and the music director years in advance because of the limited availability of the top singers. I've been exceptionally fortunate in the casts that were chosen for me.

As I immerse myself in the theme and structure of a work, ideas take shape from the sense memories the music calls forth. While

preparing *Wozzeck*, I was watching H.-G. Clouzot's *Le Mystère Picasso*, a documentary about Picasso at work. Picasso and Clouzot are having a conversation during which Picasso tells Clouzot that the screen is not wide enough to encompass his vision. Until then the film was being projected in the standard ratio of 1.85 to 1; at Clouzot's command, the screen is expanded to cinemascope, and Picasso continues drawing on a wider "canvas." I thought, Why not use this kind of dynamic framing on the stage? Why not expand or contract the "size" of the stage as befits the scene?

Wozzeck consists of fifteen scenes, five each in three acts. I decided to frame the stage picture in various shapes to best convey the image. Masking pieces would come from above and from the sides to form either a rectangle or a square or to make the scene wider or more intimate. For example, for a low-ceilinged, smoke-filled tavern scene, only the lower half of the stage was visible, while the upper half was masked out.

I used the entire stage for the scene where Marie is seduced by the drum major outside her little house. I underlit the tavern space so that various sexual activities, gay and straight, could be suggested around the corners and edges of the room, until the patrons notice that Wozzeck's hands and clothes are bloodstained after he's killed Marie in the forest. As the patrons see the bloodstains, the walls begin to close in on him and Wozzeck has to hold them back with both arms, until finally he pushes them away to reveal—the woods, full stage, as he returns to find Marie's body and search for his razor to destroy the evidence. He wanders into a pool of water near a large rock and drowns.

In the finale of Act 3 the only scenic piece is a railroad track (possibly to Auschwitz) disappearing into the distance on a bare stage. A group of children are playing around the tracks with Marie's little boy, now an orphan. The children mock him and run

off as he hops around, using a broomstick for a hobby horse. A little girl and the boy are the only ones left. Then the girl runs off, releasing a white balloon into the air, which represents the soul of Marie. Now the boy is alone. He hip-hops on his broomstick, going upstage; then I had him stop, turn to the audience, and put the broomstick on his shoulder, like a soldier's rifle. Slowly the ambient lights fade, leaving only a spotlight on him that irises down, like the end of a silent film, followed by the curtain. This is the most satisfying moment I've directed, in film or on the stage.

When the curtain fell, there was a long silence, then the loudest roar I've heard in a theater. The audience was on its feet, and I was led from my box seat to the stage, where I joined Zubin and the cast. They were drenched with sweat but smiling with joy as they welcomed me to their company and we took bows. The shouts and screams continued as I was called on to take a solo bow. Zubin whispered to me, "If this was Vienna, we'd be up here for an hour." It meant so much that this man who I so deeply respected felt that our mutual effort would have been even more successful in its country of origin. The critical reaction was as enthusiastic as the audience's, not a common occurrence in opera, especially for a German opera in Italy.

Directing an opera in Florence, a center of world culture, gave me a feeling of renewal. We rehearsed six days a week for four weeks, but I was never exhausted. On my days off, Sherry and I would walk to every quarter of the city, discovering Florentine culture. We rented an apartment in the Oltramo section, south of the river. I walked to rehearsal each morning along the Longarno, stopped at an outdoor café for coffee and a croissant, then I'd go into a centuries-old church and drop a coin in a slot to turn on a dim light that barely illuminated a Ghirlandaio or a Bellini. The magnificent monuments to Christianity and the architectural vi-

sions of the Medici were everywhere, and we experienced them not as tourists but as adopted Florentines.

The rehearsals were also a voyage of discovery. Singers who work regularly at the world's preeminent opera houses must have not only a God-given talent, but study and practice constantly, speak several languages, and become fluent in a wide repertoire, in addition to being able to act while singing. To succeed in opera is more difficult than in the movies, where stardom is often based solely on a personality that resonates with the public.

As a result of the success of *Wozzeck*, I've directed many other operas—in Los Angeles; in Washington, D.C., at the Kennedy Center; in Turin, Munich, Tel Aviv, Vienna, and Florence again. I've directed works by Bartók, Puccini, Verdi, Saint-Saëns, Offenbach, and Richard Strauss.

Each of these experiences has given me the opportunity to immerse myself in different cultures while working within them.

AFTERLIFE

For more than twenty-five years Bill Blatty and I argued over the scenes I cut from *The Exorcist*. These conversations became acrimonious to the point that we didn't talk to each other for years at a time, but finally our differences became less emotional, and we could laugh at them. But I resisted any notion of reexamining or recutting the film.

In 1999 Blatty told me he talked to Dan Fellman, head of distribution for Warner Bros., who agreed to rerelease *The Exorcist* in first-run theaters, with an advertising campaign and TV spots, *if* I would restore the footage cut from the 1973 release. This got my attention, but I didn't know if any of the previously unused negative could be located. Bill called Ned Price, head of postproduction and technical operations for Warner Home Video, and apparently they had all the negative intact and in good condition.

"Will you just look at it with me, Bill?" Blatty pleaded. "That's all I'm asking."

Something in his voice moved me, so I reluctantly agreed. The film was one of the most successful of all time, regarded as a classic despite hundreds of rip-offs. Why change it now? I told Bill I was reminded of a story about the Post-Impressionist painter Pierre Bonnard, who went into the Musée d'Orsay, where one of his paintings was on display. He proceeded to open a small bag that

contained a palette, paints, and brushes and began to paint over the canvas. He was seized by guards and taken to a security room.

"But I'm Bonnard," he said; "the painting is mine, and I'm fixing it."

"The painting is finished, M. Bonnard, it's in the Musée d'Orsay!"

That's how I felt about *The Exorcist.*

Ned Price, a staff editor, Blatty, and I gathered in an old editing bay on the Warner Bros. lot that hadn't been remodeled since the studio's founding in 1928. Blatty and I hadn't seen each other for many years, though we'd occasionally speak on the phone after he moved to the East Coast. He was heavier, grayer, slightly stooped, and moved a little slower. We hugged, and I was reminded that but for him I would not have made the film for which I'll probably be remembered.

The editor turned off the lights, and we reviewed the scenes I had cut. There was an early visit by Chris to Dr. Klein's office just after his first examination of Regan. Regan still appears normal, but there's an uncomfortable undercurrent to the scene.

There was a light moment between Father Merrin and Chris just before the exorcism, where she offers and he accepts a drink.

There was a scene on the stairs of the MacNeil house between Merrin and Karras during an interlude in the exorcism, in which Merrin offers the meaning of Regan's possession to Karras: "I think the point is to make us despair, to see ourselves as animal and ugly, to reject the possibility that God could ever love us." Blatty always felt that this was the moral center of the film that would allow the audience not to despise itself for enjoying the horrific scenes that preceded it. He thought that despite efforts we made to show that the demon did not take Karras out the window but that Karras

did it himself as an act of love to save the girl, many in the audience thought it was the devil's work and that the film ended on a downbeat note.

We originally filmed an epilogue between Father Dyer and the detective, Lt. Kinderman. The scene is light and hopeful. Kinderman offers to take Dyer to lunch. The idea was that in their light banter, Karras's spirit lives on and his sacrifice will be remembered.

In 1973 I felt that all these ideas were implicit and that the story needed no underlining. If people wanted to believe that the demon took Karras instead of Regan, they should be free to do so.

We also recovered a shot that had become iconic for *not* having been included, the Spider Walk, wherein Regan walks backward down a flight of stairs on her hands and feet, ending in a close-up with blood streaming down her face, upside down. A contortionist named Linda Hager performed this stunt, and the only reason I didn't use it in the original version was that we were unable to conceal the thin wires that supported her.

After we reviewed about twelve minutes of material, I sat silently for a moment. The lights came on, and I remember thinking, Well, this stuff isn't bad, I don't think it can *hurt* the film or its reputation. I turned to Bill and said, "I think you're right." His face lit up. As we walked out of the cutting room, I put my arm around him and said, "You know, I finally get what you were trying to say."

Along with Bud Smith, one of the film's original editors, we began to integrate the new footage. I added a few other images, including, at the very beginning, a shot of the MacNeil house showing Regan's window as the light goes off, followed by a dissolve to the alabaster statue of the Virgin that was later desecrated. I added more subliminals of the demon face, and with the use of CGI (computer generated imagery), which didn't exist when we

made the film, we "removed" the wires on the Spider Walk. We remixed the sound track, adding more subliminal sounds to the state-of-the-art, 5.1 Dolby stereo. We then sonically cleaned the entire negative, removing all scratches and dirt. When we'd finished, it looked and sounded like a new film.

On a balmy Los Angeles evening in September of 2000, Blatty and I sat at a window table in a Starbucks next to the historic Fox Bruin Theatre in the heart of Westwood, California. People were lined up around the block, waiting to get into the theater. There was a buzz in the crowd of largely young people, many of them the sons and daughters of those who'd lined up at the now-demolished National Theatre a few blocks away in December 1973. We clinked our coffee cups, laughed, and toasted one another. The enthusiasm and acclaim continued in theaters around the world.

Less than a year later, in May 2001, torn between addictions, Jason Miller died of a heart attack in Scranton, Pennsylvania. I wonder if he'd have worked harder as a playwright and had a happier life if I hadn't picked him from a photograph in a newspaper and led him to the temptations of Hollywood. He'd achieved success with one play, but nothing afterward. A sense of guilt came over me at the announcement of his death. Though my discovery of him brought him an Academy Award nomination and instant recognition as an actor, it led to an unfulfilled life.

THE MARINE CORPS
AND THE TRACKER

Scott Rudin is a smart, prolific producer of films and plays. He's also stubborn and abrasive, qualities I share. Often his failures are as interesting as his successes. He was under contract to Paramount when he brought in an original script he had developed for years with Jim Webb, then a novelist and military lawyer who was a Marine Corps first lieutenant and rifle platoon commander in Vietnam. Wounded in combat, Webb came out with a Navy Cross, a Silver Star, a Bronze Star, and two Purple Hearts. By coincidence, he was a student at Georgetown Law School when I was directing *The Exorcist* on campus.

In 1987 President Reagan appointed Webb Secretary of the Navy, but he resigned less than a year later over a disagreement with the President about the Navy's overall size. Jim is complex, principled, and courageous. At times he can be argumentative and mean-spirited, but in fairness, he describes *me* as the only man in the country with a temper worse than his. An American soldier has no better friend than Jim Webb. He was an outspoken opponent of the Vietnam War memorial designed by Maya Lin, calling it "The Black Ditch of Shame," and campaigned successfully for another statue nearby, a depiction of three battled-scarred veterans.

430 · THE FRIEDKIN CONNECTION

Webb's screenplay, *Rules of Engagement*, was about loyalty and the moral ambiguity of warfare. A fictional account of Jim's own experiences, it tells of the clash between American relations in the Persian Gulf and military justice for one man. The rules of engagement are flexible guidelines devised by the U.S. military to minimize excessive violence in combat. But combat *is* excessive violence, soldiers are sent into battle to kill people and blow things up. Webb's script asks the question, "What constitutes murder in a military action?"

The film begins in Vietnam. A Vietcong unit ambushes a marine platoon led by Lieutenant Hays Hodges. To rescue his friend, Lieutenant Terry Childers and *his* platoon capture another Vietcong unit and force its commanding officer to stop the attack on Hodges's platoon, saving their lives. Thirty years later, Childers, now a colonel, is commanding a marine expeditionary unit to rescue the American Ambassador in Yemen and his family from a dangerous protest outside the embassy. Marines are killed and wounded, and Childers orders his men to open fire on a crowd of civilians gathered around the embassy. The question of the film is whether Childers ordered his marines to fire on an innocent Yemeni crowd, or did the crowd have weapons and fire first? He's charged with murder and asks his friend Hodges, now a military lawyer, to defend him. The deck is stacked against Childers, and the national security adviser would rather have him take full blame than that the incident be viewed as a failed policy of the United States.

It was left to Webb and me to polish the script, which meant clarifying story points, but we couldn't agree on how to accomplish this. We were two equally strong-willed people, unwilling to compromise. In the end, Rudin handed the project off to my friend and benefactor Dick Zanuck, who had become a successful producer

after leaving the executive suite; he coproduced *Jaws*, *The Sting*, and *Driving Miss Daisy*, winning Academy Awards and big box office returns. We turned the script over to a young writer, Steve Gaghan, and worked with him for three months to make it more penetrating and unpredictable. Tommy Lee Jones signed to play Hodges and Samuel L. Jackson to play Childers. Ben Kingsley was cast as the American Ambassador; Anne Archer as his wife; Guy Pearce as the prosecutor; Bruce Greenwood as the national security adviser; and the Moroccan actor I so admired and worked with on *Sorcerer*, Amidou, was cast as a Yemeni doctor.

Dale Dye was our technical adviser for the combat scenes. Dale, who served in the military for twenty years, owned a company called Warriors Incorporated, made up of former combat vets who trained actors to play soldiers. He did the same for *Saving Private Ryan* and *Platoon*. He started by taking Tommy Lee and Sam along with his vets to bivouac in the woods, day and night, for two weeks. When they came out, they had an understanding of the anxieties and fears, the heat and exhaustion, felt by combat soldiers.

Gaghan's script was an improvement on Webb's, but Jim hated it and tried to frustrate our ability to get cooperation from the Department of Defense. As a former Secretary of the Navy, he had clout and connections. Permits we received were canceled at the last minute, and only through the efforts of Jack Valenti did we get as much cooperation as we did. Jack intervened with Phil Strub, the Pentagon's film liaison, who granted us limited permission to film aboard the USS *Tarawa*, an amphibious assault ship on maneuvers near the naval base in San Diego. The *Tarawa* would later be stationed in Yemen, providing logistical support after the USS *Cole* was attacked by al-Qaeda in Sana'a.

In the film the ship is called the USS *Wake Island* and is stationed in the Indian Ocean, when a report of the attack on the

embassy in Yemen comes in. We were able to bring Sam Jackson on board, leading a troop of marines to be dispatched on CH-46 twin engine Huey helicopters to rescue the Ambassador and his family. We had one day to film aboard the ship, but the captain and his crew were cooperative and we got everything we wanted. Strub denied us everything else, and filming became a costly logistical battle. Again because of Webb's determination to sabotage the film, we were denied permission to film at Camp Lejeune, the Marine Corps base in North Carolina. We had to rent an abandoned Signal Corps facility near Manassas, Virginia, and hire off-duty Marines as extras.

We of course got no assistance from the government of Yemen to film there, but with the help of Amidou, a Moroccan citizen, we were allowed to film in Ouarzazate in southern Morocco, on a plateau of the Atlas Mountains surrounded by the Sahara Desert. With the approval of King Mohammed VI, we were given full cooperation. Bob Laing, our production designer, who worked as an assistant on *Sorcerer*, hired a Moroccan crew to paint sections of the old Kasbah to more closely resemble Sana'a in Yemen, and the people of Ouarzazate already wore the clothing of the Yemeni. The Moroccan Air Force lent us three Chinook CH-47 helicopters, a slightly different model than the ones we used on the USS *Tarawa*, but Laing had them painted to resemble the steel gray CH-46s.

The raid on the U.S. Embassy set in the Kasbah was the most difficult sequence I've ever filmed, and the most realistic. It looks like news footage while capturing the emotions of the Marines and the demonstrators. The weather was hot and dry, and many of the crew got food poisoning and were wiped out for long periods. It took three weeks to shoot this fifteen-minute sequence and one other in Morocco, where Hodges goes back to Yemen to determine

the truth about the charges against Childers. It was Dick Zanuck's daily encouragement and advice that made me appreciate again the value of a good producer.

We returned to Los Angeles to film the court-martial sequence on the Paramount lot. Tommy Lee and Sam were intuitive actors, and we never had to discuss character motivation. Directing was a matter of showing them where I wanted them to be in the frame. Occasionally I'd ask for a little more or a little less emotion or to play it faster or slower, louder or softer.

The film was a box office hit, but many critics saw it as jingoism, especially in Europe, where my films were generally well received. In the film's first few weeks of release, protests were lodged. The American-Arab Anti-Discrimination Committee (ADC) described *Rules of Engagement* as "probably the most racist film against Arabs ever." It was also denounced by one William Rugh, former American Ambassador to Yemen. The most widespread complaints came from Yemen's ambassador to Washington, D.C., Abdulwahab Abdulla al-Hajri. He called the film a complete distortion and a slander against his people: "All of a sudden Yemenis, even women and children, have become terrorists and want to kill Americans," he said. "It's a total ruin for us. It ruins our image."

In Webb's original draft he set the story in a fictitious Middle East country. When I asked him where such a scenario was most likely to occur, his instant response was Yemen.

In several big cities around the United States, demonstrations were organized outside theaters where the film was playing. I was concerned for a number of reasons. I believed our scenario was plausible, but I had misgivings about bringing shame or hardship to one of the poorest countries in the world. So I called the Yemen Embassy and asked for Ambassador al-Hajri. I told him I was the

guy who defamed his country and I wanted to meet him, apologize, and explain my position. He invited me to the Yemen embassy in Washington, D.C., the following week. His Excellency, the brother-in-law of Yemen's then-President Ali Abdullah Saleh, was educated in Cairo and Washington, D.C. He was his country's top representative in the United States for three years.

I apologized for the discomfort to the people of Yemen, and he permitted me to show him my research, proving that Yemen *was* harboring terrorists. The Ambassador studied the articles carefully, then set them aside. "Mr. Friedkin," he said quietly, "you made a powerful film. I'm just sorry you chose Yemen as the setting. It will do irreparable harm to our tourism." He invited me to Yemen as his guest and told me I could film anything I wanted there without restraint. Various dates were scheduled, then broken, because of the worsening situation in his country that led to the 2012 overthrow of President Saleh.

Not everyone found the film offensive. Many soldiers, prominent military men, and even the National Security Adviser, Sandy Berger, told me how powerful and realistic they thought it was. Colonel David Hackworth, the most decorated officer to come out of Korea *and* Vietnam, wrote several columns praising the film. "Hack" called his cousin Jim Webb and told him that the film was terrific, and he should at least see it. A few days later Jim called to tell me he was proud of the film, with one caveat, the scene where Childers shoots a captured Vietnamese soldier in the head. We were friends again, and in 2006, when Jim was elected to the U.S. Senate from Virginia by a narrow margin, Sherry and I were invited to his swearing-in and a very small after-party, attended mostly by Marines he had served with. At the end of his brief remarks, he said: "Anyone can become a U.S. Senator, but not everyone can be a Marine."

* * *

The Hunted was based on the exploits of Tom Brown Jr., a wilderness tracker and survivalist. Though never having served in the military nor killed anyone himself, he claims to have trained the Delta Force, the Navy Seals, and the Special Ops to track, kill, and return to safety. He told me he was shown long-distance aerial photos of Iraq and was able to determine what roads were being used for heavy transport and missile installations, simply by viewing their tracks.

He also said he could come into a room and, by examining a rug, determine how many people had been there in the previous few hours and what emotions they might have experienced, just by examining pressure points left by their footprints. He claims he learned his skills at the age of seven from an Apache shaman named Stalking Wolf, whom he called "Grandfather"; it's the spiritual and mythological claims he makes that most disturb his critics.

His exploits were open to question, but I thought he was a fascinating guy. I went to work on a script with a promising young writer, Art Monterastelli, who had written only for television. The story tells of a former special ops instructor, L. T. Bonham (Tommy Lee Jones), called in by the FBI to apprehend his gifted student, Aaron Hallam (Benicio Del Toro). Bonham had trained Hallam to be an assassin. The film was structured as a cat-and-mouse chase with the cat and the mouse constantly changing places. I shaped it as a modern riff on the Biblical story of Abraham and Isaac, wherein Abraham is ordered by God to sacrifice his own son as a test of his faith.

Tommy Lee and I developed a trust that enabled us to work quickly and efficiently. He was always "ready" and in character, though he was skeptical of Tom Brown Jr. and distanced himself

from him. Benicio Del Toro, then thirty-six years old, had won all the major critical awards and an Academy Award as Best Supporting Actor for his role in *Traffic*. His process was different from Tommy Lee's, and their scenes were a contrast in styles. Benicio worked on the "inner life" and back story of his character and would immerse himself in what he felt was Hallam's state of mind. Tommy Lee *was* Bonham.

We filmed in Portland, Oregon; Mount Hood; and in many parts of the Pacific Northwest wilderness. The sequence that introduces Hallam was filmed on a vacant industrial lot in Portland. We recreated the burning of Kosovo during the Bosnian-Serbian War, where in addition to the horrors of ethnic cleansing there were also NATO air strikes. Hallam is sent on an off-the-books mission to kill a Serbian commander who has murdered Albanian citizens. He's awarded a Silver Star but is tormented by nightmares of the violence he has seen and performed. When Hallam returns home and commits other savage killings, Bonham is sought by the FBI to find him. Bonham lives alone in a cabin in British Columbia, where he works for the Wildlife Fund. In a scene filmed during a snowstorm on Mount Hood, we introduce him as he's tracking a wounded white wolf caught in a hunter's trap. Bonham heals its wound with wet, grassy earth pulled from beneath the deep snow.

When I asked Academy Award–winning cinematographer Caleb Deschanel to shoot *The Hunted*, he was reluctant. I had a reputation among cameramen for being hard to work with. For whatever reason, perhaps curiosity, Caleb decided to do the picture. His compositions and lighting set the naturalistic mood and captured the emotions in every scene. We never had a disagreement, and we brought out the best in each other. We have a bond of friendship and respect that continues to this day.

Tom Brown was our technical adviser. He taught Tommy Lee and Benicio how to make knives from raw stone and rusted steel, and with Mark Stefanich, a former member of Seal Team 6, taught them the techniques of military assassination. One of the best lines of dialogue came from Mark: "Once you've learned how to kill *mentally*, the *physical* part comes easy. The hard part is learning how to turn it off."

Tom brought two expert knife fighters to the set, Tom Kier and Rafael Kayanan, who also trained Navy Seals and are acknowledged masters of the Philippine Sayoc Kali combat style, evolved over hundreds of years. It became the basis for the fights in *The Hunted*, which were skillfully executed by Benicio and Tommy Lee. I use "doubles" only for extreme long shots and tight close-ups. The knife fight in the forest, in which Tommy Lee is unarmed and Benicio has a hand-crafted metal knife, was the last scene to be shot. It was going smoothly until, with only two setups left to complete the film, both dove to the ground to retrieve the fallen knife. Benicio fell on his wrist—and broke it. He had to be helicoptered to a Portland hospital, where he underwent surgery, losing the use of his right hand for six months. It was a simple move they had rehearsed and perfected for weeks, and it seemed to hold no prospect of danger. We had to shut down, with only a few shots left to finish.

Benicio held his anger in check and worked to rehabilitate his hand. We went back to Oregon with most of the same crew and finished the sequence. (If you see it, you will have no idea where the interruption of six months occurred.) I still admire the film's energy, tension, and spontaneity. It embodies themes that continue to haunt me: guilt, obsession, the breakdown of social order, a man's inner conflict over his own actions.

The four films I directed for Paramount aspired to realism, but realism was no longer in favor. If *Star Wars* in the '70s was a tidal wave that washed everything else away in its wake, the 1990s were an earthquake. In the competition for audiences between fantasy and reality, fantasy was the clear winner. With the digital revolution, it became possible to create images on a computer, changing the way films are made and the way people see them.

In July 2006 Sherry and I stopped in London on our way to Africa for a camera safari. I took her to meet Harold Pinter, the year after he received the Nobel Prize in Literature. He chose a simple Italian restaurant just outside Chelsea. He was waiting when we arrived. He had been in pain for several years and undergone an operation and chemotherapy for esophageal cancer. He had difficulty walking and had lost a lot of weight and most of his hair. Sherry was nervous about meeting him because of his reputation for abrasiveness and his intolerance of American foreign policy. It's also intimidating to be around a Nobel Prize winner.

But Harold was charming. He gave her a personally autographed copy of his bound book of poetry. He had been married to the writer Antonia Fraser for twenty-six years, and Sherry asked how they met. "Funnily enough, it was after a revival of *The Birthday Party* early in 1975," Harold said. At a dinner party he and Antonia sat at opposite ends of a long table. She got up to say good night to Harold, and he asked, "Must you go?" She thought for a moment and answered: "No, it's not essential." He drove her to her house and stayed until 6:30 the following morning. She was married with six children; Harold had been unhappy with Vivien for many years. He told us of a recent screening of

The Birthday Party in his honor at the British Film Academy. He said he thought it played great and he was proud of it. "It's really a wonderful film," he said. I was moved not only to hear this from him but also to see these two people who meant so much to me, forty years apart, getting along so well.

FADE OUT

I had developed leg pains each time I walked even the shortest of distances. MRI scans showed I had bone spurs clawing against my spinal nerve. In October 2008 I had a six-hour operation for spinal stenosis, which at my age was dangerous. For weeks afterward I had a private nurse to help me walk again. No sooner had I recovered when heart pains recurred. The new diagnosis: congestive heart failure. One of the probable causes was type-2 diabetes. I entered a long phase of physical discomfort, serious illness, and spiritual crisis. It occurred to me that I might die—and soon. I had complete faith in my doctors—P. K. Shah, the heart specialist, Richard Gold, my internist, and Anne Peters, for diabetes—who made me realize that if I didn't radically change my lifestyle, I would soon be dead. I went on a strict diet and enough medication to cure a small country. But it was Sherry who saw that I had the best care possible, and it was her love and faith that gave me the strength to push back against death once again.

On Christmas Day 2008, Harold Pinter died of a rare disease in which the body attacks itself. Deep depression, the black dog poised above my head.

In April 2009, I received a Life Achievement Award at the first annual thriller film festival in Beaune, France, a small town in the wine capital of Burgundy. The award was presented by Claude

Lelouch, whose remarks were warm and generous, and my acceptance speech was devoted to my appreciation of his work and that of the French New Wave.

The next day, like a sudden storm, I experienced a series of sharp stabbing heart pains. We returned to Los Angeles, where the pain subsided. I took three or four nitroglycerin pills a day for several weeks, but otherwise ignored the symptoms.

As a favor to the conductor Kent Nagano I directed Stravinsky's *Histoire du soldat*, an oratorio with music and dialogue. Kent brought members of his Montreal Symphony to Los Angeles, and we staged it at a theater in Santa Monica. Afterward I couldn't go onstage to take a bow. Again, stabbing chest pains. Blood tests and an angiogram showed I needed a triple bypass. Two weeks later I was in the operating room, then in hospital recovery for a week. The operation was a success, and my heart function returned to normal.

When I got home, my vital signs were stable, but from the incision there seemed to be a constant discharge of reddish-orange pus. Blood samples showed I had acquired a life-threatening hospital-borne infection called serratia, extremely resistant to antibiotics. I was readmitted to the hospital. A midnight CT scan suggested that the infection was superficial and had not spread. The heart surgeon sought my permission to reopen the incision and treat the infection, but I lost faith in him and in the hospital. I remember shouting at him: "You fucked me up!"

At Sherry's insistence I was moved by ambulance to another hospital, where I was met by six specialists and another CT scan was performed. The new doctors told me that the first scan had been incorrectly interpreted by the other hospital, and the infection had spread from my bloodstream into the chest bone.

"What does that mean?" I asked.

Gravely, one of the doctors said, "If it's spread too far, we'll have to remove your sternum." The sternum is the breast bone, which protects the heart, lungs, and major blood vessels. If it's damaged or removed, you have a big hole in your chest. It could be replaced by plastic surgery, but only after another chest operation.

I looked from one doctor to the other. Their expressions weren't encouraging. Sherry was tearfully stoic. The thought occurred to me through exhaustion and a haze of mind-altering painkillers that this could be my "appointment in Samarra." The wound was erupting once again like a lava flow. I considered the possibility that I might die without having accomplished anything of lasting value.

Two weeks after the bypass, I was back in surgery for a partial sternectomy and reconstruction, an operation with less than a 50 percent survival rate. I asked the new surgeon, Dr. Richard Shemin, "Have you ever done this before?"

"No," he answered honestly. "But I know how to do it." He saved my life.

Ten days later I awoke from a troubled sleep, woozy and disoriented from the antibiotics, the stabbing pain still raging in my chest. I could hear distant, high-pitched children's voices from a school playground. Then silence. A sudden image of myself pumping a little three-wheeler bike as fast as the wind along Sheridan Road in Chicago when my world was filled with promise.

I was hospitalized for a month, followed by home care and visits to the hospital for check-ups or half-hour walks in a quiet neighborhood park. This went on for another three months.

Suspended by a fragile thread, I thought about what I had gained and at what cost. And what I had lost. My body was broken, but I was alive, and with a sense of hope.

PART V

FADE IN

PUCCINI

Placido Domingo asked me to direct *Il Tabarro* and *Suor Angelica*, the first two of Puccini's three-part opera *Il Trittico*, for Los Angeles Opera in the fall of 2009. There was a caveat, and Placido raised it diplomatically, as was his style; he could charm the mustard off a hot dog.

"Billy," Placido began, "your *Schicci* will always be our production of *Schicci*. But would you consider another idea?" For years he had been pursuing Woody Allen to direct an opera, and Woody had finally agreed. The only opera he knew well enough to direct was Puccini's short comic gem *Gianni Schicci*, the third and most popular of the trilogy and one I had directed twice. I thought it was a great idea and welcomed it wholeheartedly, as I consider Woody the best living American filmmaker.

The event was announced to great fanfare, and we went into rehearsal in early August.

Puccini wrote *Il Trittico* at the end of his career, after *La Bohème*, *Madame Butterfly*, *Tosca*, and other masterpieces. Its three one-act operas are each about an hour long, completely different in character and style. The common themes are death, damnation, forgiveness, and, in Puccini's words, "The great suffering of small souls." No composer has written more beautiful melodies or better combined truth and beauty.

Il Tabarro (The Cloak) is opera noir, a realistic thriller set on the banks of the Seine, involving a barge owner whose wife is having an affair with one of his workers. It combines jealousy, betrayal, and murder; Puccini would have been a great novelist or filmmaker. The characters are finely drawn, sympathetic, longing to change their lives but without the ability to do so.

In working with the principals—Mark Delavan as the barge owner, Anja Kampe as his sexy, distracted wife, and Salvatore Licitra as her ill-fated lover—I asked them to mine their own experiences of rage and passion in an effort to explore what leads one man to murder and another to become his victim. I directed *Il Tabarro* in the darkly realistic manner of a Georges Simenon crime novel; clear, concise, and ultimately chilling.

Suor Angelica (Sister Angelica) is set in a convent in Tuscany and written for female voices. Angelica is beloved by the other nuns. She was sent to the convent seven years before by her noble family to do penance for having a child out of wedlock. Her aunt, the Principessa, one of the great villains in opera, comes to tell her the child has died. Angelica is driven to madness and suicide, but after taking poison, she begs forgiveness, and in her dying moments, the Holy Virgin appears, to reunite her with her dead child. The apparition is either a hallucination or a miracle, and I chose to interpret it according to Puccini's direction: "The Angel of Mercy *appears*." Puccini was not a pious Catholic, but his sister was a nun, and he first played the piano score of *Suor Angelica* at her convent, where the sisters were moved to tears. I felt this great opera had the power to produce that emotion in a modern audience.

Knowing nothing about convent life, I sought the advice of an extraordinary woman, Sister Mary Jean Meier, eighty-three years old, a member of the Order of the Sisters of Mercy. I have never known a more vital, life-affirming person. She lived her faith

and gave me to understand the nature of her calling. We became friends, and when I was seriously ill, she said prayers for me every day and asked fellow priests and nuns around the world to do the same. I asked her to speak to the principals and the chorus of *Suor Angelica* at our first rehearsal.

With her generous spirit and sense of humor, Sister Mary Jean described convent life and cautioned them not to portray the sisters as stereotypes. "We love to gossip," she said. "We have faults and misgivings and special interests as all women do. So please don't portray us as outside the norms of human behavior or 'holier than thou.' The only thing we all have in common is our devotion and love of Christ." Her comments, her very presence, were more significant than my direction.

The appearance of the Virgin is seldom if ever portrayed literally in today's secular world. It's usually suggested by the shadow of a crucifix crossing the stage or a bright white light or the illumination of a stained-glass window. Often it's mocked as an insane hallucination.

I cast a young actress to appear "magically" in the blue-and-white garment of the Virgin of Guadalupe. When I started to rehearse the Virgin's descent, the conductor, James Conlon, asked if we could speak privately.

"Please don't do that," he said quietly.

"Why not, James?"

"I was raised Catholic," he told me, "but I'm no longer a believer."

"I understand," I said. "But this is not about your beliefs or mine. Puccini in his stage direction says 'the Angel of Mercy appears.'"

"You don't have to do it literally. I'm asking you not to do it," he repeated. "I think people will laugh or ridicule it."

"I don't care," I said.

448 · THE FRIEDKIN CONNECTION

We had other conflicts. He would ask singers to look right at him during performances. This gives conductors control of the tempi but destroys the singer's ability to "act" and not just "sing the role." Late in rehearsal Conlon wanted the offstage chorus, dressed in full nun's habit, to sing the finale from a box in the audience. I was furious. Not only was the chorus fully audible *backstage*, but their voices had an ethereal effect. I felt it was payback for my defying his request about the Virgin.

I took Placido aside and told him that if he allowed Conlon to do this, I would publicly resign and state my reasons. Placido spoke to him privately, and the offstage chorus remained backstage. From that point on our relationship was frosty, but in the end the production was an unqualified triumph: sold-out performances and ecstatic reviews from around the world. Placido hugged me after the opening and shouted, "You will make all Los Angeles Catholic with this production." The truth is that Conlon conducted the music brilliantly. The young American soprano Sondra Radvanovsky's magnificent voice and acting made *Suor Angelica* a memorable event. Grown men in tuxedos and women in evening dress of all faiths or no faith were sobbing. And so was I at every performance.

I knew Sondra had the ability and desire to be a Suor Angelica for the ages. There was nothing I could tell her about singing, but we worked intensely on her dramatic portrayal. There is a portal to every artist that when unlocked will open a wellspring of emotion. Sondra told me the death of her father hit her harder than anything in her life. I would quietly remind her to revisit that time at each rehearsal and it was this sense memory she brought to her performances. I consider *Il Trittico* the absolute high point of my work as a director. Sister Mary Jean, along with other members of the Sisters of Mercy, expressed their gratitude and enjoyment to me, which was the *best* review.

CATHARSIS

"The belief in a supernatural source of evil is not
necessary; men alone are quite capable of every
wickedness."

—JOSEPH CONRAD

I had committed to two more operas for 2005, Saint-Saëns's *Samson and Delilah* in Tel Aviv and *Aïda* in Turin, Italy, both of which were consistent with my standard dark fare. I spent a year preparing them. It was a year since *The Hunted* and I had no prospects for another film.

There comes a point when your days as a film director are numbered. Doesn't matter what's on your résumé or that you won an Oscar. Time, once having smiled upon me seductively, was now laughing in my face. The major studios weren't going to give me one of their franchises and I had no interest in them.

As fate would have it, some friends in New York suggested I see a play called *Bug* before it ended its run in a small theater in Greenwich Village. In the fall of 2004, I went alone to the Barrow Street Theater, not wanting to waste Sherry's time in case it turned out to be a dud. The play was as powerful and compelling as anything by Harold Pinter. It took me completely by surprise. It was

the work of a young playwright who was destined to become an exciting new voice in American theater. Tracy Letts is a fine actor as well as a playwright. His first play was *Killer Joe*, written when he was twenty-five in 1991. It had its initial performance two years later in a forty-seat theater in Evanston, Illinois. His second play, *Bug*, was first performed in London in 1996 but didn't reach an American stage for four years. In 2004, it won a bunch of awards off-Broadway including Outstanding Play.

Bug is a one-set play with only five characters, but I felt it could become a disturbing character-driven film. The play blurs the line between reality and illusion. Agnes, a waitress in a lesbian bar who is haunted by the disappearance of her young son, lives in a seedy motel on the outskirts of a small town in Oklahoma. She is hiding from her abusive husband, Jerry Goss, who's just been released from prison and is stalking her. A friend and fellow waitress, R.C., introduces Agnes to Peter Evans, a drifter, who tells her he's a Gulf War veteran and that he was subjected to military experiments in which lethal bugs were injected into his bloodstream. Agnes feels compassion for him and invites him to move in with her. Lonely and vulnerable, she gradually comes to believe Peter's wild stories and theories. Cocaine plays a large part in their hallucinatory behavior. The cramped motel room is a metaphor for their demented inner lives. Agnes is outwardly self-sufficient; inwardly she lives with fear and regret. Peter, at first shy and tender, is psychotic. A man claiming to be someone named Doctor Sweet, Peter's personal physician, pays an unexpected visit that leads to murder and self-immolation.

Bug is black comedy, pitch-black, a *folie à deux*, wherein delusional beliefs pass from one person to another in a kind of shared psychosis. It was certain to offend audiences even as it challenged their expectations.

Tracy was forty years old when we met; tall, thinning blond hair, pink-skinned, wearing dark-rimmed glasses. He had the bearing of a college professor but there seemed to be an inner sadness behind his bright smile. He grew up in Durant, a small town in southeast Oklahoma, and lived with his parents for a while in a trailer park. His mother and father were college English teachers. His father, Dennis, became an actor and his mother, Billie, wrote a best-selling novel, *Where the Heart Is*, that later became a movie. At seventeen he moved to Dallas to become an actor, without much success, and in the late nineties he went to Hollywood, where he got a few small acting jobs, not enough to earn a living. When he auditioned for and didn't get a small part on *The Love Boat*, he moved to Chicago and became a member of what is considered the best theater ensemble in America today, the Steppenwolf Company.

Letts's play shows how paranoid connections feed on themselves. I didn't realize it at the time, but in making the film I would delve into my own paranoid tendencies. I don't believe helicopters are following me or little green men have access to my brain but I often get a sense that whatever can go wrong, *will*. The phone call that was supposed to come, *won't*. The deal that was supposed to close will fall apart. Out of a black cave march the Seven Dwarfs of Ignorance, Fear, Disappointment, Anxiety, Insecurity, Anger, and Depression.

Tracy was skeptical when we first met. He didn't believe anyone would want to make a film of *Bug* and he initially thought my call might have been a practical joke, but he agreed to come out to Los Angeles. I put him up at the Sunset Marquis, where I first stayed almost forty years before. For the next two days we talked about how we might adapt *Bug* into a screenplay. I wanted to be faithful to the play. Though it was claustrophobic, I felt it was cinematic.

I told him I wasn't sure I could get it made but I would give it my best shot. We agreed to open the play up slightly, to show the exterior of the motel, the bar where Agnes works, the grocery store where she remembers losing her son. I told Tracy that if at all possible I would cast Michael Shannon, who created the role of Peter onstage. I could think of no better actor, certainly no major star who would be more effective. Shannon was thirty-six years old, shy and soft-spoken. He had small parts in at least twenty films before I saw him onstage in *Bug*. I've never known an actor more focused, dedicated, or capable of reaching the outer ranges of human behavior.

I optioned the play for five thousand dollars for one year and Tracy started writing the screenplay. I asked him if he wanted to show the bugs and he said, "I don't think there *are* any bugs." Like Pinter, he was reluctant to interpret his own work.

The independent film world is an alternative to the major studios. The films are often edgier and cost less. I was able to get the film financed by Lionsgate, a kind of "little engine that could" production and distribution company known then for small-budget films. It was run by vice-chairman Michael Burns, a smart, decent man with a keen sense of humor. *Bug* wasn't his idea of a commercial film, but if I could make it for four million dollars or less he could market it as a horror film "from the director of *The Exorcist*," and get in and get out before audiences realized it was deeper and more disturbing *psychologically* than *viscerally*. The film had shocking elements and "shock" was good for a Lionsgate picture.

"But I need two stars," Burns said. "I'm not gonna do this with Michael Shannon."

I agreed to make the film for director's scale, and the actors would have to work for scale as well. Though the story is set in

Oklahoma, we opted to shoot in tax-credit-friendly Louisiana, the go-to state for most film production and a lot of the television shows produced in the United States. The Louisiana Motion Picture Tax Incentive Act provides incentives that can reduce the cost of all production money spent in the state over three hundred thousand dollars. The more local personnel you hire, the bigger the tax credit. The state benefits by adding more jobs to the payroll as well as creating a higher demand for goods and services, hotels and restaurants. Other states have adopted this idea but none as successfully as Louisiana.

Tracy and I were determined to keep Michael Shannon, though a lot of well-known and capable actors wanted to do this role. An agent suggested Ashley Judd to play Agnes. She's beautiful, of course, but when we met I discovered the quality that most appeals to me in an actor: intelligence. Ashley *understood* Agnes, having experienced her own "chaotic and dysfunctional" childhood. By coincidence she had previously starred in *Where the Heart Is*, the film version of the novel by Tracy's mother.

In an early scene between Peter and Agnes, he tells her:

People can do things to you—things you don't even know about. They try to control you. they try to force you to act in a certain way. They can drive you crazy, too . . . You're never really safe. One time, maybe a long time ago, people were safe, but that's all over. Not anymore, not on this planet. We'll never really be safe again. We can't be, not with all the technology, the chemicals, and the information. . . . Sometimes, though, when you're lying in bed at night, you can feel it. All the machines, people working their machines, their works, humming. I don't like to go on about it, 'cause it freaks people out. I wish I didn't think about it either, but

454 · THE FRIEDKIN CONNECTION

they don't let you forget. They want you to know they're there. Nothing makes them happier than knowing the people are aware the machines are up and running.

Shannon delivered this speech so simply and with such conviction, and Ashley became so caught up in it, it was a magical confluence of writer and actors. I don't believe it can be done better. Though delivered by a troubled, possibly damaged man, the ideas are prophetic.

The camera knows when an actor is faking it. When he doesn't *believe* what he's saying. Ashley and Michael gave meaning and life to Tracy's creations.

For the role of Goss, Agnes's husband, I met with a number of actors but nothing clicked. In April of 2005, Sherry and I went to the opening of Steve Wynn's new hotel in Las Vegas where we sat at a table with Harry Connick Jr. and his wife, Jill Goodacre, a former Victoria's Secret model. Jill was curious about *The Exorcist* and how we achieved certain effects and I answered her at some length. At one point, Harry cut in: "Bill, don't you think you been talkin' to Jill for a long time?" I looked at him. His expression was cold and threatening. I started to apologize, when he broke into raucous laughter. "Hey man, I'm only kidding." He shook my hand and said, "I'm your biggest fan. If you ever have a part for me, I'd love to work for you." In that moment, I had seen exactly what I was looking for in the character of Goss. It was casting against type but I asked him if he would be available in his hometown of New Orleans after the Fourth of July, and when he said he would, I hired him on the spot to play Goss.

My casting director, Bonnie Timmermann, came up with a wonderful New York theater actor, Brian F. O'Byrne, to play Doctor Sweet, and Lynn Collins to play Agnes's friend R.C. Largely

because of the casting of Ashley, Lionsgate gave us a tentative green light and reluctantly approved Michael Shannon.

I hired an energetic young line producer, Holly Wiersma, and a talented director of photography, Michael Grady, who lit quickly and operated the camera himself. Franco Carbone was a production designer whose work on a variety of low-budget films impressed me. He and Holly sent me photos of possible locations around New Orleans. There were no available soundstages but we were able to rent space in the large gymnasium of the Grace King High School in Metairie, Louisiana, near Lake Pontchartrain. The school would be out of session for summer vacation so we had from early July to early September to complete our shoot. I was in daily contact with Holly while final negotiations with Lionsgate dragged on. There were times when it looked like the picture would fall apart over legal minutiae.

I arrived in New Orleans on July 5 to be greeted by Hurricane Cindy, the first hurricane of the season, though unfortunately not the last. Seventy-five-mile-an-hour winds, sheets of rain all day long, three hundred thousand homes without power in Louisiana and the Gulf, the worst blackouts in forty years. Debris was all over the streets while we tried to scout locations.

We rehearsed on-set for a week. I let Ashley choose her own personal effects to be placed around the rooms and Franco Carbone expanded the single motel room to include a separate bedroom, living room, and small kitchenette. Franco's set was dark, seedy, and unkempt. We later wrapped it from floor to ceiling in aluminum foil and it was lit only by bug-zapping hurricane lamps, when Agnes and Peter insulate the rooms to prevent the "bugs from transmitting signals to the outside world." The earlier warm tones gave way to an icy blue for the final scenes.

There is no greater joy for a filmmaker than to watch a cast

perform difficult material at so high a level. There were times when Ashley and Michael performed with such raw energy, I was afraid they would hurt each other. Grady lit the set and operated the camera imaginatively. Sometimes we'd use two additional cameras so we could limit having to redo a scene from different angles. While the content was often disturbing, the mood on the set was focused and relaxed. I would occasionally look at the dailies with Darrin Navarro, the editor, but I didn't start editing until the shooting was finished. I wanted a completely fresh attitude in the cutting room without the pressure of filming each day.

In the final week of filming, daylight was gone by noon. Fortunately, we finished our New Orleans locations and were on the soundstage. Darkness, rain, and thunder persisted for days. On what was to be our twenty-first and final shooting day, we filmed the sequence in which Agnes and Peter prepare to die together, fearing any further contact with the outside world. They pour kerosene over each other and light a match, sending the rooms up in flames. The special effects team poured flammable liquid over the aluminum foil walls and I set three cameras on different lenses at the furthest wall from the one that would be ignited.

When the wall was aflame, the fire quickly leaped across the room, singeing the faces of the camera crew who quickly abandoned their cameras and jumped off the set, avoiding certain death. The effects crew had mistakenly used too much fluid. Everyone freaked, but fortunately no one was seriously hurt. Franco set up another aluminum foil wall overnight and we set the cameras in the same positions the next day but operated them remotely, with no one on-set. The effects crew prepared the wall correctly this time and the New Orleans portion of the shoot was over.

I flew back to Los Angeles and two weeks later, on August 29,

Hurricane Katrina blasted New Orleans. The levees collapsed and eighty percent of New Orleans was flooded, including our "soundstage" at the Grace King High School.

By November of 2005, Darrin and I had our first cut and we ran the film for Tracy. He was enthusiastic and gave us helpful suggestions. We incorporated most of them. The executives at Lionsgate wanted to hold the release and send the film to Cannes, where it was turned down for the main competition but accepted by the Directors Fortnight along with twenty-one other films. The Fortnight is traditionally reserved for young filmmakers. I was seventy years old. "This is a lineup about youth," said Olivier Père, the artistic director.

Tracy and Michael Shannon paid their own way to Cannes as Lionsgate refused to bring them over. But I had them join me for every interview and the film was received enthusiastically. *Bug* was given the highest award of the Fortnight, the FIPRESCI Prize, by the International Federation of Film Critics, which has more than two hundred members. So much for "youth."

After many postponements, Lionsgate opened *Bug* in 2007 on sixteen hundred and sixty-one screens, advertising it, as expected, "from the director of *The Exorcist*." It was an ill-advised campaign and an overly ambitious release. But it was a return to essentials for me: a few actors, a small but efficient crew, and no special effects; just a tight story that holds its mysteries. It's exactly the film I wanted to make and I would pursue a similar course for whatever time was left to me.

In the four years after *Bug* came out, I made a series of false starts and had no tangible prospect of making another film. I directed Richard Strauss's opera *Salome* in Munich, then Puccini's *Il*

Trittico, and I thought I might devote the rest of my life to directing for the stage.

Then in the summer of 2009 while I was recovering from various surgeries, Tracy Letts called. We hadn't spoken for—how long?—at least a year. In a cheery voice, he said, "Hey, Bill. Would you be interested in making a film of *Killer Joe*?"

Letts wrote *Killer Joe* with a deep-rooted sense of anger. After a series of readings and a gestation of three years, it had its first production in 1993. The first review of that Chicago production described it as "a hideous carnival of brutality and degradation that leaves you feeling dirty."

The story is set in a trailer park on the outskirts of Dallas. A young drug dealer, Chris Smith, owes six thousand dollars to the local crime boss, Digger Soames. Digger will have him killed if he doesn't pay up. Chris enlists his low-life father, Ansel, and his raunchy stepmother, Sharla, in an attempt to kill his *real* mother, Ansel's first wife, Adele, for her fifty-thousand-dollar life insurance policy. The policy is payable to Dottie, Chris's younger sister. They try to hire Joe Cooper, a Dallas detective, the essence of cool, who moonlights as a contract killer. Joe's price is twenty-five thousand dollars, up front. Chris and Ansel are broke but Joe will accept Dottie as a retainer, to which the father and brother readily agree. Though outwardly low key and charming, Joe is a thundercloud who can weep or kill, a force of nature. By inviting him into their lives, the Smiths have let in a monster and must deal with the consequences. Ansel and Sharla's marriage is flawed, forcing them to face the truth of what they've become. Yet even in their terrible relationship, there is intimacy and genuine caring. The violence between Chris and Ansel is dangerous, but also subversively funny.

Letts believes Joe was probably "ex-military, an escapee from

an abusive, dead-end childhood." He tries to bring order to the chaotic lives of the Smith family and when they resist, he explodes. Chris is beaten to a pulp by Digger's men and by Joe; Joe forces Sharla to perform fellatio on a fried chicken leg.

Chris senses there's a moral order to the world, but he can't quite grasp it. He has cunning and a sense of humor, but he's redeemed only by his love for his sister. His fatal flaw is in sacrificing her for his own preservation. The story begins on a night of lightning, thunder, and rain with Chris calling for Dottie. Though it's beyond his comprehension, she is his salvation. Dottie is not retarded, not slow, not brain-damaged. She is innocent, with a kind of resilience. She also has a sense of humor. Letts describes her as "the keeper of rage of all women."

I was completely drawn to Letts's film script. But who would finance it? It takes place in a morally ambiguous world with no character an audience can root for. I didn't realize how long or difficult the process would be to get it made.

I met with potential actors and producers. Ellen Page was interested in playing Dottie. She was twenty-one years old and already on the road to stardom. I loved her in the film *Juno* and in an earlier film she made called *Hard Candy*, in which she lures a rapist to his house, tranquilizes him, then tortures him. It was a stunning performance. We had a meeting during which she said she'd commit to the picture. Two days later, her agent called to say she changed her mind.

Kurt Russell was interested in playing Joe but he told me he was afraid of the role. His companion of many years, Goldie Hawn, said she'd leave him if he did it. After two weeks he called to say he'd have to pass.

Perhaps you've observed a pattern. My films would pass from light and hope into darkness, despair, and back. Sometimes they'd

end in success; often failure. I worked as much on the failures as the successes but they were all equally difficult to realize. In adapting four plays into films, I started with the conviction that they were well-constructed dramas to begin with, with fully developed characters I understood. I wasn't interested in changing them.

As I recall my experiences in the world of Independent film I now realize how much of my time was spent on trivia that stifles the imagination. I would have been a better director if I had been part of the studio system that prevailed through the 1930s and '40s. Directors were on staff and given assignments by the heads of production. You could direct as many as four or five films a year. You were handed a budget, a schedule, a cast, and a script that was developed by the studio heads. Actors and technicians were also on staff and the pictures were consistently well made and sometimes great. You didn't have to worry about raising money or finding a cast and crew. Reputations weren't destroyed on the basis of one film. Now, every new film is like reinventing the wheel.

Almost a year later, I was still without a producer or a cast for *Killer Joe.* Watching television one night I saw an interview with Matthew McConaughey. It turned out to be providential. McConaughey is obviously a handsome man, but on this program he was also intelligent, sensitive, and soft-spoken with a lilting East Texas accent. I was leaning toward an older, more grizzled actor for Joe, until I saw this interview. McConaughey's work in the 1990s was a mixed bag of serious films, comedies, and a horror film. By 2000 he was the go-to guy for romantic comedies, "rom-coms." Matthew said that "doing these rom-coms was tougher than anything more serious." I had a hunch his good looks could work "against type." There was no reason Joe couldn't be suave, and even-tempered, disguising a basically evil nature. I sent him the script.

When he read it, he threw it across his living room into a trash bin. He wanted to "take a shower with a wire brush." But one of his advisers told him they had seen the play and that it was funny (in a dark sense) and about people Matthew grew up with in East Texas. He pulled it out of the trash bin, read it again, and said to his agent, "Maybe I better meet with Friedkin."

We met at his house on the aptly named Wildlife Road in Malibu, surrounded by three large Airstream trailers. It was a beach-style house, not on the ocean but within walking distance. There was a basketball hoop and a lot of toys strewn around the lawn where Matthew and his two-year-old son Levi and baby daughter Vida were playing under the watchful eyes of his future mother-in-law. Matthew and I talked about the script and how Joe's outwardly placid nature was a cover for what lies beneath. We agreed that the humor had to come from "playing it straight," never going for the joke. I told him I planned to do the exteriors first, then shoot everything inside the trailer on a set and in sequence. I said we could make the film in twenty-five days. I wanted the actors to bring their "A-Game" to the set and go for performance on the first take.

Shortly after our meeting he called to tell me he'd commit and his agency, CAA, offered to help set the picture up. At least a dozen producers passed before CAA arranged a meeting for me with Nicholas Chartier, the thirty-six-year-old producer of *The Hurt Locker*, winner of six Academy Awards including 2009's Best Picture. Born in France, he was twenty years old when he worked as a janitor at Disneyland outside Paris. He came to Los Angeles to write pornographic shows for cable TV and went on to become a foreign sales agent, mostly for straight-to-video movies.

Foreign sales are the life's-blood of independent films. They don't always cover the full cost but they provide enough cushion, along with television and home video rights and, hopefully, a domestic

462 · THE FRIEDKIN CONNECTION

distribution advance to get the film into production. The producer
has to cover the difference, but pre-sales determine the budget.
Chartier is headstrong and impulsive. He is said to have mortgaged
his house to raise the $15 million to make *The Hurt Locker*. I asked
him why he made the film after every studio passed on it: "I thought
Kathryn Bigelow was a talented director and I wanted to work with
her," he said. The film made no money but he was justly proud
of it. His background was in the world of low-budget quickies but
his own tastes were more refined. He moved easily between both
worlds. He said he would try to set the picture up and he was happy
McConaughey would commit, at much lower than his normal fee,
and that CAA would help with other "name" actors. A short time
later, Jennifer Lawrence came to meet me.

She was twenty and nominated for an Academy Award for a
small but affecting independent film, *Winter's Bone. Rolling Stone*
magazine called her "the most talented young actress in America."
She's beautiful, also intelligent and compelling. As soon as she sat
down she said she "was the only actress in America who could play
Dottie." At that moment I believed her. She said she wanted to do
challenging roles in quality independent films. Chartier sensed her
trajectory and felt she would be a star by the time *Killer Joe* came
out. But by mid-July, with nothing firmly in place, she dropped out
to take a role in *X-Men: First Class*.

For the next three months, Chartier tried to pre-sell foreign
territories while I attempted to pull together the rest of the cast.
For this, we hired Denise Chamian, who cast *Rules of Engagement*
and *The Hunted* for me. She was casting nine other films that year
but found time for *Killer Joe*. The foreign sales were slow-moving,
with small advances. McConaughey in this kind of film was not
worth a lot of front money to foreign buyers. Denise suggested
Emile Hirsch for the role of Chris. A great choice, but Chartier

wanted another actor he thought would bring higher foreign advances. Fortunately, McConaughey's agents had cast approval and they would only approve Emile. He was twenty-five and had been working steadily as an actor since he was eight. I saw him in *Alpha Dog, Into the Wild*, and *Milk*, and thought he had a quality like James Dean and Montgomery Clift. He understood the script, loved it, and saw it as we all did as funny in a disturbing way.

We then went to Thomas Haden Church, a brilliant and underrated actor, to play Ansel. Tom grew up in Laredo, Texas, so, like Matthew's, his accent was perfect. I thought he was wonderful in the film *Sideways*, for which he was nominated for an Academy Award as best supporting actor. Tom is the real deal. You never see him "act"; he inhabits his characters and is careful about his choices. I cast him over the phone without a meeting. Letts suggested Gina Gershon to play Sharla and, to my surprise, Nick immediately approved. She's smart as well as sexy, and at one time Tracy wanted her to do the play onstage but she turned it down, saying she could never do it six or seven times a week. When I went to her for the film, she was ready. Denise then sent me an unsolicited audition video by a twenty-year-old actress named Juno Temple. I had never heard of Juno nor seen her in a film. Her audition was the seduction scene between Dottie and Joe, with her ten-year-old brother playing Joe. I watched the video in awe. She was pitch-perfect. (Her brother wasn't bad either.) She was a little kooky, blond and cute. I thought she was a perfect choice for Dottie.

Chartier didn't agree: "Not sexy enough . . . " "Too childlike," . . . another of many disagreements I was to have with him. He had other actresses he wanted me to consider and I saw some of them two and three times but I held out for Juno, without having met her. I invited her to Los Angeles and she was every bit as captivat-

ing in person, but to my surprise she had a British accent! Yet she could sound like a Texan at will.

The long casting process with many stumbles finally produced an ideal cast. I asked Caleb Deschanel if he'd photograph the film and though he had a thriving commercial company and was in constant demand for big features, he accepted. I told him we had to do the film in twenty-five days, were all working for scale, and would have to shoot with digital cameras. He said he'd put some other commitments aside and agreed to do it. "I haven't shot this fast for forty years," he said. "It would be a hell of a challenge and the script is great." He convinced the ARRIFLEX company to let us rent the prototype of their new compact digital camera, the Alexa. The capabilities of this camera are superior to film especially in post-production where you have a wider latitude in achieving color, definition, and density.

I put together the rest of the crew: Michael Salven, Dave's son, would be my assistant director for the fifth time. He's the best and most organized A.D. I've ever worked with. Franco Carbone, the production designer, and Peggy Schnitzer, costumes, worked with me on *Bug* and I came to like and respect them. Nick wanted his own production staff. I had never heard of any of the films they worked on and my problems with them multiplied each day. I felt they were pennywise and pound foolish and I mostly let Michael Salven deal with them.

And so we all went to New Orleans, which would double as the outskirts of Dallas—again because of the generous tax credits. The city had recovered from Katrina, except for areas like the Ninth Ward, which still resembled bombed-out Europe.

Though I continued to have many clashes with Nick's production people, I respected *his* opinions, which he was never shy about expressing. Often he was right. He was on the set only a few days

but he saw the dailies and his line producer would repeatedly tell me Nick hated them: "Why doesn't the camera move?" "This scene is boring . . ." "The film has no pace . . ." I was grateful to Nick for getting the picture made but I never felt he really understood it or that we were on the same page.

There were also problems finding and clearing locations, which was the responsibility of the production manager. In Tracy's script, the murder of Adele, the mother, occurs when Joe sedates her and he and Chris push her car onto a railroad siding at night. The car is demolished by an oncoming train. No railroad line in Louisiana would give us permission to stage such a scene but I didn't get this information until days before we had to shoot it. The producers had no alternative. Tracy was acting in a play in Chicago and was unavailable to write a new scene. I emailed him *my* solution: Joe sets the car on fire in a deserted parking lot after making it look as though Adele was drunk and smoking grass. Chris watches, horrified, as the car explodes.

During a location scout, I found a deserted area on the outskirts of downtown New Orleans. Old red brick and rubble, chipped cobblestone streets, an area that looked like a war zone. I improvised a little chase scene in this area in which two bikers hunt Chris down, trap him, and beat him to a pulp on orders from Digger Soames, to whom Chris owes money.

We found a funky old trailer park and used the exterior of a dilapidated trailer, whose interior we duplicated on a soundstage. I rarely did a second take for performance. We would only do another if there was a technical problem, and the atmosphere on set, even for the most controversial scenes, was relaxed. We shot five-day weeks but rehearsed upcoming scenes on weekends. By the end we all formed a bond. I said to Juno, "I'd like to adopt you." She gave me a hug and said, "You can be my *American* father."

We were sad when it was over, twenty-seven shooting days later, but Darrin Navarro and I finished a first cut in sixteen days. It ran two hours and ten minutes. I brought Nick into the cutting room several times and his notes were perceptive. The film's running time came down to one hour and forty minutes. Tracy came in for two days and gave us notes; mostly he wanted parts of scenes we had taken out restored. I told him I was concerned we might get an NC-17 rating. "You're wrong, Billy," he said. "There's way more objectionable stuff out there playing with an R."

With Aaron Levy, the young sound mixer I first worked with on *Bug*, we finished the mix in seven days, a new record for me. When we were done, Chartier said he hated the music I had chosen, a kind of country rock score. My first reaction was to resist him with extreme prejudice but I was impressed that his passion was as deep and obsessive as my own. He asked Tyler Bates, a prolific film composer, to see the film. Tyler was best known for lavish orchestral scores on big budget pictures such as *300*, *Dawn of the Dead*, and *Watchmen*. He offered to write and perform a new score for us, using no other musicians. We talked about a new approach. I told Tyler that if we were going to abandon the original score, I wanted softer textures, nothing melodic, except for a brief "Dottie's Theme" that would be based on Franz Lehar's *Merry Widow Waltz*. I felt this could suggest the notion of a warped Cinderella story; she finds her Prince Charming but he turns out to be a hired killer. Tyler would select one of the many exotic stringed instruments from his collection, start to play something, and I'd say "Yes, like that." He'd scribble a few musical notes on a page then record something and play it back at a different speed or distorted with echo. These were "mood" lines that in the final mix we played at the lowest possible level. The score is barely perceptible but gives the film a sustained, nervous undercurrent. Nick was right in per-

suading me to change the score. But there were conflicts with the line producers to the end. In the final stages of color timing, we encountered problems that required more time than was budgeted. I received an email from the associate producer informing me that due to deadline and cost restraints, no further changes to the film could be made. This, to me, was his attitude throughout. "We can't do this," "we don't have permission to do that." He was usually the heavy. I felt that he and his cohorts were obsessed with making the *budget*, not the film. I ignored him and didn't make delivery for a couple of weeks. By then the film was accepted in competition by the Venice Film Festival.

Not the paintings of Canaletto, Bellini, Giotto, nor the evocative prose of John Ruskin can do justice to the experience of *being* in Venice, especially on the Lido when the film festival is on. I've shown films there many times but *Killer Joe* is the first I've had in competition. The audience and critical response was fantastic and Chartier was getting offers from foreign territories. On the night before the prizes were given, the head of the festival, told me he thought *Killer Joe* was going to win. It was the choice of most of the journalists. But the top prize deservedly went to a Russian film, directed by Andre Sokurov.

Audience reaction at the Toronto festival was slightly muted, I thought, but the reviews were strong, and Nick worked his ever-present cell phone closing more deals. When the overwhelmingly positive reviews appeared, Nick sent me an email: "The film is great." The domestic distribution rights were bought by LD Productions, a new distribution company formed by a financier named Mickey Liddell, and David Dinerstein, former head of marketing at Miramax, Fox Searchlight, and other independent companies. *Killer Joe* would be their first release and with great enthusiasm

they set up test screenings in Paramus, New Jersey; Austin, Texas, and elsewhere. In each market the film played great but there were dissenters. At a screening in San Francisco, a woman approached me after an audience Q&A: "I'm just a normal audience," she said, "but I always look for redemption when I see a film. Where is the redemption in your movie?" I had to tell her, "There is none."

In March, the MPAA Ratings Board gave the film an NC-17, citing "Graphic, *aberrant* content including violence and sexuality and a scene of brutality."

An NC-17 is the Scarlet Letter of film ratings. In our case the A was not for Adultery but Aberrant behavior. *Aberrant* could be applied to Charles Manson or Hitler. The original intent of the rating was to separate adult films from pornography as a warning to parents of children under 17. The NC-17 replaced the X in 1990, but its effect is the same. Major theater chains won't play an NC-17, major video outlets won't sell it, and many people won't see it, as the rating doesn't separate adult subject matter from "filth."

We were stunned. Many films depict more violence and sexuality than ours but still get an R or even a PG rating. But a major studio film will *never* get an NC-17 because the six studios sponsor the ratings board. It's the independents that get slapped with it, so the board can justify its existence. The board's decisions are arbitrary. They have no objective standards. We don't know how many people are on the board or *who* they are. We don't know how they were selected. Is it political or are they "friends of friends"? Their decisions have no legal authority but they do affect box office. Do *you* want to see a film that's labeled "aberrant" with "excessive" violence or sexuality? Remember that *The Exorcist* got an R from the first ratings board, with no cuts.

Liddell and Dinerstein immediately appealed. Yes, there is an appeals process. That committee consisted of thirteen exhibitors.

Dinerstein asked me to attend. I was directing the opera *Tales of Hoffman* in Vienna but I told him I wouldn't go even if I *was* available. What was I supposed to say? "Please don't give my movie an NC-17?" Dinerstein thought that since Tracy was a recent Pulitzer Prize winner for his play *August: Osage County*, his prestige might possibly sway the board. At the appeal, Dinerstein spoke for about half an hour, citing examples of films that contained more violence and sexual content than *Killer Joe*. Then Tracy spoke for about five minutes trying to persuade the board that our film was not exploitative; the violence and sexuality were part of the fabric of the lives of his characters. He felt frustrated and humiliated having to justify his work. "It wasn't about anything *specific* in the movie," he told me. "It was the movie itself. They objected to it *in total*." At one point Tracy said to them: "It's like we're being punished for doing this *convincingly*." Their response was, "The fact that the violence was *personalized* is definitely one of the reasons." Tracy asked, "In other words, if the violence was *depersonalized* it wouldn't bother you?"

"No, it wouldn't," they said. "If this was just some guy dying, like in *Saw*, we wouldn't care."

Tracy felt their decision had already been made but he said, "Because we've given these characters depth and the actors play them well, you feel we deserve an NC-17." Their answer was "Yes." The board took twenty minutes to uphold the rating, unanimously, 13 to 0.

Some weeks later, when I returned from Vienna, Dinerstein and Liddell said they thought if we made just a few trims, literally frame cuts, the board would be satisfied and reverse the rating. I invited them to come to the cutting room and show me exactly what they were prepared to cut. Darren and I carried out their suggestions, which meant trimming the fellatio scene and the final scene in

which Joe beats Chris. Their edits amounted to seventeen seconds but for good measure, I took out another twelve, a total of twenty-nine seconds, which I felt would have no effect on the impact of the film. Dinerstein and Liddell were happy and confident. After I'd made the cuts, I was ashamed. The loss of twenty-nine seconds would not hurt the film but the idea of giving in to the board, or even attempting to, was *aberrant* to me. Their final verdict came back two days later. I don't know what took them so long. The NC-17 was of course upheld. And so the film went out uncut with the most draconian rating possible. I was actually thrilled. I was too old to bow down before an anonymous gaggle of morality police. I felt the film would be distinguished by its harsh rating, separated from the pack of R-rated films that compromised to achieve the MPAA's blessing. In England, the film played with an 18+ rating, no cuts. In France and Belgium, three-year-olds could see it if accompanied by a parent. Nowhere in the world was I asked to cut it, not even Russia, with one exception. Germany! The German censors were specific about scenes they wanted to remove. I wrote the distributor that if they made cuts I would publicly denounce my own film in the German press and on television, on Facebook and Twitter. I would characterize it as a return to the book burning in Germany of sixty years ago. I told them they could *ban* the film but they couldn't cut a frame of it. Fortunately, E-One, the controlling distributor, agreed with me but the release in Germany was severely limited.

Killer Joe is loved and hated. Praised and denounced. But it's the film I wanted to make and I'm proud of it and it found a small audience of passionate devotees.

It's been suggested I made *Killer Joe* as a response to the regular fare of the Hollywood studios and that may be true. I like to think that I made it only because I love the material and I believe Tracy's

work is a direct line from Harold Pinter's, which had so profound an effect on me.

It will be a long time, I think, before anyone makes another film as provocative and controversial, as "in your face" as *Killer Joe*. The risks are too great, the rewards too small. It was like hitting a wall. I may not be able to climb over it, but I'll never go back.

A life in film is like a long train ride. Sometimes it's fast, other times slow. People get on, others get off, and a few ride with you forever. The thing is, you don't know where it starts or when it will end.

20

REEL TWELVE

Random Thoughts on Directing

F. Scott Fitzgerald kept an index card pinned to the wall above his desk. It read: ACTION IS CHARACTER.

Fitzgerald was referring to characters in a novel but it's true in film as well. What the characters *do*, not what they say, is who they are. The most important thing a director does is to choose his material. Next comes casting; if you miscast a key role, the entire work will suffer. If an actor is physically right for a role, then what most interests me is intelligence: the ability to understand and absorb layers of character and portray them effortlessly.

The best advice a director ever gave a performer is Sergei Diaghilev's advice to Vaslav Nijinsky. From 1909 to 1929, Diaghilev was head of the world-renowned Ballets Russes. Nijnsky was his principal dancer. Once, before he went on stage, Diaghilev took him by the shoulders and said: "*Etonnez-moi.*" Surprise me! Often, when I get a good take, I'll do the same, letting the actors know they're free to explore the unexpected. I'm more interested in spontaneity than perfection. While it helps to have *some* knowledge of art, music, literature, and photography, the most important part of

a director's work is to help the actors realize their performances, to create an open atmosphere on the set, where the cast and crew can make creative contributions and not feel as though they are being judged. With *Cruising*, I failed in this. Because of my own insecurities, I was of little help to Pacino, who somehow managed, in a hostile environment, to achieve a focused performance in what was an unfocused story. On reflection, I've come to appreciate his work, something I was unable to do during production.

Films are constructed one shot at a time, but directors have to keep the whole film in mind every step of the way.

I don't give much credibility to the auteur theory. A director's intelligence *can* inform a film—the films of Fellini, Antonioni, Bergman, and many others attest to that—but film, like theater, is the most collaborative of art forms.

To become a director you must have ambition, luck, and the grace of God. Talent counts, but without luck and ambition, opportunities won't occur.

The Waiting Room

Only when time has passed do events begin to make sense. Harold Pinter told me a wonderful line from L. P. Hartley's novel *The Go-Between*: "The past is a foreign country. They do things differently there."

In many ways I'm still the same insecure kid I was in high school. My emotions are flammable and can be set off by a random spark. My failures line up before me each day like soldiers at attention while my successes play hide-and-seek like fireflies.

I embody arrogance, insecurity, and ambition that spur me on as they hold me back. And while I've been healed of physical

wounds, my character flaws remain for the most part unhealed. There's no point in saying I'll work on them. I spend part of each day acting out my worst instincts while I try to conceal them from those I care about. Every one of my films, plays, and operas has been marked by conflict, sometimes vindictive. The common denominator is me, so what does that tell you?

Good and evil co-exist in me as in all of us, and I believe it's a constant struggle for our better angels to prevail. This is a theme in all my films and remains a personal struggle, but I've been blessed with a loving, devoted wife and two wonderful sons I dearly love and they constantly help me suppress my darker impulses.

In spite of all the gifts God has given me, I still occasionally harbor anger and resentment. My salvation is to channel them into my work.

The kind of films I once loved and still do are rarely made now. The action sequences for which my colleagues and I were celebrated now seem relics of another age. Computer wizards have rendered them old-fashioned. The heroes of today's films are super-heroes. The villains are super-bad. The world explodes every day on a movie screen. After total destruction and annihilation, what's left? And yet cinema is about illusion, and the illusions have never been more graphic or convincing. If I were to make *The Exorcist* today, I'd use digital technology.

I used to ride my three-wheeler bike as fast as I could along Sheridan Road past the furniture outlet, the little grocery store, the movie theater, a scarf wrapped around my nose and mouth, faces blurring past, legs pumping, scattering pigeons. My world always ended at the shore of the frozen Great Lake, watching the ice floes, jagged pieces of a big white puzzle breaking in the sun. No worries then about what lay ahead. Everything would be fine. And soon

I'd be in the warmth of our one-room apartment, drinking the hot chocolate my mother made, listening to one of my favorite radio programs, waiting for my father to come home from work.

Before long I wasn't scared of the movies anymore. I couldn't wait to enter the safe darkness of a theater and become lost in another world. The films I once loved are still old friends. I visit them often and discover something new about them each time. Occasionally a film moves me in the same way as those that inspired me and this gives me hope there will be others. Someone will surely come along and use the new technology in as innovative a way as Orson Welles did with what was available to him in 1940. I don't fall into the misguided trap of thinking that my generation made masterpieces, and today's filmmakers are making garbage. That's what old Hollywood said about the films of *my* generation.

Just when you learn how to do it, you're too old. Except in your dreams. Lately I've been remaking my movies, reshooting scenes in greater detail than I did originally. Several times in the middle of the night I awake and think, Well that was a dream, and it's over. Then I fall back to sleep but the work continues. At this rate I'll be shooting forever. The scenes aren't from one film, they're from many, but somehow they seem to connect, to make dream sense. I'm relaxed and in control. No anxiety, no sense of dread.

I haven't made my *Citizen Kane*, but there's more work to do. I don't know how much but I'm loving it. Perhaps I'll fail again. Maybe next time I'll fail better.

ACKNOWLEDGMENTS

Richard Pine, of Inkwell Management, suggested I write this book. Jonathan Burnham, my publisher, suggested how I might go about it. Gail Winston had the formidable task of trying to make sense of it. My assistant, Marcia Franklin, worked tirelessly on its completion. I'm deeply grateful to them for their patience and guidance.

ACKNOWLEDGMENTS

FILMOGRAPHY

2012	*Killer Joe*
2007	*Bug*
2003	*The Hunted*
2000	*Rules of Engagement*
1997	*12 Angry Men (TV movie)*
1995	*Jade*
1994	*Blue Chips*
1990	*The Guardian*
1987	*Rampage*
1985	*To Live and Die in L.A.*
1983	*Deal of the Century*
1980	*Cruising*
1978	*The Brink's Job*
1977	*Sorcerer*
1974	*Fritz Lang Interviewed by William Friedkin (documentary)*
1973	*The Exorcist*
1971	*The French Connection*
1970	*The Boys in the Band*
1968	*The Night They Raided Minsky's*
1968	*The Birthday Party*
1967	*Good Times*
1966	*The Thin Blue Line (TV documentary)*
1962	*The People vs. Paul Crump (TV documentary)*

PHOTO CREDITS

The Boys in the Band
Stills © 1970 Leo Productions Ltd. Courtesy CBS Broadcasting Inc.
Boys in the band (black turtlenecks), photo by Irving Penn © 1970 Leo
Productions Ltd. Courtesy CBS Broadcasting Inc.

The French Connection
Stills © 1971 Twentieth Century Fox.

The Exorcist
Stills licensed by: Warner Bros. Entertainment Inc. All rights reserved.

Cruising
Stills licensed by: Warner Bros. Entertainment Inc. All rights reserved.

To Live and Die in L.A.
Stills © 1985 by METRO-GOLDWYN-MAYER STUDIOS, INC.
All Rights Reserved. Courtesy of MGM Media Licensing.

Los Angeles Opera
Photographs by Robert Millard/Los Angeles Opera © 2002–2008.
Artists from the LA Opera productions of *Suor Angelica*, *Il Tabarro*,
Gianni Schicchi and *Duke Bluebeard's Castle* courtesy of the American
Guild of Musical Artists.

Bug
Stills provided through the courtesy of Lionsgate.

Killer Joe
Stills © 2012 LD Entertainment.

Photo of Sherry Lansing by Jenn Munkvold + Taylor Peden.

All other photographs courtesy of the author.

Endpaper Images
Photograph of William Friedkin directing on the set of *The Exorcist* ©
Condé Nast Archive/Corbis.
Photograph of Director William Friedkin looking through the camera
on the set of *The Exorcist* © Bettmann/Corbis.

INDEX